Theoria

031610

Theoria

ART, AND THE ABSENCE
OF GRACE

Peter Fuller

Chatto & Windus
LONDON

Published in 1988 by
Chatto & Windus Ltd
30 Bedford Square
London WC1B 3SG

A CIP catalogue record for this book
is available from the British Library

ISBN 0 7011 2942 5

Copyright © Peter Fuller 1988

Photoset in Linotron Sabon by
Rowland Phototypesetting Ltd
Bury St Edmunds, Suffolk
Printed in Great Britain by
Redwood Burn Ltd
Trowbridge, Wiltshire

*This book is dedicated to Sally
and W. George Fuller,
with thanks and affection*

Contents

List of Illustrations

Acknowledgements

This book has been a long time in the writing: too long. So many people have helped me with it in one way or another that I could not begin to name them all. Even so, I would like to express my thanks to some of those without whom *Theoria* would never have seen the light of day.

Firstly, I would like to thank Maurice Cowling and Roger Scruton, both of whom played significant parts in the changes of mind chronicled here. I would also like to express my gratitude to Carmen Callil, my publisher; without your unflagging faith in *Theoria* and your enthusiastic insistence that I should bring it to completion, Carmen, I don't think I would ever have reached the final chapter! I am also indebted to Jenny Uglow and Robert Lacey of Chatto & Windus and to Linda Saunders, my assistant, for all their painstaking, patient and detailed work on the text. Thank you.

In writing *Theoria*, I read and was influenced by the work of innumerable other writers. There are a handful of books, however, which had a special and particular effect upon my thinking and which I would like to acknowledge here; these include P. D. Anthony's *John Ruskin's Labour* – easily the best book on Ruskin's social theory; Eve Blau's *Ruskinian Gothic*; Maurice Cowling's *Religion and Public Doctrine in Modern England*; Hilary Fraser's *Beauty and Belief*; Margaret A. Rose's *Marx's Lost Aesthetic*; Nicholas A. Rupke's pioneering *The Great Chain of History: William Buckland and the English School of Geology, 1814–1849;* and Nicolette Scourse's informative *The Victorians and their Flowers*. I have also been greatly influenced by Peter Atkins's *The Creation*, Richard Dawkins's *The Blind Watchmaker*, and E. O. Wilson's inimitable *Biophilia*.

Needless to say, none of those acknowledged here is in any way responsible for any errors or aberrations of thought which the book may contain.

Finally, I would like to thank Stephanie, my wife, Sylvia, my daughter, and Laurence, my son – all of whom have, in differing ways, been rather more closely associated with John Ruskin than they may have wished. I am grateful to you all for putting up with him, and with me, while I pursued him. I also want to thank Jeanne Elliott for her gift of a specimen of *Alisma Plantago*, which aroused my suspicions, and to Nicholas Guppy, who confirmed them.

Peter Fuller, Bath, 1988

Introduction: Modern Painting

Consider *Convent Thoughts*.

The manifest subject of this herbaceous picture, which now hangs in the Ashmolean in Oxford, is a young Victorian nun contemplating a passion flower. She is standing on a small island, in the middle of a pond – where we might expect a fountain to be – inside a walled garden; in her left hand she holds a beautifully illuminated, medieval, religious book. The artist has painstakingly depicted numerous varieties of lilies around her. Towards the back of the profuse flower-bed, a rose bush blooms conspicuously. At the nun's feet, water lilies grow and red and white goldfish swim.

When the work was exhibited at the Royal Academy exhibition of 1851, the artist, Charles Collins, provided a clue to its interpretation in a text from the Book of Psalms published in the catalogue: 'I meditate on all Thy works; I muse on the works of Thy hands.' The picture is redolent with laboured symbolic intent, radiating out from the passion flower itself, whose crossed stamens have put the young nun in mind of the crucifixion of her Lord. But the response from critics and public alike was hostile, many would feel justifiably so. For Collins's *Convent Thoughts* seems, today, a silly picture – the embodiment of everything which modern sensibility despises about the Victorian world.

Even so, *Convent Thoughts* was one of the pictures John Ruskin singled out when he wrote to *The Times* in 1851 to counteract the adverse criticisms the Pre-Raphaelites had been receiving. Two years later, William Rossetti, the Brotherhood's scribe, was writing, 'We have emerged from reckless abuse to a position of general and high recognition.'[1] Before we look at what it was about Collins's picture which found favour with Ruskin, we must ask ourselves what it is that so arouses our disdain.

It can hardly be a question of overt subject matter; the idea of a chaste and holy virgin in an enclosed garden of flowers first entered

Christian iconography in the fifteenth century, and since then has inspired some of the greatest art and literature of the Western tradition. Indeed, such pictures have sometimes been seen as the very source of landscape tradition, an art form which reached its apotheosis in Turner.

Nor yet can it be that the nun's preoccupation with divine incarnation, and its types in nature, is something intellectually alien to us. After all, much of the finest art of Christendom revolves around these themes; and we do not feel we have to enter into the beliefs of, say, the early fifteenth century Cologne master who painted the little Paradise garden, now in the Frankfurt Gallery, before we can respond to its intimate glories. Nonetheless, when we view *Convent Thoughts*, we want to call it 'sentimental', or even to dismiss it as being ridiculous. Why?

Collins may have wanted to evoke the grandeur of the Christian theme of the incarnation, of God, veiled in flesh, entering the world of nature, and dying that we might live. But neither the expression of the nun, nor the depiction of the garden around her, speaks easily or convincingly of any continuity between worldly and heavenly things. The grand spiritual themes simply fail to connect with his coy, Victorian model in fancy dress. We can never escape the conclusion that he has been unable to pass beyond mundane resemblances. Collins is overwhelmed by an intractable sensuous and sensual reality. If the mawkish woman's passion flower reminds *us* of anything it is of her repressed sexuality. For all its religiosity, *Convent Thoughts* is nothing if not common-or-garden. The flowers that surround the nun speak to us not of the orchards of Lebanon, let alone of the agonies of Gethsemane, but of Sunday afternoon visits to National Trust gardens, or even seed merchants' catalogues.

This is a matter of technique as much as of imagery: Collins clearly aspired to the luminous flatness of stained glass or fifteenth century manuscript illumination; yet the effect is shattered by his inability to subdue tactile illusions. The nun, and her garden, are suspended in a curiously foreshortened, one might say 'surreal' pictorial space, somewhere between a Lady Chapel window and a Kodachrome print. Secure in our late twentieth century aesthetic superiority and worldly wisdom, we can afford to turn away from this comical failure with a wry smile.

But can we?

* * *

Now consider *Portrait of God*, made by Julian Schnabel in 1981.

This picture consists – not to put too fine a point upon it – of a blue daub of oil paint smeared across a piece of old tarpaulin. The following year, a Tate Gallery catalogue proclaimed Schnabel as 'one of the most celebrated young artists working anywhere in the world today.'[2] Not even Schnabel would claim that he had suffered from an overwhelming sense of the *Mysterium Tremendum* when painting this picture. He himself has denied that he has any spiritual sensibilities, saying only that 'a feeling of God', for him, means making paintings so large that 'they can massage me into a state of unspeakableness'.[3]

Or take *Praying Garden*, made in 1982 by the British 'artists' Gilbert and George. This picture shows Gilbert crouching with his hands pressed together in front of a lily, which has been coloured in a sickly, synthetic purple. He is surrounded by black and grey images of foliage. George, his lover, is falling, upside down and apparently naked, out of a uniform red sky above him. On one side of the painting is a blue, and on the other a green, cat.

Gilbert and George produce such pictures together: they like to claim, 'Our whole life is one big sculpture.' Their images almost always refer in some way to themselves. They use only photographic techniques: 'The idea that evidence of the hand is good – that's what we dislike.'[4] Predictably, their work is without any sense of touch, aesthetic sensitivity, nuance or tradition. Indeed, they have repeatedly expressed their antagonism towards 'élitism', and would not appear to have been significantly influenced by any of the great art of the West. Their colours clash and jostle with all the glaring smoothness of billboards; and their space is literally flat and superficial. These large, gaudy montages incessantly refer to their narcissistic preoccupations with each other, with alcohol, and with young boys. Another work of 1982, *Flower Worship*, shows a youth in tight blue jeans lying in the foreground of a picture with huge, luridly coloured daisies drifting in the sky above him.

But, they say, 'We don't like documentation. None of our works are documentaries. They are thoughts, spiritual.'[5] On another occasion one of them explained: 'We try to reach, to find a soul or kind of God that is beyond our art.'[6] In fact, their images cannot rise above their obsessive preoccupation with urban violence, lumpen philistinism, sexual products and organs, and personal depravity. A peculiarly ugly series of the late 1970s, composed out of black-and-

white and red-coloured photographs, incorporating reproductions of graffiti, was presented with titles like *Prostitute Poof*, *Cock VD*, *Bollocks We're All Angry*, *Bent Shit Cunt*, *Smash the Reds*, *Bugger*, *Queer*, and *Prick Ass*. The latter shows their heads separated by an image of the crucified Christ; the top of the picture is inscribed with the scrawled word 'Prick', and the bottom with 'Ass'. In the centre, there are red-coloured photos of the inner city, and at the edges shots of a derelict down-and-out.

Gilbert and George won the Turner Prize in 1986, an annual award of £10,000, made under the auspices of the Tate Gallery to the individual(s) who, in the opinion of the jury, has done the most for art in Britain in the previous twelve months.

* * *

Collins's *Convent Thoughts* was first exhibited in 1851, the year of Turner's death and of the opening of the Great Exhibition. Its gauche awkwardness reflects the tug of the long, withdrawing roar of the Sea of Faith. *Portrait of God* was painted in the year of *A New Spirit in Painting*, an influential exhibition, which included several Schnabels, held at London's Royal Academy in 1981. Between these two dates lies the rise, the fall, and the final collapse of the modern movement in art.

For Thomas McEvilley, a windy American apologist for Schnabel, his venal and derelict pictures testify to the continuing life of the modernist tradition in a post-modern world;[7] Gilbert and George, who make no secret of what one American critic has called 'their horror of Modernism',[8] have hardly succeeded in recultivating the terrain which the late modern movement left devastated. Indeed, we may stand on the far shore of a collapsed modernity, but our most acclaimed artists have not resolved the spiritual and aesthetic crisis which, however unsuccessfully, Collins endeavoured to confront.

* * *

Ruskin was one of the few men in the nineteenth century to foresee what might happen to art. At various times in his life, however, he also began to glimpse beyond the spiritual blankness he had predicted. When he wrote to *The Times* in defence of the Pre-Raphaelites, Ruskin declared that no one who knew his writings would suspect him 'of desiring to encourage them in their Romanist and Tractarian tendencies'. He continued:

. . . and I have no particular respect for Mr. Collins' lady in white, because her sympathies are limited by a dead wall, or divided between some gold fish and a tadpole – (the latter Mr. Collins may, perhaps, permit me to suggest *en passant*, as he is already half a frog, is rather too small for his age). But I happen to have a special acquaintance with the water plant, *Alisma Plantago*, among which the said gold fish are swimming.[9]

He went on to say that he had never seen the plant 'so thoroughly or so well drawn'. Many have assumed that in saying this, Ruskin was defending 'naturalism'. But this was not so. There is, I believe, much to be learned from trying to understand what Ruskin meant when he issued his strictures upon *Convent Thoughts*, and yet praised the painting of the leaf of *Alisma Plantago*, the common water plantain. And, in a sense, the quest for such understanding is what this book is about.

I try to show the radical differences between Ruskin's ideas about art and nature and those espoused by the modern movement, which came after him. (This is especially important because Ruskin has sometimes been claimed as the founder, or at least the precursor, of modernity in art and architecture.) I then go on to demonstrate how Ruskin's aesthetic ideas were rooted in the religious and scientific thinking of his day: Ruskin's system depended upon the idea that nature was in some sense a garden made by God, for man. Was he, in fact, so misguided in his belief that aesthetic response to the natural world required deep tendrils in moral and spiritual life if it was to survive? But how is that possible when the naked shingles of the world have been exposed?

We will have to explore just how important ideas of natural theology were to the 'progressive' side of the Gothic Revival and, indeed, to Pre-Raphaelitism itself. The break-up of Ruskin's belief in the unity between science and theology precipitated a crisis in his thinking about both art and life. Though this deep anguish of the mid nineteenth century has often been remarked, were the *aesthetic* dilemmas which it created in fact ever resolved? Ruskin's successors simply sought to evade the issue: William Morris – a much weaker thinker than Ruskin – carried on as if there was no difficulty in having Gothic without God . . . All sorts of attempts were made to recapture the spiritual depth which Gothic art had possessed – most notably through the pursuit of transcendent abstraction; but these, too, ended in failure. Modernists began to put their faith in machines and man's capacity to remake the natural world in his own image, according to his

own needs. We will explore how this Adamite arrogance proved the undoing of the modern movement: after the Second World War, it crumbled into the perverse banality of *Praying Garden*.

But this was not the whole story. As we worry out the meaning of Ruskin's fascination with the painting of the common water plantain in a poor Pre-Raphaelite picture, we discover his importance for today's aesthetic dilemmas. If Ruskin was not a forerunner of modernism, he was the inspiration of a continuing, if neglected, romantic tradition. Far from being 'escapist', this tradition has expressed imaginative, spiritual and aesthetic insights which modernity disregarded. Today, those insights are coming into their own; as we struggle to find our way out from under the rubble and ruins of modernity, Ruskin's critical enterprise seems to acquire a renewed relevance. He was, in effect, the first post-modernist – and his thinking about art runs deeper than many of those who came later. Perhaps that unity between scientific, spiritual and aesthetic life, which Ruskin longed for, is again becoming possible . . . I end up by indicating how work in the new biology and today's higher mathematics offers a tantalising vindication of Ruskin's strangest aesthetic ideas. He provides clues not only to the spiritual and aesthetic dilemmas of his time, but also of our own.

But before we can make sense of Ruskin's interpretation of *Convent Thoughts*, we must first ask, 'What manner of man, then, was he?'

I

Praeterita in Eden

There was, as they say, madness in the family. John Ruskin's paternal grandfather, John Thomas Ruskin, was a Scottish grocer and vintner. In 1817, in debt and insane, he took his own life at the family home at Bowerswell, near Perth. The following year his son, John James, married a first cousin, Margaret Cock, after a ten-year engagement. Their only son, John, was born in Hunter Street, London, in 1819 – the same year as Queen Victoria.

John James was, as his son described him, 'an entirely honest merchant', who restored the family's name by paying off his father's debts. For most of his working life he was the active partner in a sherry importing firm called Ruskin, Telford and Domecq. When John was four years old, the family moved to Herne Hill, near Camberwell, where they remained for twenty years. Though prosperous, the household was pervaded by the probity of puritanical Evangelicalism. Ruskin later described it as 'at once too formal and too luxurious'. He probably exaggerated when he wrote that he was allowed no toys until he was about five, when he was given 'two boxes of well-cut bricks'; but through a mixture of such indulgences and whippings, he 'soon attained serene and secure methods of life and motion' and passed his days 'contentedly in tracing the squares and comparing the colours of my carpet'.[1]

Family life revolved around obligations rather than intimacy. Ruskin paints a picture of a world drained of spontaneity and feeling: no one ever raised their voice, but not even the servants were allowed to do anything for him 'but what it was their duty to do'.

Margaret was a dominating woman who combined shrewishness and solicitousness. Unbending in her piety, unerring with her needle, and opposed to 'theatricals' on religious grounds, she had, according to her son, solemnly devoted him to God before he was born 'in imitation of Hannah'. John James acquiesced to his wife on such issues. He was more concerned about his son's position in *this* world.

Obsequious, conscientious, authoritarian, and an incorrigible snob, he came to focus all his ambitions on the idea that his only son would become a great poet.

In old age, Ruskin complained that in his childhood he had had 'nothing to love': his parents were like 'visible powers of nature' to him, 'no more loved than the sun and the moon'. He felt that the evil consequence of all this had not been that he grew up selfish and unaffectionate, but rather that when affection did come, 'it came with violence utterly rampant and unmanageable, at least by me, who never before had anything to manage.'[2]

But life was not without its consolations; many of them came through Henry Telford's travelling carriage. Margaret and John would often accompany John James when he borrowed his partner's splendid vehicle to scour the country for new orders for sherry. And so, under his father's guidance, the boy acquired a precocious knowledge of the art and architecture of many of the great houses in Britain. In 1824 the Ruskins toured the Lake District, before journeying on to Scotland. This trip made a deep impression upon John:

The first thing which I remember, as an event in life, was being taken by my nurse to the brow of Friar's Crag on Derwent Water; the intense joy, mingled with awe, that I had in looking through the hollows in the mossy roots, over the crag, into the dark lake, has associated itself more or less with all twining roots of trees ever since.[3]

Ruskin explained that whenever these journeys 'brought me near hills, and in all mountain ground and scenery, I had a pleasure as early as I can remember . . . infinitely greater than any which has been since possible to me in anything.'[4] He compared the intensity of the experience to the joy of a lover in being near 'a noble and kind mistress', and claimed it was no more explicable than the feeling of love itself.

In old age, he remembered the garden of Herne Hill as a paradise on earth, blessed with 'magical splendour of abundant fruit: fresh green, soft amber, and rough-bristled crimson bending the spinous branches; clustered pearl and pendent ruby joyfully discoverable under the large leaves that looked like vine.'[5] The main difference between this garden and the Garden of Eden, he wrote, was that in the former, 'all the fruit was forbidden; and there were no companionable beasts.' But, in other respects, the little domain answered every purpose of Paradise to him. 'My mother,' he wrote, perhaps consciously recalling the imagery of the medieval enclosed gardens he had always loved, 'herself finding her chief pleasure in her flowers, was often planting

or pruning beside me, – at least if I chose to stay beside *her*.' But his mother's presence was neither a 'restraint', nor 'a particular pleasure' to him, since he felt so very much alone. He confessed that he began to lead 'a very small, perky, contented, conceited, Cock-Robinson-Crusoe sort of life', in which it seemed to him quite natural that he occupied the 'central point' of the universe.[6]

Throughout Ruskin's life his response to nature, and also to art, was imbued with something of those feelings of affection which he found it so difficult to express appropriately in his relations to people. 'I am never long enough with men,' he once confessed to his father, 'to attach myself to them; and whatever feelings of attachment I have are to material things.'

His youth was spent drawing, travelling with his parents, reading, studying minerals, and writing poetry. His first published poem, 'On Skiddaw and Derwent Water', appeared in *Spiritual Times* in 1830. In 1831, he described his response to Snowdon by moonlight:

> Folding like an airy vest,
> The very clouds had sunk to rest;
> Light gilds the rugged mountain's breast,
> Calmly as they lay below;
> Every hill seemed topped with snow,
> As the flowing tide of light
> Broke the slumbers of the night.[7]

On Ruskin's thirteenth birthday, Henry Telford made him a present of Samuel Rogers's book *Italy*, illustrated with vignettes after Turner, which triggered one of the great obsessions of his life. Soon after, he became acquainted with Samuel Prout's engravings of Flanders and Germany. Such was his enthusiasm for these works that, in 1833, the family set off on the first of their many continental tours. They travelled along the Rhine to the Alps, where – some might think happily – Ruskin's scientific fascination with geology began to take precedence over his poetic romanticism. Even before he wrote *Modern Painters*, he was struggling to reconcile the 'airy vest' and the 'twisted strata'; in 1836 he wrote a long letter, which was never published, for *Blackwood's Magazine* defending Turner against the critics. As we shall see, it was all 'airy vest'.

The following year, Ruskin arrived in Oxford as a gentleman-commoner of Christ Church; his mother went too, to keep house for him. These were unusual arrangements for an undergraduate, but Ruskin's emotional life was making him ill. Not for the last time, he

found himself seized by 'unmanageable' and unrequited affection for an unattainable and inappropriate young woman – in this case Adele Clotilde Domecq, a daughter of one of his father's sherry partners. Adele was a Catholic and betrothed elsewhere. Ruskin's unrequited love provoked the first of the many deep personal crises which punctuated his life, precursing his eventual attacks of insanity. These disturbances involved his whole personality, affecting his mental, emotional, sexual, intellectual and physical life. Only rarely, however, did they affect his productivity; while at Oxford he won the prestigious Newdigate Prize for poetry and wrote on architecture for the *Architectural Magazine*. But he was pronounced 'consumptive' and had to go down from Oxford; it was to be another three years before he could finally describe himself – as he did when publishing the first volume of *Modern Painters* – as a graduate of Oxford.

Soon after leaving Oxford, Ruskin had an experience when walking along the road to Norwood which changed his drawing style – and had a profound effect on his ideas about art. He noticed a piece of ivy round a thorn stem which seemed, even to his critical judgement, 'not ill "composed"'. He made a light and shade pencil study of it on the grey paper of his pocket-book:

When it was done, I saw that I had virtually lost all my time since I was twelve years old, because no one had ever told me to draw what was really there! All my time, I mean, given to drawing as an art; of course I had the records of places, but had never seen the beauty of anything, not even of a stone – how much less of a leaf.[8]

This intense aesthetic and spiritual experience was repeated on a trip to Fontainebleau, where Ruskin found himself 'lying on the bank of a cart-road in the sand, with no prospect whatever' – except for that of a small aspen tree against the blue sky:

Languidly, but not idly, I began to draw it; and as I drew, the languor passed away: the beautiful lines insisted on being traced, – without weariness. More and more beautiful they became, as each rose out of the rest, and took its place in the air. With wonder increasing every instant, I saw that they 'composed' themselves, by finer laws than any known of men. At last, the tree was there, and everything that I had thought before about trees, nowhere.[9]

The crux of these experiences – to which Ruskin returned in his writing, almost as if they were parables – appears to have been that seeing 'what was really there', for him, meant perceiving the way in which natural forms '"composed" themselves, by finer laws than any

known of men'; what was 'really there' was something more than could be revealed by empiricism, or what we would call naturalism. The stones and leaves were means of revealing the truths of God for him.

The family moved to Denmark Hill in 1842, and it was there that John wrote the first volume of what was to swell into his epic work, *Modern Painters*. Like the letter he had written six years previously, *Modern Painters* was begun as a reply to scoffing press criticisms of Turner's work; but the book swelled uncontrollably into five long volumes, reflecting radical changes in Ruskin's ideas. The second volume was much delayed, and did not in fact appear until 1846. By this time, Ruskin was teetering on the brink of another morbid crisis, fuelled, once again, by unrequited love, theological doubt, and geological speculation. In 1847 he went to stay with his Scottish cousins, the Grays, now living at Bowerswell, Perth, in the very house where John Thomas had committed suicide.

There, Ruskin again met Effie Gray, for whom he had written the children's story *The King of the Golden River* when she had stayed at Herne Hill six years previously. The couple were married at Bowerswell the following year. The early days of the marriage were peaceful enough: it was as if by marrying Effie he had 'solved' the emotional turbulence which constantly threatened him. The couple soon set up in Venice, where Ruskin began to work on the other great epic of his early years, *The Stones of Venice*. Effie enjoyed the city's glittering social life.

Beneath the surface, the marriage was hollow. Neither partner was really capable of relating to the other, emotionally, intellectually, or sexually. When in England, the couple lived with Ruskin's parents, who proved no less cloying and intrusive than they had before their son's marriage. Effie understandably came to detest the old pair, and Ruskin was quite unable to see why. As is well known, he and Effie never consummated their relationship. He tried to explain why in a letter he wrote to a friend soon after the separation:

I never attempted to make her my wife the first night – and afterwards we talked together – and agreed that we would not, for some time consummate marriage; as we both wanted to travel freely – and I particularly wanted my wife to be able to climb Alps with me, and had heard many fearful things of the consequences of bridal tours.[10]

It has been said that he was frightened on the wedding night by the sight of his wife's pubic hair; more probably, he was perturbed by her

menstrual blood. Matters continued as they had begun, and the relationship was fouled beyond repair by a sense of irritation, frustration, remoteness and emotional coldness. In another letter to a friend written after the break-up, Ruskin gave a vivid vignette of 'our usual intercourse':

Effie is looking abstractedly out of window.
John. 'What are you looking at, Effie?'
E. 'Nothing.'
J. 'What are you thinking of then?'
E. 'A great many things.'
J. 'Tell me some of them.'
E. 'I was thinking of operas, and – excitement – and – (angrily) a great many things.'
J. 'And what conclusions did you come to?'
E. 'None – because you interrupted me.' Dialogue closed.[11]

Characteristically, Ruskin noted this exchange in a spirit of self-justification: but one does not have to be a marriage guidance counsellor to sniff the authentic odour of genuine irreconcilability.

In 1851, Ruskin stepped forward in defence of the Pre-Raphaelites with his letter to *The Times*. Two years later, he and Effie went on holiday with John Millais to Glenfilas, in Scotland. There Millais painted a famous portrait of Ruskin, which shows him standing, hat in hand, on some immaculately painted rocks, beside a waterfall. Ruskin's own rock drawings from this time indicate just how close his aesthetic ideas were to those of his protégés. The following spring, Effie left Ruskin for Millais, and their marriage was annulled on grounds of non-consummation. Ruskin's response was almost one of relief: he expressed to Millais the forlorn hope that these events would not spoil *their* friendship. A month after the annulment, holidaying on the continent, with 'the green pastures and pine forests of the Varens' softly seen through the light of his window, Ruskin wrote that he could not 'be thankful enough, nor happy enough'.

Back in England, he began to enjoy a growing success as a lecturer. He even began to teach drawing at F. D. Maurice's Working Men's College in Red Lion Square. The erratic and unreliable Dante Gabriel Rossetti was roped in to help him. In 1856, the third and fourth volumes of *Modern Painters* appeared. The next year he gave his important lecture on 'The Political Economy of Art' in Manchester. And he became deeply involved in the building of the Oxford University Museum, in the Gothic style. He also plunged into the arrangement

of the vast number of unclassified drawings Turner had left behind at his death. Though he saved many drawings which would otherwise have gone rotten in the cellars of the National Gallery, he did not hesitate to destroy others he deemed too sensual. This destructive behaviour seems to have been a perverse defence against a threatening aspect of himself; for Ruskin's affective, intellectual, and spiritual life was again undergoing profound changes.

In 1858, Ruskin met an Irishwoman, Mrs La Touche, who wanted him to teach drawing to her two daughters, Emily and Rose. Ruskin became infatuated with Rose, who was ten years old. Later that year, while staying in Turin, he pigged himself in a local restaurant, gloated openly at beautiful girls, went to a Waldensian Chapel where the preacher was 'a little squeaking idiot', became 'a conclusively *un*-converted man', and recognised the 'God-given power' in the fleshly paintings of Paul Veronese, and other 'sensual painters, working apparently with no high motive'. He came to revalue sensual experiences – in both life and art. He abandoned conventional Christianity in favour of his own 'Religion of Humanity', which he was to practise until about 1874.

The 1860s saw the publication of those books on civic, social and political life which were eventually to make Ruskin internationally famous. Ruskin's excursions into political economy caused a rift with John James – who favoured the ethics of liberalism and a free market. His writings in these years were also associated with a deepening personal depression, mingled with social despair.

In 1864, John James died. Ruskin's mother was becoming increasingly frail. He persuaded a Scottish cousin, the youthful Joanna Agnew, to come and join the household. She was to be a dominant domestic influence over the remainder of his life. That same year, in Manchester, he gave the lectures which later became his best-selling book, *Sesame and Lilies*. They reveal a cloying note. In a talk called 'Lilies: Of Queens' Gardens', he asked the members of his audience to suppose that, at the back of their houses, each of them had a garden large enough for their children to play in and also that they could not change their abode. He further wanted them to suppose that they could double their income, or even quadruple it, 'by digging a coal shaft in the middle of the lawn, and turning the flower-beds into heaps of coke'.

'Would you do it?' he asked them. 'I hope not. I can tell you, you would be wrong if you did, though it gave you income sixty-fold

instead of four-fold.'[12] Yet, he continued, this was what was happening to the 'little garden' of England. 'And this little garden you will turn into furnace-ground, and fill with heaps of cinders, if you can.' This idea of 'The Machine in the Garden' – of a childhood paradise polluted, and rendered noxious by economic imperatives, and mechanical intrusions – was at the core of all Ruskin's thinking. Ruskin thought that the women of England – 'you queens – you queens' – were especially well placed to resist these processes. 'Of Queens' Gardens' ends with an evocation of the enclosed garden of the Song of Solomon: 'There you shall see with Him the little tendrils of the vines that His hand is guiding – there you shall see the pomegranate springing where His hand cast the sanguine seed . . .'[13]

Ruskin went on trying to communicate with working men, but he also became increasingly involved with the 'education' of young girls. His romps in fancy dress with the pupils of Winnington Hall – a girls' school, the headmistress of which he knew well – would not pass unremarked today. The lessons he gave there in the form of dialogues were gathered in the oddest of all his books, *The Ethics of the Dust*, a synthesis of geology, political economy, mythological speculation, and home-spun moralising – a children's primer of the Religion of Humanity.

His 'relationship' – if such it can be called – with Rose La Touche did not improve. In 1866, when he was forty-seven, and she eighteen, he proposed marriage, and was told to wait until her twenty-first birthday for a reply. Rose was excessively pious, and was pricked by the unorthodoxy of Ruskin's beliefs. The surviving fragments of her writings indicate how fearful this childish girl must have been of the emotions she unleashed in an eminent, verbose and tyrannical older man.[14] Ruskin again sank into a deep depression, sometimes disguised by manic productivity. Rose imagery began to trail and twine through all his thinking. Thomas Dixon, a Sunderland cork-cutter with whom he corresponded, was treated to a letter on the subject of 'Rose-Gardens: Of Improvidence in Marriage in the Middle Classes; and of the advisable Restrictions of it'. Here Ruskin argued that permission to marry should be regarded as a reward to be dispensed every six months and the girls who had won it should be crowned 'by the old French title of Rosieres'.[15]

He began to express fears concerning his own sanity, and he denounced Rose's pietistic beliefs in public and in private. Once again, he sought solace in stones and minerals. He published numerous

articles on agates and other banded and brecciated minerals in the *Geological Magazine*, and began to fill the tenantless house at Herne Hill with his ever-growing collection of geological specimens, keeping only the finest at Denmark Hill. He also lectured at University College, London on the nature of myth under the title, 'Queen of the Air'. In 1869 he was elected Slade Professor of Art at Oxford, where his lectures on diverse subjects proved enormously popular. In 1871 his mother's death began to cast a long, dark shadow over his life; he bought Brantwood, a house overlooking Lake Coniston, which became, in effect, the first home of his own he had ever had.

In Oxford, in 1872, he began to lecture on the relationship between art and the sciences; a series on birds in nature, mythology and art, 'Love's Meine', followed in 1873; and one related to speculative geology, 'Deucalion', in 1874. The following year he spoke about wild flowers and plants in an important series of talks later collected as *Proserpina*. He stressed that the Garden of Eden 'is spoken of in Scripture as perpetually existent'; whenever a nation 'rises into consistent, vital, and through many generations, enduring power', *there*, he argued, was 'still the Garden of God'. Such a nation was still fed, at its roots, by 'the water of life', and still 'the succession of its people is imaged by the perennial leafage of trees of Paradise'.

He ruminated upon whether this might ever be said of England, adding, 'How much more, of lives such as ours should be, – just, laborious, united in aim, beneficent in fulfilment, may the image be used of the leaves of the trees of Eden!'[16] As Dinah Birch has put it, in these studies Ruskin 'hoped to instil the scientific study of the world with a sense of the imaginative truths embodied in its culture'.[17] But these works also revealed the frailty of Ruskin's hold upon sanity: in the early 1870s his writing became more and more manic. He also plunged into a diffused range of decidedly eccentric utopian and 'practical' activities.

By the mid 1870s, Ruskin had regained a more conventional religious faith. Perhaps he needed it. In 1875 Rose died. In Venice, the following year, he began to identify Rose with Dante's Beatrice and with St Ursula. He renewed his contacts with spiritualists, and fantasised that he communicated with Rose, perceiving 'signs', symbols, meanings, and coincidences everywhere he looked. He deprecated not only Tintoretto, but even Turner, railing against their sensuousness, and looking for consolation to the religious paintings of pre-Renaissance Christianity. His monthly journal for working men, *Fors*

Clavigera, became crowded and clouded by his mystical and super-stitious elaborations. In 1878 he was afflicted with a bout of clinical insanity.

After the notorious libel case Whistler brought against Ruskin in 1878, he resigned his Slade professorship. He continued working, albeit somewhat chaotically and disjointedly. In 1880 he even felt well enough to tour the cathedrals of northern France. But the attacks of madness were to continue to plague him: he underwent major crises in 1881, 1882 and 1885. During a remission, in 1883, Ruskin resumed his Oxford professorship: his lectures on 'The Art of England' and 'The Pleasures of England' were sedate enough. 'At last,' he told his listeners, 'bursting out like one of the sweet Surrey fountains, all dazzling and pure, you have the radiance and innocence of reinstated infant divinity showered again among the flowers of English meadows by Mrs Allingham and Kate Greenaway.'[18]

But the world beyond the cottage garden was rather different; for many years he had been haunted by his obsession that strange and diabolic meteorological conditions were heralding the 'failure of nature'. In 1885 he resigned his professorship at Oxford for the last time, giving as his reason the vote to establish a physiological laboratory with facilities for dissection at the Museum with whose construction he had been so deeply involved. He saw this development as a victory by the scientists to whose clinical conception of nature he was now so vigorously opposed. But madness was closing in again.

Ruskin withdrew to Brantwood, his house on Lake Coniston. There, for the next four years, he worked intermittently on his idealised autobiography, *Praeterita*, in which he portrayed his life with all the colours and charm of a Mrs Allingham painting – and a great deal more sophistication. Painful memories, like his six-year unconsummated marriage, he simply erased. He made his last continental tour in 1888, but by then his creative and public work were finished. As he approached the end of his autobiography in June 1889, Ruskin wrote:

I draw back to my own home, twenty years ago, permitted to thank Heaven once more for the peace, and hope, and loveliness of it, and the Elysian walks with Joanie, and Paradisiacal with Rosie, under the peach-blossom branches by the glittering stream which I have paved with crystal for them.[19]

The last decade of Ruskin's life was spent in virtual seclusion – almost imprisonment – at Brantwood. It is as if a curtain comes down on him: he neither writes, nor draws, nor is he ever seen in public. We

glimpse him, occasionally, largely through photographs – a bewildered old sage, swaddled and cosseted by 'Joanie'. In 1874, Joanna had married Arthur Severn. The couple moved from Denmark Hill to the house in Herne Hill, surrounded by Ruskin's beloved childhood garden. But when Ruskin's mental condition incapacitated him, they moved up to Brantwood, where Joanna house-kept and nursed him. The Severns became ever more protective concerning their illustrious dependant. They carefully monitored his visitors and censored his mail.[20] Ruskin himself wrote the pathetic little ditties with which Joanna sang him to sleep. Sometimes he babbled to her in baby talk; or he gazed across the troubled waters of Lake Coniston, brooding about the malignant storm-clouds. In 1900 he died.

The faithful Collingwood was among the mourners. He wrote that when the dead march sounded, the coffin was covered with a pall given by the Ruskin Linen Industry of Keswick, lined with bright crimson silk, and embroidered with the motto, 'Unto This Last'. Ruskin's favourite wild roses showered over the grey field where he was laid to rest, 'just as they fall in the *Primavera* of Botticelli'. But, Collingwood noted, 'There was no black about his burying, except what we wore for our own sorrow; it was remembered how he hated black, so much that he would even have his mother's coffin painted blue; and among the white and green and violet of the wreaths that filled the chancel, none was more significant in its sympathy than Mrs Severn's great cross of red roses.'[21]

2
Two Paths in the Political Economy of Art

'The human race,' I found myself reading, 'may be properly divided by zoologists into "men who have gardens, libraries, or works of art; and who have none."' The former class, Ruskin wrote, would include 'all noble persons', except only a few who 'make the world their garden or museum'.[1] I first started to study Ruskin when I was a student at Peterhouse, Cambridge, in the mid 1960s. In 1967, I came across a copy of *The Political Economy of Art* in the old college library; I soon discovered it was unlike anything I had ever read before.

Ruskin explained that only 'ignoble persons' 'have not, or, which is the same thing, do not care for gardens or libraries'. But by 'garden' he meant as much the Carthusian's plot of ground 'fifteen feet square between his monastery buttresses' as 'the grounds of Chatsworth or Kew', and, by 'art', an old sailor's treasured print of the *Arethusa* as much as, or even rather more than, Raphael's *Disputa* – for one of the thrusts of his argument was opposition to 'vulgar luxury'.

The book contains the lectures Ruskin gave in 1857 when he was invited to Manchester to speak on the occasion of a major 'Art Treasures' exhibition. He reread these talks twenty-two years later, retitled them 'A Joy for Ever (and its Price in the Market)', and pronounced that everything he had since written on the political influence of the arts had been little more than an expansion of this work.

Manchester was the mecca of *laissez-faire* capitalism, and the head-quarters of the economic 'liberals' who believed that everything should be left to the operation of market forces. The worthy manufacturers and their wives who crowded into the Manchester Athenaeum no doubt expected to hear some edifying aesthetic sentiments from the increasingly fashionable apostle of Turner, and author of *Modern Painters*. Few could have gone along expecting what they got. For

1857 was a time of transition in Ruskin's thinking, a year before his 'unconversion' in Turin, after which he argued that 'a good, stout, self-commanding, magnificent animality is the make for poets and artists.' His thoughts were shifting from the Kingdom of God to the societies of men, albeit *under God*, and to his hardening conviction that the modern world involved the betrayal and pollution of all that was worthwhile in man's intellectual, spiritual, and artistic life.

In Manchester, he compared the body politic to a garden. 'I shall ask you to consider with me the kind of laws by which we shall best distribute the beds of our national garden,' he told his listeners, 'and raise in it the sweetest succession of trees pleasant to the sight, and (in no forbidden sense) to be desired to make us wise.'[2] He took the organic image of social life literally, arguing that there was something 'unnatural' in competition; hence his bitter criticisms of the indifference of the existing government to the quality of life of the governed. How, he wanted to know, was *laissez-faire* theory and practice compatible with, say, the employment of artists, the education of workmen, the elevation of public taste, and the regulation of patronage? He was especially concerned about the way *laissez-faire* capitalism was destroying what today might be called 'the aesthetic dimension' of human life – though, as we shall see, he tended to shun the word 'aesthetic' itself. He complained that contemporary society seemed to be squeezing out art altogether; he pointed to the tasteless luxury of the rich; ignorant patronage; the destruction of ancient buildings; and the decline of artistic work in ornament, furniture and dress.

Ruskin regretted that market forces were such that 'a satisfactory example of first-rate art – masterhands' work' was out of the range of a man 'of narrow income'. And yet, he thought, this was an evil 'perfectly capable of diminution'. He told his Manchester audience that the goal ought to be 'to accumulate so much art as to be able to give the whole nation a supply of it, according to its need'. But he in no wise welcomed the dawning age of mass, mechanical reproduction; he believed instead in the regulation of art's distribution 'so that there shall be no glut of it, nor contempt'. He warned against those 'who want to shower Titians and Turners upon us like falling leaves'.[3]

The lectures were scattered with suggestions about what government might do to make things better: for example, he said it would be a good idea if government regulated the production of artists' materials – like paper and paints – to ensure quality. Surprisingly, *laissez-faire* though they were, Ruskin's audience seems not to have

objected when he asked this, among 'many favours ... from our paternal government'. At least they applauded frequently while he was speaking. Perhaps they were mollified by the anti-democratic flavour of even his most utopian imaginings, and by his insistence that it was not wealth he opposed but its wrongful use. But when the press had a chance to study the lectures, they appeared to have realised something of their significance: the *Manchester Examiner and Times* dismissed Ruskin's pleas for the involvement of the state in artistic life as 'genius divorced from common sense', and as 'arrant nonsense'.[4]

When I chanced upon these potent lectures over a century after they were first delivered, they had a profound effect upon me. I resolved to study Ruskin for my next undergraduate essay. My supervisor suggested a title: 'Ruskin's social, economic and aesthetic teaching was confused by puritanical prejudice. Discuss.' I got out that essay recently and was not surprised to find a highly ambivalent, even muddle-headed, text. I had wanted to say that however bigoted Ruskin may have been, he was also *right* in his emphasis upon the aesthetic elements of human life – what he called, 'the qualitative channels of human experience '; but I also found that I wanted to berate him, not just for his religiosity and evangelical ethics, but also for his 'blindness' towards what I then took to be the aesthetic potentialities of the new age.

I could not endure Ruskin's preference for Gothicism over and above engineering; for wood and stone, rather than iron; for ornament as against structure; and for the arched rather than the rectangular window frame; and this despite the fact that I had spent most of my first year in Peterhouse, in rooms facing the Combination Room and the great thirteenth century Hall, built out of Hugh of Balsham's bequest, the oldest surviving college building in Cambridge, refurbished in the nineteenth century with glass and 'Daisy' tiles provided by Morris, Marshall, Faulkner and co. Subsequently, necessity dictated I should be transported out of Great Court, across Gisbourne Court, the castellated, mock-Gothic, nineteenth century extension, and into Fen Court, an aesthetically derelict piece of 1930s functionalism, only a little less ugly than the rectilinear phallus of the William Stone Building, which rose up like the member of some great mechanical rapist in the college gardens which lay beyond the Fitzwilliam Museum.

Thus ensconced in the top floor at Fen Court, I confidently derided

Ruskin's architectural 'conservatism'. The problem, I believed, was his 'refusal to consider structural engineering as a genuine art form in its own right'; I criticised his separation of building (and engineering) from architecture, and his attempt to justify the use of 'carved stone' rather than iron by reference to the scriptures. But I continued to write as if there was no difficulty in separating a Ruskinian kernel from the husk of his archaic religious thought, and assimilating the former to modernism while quietly flushing away the latter.

The confusion of my views about Ruskin at that time was perhaps less surprising than the fact that I chose to write about him at all. There were those who recommended that Ruskin should be read: Raymond Williams among them. But his influential *Culture and Society*, first published in 1958, now seems remarkable largely because he succeeded in discussing nineteenth century thought almost without reference to religious beliefs. Williams encouraged my view that there was a 'materialist' Ruskin, who could be detached from the swamp of his anachronistic 'idealism', and preserved intact for the modern world. But I don't think there were many who took his exhortation to study Ruskin seriously. When Kenneth Clark published his anthology of selections from Ruskin in 1964, he prefaced it with the remark that no other writer had suffered so great a fall in reputation.[5] In the mid 1960s you could easily buy copies of Ruskin's works for one shilling. Even then, plenty of academic scholarship focused on the unresolved details of Ruskin's sexual and marital history, or lack of such a history. But as a cultural force at that time he was not an echo, let alone a voice.

My generation of revolting students was certainly preoccupied with many of the issues about which Ruskin felt so deeply, and wrote so persuasively; like Ruskin, we also felt that the body politic was in convulsions of an epochal and transforming character. Unlike Ruskin, we were convinced that these changes would lead to a better world. And we were infatuated with the ethic and aesthetic of modernism.

In those heady days, the colleges were in ferment: 'Bliss was it in that dawn to be alive,/But to be young was very heaven!' But our eyes turned constantly towards ideas and events taking place across the Channel or the Atlantic. Thus was the ground deserted for the arid thistles of structuralism, semiotics and 'deconstruction' which blighted critical studies in Cambridge at the end of the following decade. But, in the 1960s, it never seems to have occurred to many of us to refer

to that rich British tradition of thinking about such matters which Ruskin founded. I well remember how an undergraduate colleague felt that even such an ambivalent endorsement of Ruskin as I had written amounted to a betrayal, not just of the modern movement, but also of the revolutionary politics to which so many of us were then committed. Even so, I went on reading Ruskin.

I was greatly influenced by Maurice Cowling, my moral tutor, whom I visited frequently in his rooms in Gisbourne Court, where he would offer me a cigar, a glass of whisky, and the benefit of his scathing tolerance. Cowling was later described by Bernard Williams, Provost of King's College, Cambridge, as having 'dark associations' with that 'scepticism and distrust of all merely secular improvement' which was to be found amongst the more 'unreconstructed sort of cardinal' in the 'unliberated heartland of the Church of Rome'.[6] But perhaps because Cowling was so acutely aware of the limited efficacy of argument, however convincing, he was less absolutist than any ethically earnest liberal, or leftist, ever was. For example, his dislike of Marxism was greatly exceeded by his dislike of anti-Marxism. Marxism, he once wrote, 'is not so much untrue, as for certain purposes and in limited respects, true and unimportant'.[7] His stance resembled that of those I encountered on the left in that it was realist and relativist; but if Cowling believed that it was our duty to accept modernity, equally he held that it was our duty to resent it: 'Modernity is the practice we have and the life we lead, and . . . we have all to accept it and live as it commands us, even when we despise it.' Cowling has said that his brand of Christian conservatism was 'a Jacobitism of the mind which can do little more than protest its conviction that the modern mind is corrupt.' Unlike Raymond Williams, he taught that it was from religion that modern English intellectual history should begin. 'That it does not so begin,' he wrote, '– that it begins rather with the history of political, philosophical, literary, critical, aesthetic, economic or educational activity . . . registers historians' reluctance to give critical consideration to the culture to which they belong.'[8] Cowling perceived that central to Ruskin's teaching was his emphasis that God had given 'a mysterious and questionable Revelation', and that his theory of art, as laid out in the second volume of *Modern Painters*, was 'God-intoxicated'.

'God-intoxication' was hardly the spirit of the late 1960s. But sometimes I would walk from Peterhouse, past Pembroke College, to the complex of science laboratories, and seek out the geological

collection put together by Adam Sedgwick, the nineteenth century divine and geologist, in order, he hoped, to make known the activity of God. There, I would remember how, in the evangelical milieu of my childhood, the relationship between theology and science still seemed contentious. But such issues hardly animated the student body in those turbulent days: neither religion nor science seemed to add anything to knowledge of the 'beautiful'; the word itself was never used without a cringing apology. Aesthetic, ethical and political issues became conflated into the same social *mélange*. Ruskin was forgotten. Any refusal to go along unconditionally with what I would now describe as the philistinism of the 'avant-garde' was read as a sign of political conservatism, and assumed to be morally reprehensible.

Certainly, when I went to London in 1968, soon to work as a professional art critic, no one as far as I can recall read Ruskin, at least not in avant-gardist and New Left circles. Discussions about 'Art and Society' continued to dominate the art community throughout the 1970s; but if Ruskin was ever mentioned, it was invariably to imply that what had angered him about nineteenth century capitalism had been rectified, and as for what he said about art . . . that was either wrong or irrelevant.

Other thinkers were shaping our aesthetic ideas. One of the gurus of that era was Marshall McLuhan, who taught that the new electronic interdependence recreates the world in the image not of a garden, or a library, but rather of a 'Global Village'. McLuhan argued that the mass media were remodelling men and women, and transforming their sensory capacities: 'at the high speeds of electric communication, purely visual means of apprehending the world are no longer possible.'[9] But McLuhan – a pious Roman Catholic – did not despise modernity: for him it was a total system, as Gothic had been for Ruskin. The new media could produce a new man, in a new world: 'We have become aware of the possibility of arranging the entire human environment as a work of art . . .' Harold Rosenberg's criticism of McLuhan – 'to expect Adam to step out of the TV screen is utopianism of the wildest sort' – was justified. That *was* what McLuhan expected.[10]

This sort of thinking was given a fashionably leftist twist and gloss in 1968, when Walter Benjamin's essay 'The Work of Art in the Age of Mechanical Reproduction' (written in the 1930s) became easily available in English translation for the first time.[11] Benjamin had written about how modern means of producing and reproducing

images were shattering the 'cultic' associations and the 'aesthetic aura' which had once surrounded works of art. (At that time, naturally, we gave no weight to the fact that in private, at least, Benjamin was an aestheticist, mystic and collector, a man who believed in nothing so much as the distinction between the sacred and the profane.) Benjamin claimed that this demystification of art was part of progress and proletarianisation – both, in his book, intrinsically positive developments. He saw traditional literary, musical and artistic forms as streaming into an 'incandescent liquid mass', out of which he believed the new forms would be cast . . . Now that sort of talk was much more congenial to those of us who were interested in art, revolution and suchlike, than God-besotted old Ruskin, who could not even take cast-iron.

And then, in the early 1970s, I came under the influence of John Berger, who mixed McLuhan and Benjamin together in a book and television series called *Ways of Seeing*, a riposte to another book and television series, Kenneth Clark's *Civilization*, by which Berger had been greatly offended. Berger (at least the Berger of *Ways of Seeing*) wanted to purge art of those 'cultic' associations more relentlessly than Benjamin ever did. He argued that 'the spiritual value of an object, as distinct from a message or an example, can only be explained in terms of magic or religion', and went on to say that since, in modern society, neither of these was a living force, 'the art object, the "work of art",' was 'enveloped in an atmosphere of entirely bogus religiosity' – essentially an attempt to camouflage an obsession with price. The issue, as he saw it, was between 'a total approach to art' and the traditional esoteric approach 'of a few specialized experts' who were 'the clerks of the nostalgia of a ruling class in decline'. Their expertise and connoisseurship were being rendered obsolete by the proliferation of new means of reproduction. 'For the first time ever, images of art have become ephemeral, ubiquitous, insubstantial, available, valueless, free . . . They have entered the mainstream of life over which they no longer, in themselves, have power.'[12]

All this led Berger to despise the idea of conservation. He severed art from concepts of aesthetic value and spiritual concern altogether. In 1970 he sent me a letter outlining what he described as a 'viable critical stance to the art world'. He referred to 'the use by a certain number of artists of visual communication . . . to pose and investigate a whole series of new social and philosophical questions'. The critic, he argued, needs to enter the questions posed: 'The answers, which

must lie outside the works, are more important than any "quality" of the works-in-themselves.'

For a year or two I, too, half-thought that an interest in aesthetic quality was a disguised interest in market price; and, briefly, I celebrated the idea that photography had left painting for dead. But I began to realise that the relentlessly modern, technological, and anti-spiritual emphases of *Ways of Seeing* were not so much the eyes of a better future, but a reflection of the blindness and occlusion of the present. It was not so much that *Ways of Seeing* actually *caused* a shift in taste: rather it was itself a reflection of a prevailing tendency towards general anaesthesia.

And so, at first almost guiltily, I began to look again at that work to which *Ways of Seeing* was supposed to be a reply – namely at Kenneth Clark's *Civilization*. I soon discovered that Berger had not represented Clark's values fairly. For example, he criticised Clark's interpretation of Gainsborough's painting *Mr and Mrs Andrews*, and argued that Clark failed to point out 'the proprietary attitude' of the couple 'towards what surrounds them'. This attitude, Berger wrote, 'is visible in their stance and their expressions'. He reminded his readers that if a man in eighteenth century England stole a potato, 'he risked a public whipping ordered by the magistrate who would be a landowner.' He went on to attack the 'Cultural Establishment' for its evasion of this issue of property.[13]

But I discovered that Clark was every bit as outraged by the inhumanities and ethical injustices of capitalism as Berger – and he, too, urged that we should bear them in mind when regarding the art of the past. *Civilization* warned its readers not to forget the horrors of those days, 'the hundreds of lashes inflicted daily on perfectly harmless men in the army and navy; the women chained together in threes, rumbling through the streets in open carts on their way to transportation'. Clark shared Berger's view as to the causes of these injustices: 'These and other even more unspeakable cruelties were carried out by agents of the Establishment, usually in defence of property.'[14]

The truth was that Clark was very far from being one of those 'clerks of the nostalgia of a ruling class in decline', those 'specialized experts', who perpetuated connoisseurship as a veil for their interest in art as property; for Clark, as much as Berger, advocated 'a total approach to art', one which endeavoured to relate it to every aspect of experience. But the difference between them was that Clark was

unswayed by the passing fashions of modernity. In public as well as in private, as he himself put it, he held 'a number of beliefs that have been repudiated by the liveliest intellects of our time.' He believed that art still had, or ought to have, much to do with man's highest and noblest aspirations; above all, he saw no need to go along with that repudiation of aesthetic and spiritual quality upon which Berger's 'new' technological anti-aesthetics were based. Rather, Clark believed that the arts were a means of continuing to affirm the life of the spirit in an increasingly ugly, fragmented and materialistic world. And the more I read him, the more I came to hear echoes – albeit more graceful and less imperious – of that haughty and puritanical voice I had first encountered in Peterhouse's library.

And so, inevitably, at the end of the 1970s, I found myself reading Ruskin again. Of course, I recognised that we no longer lived under the kind of *laissez-faire* capitalism that had so appalled him – though it sometimes seemed as if Margaret Thatcher's government dearly wished to return us to those evil days. The fact was that through books like *Unto This Last*, something of Ruskin had permeated into the British labour movement, and the emergent ideology of the modern welfare state. Again and again in Ruskin's social writings I found foreshadowings of ideas which ought to have appalled his Manchester audience, but which, at least until the rise of Thatcherism, were part of the 'common sense' of our century, shared by both left and right alike, for example such ideas as that government must intervene to mitigate the effects of market forces and to provide educational, health, and cultural facilities. Yet, as I read deeper into Ruskin, I came to see him neither as I had in that fumbling essay of 1967, nor as some kind of tame prophet of the modern welfare state.

Setting out to read Ruskin's work today is like starting to climb an unknown mountain on which it is easy to lose one's way among granite stubbornnesses, dangerous crevices, valleys clogged with the silt of dead ideas, and confused strata of categories. On its slopes, one constantly encounters strange fossils of thought, glacial drifts of verbiage, springs of clear insight, and glints of an almost unnaturally acute perception. Despite the arduous rocky passages, where the going just gets so tough that one wants to give up, it is infinitely varied, fascinating for its dappled surface, rich in filigreed rocks and luminous hoar-frost, with spectacular changes of view and backtracks of argument at every turn. Above all, it is majestic, with its foothills and lower slopes rising firmly from the common-or-garden facts of nature

and physical being, but soaring to those dizzy and sublime heights, swathed in clouds of rapture, where an atheist, like myself, must leave Ruskin to tramp on, by himself, to meet with his maker.

But Ruskin's work is not, as some of his anthologists would have us believe, merely a quarry of paradoxes and purple passages. For what he is saying, and the way he says it, is all of a unity: the unity in profusion, contradiction, and accretion of the Gothic cathedrals whose beauties he did so much to popularise. This unity, however, was not only at odds with the *laissez-faire* capitalism of mid-nineteenth century Britain. I feel it shining forth from the thirty-nine volumes of the Library Edition of Ruskin's works, as an even more formidable indictment of twentieth century monopoly capitalism and its sad apology for a living human culture.

3
A View from the Eagle's Nest

'I do not think that the causes of the colour of transparent water have been sufficiently ascertained . . .'[1] With these words, Ruskin opened his 'Enquiries on the causes of the colour of the Water of the Rhine' in Loudon's *Magazine of Natural History* in 1834 – and also his public career as a prose writer. Ruskin's mother may have devoted him to God, but the summit of the child's ambition was to become President of the Geological Society. In old age, he admitted that nothing he had subsequently acquired – not his most radiant Turner or choicest medieval manuscript – had given him pleasure so keen as that he felt in the possession of his first box of minerals.

But his earliest scientific speculations – prior to going to Oxford in 1837 – are, in the light of what came later, surprisingly free of religion, philosophy or aesthetics. At first, science seemed to Ruskin to have no connection with the study of the scriptures urged upon him by his mother; nor with the intense pleasure he derived from Turner's paintings.

In 1836, the young Ruskin was distracted from his geological ruminations by the appearance of an unfavourable notice of Turner in *Blackwood's Magazine*. He wrote a reply which was not published, because, when his father sent it to Turner, the artist replied that he 'never moved in such matters'. This letter is often said to represent the 'germ' of *Modern Painters*, the first volume of which was published some seven years later. But this is not so. Ruskin's youthful arguments in Turner's defence strike more familiar and acceptable tones to a modern ear than any he was later to advance.

'Turner,' he wrote 'may be mad: I daresay he is, inasmuch as highest genius is allied to madness; but not so stark mad as to profess to paint nature. He paints *from* nature, and pretty far from it, too.' Ruskin attributed this distance to an imagination 'Shakespearian in its mightiness'. Turner was 'an exception to all rules' who could 'be judged by

no standard of art'. 'In a wildly magnificent enthusiasm,' he wrote, '[Turner] rushes through the aetherial dominions of the world of his own mind, – a place inhabited by the *spirits* of *things*.' Ruskin staked everything on the artist's *imagination*, which he opposed to the apprehension of reality and truth.[2]

Then, in 1842, the *Literary Gazette* slated Turner's paintings at a Royal Academy exhibition in terms which, many years later, Ruskin himself was to use of Whistler. The pictures were said to look as if they had been produced 'by throwing handfuls of white and blue and red at the canvas, letting what chanced to stick, stick.' While on holiday with his parents in Chamonix, Ruskin resolved to answer such criticisms. 'The thing swelled under my hands,' he later complained. 'Before the volume was half-way dealt with it hydra-ized into three heads, and each became a volume.' The fifth and final volume did not, in fact, appear until 1860; by then Ruskin had changed his ideas about art, and much else besides. But the argument advanced in Volume One is clear and relentlessly consistent; it bears little relationship to that advanced in the unpublished letter to *Blackwood's* six years earlier.

In *Modern Painters* Volume One, Ruskin complained about land-scape paintings of the past – his repeated examples tended to be works by Claude, Poussin, Salvator and the Dutch, because these were the paintings he knew best from the National and Dulwich galleries – on the grounds that they were lacking in *truth* in relation to nature. 'Every alteration of the features of nature,' Ruskin now insisted, 'has its origins either in powerless indolence or blind audacity.'[3] 'Modern artists, as a body,' he wrote, 'are far more just and full in their views of material things than any landscape painters whose works are extant.'[4] And so, far from suggesting that Turner can be judged by 'no standard of art', Ruskin rather claims that he was the justest and fullest painter of the modern school – simply because he was the most truthful.

'Every class of rock, earth and cloud,' Ruskin asserts, 'must be known by the painter with geologic and meteorologic accuracy.' He examines the contrasting ways in which the ancients and the moderns depict sky, earth, water, vegetation, and – briefly – architecture. The moderns in general, and Turner in particular, are shown to be more 'truthful' on every count. Turner is 'as much of a geologist as he is a painter'.[5] Ruskin sometimes offers minute descriptive analyses of Turner's drawings to underline Turner's geological accuracy. For

example, he regards Turner's painting of the Caudebec, in the 'Rivers of France' series, as 'the clear expression of what takes place constantly among hills'.[6] He describes how Turner has given 'the perfect unity of the whole mass of hill, making us understand that every ravine in it has been cut gradually by streams'. He elaborates this idea in great detail:

... observe how, in the ascent of the nearest eminence beyond the city, without one cast shadow or any division of distances, every yard of surface is felt to be retiring by the mere painting of its details, how we are permitted to walk up it, and along its top, and are carried, before we are half-way up, a league or two forward into the picture . . .[7]

We are a long way here from the stark madness of one who professes to paint nature when, in fact, he is rushing through 'the aetherial dominions of the world of his own mind'. And yet Ruskin explains that he does not mean to assert that the great painter is necessarily acquainted with the geological laws and facts he has illustrated. 'I am not aware whether he be or not. I merely wish to demonstrate, in points admitting of demonstration, that intense observation of, and strict adherence to, truth, which it is impossible to demonstrate in less tangible and more delicate manifestations.'[8] Nonetheless, Ruskin's defence of Turner was, in twentieth century terms, anything but naturalist.

Ruskin always emphasises the comparison between the earth and the human body. 'Ground,' he writes, 'is to the landscape painter what the naked human body is to the historical.'[9] The earth, he argues, can itself be as expressive as physiognomy and limbs – for the representation of which he expressed a puritanical antipathy. Mountains played a large part in his terrestrial anatomy; the muscles and tendons of the earth's anatomy are, he writes, in the mountain 'brought out with force and convulsive energy, full of expression, passion and strength'. He continues:

... the plains and lower hills are the repose and the effortless motion of the frame, when its muscles lie dormant and concealed beneath the lines of its beauty, yet ruling those lines in their every undulation. This, then, is the first grand principle of the truth of the earth. The spirit of the hills is action, that of the lowlands repose; and between these there is to be found every variety of motion and of rest, from the inactive plain, sleeping like the firmament, with cities for stars, to the fiery peaks, which, with heaving bosoms and exulting limbs, with the clouds drifting like hair from their bright foreheads, lift up their Titan hands to heaven, saying, 'I live for ever!'[10]

Ruskin's correlation of the substance of the earth with women's bodies is vivid and sensuous. It vibrates with the intensity of the sexual experiences he never knew; the joy he experienced when he came near mountains was 'no more explicable or definable than the experience of love itself'. And yet he did not wish to 'humanise' the landscape. Rather, he wanted to draw attention to the fact that 'external nature . . . has a body and a soul like man; but her soul is the Deity.'[11] A painter could represent the body of nature; or the spirit in its 'ordinary and inferior manifestations'. Alternatively, he could represent the spirit 'in its secret and high operations; and this shall be like, only to those to whose watching they have been revealed.' Turner's imagination, Ruskin argued, was such that he had penetrated beyond appearances and seen those 'secret and high operations'. Turner was, thus, a great *realist* by reason of the fact that he revealed the presence of God in his nature; and Ruskin possessed the ability to recognise this revelation.

Ruskin was insistent that the 'work of the Great Spirit of nature' was not only to be detected in the exultations of the mountains; it was, he said, 'as deep in the lowest as in the noblest objects'. He argued that 'to the rightly perceiving mind' there was 'the same infinity, the same majesty, the same power, the same unity, and the same perfection manifest in the casting of the clay as in the scattering of the cloud, in the mouldering of the dust as in the kindling of the day-star'.[12]

God's self-revelation was not self-evident; a man could be 'tone deaf' to the presence of the Divine in nature, and fail to see the spirit in the mass – in much the same way that it was possible to feel lust, without love, for a woman. (For example, Ruskin said of William 'Bird's-Nest' Hunt that he 'fails in foliage . . . fails as the daguerreotype does, from over-fidelity'.) But, he insisted, a man could develop his responses and learn to see a leaf not just as vegetable tissue, but also as God's handiwork, a continuing embodiment of moral and religious truth. Under those circumstances, even the simplest forms of nature were 'strangely animated by the sense of the Divine presence, the trees and flowers seem all, in a sort, children of God'.

Turner's greatness lay in the fact that his truth to nature – in small things as in great, in the depiction of pebbles as much as of mountain ranges – was of such a kind that he made the presence of the Divine within nature apparent unto man, or at least unto those men who could see him aright. For Ruskin insists upon 'the absolute necessity of scientific and entire acquaintance with nature before this great artist can be understood'.[13] He claimed that if you are acquainted with

nature, 'you will know all he has given to be true, and you will supply from your memory and from your heart that light which he cannot give.'[14] If, on the other hand, you are 'unacquainted with nature', Ruskin advises that you 'seek elsewhere for whatever may happen to satisfy your feelings; but do not ask for the truth which you would not acknowledge and could not enjoy'.[15] Ruskin felt that in every new idea which we receive from His creation, 'we shall find ourselves possessed of an interpretation and a guide to something in Turner's works which we had not before understood'.[16]

For Ruskin, Turner's unswerving truth to nature thus has a *prophetic* quality: Turner's imaginative grasp of nature reveals God to man. Central to my argument, as to Ruskin's, is the idea that the disintegration of natural theology had *aesthetic* effects which modernism did not so much solve as evade. In the first edition of *Modern Painters* Volume One – in a passage which was understandably mocked by reviewers, and excised from subsequent editions – Ruskin described the painter whom the *Literary Gazette* had accused of throwing handfuls of paint at the canvas as 'glorious in conception – unfathomable in knowledge – solitary in power – with the elements waiting upon his will, and the night and morning obedient to his call, sent as a prophet of God to reveal to men the mysteries of His universe.'[17] He concluded with an image of Turner, 'standing like the great angel of the Apocalypse, clothed with a cloud, and with a rainbow on his head, and with the sun and stars given into his hand'.[18] For Ruskin, Turner's pictures were in a direct line of descent from the Gothic cathedrals. For Turner, too, fathered forth the glory of God to those who had eyes to see it. In a passage he did not subsequently alter or excise, Ruskin wrote:

In all that [Turner] says, we believe; in all that he does, we trust. It is therefore that we pray him to utter nothing lightly; to do nothing regardlessly. He stands upon an eminence, from which he looks back over the universe of God and forward over the generations of men. Let every work of his hand be a history of the one, and a lesson to the other. Let each exertion of his mighty mind be both hymn to the Deity, revelation to mankind.[19]

It is often suggested that Ruskin's early aesthetic ideas arose out of his Evangelical background. But this view requires caution. Certainly there is a Biblical emphasis on every page. But Britain in the 1830s differed from, say, Germany, in that here, as Stephen Neill has put it, 'almost all good Christians ... were what would now be called "fundamentalists".' Evangelicals, Tractarians, Broad-Churchmen,

and even Catholics, 'all accorded the Bible an unqualified reverence, and all believed that, if its inerrancy were successfully impugned, the whole Christian faith would collapse.'[20] Ruskin showed an interest in typology – or the study and interpretation of Biblical 'types'; but again, such thinking was by no means peculiar to the Evangelical party. At first Ruskin believed that God's revelation of himself in the scriptures, science as a means of studying nature, and art as a product of the human imagination, were relatively separate activities. 'I believed that God was in heaven,' Ruskin wrote, remembering his childhood, 'and could hear me and see me; but this gave me neither pleasure nor pain, and I seldom thought of it at all. I never thought of nature as God's work, but as a separate fact or existence.'[21]

But as he grew up, he learned to place an ever greater emphasis on nature as 'God's second book', a *locus* of divine revelation. Natural theological thinking of one kind or another was also ubiquitous in English intellectual life in the early decades of the last century; but Ruskin's aesthetic theories depended upon a variety of natural theology which was *antithetical* to mainstream Evangelical opinion: he came to believe that natural theology could root itself firmly in *modern science*.

Ruskin may first have encountered the modern 'diluvial' theory of geology in the 1830 edition of Saussure's *Voyages dans les Alpes*, where the author discusses the idea that the momentous currents of the flood caused the distribution of erratic boulders around Lake Geneva. Certainly, when Ruskin himself visited the spot with his parents in 1835, thoughts about the effect Noah's flood had had on the landscape came immediately to his mind:

> When o'er the world the conquering deluge ran,
> Rolling its monster surges, far and wide,
> O'er many an ancient mountain's lordly span,
> And when upon the all devouring tide
> Wallowed the bulk of the leviathan
> Where cultivated plains are now descried;
> And when the toppling peaks of mountains old
> Were shook from their foundations into ruin,
> Like shingle at the ocean's mercy rolled,
> That worked, and worked, – ever its work undoing, –
> Heaping up hills beneath its bosom cold,
> Then wide again the devastation strewing, –
> Then the dark waves, with nothing to obstruct 'em,
> Carried these blocks from far, and here it chucked 'em![22]

'Such,' Ruskin exclaimed in the next line of this teenage poem, 'are the dreams of the geologist!' He may have read about 'advanced' geological ideas in Loudon's magazines; but in 1836 Loudon sold the *Magazine of Natural History* to Edward Charlesworth, a geologist, who invited Ruskin to attend the meetings of the Geological Society, and promised to introduce him to William Buckland and Charles Lyell, warring doyens of the English and Scottish schools.

John James Ruskin, always more open, worldly and eclectic than his wife, encouraged his son's interests in the geologists in general, and Buckland in particular. When John James visited Oxford in 1836, he went to see Buckland, and soon after seems to have bought a copy of his *Bridgewater Treatises on Geology*, in which the eminent geologist shifted away from his earlier, narrowly Biblical way of thinking and denied that such phenomena as erratic distribution of differing rocks could be explained solely in terms of the Mosaic deluge. Unlike many Evangelicals, John James was unperturbed by the new theories and did everything he could to encourage Buckland's influence over his son.

Ruskin went along to his first meeting of the Geological Society early in 1837; when he went up to Oxford the following month, he began to see a good deal of Buckland and his friends. Margaret Ruskin's letters home to her husband are dotted with such comments as 'John was much delighted with Dr Buckland's lecture yesterday, heard some things quite new to him.'[23] Ruskin showed Buckland his geological specimens from Switzerland, and even began to draw visual material for the doctor's lectures. Buckland, in turn, began to invite him to dinners, where he met many scientists, like Charles Darwin: 'He and I got together,' Ruskin wrote, 'and talked all the evening.'[24] Another letter to his father vividly describes the clutter in Buckland's rooms of 'broken alabaster candlesticks, withered flower-leaves, frogs cut out of serpentine . . . stuffed reptiles, deal boxes, brown paper, wool, tow and cotton'.[25]

Through Buckland, Ruskin became absorbed into the ambit of the English School, and became known as one of his 'party'. Until recently, Buckland has received a bad press from historians of science; this has simply been copied by Ruskin's biographers. According to Joan Abse, Buckland was 'a genial eccentric';[26] whereas Timothy Hilton records without qualification Henry Liddell's view that Buckland had not the intellectual calibre to occupy a chair in the university.[27] Hilton does not, however, report the view of Robert Lowe, faithfully recorded

by Margaret Ruskin in one of her letters to her husband, that Buckland and Daubeny, another of the Oxford geologists, 'were the only Professors in the University deserving their chairs or worth attending'.[28] Ruskin scholars have had little to say about the substance of his intellectual and geological ideas, and most of what has been said is wrong. Nothing, for example, could be further from the truth than Joan Abse's view that Buckland was 'ardently engaged' in 'a battle to reconcile the Biblical account of creation' with the 'revolutionary discoveries in geology' of Charles Lyell.[29]

* * *

Buckland described geology as 'the knowledge of the rich ingredients with which God has stored the earth beforehand, when He created it for the then future use and comfort of man'; Adam Sedgwick, of Cambridge, called their discipline 'sermons in stones'. Like most intelligent men and women in the early nineteenth century, both men subscribed to a version of 'natural theology': they believed that the world was the handiwork of God, and, in some sense or other, revealed his goodness. Nonetheless, in terms of the state of knowledge in their own day, Buckland and Sedgwick were hardly conservatives. With Buckland, in particular, more than an element of pragmatism entered into his insistence that the ultimate truths revealed by geology were theological.

Natural theology was not a new idea. 'Who can look on nature,' asked St Hilary, 'and not see God?' The immanence of God within his creation has been, until this century, one of the most central and consistent themes of Christian teaching, one which Christianity inherited from the Greeks. It seemed impossible to believe that what Origen called 'the sacred economy' of the universe was fortuitous; as St Augustine put it, 'every aspect and process of nature proclaims its Creator.' 'The wonders of the visible creation,' Gregory the Great said, 'are the footprints of our Creator.' Thus it seemed to follow, as St Basil argued, that the more men and women penetrated the laws on which the universe was founded and sustained, the more did they behold the glory of God.

The great cathedrals of Western Christendom, with their elaborate ornamental carvings in wood and stone of foliage, animals and human life, were the architectural embodiment of this idea. The belief that nature fathered forth the glory of God was intensified by the Reformation as theologians began to look for sources of revelation

beyond the authority of church and tradition. Luther gazed with romantic intensity upon nature, and saw there 'His pattern who is the essence, the existence, the life of the universe.' Within British Protestant traditions, such thinking was usually regarded as being compatible with scientific research. Throughout much of the eighteenth century, natural science appeared to be leading to an ever greater understanding of God's revelation of Himself in nature.

The medieval conception of nature was transmuted into a modern conception of 'The Great Chain of Being', in which creation was conceived of as a stable gradation governed by principles of goodness, plenitude and continuity, and held in a state of equilibrium by God. It was as if the hieratic view of nature slid off the west fronts of the cathedrals and organised the way in which the poet, painter, and philosopher saw the fields and the livestock themselves. '"The Great Chain of Being",' writes Arthur Lovejoy, 'was the sacred phrase of the eighteenth century, playing a part somewhat analogous to that of the blessed word "evolution" in the late nineteenth.'[30]

Soames Jenyns, an eighteenth century writer, once tried to describe how 'the divine artificer' had created the infinitely subtle gradation of nature, stretching from God to the molluscs. He likened it to the way a skilful painter uses his colours: the qualities of adjacent orders and classes 'are so blended together and shaded off into each other that no line of distinction is anywhere to be seen.'[31] The contemporary biologists assimilated the new facts they discovered about the world to this model. Perhaps the greatest artist of eighteenth century England, George Stubbs, was influenced by such ideas: he is often perceived as an empiricist and a secularist. But Stubbs's monumental study in words and drawings of *Comparative Anatomical Exposition of the Structure of the Human Body with that of a Tiger and a Common Fowl* reveals how literally he took 'Great Chain of Being' zoology. Like many who held such views, Stubbs was obsessed with the problem of predatory animals – violations of the goodness and harmony of nature – to which he returned in his mysterious paintings of a lion attacking a horse.

There were those who, like David Hume, were sceptical about all arguments from design. Some, like James Hutton, though they believed in the deity, questioned whether the fabric of the earth bore witness to other than a 'steady-state' of continuing natural processes. Others were stumbling upon indications that the earth's history had consisted of differentiated eras. For example, in 1796, while building canals,

William 'Strata' Smith noted that the rocks appeared in layers like 'slices of bread and butter', each with its characteristic fossils.

The 'argument from design' reached its apotheosis at the beginning of the nineteenth century in William Paley's *Natural Theology*. The book opens with the famous argument that just as the existence of a watch implies the existence of a watchmaker, so the existence of a perfectly functioning natural world implies the existence of God. But Paley's ideas, though influential throughout the early nineteenth century, were already anachronistic when he expressed them. Paley saw nature as a mechanical orrery. His universe barely allowed for natural development; he was ignorant of the geology of the later eighteenth century, or the threats it posed to theories like his.

Today the members of the English School – especially Buckland and Sedgwick – are still usually portrayed as craven Biblicists, holding out against the 'progressive' Scottish uniformitarians, led by Lyell. But, unlike Lyell, the English geologists recognised that the geological record implied that the earth had a history of differentiated eras. Nicholas Rupke's recent scholarship suggests that interest in the relationship of geology to questions of natural and revealed religion did not spring from a desire to defend religious orthodoxy, but rather arose from the need to gear the teaching of the new science to the requirements of Oxford and Cambridge as centres for the education of Anglican clergy.[32] Lyell's 'steady-state' theory of the universe, with its vision of a permanent present, and all its echoes of Hutton, is, if anything, more remote from twentieth century geological models than the historical geology of the English School.

Lyell believed that the geology of the world could be understood in terms of still-continuing processes of accreting change, unpunctuated by cataclysmic or diluvian events. (Lyell's influence on Ruskin was evident in Ruskin's description of Turner's painting of the Caudebec, and his revelation of 'what takes place constantly among hills'.) In *The Principles of Geology*, 1830–3, we find Lyell denying a progression in the fossil record, and arguing against any suggestion of the transmutation of species – theories which, ironically, he attributed to the projection of scriptural ideas about a progressive creation into the geological record!

In the 1820s, Buckland certainly subscribed to a 'diluvial' model; he tried to explain geological phenomena in terms of the effects of Noah's flood. The scriptures seemed, to him, to provide an explanation

of the cataclysmic events he had perceived in the geological record. For example, Buckland was responsible for the distinction between the diluvial deposits (Diluvium) and those supposedly formed *after* the flood (Alluvium).

Sometime before 1836, Buckland ceased to believe that all fossils were the relics of the first creation, annihilated by Noah's flood. In his *Bridgewater Treatise* of that year, troubled by the failure to discover any human remains in the antediluvial deposits, he effectively abandoned 'diluvialism'. The great antiquity of the earth impressed itself ever more forcefully upon him; the strata implied to him vast transformations, through immense passages of time – certainly more than seven days' work, even for almighty God. But Buckland still thought what he had discovered could be interpreted in the light of Genesis. He argued that the Mosaic narrative began with the declaration that 'In the beginning God created the heaven and the earth.' He chose to understand these words as meaning that 'the creation of the material elements' had taken place 'at a time distinctly preceding the operations of the first day'. Thus he could maintain that 'This beginning may have been an epoch at an unmeasured distance, followed by periods of undefined duration during which all the physical operations disclosed by geology were going on.'[33]

Many of Buckland's opponents in Oxford, like the orthodox Liddell, ridiculed him *not* because he seemed to be leaning over backwards to accommodate the facts to the scriptural text but, on the contrary, because they believed that science ought not to be taught in Oxford University at all; they held it was simply absurd to derive one's ideas from old stones and fossils rather than from authority and tradition. Buckland's most vociferous critics were Tractarians, who did not take too kindly to such things as his exposure of a saint's skeleton as that of a goat; and Evangelicals, like George Bugg and Henry Cole, who accused him of subverting the word of God.

Nothing set back the work of the English School so much as the religious revival of the 1830s. Even before his conversion to Rome, Cardinal Newman stood out against the prevalent natural theology. Newman believed in design because he believed in God, not in God because he saw design. It was, he thought, by examining the soul and its nature, rather than the natural world, that we begin 'to discern reflections from beyond the veil'. Instead of natural theology, Newman

and his Tractarian colleagues elaborated sacramental views of nature and art. As Newman put it:

Even when (the earth) is gayest, with all its blossoms on, and shows most touchingly what lies hid in it, yet it is not enough. We know much more lies hid in it than what we see. A world of Saints and Angels, a glorious world, the palace of God, the mountain of the Lord of Hosts, the Heavenly Jerusalem, the throne of God and Christ, all these wonders lie hid in what we see . . .[34]

He went on to say that 'we know that what we see is as a screen hiding from us God and Christ, and his Saints and Angels,' and added, 'we earnestly desire and pray for the dissolution of all that we see, from our longing after that which we do not see.'[35] This was the attitude of mind we may assume Charles Collins wished to impart to his nun when he painted her contemplating a passion flower, but focusing her devotions upon the passion of Our Lord, which it suggested to her. So great was the division Newman placed between sensual reality and the invisible world, that it is not surprising to find that, in later life, he began to wonder whether Atheism was not 'as philosophically consistent with the phenomena of the physical world, taken by themselves, as the doctrine of a creative and governing power' – and found that his faith was unaffected by this thought.[36]

Tractarian religious fervour caused attendance at Buckland's lectures to drop. The university authorities were hardly bothered. One day in 1839, Ruskin was on his way to Buckland's lecture when he was stopped by the Dean, who walked along with him. On learning where Ruskin was going, the Dean observed, 'I like that young men should attend to Sciences but do not let it occupy you too much.' That day, the famous Professor of Geology had an audience of twenty.[37]

Ruskin's association with the Oxford scientists is evident from the address he delivered to the Meteorological Society in 1837. Ruskin concluded his talk on 'The Present State of Meteorological Science' by saying:

Let the pastor of the Alps observe the variations of his mountain winds; let the solitary dweller in the American prairie observe the passages of the storms, and variations of the climate; and each, who alone would have been powerless, will find himself a part of one mighty Mind, – a ray of light entering into one vast Eye, – a member of a multitudinous Power, contributing to the knowledge, and aiding the efforts, which will be capable of solving the most deeply hidden problems of Nature, penetrating into the most occult causes, and reducing to principle and order the vast multitude of beautiful and wonderful phenomena, by which the wisdom and benevolence of the Supreme Deity regulates the course of the times and the seasons, robes the globe with verdure

and fruitfulness, and adapts it to minister to the wants, and contribute to the felicity, of the innumerable tribes of animated existence.[38]

In other words, all the meteorologists put together might see what Ruskin was soon to argue Turner *had* seen.

On 27 January 1839, Buckland preached a controversial sermon, in which he argued that among the fossils there appeared to be 'pre-Adamite' species. The old problem of the absence of human remains in the earliest deposits was worrying him again. Like the late eighteenth century philosophers of 'The Great Chain of Being', Buckland had also been preoccupied by the threat predation and competition posed to natural theology. If Stubbs had returned, obsessively, to the theme of a lion attacking a horse, Buckland adopted a manic 'zoophagy'; he ate, and served to his guests, the strangest of wild animals as food. Charles Kingsley, one of the great popularisers of natural theology, once confessed in a letter to F. D. Maurice: 'I have long ago found out how little I can discover about God's absolute love, or absolute righteousness, from a universe in which everything is eternally *eating* everything else.'[39] But, by eating 'everything else', Buckland hoped to underline how even predation could be fitted into the moral scheme of divinely ordained goodness; for the creature that was eaten 'repays with small interest the large debt which it has contracted to the common fund of animal nutrition, from whence the materials of its body have been derived'.[40] And so, ironically, Buckland's ideas about providence and utility opened his mind to the un-Biblical idea that there might have been death before the Fall – a view which offended the orthodox theory that death had entered the world *as a result of* Adam's iniquity.

Ruskin and his mother missed Buckland's notorious sermon on this theme, but they read about it, and Margaret Ruskin wrote to her husband that it would be wise 'in the Dr and his compeers . . . if they would let the Bible alone, until they had gained sure knowledge on the subject.'[41] But John James remained resolute that his son should continue to attend Buckland's lectures.

Buckland continued to interpret the findings of modern geology in the context of his conception of 'goodness' – which became rather less Biblical. Whatever reticences the university authorities may have expressed, Buckland received acclaim from both the mining industry and the public at large. For example, in 1839 he lectured to an audience of thousands from a large rock in the limestone caverns of Dudley. (Buckland may also have had a direct influence on Ruskin's

lecturing style; Buckland sometimes pranced about in imitation of a pterodactyl – techniques which Ruskin himself did not hesitate to employ.) Buckland argued that the rich mineral deposits which surrounded them expressed 'the most clear design of Providence to make the inhabitants of the British Isles ... the most powerful and the richest nation on earth'. The vast crowd spontaneously broke out into the singing of 'God Save the Queen'.[42]

However, Buckland still did not miss any opportunity which allowed him to 'harmonise' modern geology with scripture. In 1840, taking a lead from the Swiss geologist Louis Agassiz, he began to argue that the old problem of large boulders of geologically different kinds found together all over Europe and America could be explained in terms of the movement of glaciers.

Historians of geology used to be puzzled by the fact that Buckland should have shifted from what they regarded as the stupidities of diluvialism to an 'enlightened' glacial interpretation – roughly in line with today's theories. Some identified this change with a loss of faith; but Nicholas Rupke's patient research has demonstrated how Buckland was attracted to glacial geology because it seemed to him to provide a way of linking the Biblical account with the latest scientific insights into historical geology.[43] For Buckland, glacial theory supported the idea that there had been 'a non-recurrent episode in earth history ... which had ... caused the extinction of many mammals'. Glacial theory implied if not the flood, then something very like. Rupke quotes from Buckland's notes made in 1840: 'The flood that caused the Diluvium ... was probably due to the melting of the ice.'[44] Glacial theory, therefore, ought to have proved a modern geological idea acceptable to the university. But Buckland's colleagues disputed the idea, preferring improbable 'iceberg' theories, and Buckland was thrown into heated controversies with erstwhile colleagues. He turned abruptly to other issues. The historical synthesis pursued within the English School began to crumble; and study of glaciation, which had little practical application, passed out of fashion.

Buckland's thinking slid away from historical natural theology towards secular utilitarianism; in this, Ruskin was not to follow his old teacher. As we shall see, Ruskin always remained fascinated by glacial theory; and the general tenor of his thinking remained closer to that of Sedgwick – who denied that Bentham's utility, or Paley's expediency, had provided any insights into the roots of moral

philosophy. Unlike Buckland, Sedgwick was therefore uninterested in the applications of geology to public utility.

* * *

'Geology,' wrote Sedgwick, 'like every other science when well interpreted, lends its aid to natural religion.'[45] But Sedgwick too edged away from the letter, if not the spirit, of the Mosaic account. His model was less immediately Biblical than Buckland's; he argued that life was created on the planet by an omnipotent and ever-present intelligence, who constantly interfered with his handiwork, perhaps through the medium of geological catastrophes that cleared away one age of the earth's history and made way for another with new species or life forms marvellously adapted for their surroundings.

As Sedgwick put it in his *Discourse on the Studies of the University* of 1832, geology 'shows intelligent power not only contriving means adapted to an end: but at many times contriving a change of mechanism adapted to a change of external conditions; and thus affords a proof, peculiarly its own, that the great first course contrives a provident and active intelligence.'[46] Sedgwick, who had taught Darwin, nonetheless believed that the theory of the 'transmutation of the species' was no better than a 'phrenzied dream'.

Sedgwick was more of an Evangelical than Buckland; he also romanticised his native Yorkshire dales just as Ruskin idealised Swiss mountain village life. Geology was thrust upon him by Cambridge University when he was made Woodwardian Professor in 1818; he had no previous knowledge of the subject. Thenceforward, his thinking was an amalgam of study of the materials out of which the earth is made, ethics, geology, social concern and religion. Like Ruskin, Sedgwick believed it was his duty to communicate his insights not only to undergraduates but also to working men. For example, in 1838 Sedgwick addressed a huge gathering of miners and artisans on the beach at Tynemouth where, according to his biographers, he 'led them on from the scene around them to the wonders of the coal-country below them, thence to the economy of a coal-field, then to their relations to the coal-owners and capitalists, then to the great principles of morality and happiness, and last to their relation to God, and their own future prospects.'[47] Sedgwick, like Ruskin, also happened to be a lifelong celibate whose predilection for young girls appears to have extended beyond the bounds of that which today would be acknowledged as merely avuncular.

Sedgwick's conception of geology made much of the value of exemplary collecting; one of the main tasks he set himself as a Professor of Geology was the gathering together of 'a collection worthy of the University and illustrative of all departments of the Science it was my duty to teach'.[48] He argued that 'a Geological Museum might be built by the University, amply containing its future collections.' And he himself set about amassing specimens, travelling the length and breadth of Britain with his hammer and bags. At first his growing collection of fossils and minerals was housed in the Arts School; then, in 1833, Sedgwick secured the use of two rooms in the Divinity School where by 1842 he had drawn together some 50,000 exhibits.

The collection is now housed in the midst of Cambridge's science laboratories, where I used to visit it. Sedgwick never defended his museum as a centre of secular knowledge. He believed not only that the 'beautiful and harmonious movements in the vast mechanism of nature' proved the existence of God; but also that every portion of the visible world bore the impress of His Divine wisdom and power. He was convinced that 'the adaptation of our sense to the constitution of the material world' would lead to the discovery of the deepest theological truths. Sedgwick said that we should learn how to see 'the finger of God in all things animate and inanimate'. His museum would not only instruct the young men of Cambridge, it would also ignite, confirm and strengthen their faith.

Sedgwick insisted that the external world proved the existence of God in two ways: 'by addressing the imagination, and by informing reason'. He described the way in which nature spoke to 'our imaginative and poetic feelings', which, he said, were 'as much a part of ourselves as our limbs and organs of sense'.[49] But Sedgwick also recognised that God's activity in nature was not transparent. 'Music,' he wrote, 'has no charms for the deaf, nor has painting for the blind.' Similarly, the 'touching sentiments and splendid imagery' borrowed by the poet from the external world would lose their magic power, and 'might as well be presented to a cold statue as to a man', if no preordained harmony existed between the poet's mind and the material things around him.[50]

Sedgwick reasoned that this *imaginative* response to nature led to awareness of God, just as much as a rational or scientific response. The glories of the external world, he claimed, are so fitted to our imaginative powers as to give them a perception of the Godhead, and

'a glimpse of his attributes'. This adaptation, he maintained, 'is a proof of the existence of God, of the same kind (but of greater or less power according to the constitution of our individual minds) with that we derive from the adaptation of our senses to the constitution of the material world'.[51]

Implicit within Sedgwick's geology, then, was an aesthetic as much as a scientific system, an aesthetic which, like his scientific system, led back unequivocally to God. He quotes enthusiastically from the psalmist: 'The heavens declare the glory of God, and the firmament sheweth his handiwork.' Sedgwick did not neglect that imaginative response himself; he wrote a great series of letters to his friend William Wordsworth, on the geology of the Lake District.

My present object is to convey some notion of the structure of the great mountain masses, and to show how the several parts are fitted one to another. This can only be done after great labour. The cliffs where the rocks are laid bare by the sea, the clefts and fissures in the hills and valleys, the deep grooves through which the waters flow – all must in turn be examined; and out of such seeming confusion order will at length appear. We must, in imagination, sweep off the drifted matter that clogs the surface of the ground; we must suppose all the covering of moss and heath and wood to be torn away from the sides of the mountains, and the green mantle that lies near their feet to be lifted up; we may see the muscular integuments and sinews and bones of our mother Earth, and so judge of the parts played by each of them during those old convulsive movements whereby her limbs were contorted and drawn up into their present positions.[52]

This letter was published, together with a text by Wordsworth, in John Hudson's Complete Guide to the Lakes in 1843. A few months later, a younger member of the Geological Society, John Ruskin, finally published his elaborate defence of Turner as painter, geologist and prophet, whose powers of imagination enabled him to see, and reveal, the Divine essence within those stony ranges.

4

Aesthesis versus Theoria

If *Modern Painters* Volume One was a work of practical criticism, Volume Two, first published in 1846, was Ruskin's attempt to set out his aesthetic theory. His sources were syncretic: eighteenth century neo-Classical theory, Platonism, and Evangelical Biblical typology – or the attempt to spot in nature 'types' or symbols of The Christ. He was also concerned to polemicise against fashionable aesthetic ideas. But the book is stamped throughout by his desire to root aesthetics in a scientific natural theology – resembling Adam Sedgwick's.

Ruskin drew a distinction between what he called *aesthesis* and *theoria*. The former he described as 'mere sensual perception of the outward qualities and necessary effects of bodies'[1] or 'the mere animal consciousness of the pleasantness' to which such effects can give rise; the latter as the response to beauty of one's whole moral being. Although the second part of his book was concerned with the imaginative, in distinction to the theoretic, faculty, Ruskin emphasised the 'penetrative' power of the imagination which, far from being a matter of fancy, or 'falsehood', reached into 'the TRUE nature of the thing represented'. Pictures produced under the guidance of a painter's imaginative faculty could thus become, in turn, the objects of the theoretic faculty to other minds.

Ruskin argued that the term *aesthesis*, and its accompanying adjective, 'aesthetic', constituted a degradation of the response to beauty in nature and in art to a mere operation of sense, or, worse still, of custom. He claimed that arts which appeal to *aesthesis* 'sink into a mere amusement, ministers to morbid sensibilities, ticklers and fanners of the soul's sleep'.[2] But, in 1846, 'aestheticism' was still unheard of as a cultural force, and Ruskin's polemical sights were aimed largely at 'Utilitarianism', which proclaimed that the beauty of an object, organism, or indeed an idea, was a derivative of its fitness, or functional and practical aptness. Utilitarianism was, in effect, a secular version of Paley's natural theology which Ruskin sniffed out and ridiculed.

He intended a criticism of his old teacher, Buckland, when he wrote that geology did better to reclothe dry bones and to reveal 'lost creations', rather than to trace 'veins of lead and beds of iron' for commercial exploitation.[3]

For Ruskin, 'aestheticist' and utilitarian positions had much in common: they reduced experience to the level of the sensual and practical, and left it there. At one point he declared aggressively: 'I wholly deny that the impressions of beauty are in any way sensual; they are neither sensual nor intellectual, but moral.' *Theoria* was the operation of the faculty by which ideas of beauty were morally perceived and appreciated; he argued that man's use and function was 'to be the witness of the glory of God', rather than merely to indulge his physical needs or sensual delights.

Most of *Modern Painters* Volume Two is taken up with a discussion of the response to beauty in the world of nature. For Ruskin, the Theoretic Faculty could recognise two different kinds of beauty: Typical Beauty and Vital Beauty. The former was an external quality, 'in some sort typical of the Divine attributes'; and the latter 'the appearance of felicitous fulfilment of function in living things'.[4]

It is Ruskin's discussion of Typical Beauty which seems strangest to us today. Much attention has been paid to his conventional interest in scriptural 'types', for example in the famous passage where he discusses Tintoretto's painting of the annunciation of Christ. The actual scene depicted is one of mouldering, mildew and ruin. But Ruskin found beauty in it because everything seemed to refer him back to the redemptive promises of Holy Scripture: 'The ruined house is the Jewish dispensation; that obscurely arising in the dawning of the sky is the Christian; but the corner-stone of the old building remains, though the builders' tools lie idle beside it, and the stone which the builders refused is become the Headstone of the Corner.'[5] All this was to have an electric effect on the young Holman Hunt and his Pre-Raphaelite friends. But this sort of literary and scriptural typology, dependent on a detailed knowledge of the Biblical texts, was by no means the most interesting or original aspect of Ruskin's discussion of Typical Beauty. Rather Ruskin brought to typological thinking an idea from his study of nature, 'God's second book'; and this was something quite alien to Evangelical or Tractarian typologists, the idea that, in its structure, *form* itself could be typical (perhaps 'proto-typical' would be more accurate here), and could reveal 'the signature of God upon His works'.

For example, Ruskin argues that curved lines are more beautiful than straight lines, and that gradated shades and colours are more beautiful than plane surfaces, not just because that is the way things are in nature, but because the division of curves and gradated surfaces into an infinite number of degrees speaks of the infinity of God – 'a clear infinity, the darkness of the pure unsearchable sea'.[6]

In his discussion of why we find some proportions beautiful, Ruskin is at pains to rule out any functionalist reading: 'everything that God has made is equally well constructed with reference to its intended functions'. But not everything is equally beautiful. Ruskin distinguishes between 'Constructive Proportion' (or 'the adaptation of quantities to functions'), which he did not believe to be inherently beautiful at all, and 'Apparent Proportion', the beauty of which immediately impresses itself upon us when we look at a leaf form, or a mountain range.

Taking as his example 'the proportion of the stalk of a plant to its head', Ruskin insists that our perception of 'expediency of proportion' (or 'Constructive Proportion') could, but rarely, affect our estimates of beauty; for the functionalist explanation of the beauty of form to be true, we would have to know all sorts of details about the structure of the plant, which we certainly do not necessarily know when we recognise it as beautiful. Indeed, such practical knowledge can often interfere with the apprehension of beauty. (For example, Ruskin argued that when we are told that the leaves of a plant are 'occupied in decomposing carbonic acid, and preparing oxygen for us, we begin to look upon it with some such indifference as upon a gasometer'.) Ruskin preferred to argue that 'the melodious connection of quantities' appeared to us as beautiful because it was 'a cause of unity', indeed, 'typical of that Unity which we attribute to God'.[7]

But, even in Ruskin's earliest formulations, his ideas about theoretic beauty display an inherent instability. His 'Typical Beauty' seems sometimes to be gliding towards Bloomsbury's modern formalism – or the belief in the autonomy of aesthetic form; just as his 'Vital Beauty' could be interpreted with the advantage of hindsight as a precursor of modern functionalism. For example, when Ruskin writes about Apparent Proportion as 'a proportion . . . which has no reference to ultimate ends, but which is itself, seemingly, the end of operation to many of the forces of nature', and describes it as 'at the root of all our delight in any beautiful form whatsoever',[8] he seems almost to precurse aestheticist and formalist ideas about 'Significant

Form'. And when he comments of a rose tree: 'Every leaf and stalk is seen to have a function, to be constantly exercising that function, and as it *seems*, *solely* for the good and enjoyment of the plant'[9] – he might seem to some to come close to functionalism.

If the distinction between *theoria* and *aesthesis* lay at the very foundations of Ruskin's aesthetic, it was, for him, one which had constantly to be renegotiated, given the shifting movements of his religious beliefs. By the time he came to write the third volume of *Modern Painters*, published in 1856, Ruskin was rather more concerned to polemicise against idealist aesthetics than against the utilitarians. He persistently prodded in the direction of contemporary German philosophy, which he claimed not to have read, but instinctively rejected because of its tendency to evaporate the natural world, or, at best, to erect a barrier between the experience of sense and of value. Indeed, in this third volume Ruskin rejected the distinction between 'subjective' and 'objective', and tried to delimit a third area of human experiencing, epitomised by the 'Pathetic Fallacy', which was nonetheless governed by truth. After his unconversion in Turin in 1858, Ruskin declared that 'a good, stout, self-commanding, magnificent Animality is the make for poets and artists'.[10] Now such experiences manifestly necessitated a revision of his underlying aesthetic theory, and this Ruskin did not hesitate to put into effect.

After he returned to England in 1858, Ruskin was invited to give the inaugural address at the Cambridge School of Art; he did not repeat his earlier view that impressions of beauty were in no way sensual. Rather, he claimed that the greatest enigma in art history was that 'you must not follow Art without pleasure, nor must you follow it for the sake of pleasure.' He asserted that the solution to this enigma was that 'wherever Art has been followed *only* for the sake of luxury or delight, it has contributed, and largely contributed, to bring about the destruction of the nation practising it.' But, he said, 'wherever Art has been used *also* to teach any truth, or supposed truth – religious, moral, or natural – there it has elevated the nation practising it, and itself with the nation.'[11]

This new position seems to imply a continuity between *aesthesis* and *theoria*, in which the experience of the latter is dependent upon the experience of the former. Indeed, when Ruskin's faith was at its most tentative – from the time of his 'unconversion' in 1858 until the death of Rose La Touche in 1875 – he had the gravest of doubts about the theory of art he had set up in *Modern Painters* Volume Two. In

1870, when he came to consider a revised series of his works, he thought about suppressing the book altogether. Not surprisingly, since at this time he was prepared to go much further in rehabilitating *aesthesis* even than he had done when he spoke at Cambridge. For example, in 1871 he told the members of the Metaphysical Society that he was a painter and therefore a much humbler and lowlier sort of creature than they. 'A painter,' he said, 'never conceives anything absolutely, and is indeed incapable of conceiving anything at all, except as a phenomenon or sensation.' That which was not 'an appearance, or a feeling, or a mode of one or the other,' was to the painter nothing.[12]

We will have to bear all this in mind when we consider Ruskin's intemperate assault upon Whistler, published in *Fors Clavigera* in 1877. For Whistler had tried to argue that art offered no more than the experience of phenomena and sensations, it was a matter of *aesthesis* . . . All of which was very much what Ruskin himself had told the Metaphysicians six years previously; but, by 1877, Ruskin had experienced something of a reconversion; he had left 'The Religion of Humanity' behind him and was rediscovering, after his own fashion, a spiritual dimension which lay beyond the operation of sense. And so Ruskin criticised the 'general tendency of modern art under the guidance of Paris' – i.e. 'Impressionism' as advocated in Britain by Whistler and his circle: 'I take no notice of the feelings of the beautiful we share with spiders and flies.'

And so, in 1883, under the influence of his newfound faith, far from suppressing *Modern Painters* Volume Two, Ruskin reissued the book in a rearranged edition all of its own. This time round, his target was definitely modern aestheticism, associated with the 'Art for Art's Sake' movement, and the celebration of the sensual, sensuous and sensational dimensions of art. The crime of such movements, from his point of view, was that they were lacking in any sort of imaginative response to the world of nature, and the spiritual truths which it revealed to an attentive observer.

Ruskin wrote a new introduction in which he claimed he could illustrate the difference between *aesthesis* and *theoria* by answering a question which was often asked of him by the aesthetic cliques of London – namely why, in pictures they had seen of his home, no attempt was made to secure harmonies of colour or form in furnishings. His answer was that he was 'entirely independent for daily happiness upon the sensual qualities of form or colour'.[13] When he

wanted such things, he took them from the sky, or fields, and not from his walls, 'which might be either whitewashed, or painted like a harlequin's jacket, for aught I care'.[14] Elsewhere, he said that the aesthetes infected 'every condition of what they call "aesthesis", left in the bodies of men, until they cannot be happy with the pines and pansies of the Alps, until they have mixed tobacco smoke with the scent of them'.[15]

But, for Ruskin himself, the slightest incident which interrupted the harmony of feeling and association in *natural* landscape destroyed it for him, 'poisoning the entire faculty of contemplation'. He wrote that if a single point of chimney of the Barrow ironworks showed itself over the green ridge of the hill in the lower reaches of his beloved Coniston Water, 'I should never care to look at it more'.[16]

But this 1883 reissue of Volume Two does not just revert to the position Ruskin had held almost forty years earlier when he published the first edition. His desire to differentiate himself from German idealism remained strong, and he suggests, as he had done in 1858, that there is a continuity between sensations and the theoretic perception of beauty. He explains elsewhere that, for the perception of beauty, he always used Plato's word, 'which is the proper word in Greek, and the only possible single word that can be used in any other language by any man who understands the subject, – "Theoria".' He goes on to say that only the Germans have a term parallel to it, '*Anschauung*'. He had, he says, assumed this to be the exact equivalent of *theoria* when he first wrote *Modern Painters*, but he now recognises that the two words do not carry the same meaning, 'for "*Anschauung*" does not . . . *include* bodily sensation, whereas Plato's Theoria does, so far as is necessary; and mine, somewhat more than Plato's.'[17] These were to be Ruskin's last significant words upon the matter.

These shifts in his position over forty years have sometimes been taken as an example of his incoherence. And yet his aesthetic theory did not oscillate in an arbitrary way; his views on the relationship between *aesthesis* and *theoria* were consistent with changes in his broader views concerning God and nature. As we have seen, any doubt that nature revealed evidences of the Divine led, inevitably, to a tendency for *theoria* to degrade into *aesthesis*, for the highest aesthetic aspirations to become mere naturalism, realism, functionalism, impressionism . . . or any of the other reductions which were to constitute the history of modernity.

But after the blows which were delivered to natural theology in the

late 1840s and early 1850s, Ruskin's confidence in the basic ideas underlining the first edition of Volume Two never recovered. About halfway through the book Ruskin declared that through his 'enumeration of the Types of Divine Attributes', i.e. through his study of curvature, Apparent Proportion, etc., he had in some measure explained 'those characteristics of *mere* matter' by which it appeared 'agreeable to the Theoretic faculty'. He then announced that, in the next volume, he would have 'to examine and illustrate by examples, the mode in which these characteristics appear in every division of creation, in stones, mountains, waves, clouds, and all organic bodies, beginning with vegetables, and then taking instances in the range of animals, from the mollusc to man; examining how one animal form is nobler than another, by the more manifest presence of these attributes, and chiefly endeavouring to show how much there is of admirable and lovely, even in what is commonly despised.'[18]

As we shall see, there are traces of this project in Ruskin's responses to Gothic architecture and to Pre-Raphaelite painting; but little sign of it in *Modern Painters* Volume Three, first published in 1856. In the 1883 edition of Volume Two, Ruskin explained that he had reflected upon the idea for fifteen years – and then given it up; for by this time 'the scientific world professed itself to have discovered that the mollusc was the Father of Man; and the comparison of their modes of beauty became invidious'.[19] Even in his old age, Ruskin does not seem to have altogether abandoned his longing for this great catalogue of proto-typical beauty, and its manifestations throughout creation: 'I may have a word or two to say, on the plan of the old book, yet.'[20] And yet he realised that his aesthetic theories had been founded upon a view of the world which, at the very time he first expressed it, was being rendered inherently unstable.

5
Nature and the Gothic

In the late 1840s, Ruskin extended his aesthetic ideas into a radical reinterpretation of Gothic – ancient and modern. But his architectural theories make little sense if we detach them from the science, i.e. natural theology, out of which they sprang. In 1844, beween the publication of the first and second volumes of *Modern Painters*, an anonymous book appeared, *Vestiges of the Natural History of Creation*. In fact written by Robert Chambers, an amateur naturalist and journalist, *Vestiges* was a resoundingly successful, if scientifically erratic, popularisation of Scottish theistic Uniformitarianism. Unlike Lyell's work, however, Chambers's was the subject of intense *public* debate. He saw God as a final cause, but he argued that the rocks had been subject to uniform laws of *natural* development – in the operation of which God did not directly intervene. 'What,' he went on to ask, 'is to hinder our supposing that the organic creation is also a result of natural laws, which are in like manner an expression of His will?'[1]

Chambers's conception of the history of the earth was in many ways more remote from twentieth century models than were Buckland's or Sedgwick's. An original 'Big Bang' has, after all, been rehabilitated; and the gradualist perspectives of Uniformitarianism have been abandoned. But what was new about Chambers's theory was its emphasis on the *secular*, or *natural* development of the world – over which an apparently redundant God had only some ultimate and abstract control. The earth of *Vestiges* was no longer divine handiwork; and the beauty of natural forms could not itself be a source of revelation.

Nowhere was the opposition to *Vestiges* stronger than among the members of the English School. In the 1830s, Sedgwick had vigorously criticised Lyell's *Principles of Geology* and postulated a series of supernaturally created adaptations to changing eras in place of ideas of uniform development. (Sedgwick was thus able to explain extinction

of species and sudden changes in the fossil record, which, to the Uniformitarians, were inexplicable.) He now heaved in even more furiously against *Vestiges*, 'a rank pill of asafoetida and arsenic covered with gold leaf'. Nor was rhetoric his only weapon. In 1845, Darwin read an article by Sedgwick, against Chambers, in the *Edinburgh Review*, and he wrote to Lyell saying, 'It is a grand piece of argument against mutability of species and I read it with fear and trembling.'[2]

Even so, as Colin Speakman has so vividly put it, Chambers touched a necessary chord of darkness, of pessimism and even despair in the Victorian imagination, the image of an empty, cruel universe that mocked conventional faith, far removed from the complacent optimism of Paley. Speakman says that *Vestiges* 'was so successful because it reflected this mood of doubt and uncertainty' and a need for 'a dynamic, changing universe, darkly hostile yet capable of growth and change, something raw, exciting, barbaric and essentially romantic'.[3]

If such thoughts were not in Ruskin's mind in the summer of 1847, when he returned to Oxford to act as Secretary of the Geological Section of the British Association, they certainly were when he left. By this time, the English School had, in effect, disintegrated. Buckland had left Oxford two years previously to become Dean of Westminster. He no longer felt obliged to produce a theological 'justification' for science which would satisfy the university authorities. He had lost interest in historical geology and turned increasingly to applications of science to public utility; Daubeny had followed Buckland into Utilitarianism. After his assault on Chambers, Sedgwick became increasingly involved in what, from the outside, appear to have been technical controversies with Murchison. At meetings of the Geological Section in 1847, Ruskin found his intellectual bearings disappearing. His confusion is evident in the letter he sent to his father:

There is nothing for it but throwing one's self into the stream, and going down with one's arms under water, ready to be carried anywhere, or do anything. My friends are all busy, and tired to death. All the members of my section, but especially Forbes, Sedgwick, Murchison, and Lord Northampton – and of course Buckland, are as kind to me as men can be; but I am tormented by the perpetual feeling of being in everybody's way.[4]

Ruskin added that he could neither bear the excitement of being in a society 'where the play of mind is constant, and rolls *over* me like heavy wheels, nor the pain of being alone'. He complained, 'I cannot look at anything as I used to do, and the evening sky is covered with strings and eels.'[5] For him such serpentine forms were typical of the

devil, rather than of God. And it was at this time that Ruskin turned his attention to water plantains and the Gothic Revival.

* * *

I have already described how, in 1968, in the squeaky tones of the student revolutionary modernist, I mocked Ruskin for his association with the Gothic Revival. I wrote that he could not be 'entirely blameless for the hideous, castellated appearance of Gisbourne Court, Peterhouse, the fairy, ethereal dream-scape of Pembroke, the stupidity of the Strand Law Courts – the list is endless.' Ruskin, poor fellow, had failed to see that modern engineering was an art form in itself.

Almost everything was wrong with this line of 'reasoning'. It was only when, in 1975, I went to live in Dalston, in the East End of London, that I began to look at Gothic Revival buildings. I started by visiting churches like the nearby St Mark's, known locally as 'The Cathedral of the East End', then the subject of a much-needed 'restoration' appeal. Chester Cheston's masterpiece rarely appeared in the architectural history books, and when it did, it was dismissed as 'painful . . . in the true Bassett Keeling style'.[6] Yet, despite my prejudice, I responded to this lofty building. Few, if any, twentieth century churches could hold their own beside it! Not far away, in Stoke Newington, there was St Matthias by William Butterfield. This led me to seek out All Saints' in Margaret Street, which even Ruskin (who was hypercritical of almost all Victorian Gothic) had praised. And soon I found myself exploring buildings by Carpenter, Street, Bodley, Seddon and Brooks, at a time when the world as a whole was awakening to the idea that 'modern engineering' had in fact provided no substitute for architecture.

I began to wonder whether the Gothic Revival had not been the last great architectural movement this country had seen. Today, I would agree with Paul Johnson in this, if in little else: Giles Gilbert Scott's Anglican Cathedral in Liverpool is surely 'Britain's greatest twentieth century building'.[7] And yet, when all was said and done, I also understood why it was, when Ruskin looked back over the achievements of the Gothic Revival, he 'felt only a sense of bitter disappointment and vexation'. For his vision of a modern Gothic was never realised; perhaps, in Victorian England, it defied realisation . . . As we shall see, that may be the task which – when all the Jencksian phoniness has died down – truly 'post-modern' taste has to face.[8]

The legacy of modernism means that, today, we still do not know

how to approach even the greatest works of the Revival. Geoffrey
Scott, author of *The Architecture of Humanism*, would have had little
patience with the judgement of Johnson. And yet it was the ideas of
Geoffrey, rather than Giles, Scott which were filling Kenneth Clark's
head when he started to write his history of *The Gothic Revival*
in the 1920s. Clark was then only twenty-five years old, a young
proto-modernist, who had been brought up on 'the pure form of
Roger Fry and the pure architectural values of Geoffrey Scott'.[9] He
believed he had simply to apply Scott's ideas to a kind of architecture
'which everyone agreed was worthless' thereby to expose 'the ethical
fallacy'. But the second edition of Clark's book, published just after
the Second World War, contained a preface in which he described
how after reading the apologists of the period – Pugin, Ruskin and
Giles's grandfather, Gilbert Scott – he was 'unconsciously persuaded'
by what he had 'set out to deride'.[10] Inevitably, however, *The Gothic
Revival* remained flawed by his initial intent; and nowhere more so
than in his discussion of Ruskin.

Clark argued that when *The Seven Lamps of Architecture* was
published in 1849, it was not a new way of looking at architecture,
but one which had been common for at least ten years. For Clark,
even Ruskin's chapter on 'The Lamp of Beauty' was 'actually no more
than the Gothic Revival doctrine of nature',[11] i.e. the doctrine that
beauty is analogous to natural form. Clark accused Ruskin of 'very
crude application' of this idea, and claimed he did little more than
'disinfect' the Gothic Revival and make it acceptable even to 'the
extreme Protestant Party'.

Evangelicals had previously seen 'mischief lurking in every pointed
niche, and heresy peeping from behind every Gothic pillar'; they
identified Medievalism 'with Romish hierarchy ... the Inquisition
and Smithfield'.[12] But, by belligerent anti-Catholicism, Ruskin prised
the Gothic Revival apart from the Papacy and allowed the movement
to become the most successful style of the later nineteenth century. If
Ruskin had not 'salted his descriptions of Italian Gothic with attacks
on Rome', he would, according to Clark, have been considered 'a
Roman Catholic apologist'. But is this really so? Or was Ruskin,
perhaps, trying to present the outlines of a new *Protestant* Gothic,
rooted in his elusive understanding of the Divine proto-types revealed
by modern science?

The Gothic Revival had its roots in eighteenth century 'Gothick' –
sham ruins, castles and façades, and the extravaganzas of Walpole's

Strawberry Hill or William Beckford's Fonthill Abbey.[13] 'Gothick' was a form of antiquarian Romanticism; the sentiments that inspired it were theatrical rather than religious – although there were those who argued that the essence of true Gothic was to be understood in terms of function, and the imitation of nature. Sir James Hall, the most prominent Scottish geologist of the later eighteenth century, put forward a theory of the Gothic based on his observation of the way in which the bark of the willow peeled away from the rods of a wicker cathedral he 'grew' in his back garden.[14]

Even ecclesiastical Gothic was not at first especially associated with the Church of Rome. The Christian Gothic Revival followed upon the Church Building Act of 1818. The Church Commissioners, charged with the provision of churches for swelling urban populations, opted for Gothic on neither spiritual nor architectural grounds, but rather as a matter of expediency: unlike the Classical style, Gothic could be built in brick, and did not require expensive porticoes. Predictably, with the exception of J. Savage's St Luke's, Chelsea, there is a mean-mindedness about this sort of work.

For Augustus Welby Pugin, both 'Gothick' and Commissioners' Gothic were anathema. He believed that to revive architecture, one must first revive faith. Pugin converted to Rome in 1834, the year that the old Houses of Parliament burned down; this did not inhibit him from collaborating with Charles Barry on the new Palace of Westminster.[15] Clark claims that it was Pugin who revived the idea that, 'in nature, God's handiwork, might be found all the highest forms of beauty'. But this is not quite true.

In 1849, the year that Ruskin published *The Seven Lamps of Architecture*, Pugin issued his *Floriated Ornament* which, according to Clark, anticipates Ruskin, and reveals 'with what Ruskinian conscientiousness Pugin has followed nature'.[16] But as Clark himself tells us, *Floriated Ornament* was *not* based on nature at all, but rather on a study of a late medieval botanical work, the *Tabanae Montanus cicones Plantarum* of 1590.

Ruskin insisted he owed *nothing* to Pugin. 'I glanced at Pugin's *Contrasts* once . . . during an idle forenoon . . . I never read a word of any other of his works, not feeling, from the style of his architecture, the smallest interest in his opinions.'[17] He insulted Pugin when he wrote that the basest of fatuities 'is the being lured into the Romanist Church by the glitter of it, like larks into a trap by broken glass.'[18] This was unfair, especially as Pugin's architectural ideas were regarded

with scepticism by the Roman hierarchy. Most commentators have focused only on Ruskin's bigotry in saying such things. This is not to be denied: Ruskin himself admitted he had felt the allurements of what he denigrated. Nonetheless, the fact is that the respective beliefs of Pugin and Ruskin led them to different conceptions of modern Gothic.

Pugin believed nature could only reveal God if man learned to read it in the light of authority and tradition; but Ruskin, at least at the time when he wrote *The Seven Lamps*, thought that the forms of modern Gothic were to be sought in leaves and living plants. In other words, he thought that the foundations of modern Gothic were being laid by modern science.

Within Anglicanism, the guardians of the Gothic Revival, before Ruskin, were High Churchmen, Tractarians and the Oxford Movement, who wanted to revive the reformed religion through the revival of rituals and traditions. Most were opponents of natural theology. The leaders of the Oxford Movement – Newman, Pusey and Keble – were not especially concerned with architectural issues; they did not want to toe the curving lines of the Gothic party. God, Newman argued, was not bound by a single human style. But the members of the Cambridge Camden Society thought otherwise; they wanted to transform drab and debilitated church interiors so that the ancient rituals of the church could again be celebrated in buildings redolent with the symbols of almighty God.

Through their monthly magazine, the *Ecclesiologist*, the Camdenians campaigned for ruthless 'restoration' on English Decorated lines. But their understanding of this style had little in common with Ruskin's. In 1843, two of the Society's founder members, J. M. Neale and Benjamin Webb, spelled out the theory of their movement in a lengthy introduction to the first book of the *Rationale Divinorum Officiorum*, by Willielmus Durandus, who had been Bishop of Mende in the thirteenth century. In 1927, Clark dismissed their work, mocking its enthusiasm for impenetrable symbolism. But he ignores how very different their Tractarian ideas were from Ruskin's.

'That the teaching of Nature is symbolical,' Neale and Webb write, 'none ... can deny.' But, they ask, 'Shall we then wonder that the Catholick Church is in all Her art and splendour sacramental of the Blessed TRINITY, when Nature herself is so? Shall GOD have denied this symbolism to the latter, while HE has bestowed it on the former? ... It would be strange if the servant could teach, what the

mistress must be silent upon: that Natural Religion should be endued with capabilities not granted to Revealed Truth.'[19]

For Neale and Webb, the symbolism of the church was analogous to the symbolism to be found in nature, but there seemed to be no intrinsic link between the two. They would have assented to Newman's belief in design because he believed in God rather than in God because he believed in design. They argue that there was something in old buildings beyond even Catholic life and discipline: that is symbolism, or, as they sometimes call it, sacramentality.

Certainly, this symbolism involves representations. For example, Neale and Webb have much to say of the symbolism of flowers: the rose is for beauty, the violet for modesty, the sunflower for faithfulness, and so on. They found nothing surprising in this: 'Our Lord's teaching' and the Sacraments themselves were 'symbolical'. But they also say that the 'material fabric' of the church 'symbolizes, embodies, figures, represents, expresses, answers to, some abstract meaning'. The fact that anything exists adapted to a certain end or use is enough to presuppose its end or use. 'Show us a pitcher, a skewer . . . : do not the cavity of the one, and the piercing point of the other, at once set forth and symbolize that which was answered in their production? Thus do even the smallest details of the true church set forth and symbolize aspects of God, and his redemptive processes. The cruciform plan and gable crosses symbolize Atonement; a hood mould above all three lancets means the unity of the Godhead; a two-light window symbolizes the two Natures of Christ, or the mission of the disciples, two by two. Doors symbolize Christ as the Door; they are placed near the west end because we enter the Church Triumphant through the Church Militant. The screen symbolizes the division between these two parts of the Church.'[20] etc., etc., etc. Durandus himself took this sort of thing to extraordinary lengths: he believed the 'arrangement of a material church resembleth that of the human body', the chancel, or site of the altar, representing the head; the transepts the hands and arms, etc.

'Symbolical' interpretation of architecture was disputed, even within the Gothic Revival. How could you *prove*, for example, Durandus's assertion that the cock at the summit of the church was a type of the preacher? Such interpretations depended on ingenious speculation, within a framework of liturgical tradition and ecclesiastical authority. The Cambridge Camden Society made much of such principles, but there were others who did not.

The members of the Oxford Architecture and Historical Society believed that Gothic was, at bottom, an imitation of nature – but not necessarily of nature's functional necessities. The society had been formed in 1839 as 'The Oxford Society for promoting the Study of Gothic Architecture'. Ruskin was a founder member, and, through his influence, Dr Buckland, scourge of Oxford Tractarianism, was elected one of the society's Vice Presidents.

We have seen how much Ruskin's aesthetics owed to the Oxford scientists; and it was these aesthetics which he felt to be threatened in that summer of 1847, when he acted as Secretary of the Geological Section of the British Association. He had perhaps glimpsed the pragmatism which had, all along, informed Buckland's espousal of natural theology. And now the professor had openly abandoned the cause, and become seduced by the school of thought that looked upon leaves as 'gasometers'. For Ruskin, it was all too much.

Ruskin's parents were – not for the first time – concerned about the state of his health. He was thus despatched, as he had been in 1841, for one month's cure under Dr Jephson at Leamington Spa. There, according to his biographer, E. T. Cook, he 'occupied himself with miscellaneous reading; and with much study, by drawing and analysis, of botanical detail, and with inner questionings on the foundations of a religious faith now first becoming shaken'.[21] We know from Ruskin's letters something of what his botanical studies were; 'I am indeed better at last,' he wrote to George Richmond, '– thanks to the perfect rest I have had here – and my thoughts and faith are returning to me. I have had great good from dissecting some water plants out of the canal.'[22] Ruskin apparently believed that in the proportions of the stem and the curvature of the leaves of *Alisma Plantago*, the common water plantain, he had placed his finger upon a type of God's beauty in the world.

But his natural theology was never again to be as firm as it had been. A sense of the meaninglessness of nature, and of living in an irredeemably fallen world, had begun to haunt him. When the worst was over, Ruskin went on a visit to Scotland, where, according to Collingwood, much of his time was spent 'in morbid despondency, digging thistles, and brooding over the curse of Eden, so strangely now interwoven with his own life'.[23]

His continuing, if shaken, belief in scientific natural theology was to be a source of consolation to him for some time. A few months after the dissection of the water plantain, Ruskin wrote *The Seven*

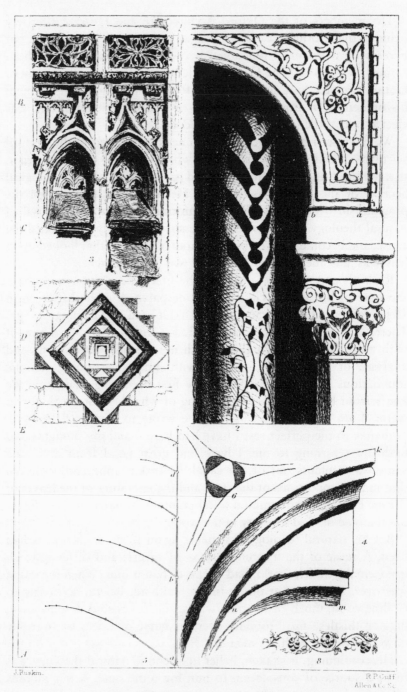

From *The Seven Lamps of Architecture*

Lamps of Architecture; these researches formed the basis of his most original chapter, 'The Lamp of Beauty'. He argued that 'on the shapes which in the every-day world are familiar to the eyes of men, God has stamped those characters of beauty which He has made it man's nature to love.'[24] And, as he saw it, the value of Gothic architecture was that the Gothic artists could humbly imitate this revelation by reproducing the *non-functional* beauties of natural proportions and natural forms.

To explain the principles of proportion, Ruskin turned to the flower stem of *Alisma Plantago*. Ruskin illustrated a profile of one side of a specimen gathered at random, and explained that 'it is seen to have five masts, of which, however, the uppermost is a mere shoot.' (See p.60.) He analysed the relations between the largest four masts:

Their lengths are measured on the line AB, which is the actual length of the lowest mast $a\,b$, $AC = b\,c$, $AD = c\,d$, and $AE = d\,e$. If the reader will take the trouble to measure these lengths and compare them he will find that, within half a line, the uppermost, $AE = 5/7$ of AD, $AD = 6/8$ of AC, and $AC = 7/9$ of AB; a most subtle diminishing proportion.[25]

Ruskin believed he had identified an instance of that 'Apparent Proportion' which, in *Modern Painters* Volume Two he had declared to be 'typical of that Unity which we attribute to God'. He returned to his analysis of the plant in the first volume of *The Stones of Venice*, published in 1851; on this occasion, he was not so much interested in the 'Apparent Proportion' of the stem, and its division by the leaf stalks, as in what he held to be the perfect curvature of the leaves themselves, which, he thought, appeared as beautiful because it approached the infinity of God. Ruskin tried to show that a certain kind of curve of intense and exceptional beauty was common not only to fine ornament but also to a range of natural forms, including the southern edge of the Matterhorn; the slope of the glacier, Aiguille Bouchard, from its summit into the valley of Chamouni – a distance of some three miles; a willow leaf traced onto paper; the curves at the lip of a paper Nautilus; the side of a bay leaf; and the leaf of *Alisma Plantago* with its interior ribs.[26] (See p.62. We can detect here something of that great catalogue of proto-types of Divine Attributes which Ruskin was never to write.) He insisted that all the examples he had instanced agreed 'in their character of changed curvature, the mountain and glacier lines only excelling the rest in delicacy and richness of transition'.[27]

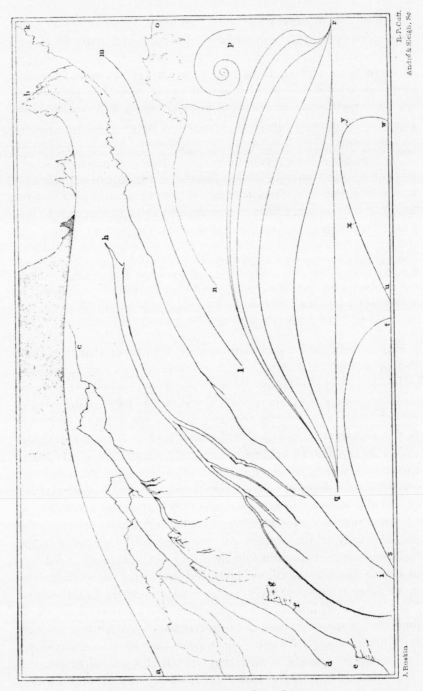

From *The Stones of Venice* Volume One

Such ideas, stemming from his dissection of *Alisma Plantago*, quickly became the trunk of his explanation of the beauty of Gothic. In the lectures on architecture which he delivered in Edinburgh in 1853, Ruskin argued that the pointed arch was the most beautiful form in which a window, or doorhead, could be built – not because it was the strongest; but rather 'because its form is one of those which, as we know by its frequent occurrence in the work of Nature around us, has been appointed by the Deity to be an everlasting source of pleasure to the human mind.'[28]

Ruskin invited his listeners to gather a branch of the common ash, and offered them a sketch of the clusters of leaves which 'form the extremity of one of its young shoots'. The first lesson he drew from the spray was a refutation of the 'error' which was, he said, common to architects and politicians alike: namely a preference for 'equalities ... and similarities'. Ruskin complained that such men held it to be necessary 'that each part of a building should be like every other part'. But, he observed, 'Nature abhors equality, and similitude, just as much as foolish men love them.' He then tried to illustrate these principles by a detailed analysis of the branch of the ash tree, stressing that 'all its grace and power of pleasing' were owing to its avoidance of 'equalities', and also to 'the lovely curves in which its stalks, thus arranged, spring from the main bough'.[29]

He then went on to argue that these curves were '*precisely as a Gothic vaulted roof springs*, each stalk representing a rib of the roof, and the leaves its crossing stones' (Ruskin's italics); 'the beauty of those leaves is altogether owing to its terminating in the Gothic form, the pointed arch.' Ruskin asked his audience if they would have liked the ash trees of Scotland as well 'if Nature had taught them Greek, and shown them how to grow according to the received Attic architectural rules of right?' He showed them a drawing of a cluster of squared ash leaves 'grown expressly ... on Greek principles'.[30] The result looks like the modular units of a twentieth century curtain wall.

He refuted those who might wish to argue that if we had been as long accustomed to square-leaved ash trees as we had been to sharp-leaved ash trees, 'we should like them just as well'. After all, Ruskin said, his audience was much more accustomed to 'grey whinstone and brown sandstone' than to 'rubies or emeralds'. When the 'bandages of fashion' were removed from the eyes and the arteries of the soul then human admiration returned 'into that bed which has been traced for it by the finger of God'.[31]

Needless to say, there is no equivalent for this kind of analysis of plant forms in Pugin, or the Camden Society, or anyone else. When Charles Eastlake came to write his *A History of the Gothic Revival in England*, in 1872, such thinking still seemed strange to him. 'We find our author dissecting the flower stem of a water plantain,' he wrote, 'and using arithmetical formulae to show the subdivision of its branches, from which he implies that a lesson is to be learnt.'[32] Eastlake, however, doubted it.

And so, even within the Gothic Revival itself, Ruskin's theories were perceived as contentious. In one sense, he drew upon the secular and 'scientific' accounts of the Gothic, initiated by men like Hall, who looked for explanations in a 'natural' and secular world. Such thinking derived its arguments from close observation of natural forms, and appealed to experiment and analysis, rather than tradition. But Ruskin's explanation of Gothic differed from this; he insisted that certain forms appeared to be beautiful in ways which refused utilitarian explanation: those forms, he convinced himself, had been traced 'by the finger of God'. Such beauty 'has been appointed by the Deity to be one of the elements by which the human soul is continually sustained'.

There was a time when it used to be argued that, of all the architects of the nineteenth century, Ruskin was closest to William Butterfield – and he had kind things to say about All Saints in *The Stones of Venice*. Butterfield's church (which was attacked by modernist architectural theorists in the early twentieth century) was a vigorous re-interpretation of Gothic, drawing upon an eclectic range of stylistic sources, and making use of modern materials. Butterfield also related to the modern geological consciousness; a range of the stones used in the rich patterning of 'structural polychromy' throughout the church seems to be re-sacralised, or offered up to God, so that the building is almost as much a museum as a church.

And yet modern scholars now recognise that Butterfield derived few of his ideas about the nature of Gothic from Ruskin. Butterfield's building was not in the Venetian Gothic style Ruskin preferred. Such was Butterfield's control over every detail that little freedom of expression was granted to individual workmen. Needless to say, decorative details did not manifest that search for the Divine prototypes upon which Ruskin placed such emphasis.

Ruskin's ideas about Gothic were first implemented not in churches, but rather in museums – albeit museums which were intended to give

expression to the Divine truths revealed through study of nature. The first was built at Trinity College, Dublin. In 1855, William Allingham described the façade as containing 'numberless capitals delicately carved over with holly-leaves, sham-rocks, various flowers, birds, and so on'.[33] As Eve Blau writes in her study of the architects, Benjamin Woodward and Thomas Deane, the simplified forms and 'clarity of outline' of this building reflect a 'preoccupation with surface articulation' which, unlike Butterfield's sculptural forms, is almost pictorial. 'The emphasis,' she writes, 'is on the façade as a frame for an eclectic assembly of architectural details, richly associational story-telling sculpture, naturalistic relief carving, and constructive color.'[34] The façade, we might say, is conceived almost as a picture comprised of the most beautiful proto-types in God's world.

Did such details and carvings in fact trace the fingerprints of God, or were they simply replicas of forms whose beauties could equally well be described in more sensuous or functional ways, without any reference to divine typology at all?

6

Pre-Raphaelitism

And so it becomes clearer why, in 1851, Ruskin wrote to *The Times* to praise the painting of the lilies and, especially, the leaf of *Alisma Plantago* in Collins's *Convent Thoughts*. In many ways, his response to Pre-Raphaelite painting had been foreshadowed in his response to the Gothic Revival.

Ruskin was not involved in the foundation of the Pre-Raphaelite Brotherhood. In 1848, when the PRB was formed, he was absorbed with his new wife, his vegetable proto-types, Gothic architecture, and *The Seven Lamps*. Of the Pre-Raphaelites, Holman Hunt knew Ruskin's published writings best. In his hasty but impassioned reading of *Modern Painters* Volume Two, Hunt had been moved by Ruskin's typological analysis of Tintoretto's painting. At first the Brothers were more concerned about the symbols of God's revelation of Himself through scripture and tradition than with the natural world. For Pre-Raphaelitism depended, in part, upon a kind of Biblical literalism which was perhaps only possible in England. The new sceptical criticism from Germany, which had raised a long series of question marks concerning knowledge of the historical Jesus made little impact here until the 1850s. The gospels were still assumed to be eye-witness accounts of events that 'really happened', and could therefore be accurately, or inaccurately, reconstructed in pictures. When, many years later, Ruskin did praise Dante Gabriel Rossetti's *Ecce Ancilla Domini!*, first exhibited in 1850, he described it as an 'effort towards a real notion of what actually did happen in the carpenter's cottage at Nazareth'.[1]

Even so, the Pre-Raphaelite pictures led to public consternation in which Ruskin shared. This had its roots in anti-Papist and anti-Tractarian sentiments. He once described how William Dyce – High Churchman, Royal Academician, painter and promoter of the German Nazarene style in England – had to drag him up to Millais's *The Carpenter's Shop* in the Royal Academy Exhibition of 1850, and force

him to 'look for its merits',[2] of which Ruskin was never wholly convinced. The work had been the subject of vehement critical abuse. In a notorious review, Charles Dickens accused Millais of depicting Jesus as 'a hideous, wry-necked, blubbering, red-haired boy in a night-gown'.[3] But it probably was not this naturalism which offended Ruskin.

Ruskin was aware that the typology on which the painting depended was Tractarian. The picture was not exhibited under the title it now bears, but with the Old Testament Biblical text, Zechariah XIII 6, 'And one shall say unto him, What are these wounds in thine hands? Then he shall answer, Those with which I was wounded in the house of my friends.' Hunt relates that Millais's picture was inspired by a Tractarian sermon he had heard in Oxford.[4] Recent scholarship has indicated how redolent the painting is with Tractarian themes.[5]

According to the art historian Alastair Grieve, there are topical Tractarian references in the painting to child baptism (e.g. the youth of John the Baptist) and regeneration through baptism (e.g. the fact that the Baptist seems to intend to wash the wound of Christ).[6] These are underlined by the well in the background, which may symbolise a font – which the Ecclesiologists said should be placed at the west end of a church. In all probability, these were allusions to the case of the Rev. C. G. Gorham, a Tractarian rejected by his bishop because of the unorthodoxy of his belief in Baptismal Regeneration. In 1850, after complicated ecclesiastical and legal proceedings, Gorham had finally vindicated the doctrine – to the delight of the High Church party.[7] The flock of sheep in front of the well are prevented from entering the garden and eating a cactus flower, recalling the demand of the Tractarians and Ecclesiologists that the laity should be separated from the clergy and that some religious knowledge should be withheld. Grieve points out that the wall, with its tools, can then be read as a rood-screen and the room itself as the sanctuary with the table occupying the place of the altar, where the blood of Christ is spilt . . .[8] And so on, in just the sort of way of which Neale and Webb would have approved. Little wonder that the painting was praised in the Tractarian press, or that Ruskin found it hard to stomach.

Criticism of the Pre-Raphaelites flared up again over their contributions to the 1851 Royal Academy exhibition – which included Millais's *The Woodman's Daughter*, *The Return of the Dove to the Ark* and *Mariana*; Hunt's *Valentine Rescuing Sylvia from Proteus*; and Collins's *Convent Thoughts*. It was on this occasion that Coventry

Patmore, the poet, prevailed upon Ruskin to write to *The Times* in defence of the young artists, which he did, emphasising that he had 'no acquaintance' and 'very imperfect sympathy with them'. He declared that no one who knew his writings would suspect him 'of desiring to encourage them in their Romanist and Tractarian tendencies'.[9] But he went on to praise their truthfulness: of Collins's picture, he wrote: 'As a mere botanical study of the water lily and *Alisma*, as well as of the common lily and several other garden flowers, this picture would be invaluable to me, and I heartily wish it were mine.'[10]

At first sight it might be thought odd that Ruskin was persuaded to speak out in favour of the Pre-Raphaelites at all. For the 'Romanist and Tractarian' interests, if not inclinations, of many of the Brothers could hardly be denied. Millais, Collins, and even Rossetti worshipped at St Andrew's in Wells Street, a fine early Gothic Revival church, renowned for its ritualism. Ruskin's anti-Papism was at full flood. He had just published a pamphlet entitled 'Notes on the Construction of Sheepfolds', in which he assailed Tractarian ideas head on; he attacked the idea of a priesthood which buttressed its authority through appeals to tradition and the claims of the High Church clergy to be vicars of Christ on earth. The Roman hierarchy had recently been re-established in Britain, and Ruskin was not in favour of tolerance: 'Three centuries since Luther – three hundred years of Protestant knowledge – and the Papacy not yet overthrown! Christ's truth still restrained, in narrow dawn, to the white cliffs of England and white crests of the Alps . . .'[11] He wanted a pan-Protestant alliance against Rome, and despised all those whom he regarded as Papal sympathisers. William Dyce was appalled, and had written a public reply to his friend's ideas.

Ruskin must have known that, in this climate, *Convent Thoughts* would have appealed immediately to the Tractarian and High Church party. For, like Millais's painting of the previous year, *Convent Thoughts* contained contentious, topical references. Indeed, in one sense, it was a 'modern life' picture; for Collins was clearly referring to the restoration of religious communities for women, which had begun in Britain under Pusey's influence in 1845. Collins almost certainly knew of the community in the parish of Christ Church, Albany Street in St Pancras, as his family home was situated not far away. His painting also reflects the passionate interest in medieval art and the Quattrocento, which in the mid-nineteenth century was so characteristic of High Church circles.

Nor, I think, can we put Ruskin's response down to disinterested pictorial preferences. For if such had been his motives, why, one wonders, did he not pick upon the flower painting in the background of John Millais's picture *The Woodman's Daughter*? Not only was Millais's painting free of overt Romanist or Tractarian references, the flowers in the background are far more fluent and beautiful – something which Ruskin, with his sharp eye, would surely not have missed. We know a good deal about the genesis of both Collins's and Millais's paintings; Collins had painted much of the background of *Convent Thoughts* while working alongside Millais, a close friend, at Botley, near Oxford.

The awkwardnesses of Collins's picture in part derive from the ambiguity of its conception; for Hunt tells us that Collins originally intended his painting as an illustration of the lady in Shelley's 'Sensitive Plant', 'Who out of the cups of the heavy flowers/Emptied the rain of the thunder showers.' In Shelley's odd verses, the woman herself was to the flowers 'as God is to the starry scheme'.[12] But Shelley's imagery has no explicitly religious content; it is sensual, sexual, even surreal. A drawing in the British Museum reveals how Collins intended to interpret the couplet. Needless to say, it contains no sign of the passion flower, let alone of the nun's habit, or medieval prayer-book. But we know from Millais that Collins changed his mind and opted for the theme of the nun when he was finally rejected by the over-holy Maria Rossetti, one of Dante Gabriel's sisters. (Maria's sister Christina herself became a nun.) Collins's unrequited passion for Maria may have had something to do with the reason why he was never admitted to full membership of the PRB; it seems to have precipitated his deepening involvement with the High Church party.

Millais's painting reflected a general tendency within the Brotherhood away from explicitly ecclesiological and Biblical subjects, towards paintings emphasising 'God's second book', the world of nature. Ruskin himself was soon to acclaim Millais as capable of becoming a 'second Turner'.

But Ruskin's greater interest in Collins's picture is explicable if we remember what he ignores, and what he focuses his attention upon; for Ruskin's approach to Pre-Raphaelitism was identical to that which he had already adopted towards the Gothic Revival. Just as those aspects of Gothic Revival symbolism which so preoccupied Neale and Webb were of little interest to Ruskin, so he made no mention of the relentlessly laboured religious symbolism radiating out from the

passion flower itself. The early Spanish missionaries to South America were the first to see in the passion flower's crossed stamens a symbol of the crucifixion of Christ. They also saw in the five anthers of the flower the five wounds Christ received when he was nailed to the cross by three nails, represented by the plant's three branches. The 'filaments' seemed to suggest the crown of thorns and the calyx the glory that surrounded Christ's head.[13]

Ruskin had not a word to say about such matters. And yet, in a sense, the picture *depends upon* symbolism of this kind. All those lilies point towards maidenhead, and the identification of the nun with the types of the Virgin Mary. Collins was reluctant to leave the 'reading' of such themes to chance or intuition; *Sicut Lilium*, a Latin tag incorporated into the frame of his picture, refers to a text from the Song of Solomon, 'As the lily among thorns'. As Malcolm Werner has pointed out, this text was often taken as a 'type', or prophetic prefigurement, of the Virgin Mary, who, in Collins's picture, is depicted with a face like that of the nun herself on the other open page of the missal she is holding.[14] Indeed, Canticles is the source of a great deal of imagery which Christian painting has traditionally associated with the mother of Christ; for example, the type of the lily as a symbol of Mary, and hence of chastity and purity, and the association of the Virgin with a *hortus conclusus*, or enclosed garden, and a sealed fountain. 'A garden inclosed *is* my sister, *my* spouse; a spring shut up, a fountain sealed.' Western landscape painting might almost be said to have begun with the attempt to depict the enclosed garden in which the Virgin Mother of Christ sat on the ground amidst the flowers, while her son played with the birds, a theme especially popular in the fifteenth century – an era evoked by the nun's reading matter.[15] The contrast between the whiteness of both the nun's habit and the nearby lilies and the red rose bush is intended to underline these associations. Lest the point escapes you, the Virgin is depicted with the features of the nun in one of the scenes in the open book; the other shows the crucifixion of Jesus. Even the goldfish, some red, some white, according to Werner, 'seem to echo the major themes of Christ's sacrifice and the nun's purity'.[16] But Ruskin mentions none of all this: rather, he seizes upon the thoroughness of the painting of the flowers, and especially of *Alisma Plantago* – almost an intruder, or a weed, which falls outside the painting's laboured symbolic order, but offers, he felt, a more certain avenue to the revelation of Divine truths.

In a second letter to *The Times*, Ruskin revealed he had received a letter which had reassured him, 'respecting what I supposed to be the Romanizing tendencies of the painters'.[17] He added that all he could say was that, 'instead of the "pilgrimage" of Mr Collins's maiden over a plank and round a fish-pond, that old pilgrimage of Christiana and her children towards the place where they should "look the Fountain of Mercy in the face," would have been more to the purpose in these times'.[18] The reference here is to the resolutely Protestant symbolism of John Bunyan's *The Pilgrim's Progress*.

Ruskin then claimed that, as they gained experience, the Pre-Raphaelites might 'lay in our England the foundations of a school of art nobler than the world has seen for three hundred years'. But Ruskin explained he did not value the Pre-Raphaelites for what some had seen as their archaism, but rather for their commitment to *truth*. 'As far as I can judge of their aim,' he wrote, 'the Pre-Raphaelites intend to surrender no advantage which the knowledge or inventions of the present time can afford to their art.'[19] He went on to say that they intended 'to return to early days in this one point only – that, as far as in them lies, they will draw either what they see, or what they suppose might have been the actual facts of the scene they desire to represent, irrespective of any conventional rules of picture-making.'[20]

Again, in a lecture he gave in 1853, Ruskin insisted that 'Pre-Raphaelitism has but one principle, that of absolute, uncompromising truth in all that it does, obtained by working everything, down to the most minute detail, from nature, and from nature only.'[21] But it would be wrong to assume that he was thereby advocating secular naturalism. For Ruskin insisted that 'the great and broad fact' which distinguished modern art from old art was that 'all ancient art was *religious*, and all modern art is *profane*.' 'Modernism,' Ruskin said, 'began and continues, wherever civilisation began and continues to *deny* Christ.' The Pre-Raphaelites were to reverse this tide of modernity by their pictorial affirmation of Christ: 'They will gradually unite their influence with whatever is true or powerful in the reactionary art of other countries; and on their works such a school will be founded as shall justify the third age of the world's civilisation, and render it as great in creation as it has been in discovery.'[22]

'As great in creation as in discovery . . .' In other words, Pre-Raphaelitism was to be not only Protestant, but scientific, and in this sense, in continuity with the painting of Turner, 'the first and greatest of the Pre-Raphaelites': 'I have always said, he who is closest to

Nature is best . . . I have never praised Turner highly for any other cause than that he *gave facts* more *delicately*, more Pre-Raphaelitically, than other men.'[23] Ruskin re-emphasised that he had always said that the great virtue of the early sacred painters was that they gave 'entire, exquisite, humble realization – a strawberry plant in the foreground with a blossom, *and a berry just set, and one half ripe, and one ripe*, all patiently and innocently painted from the *real thing, and therefore most divine*.'[24]

He contemptuously dismissed the 'querulous' complaints of those who argued that Turner was generalising, vague and visionary, whereas the Pre-Raphaelites were hard and distinct: '*I* never said that he was vague or visionary.' Indeed, Ruskin objected to the *real* Pre-Raphaelite painting of Italy, the work of the early religious artists, on the grounds that 'the grasp of nature is narrow, and in most respects too severe and conventional to form a profitable example when the landscape is to be alone the subject of thought.'[25] Nonetheless, he was full of praise for the way in which, in such painting, one found 'entire, exquisite, and humble realization of those objects it selects' – especially plants and flowers. 'The ferns that grow on the walls of Fiesole,' he wrote, 'may be seen in their simple verity on the architecture of Ghirlandajo. The rose, the myrtle, and the lily, the olive and orange, pomegranate and vine, have received their fairest portraiture where they bear a sacred character.'[26]

Again, we can see the great hope of Ruskin's early aesthetic thinking: aided by modern scientific imagination, the painter would be able to see and to represent aspects of the Divine which had previously been hidden. By making these, rather than antiquated symbolic associations, the basis of his art, the modern painter, like the modern Gothic architect, might produce new and original works of art; these would nonetheless be 'reactionary' in that, unlike the products of what Ruskin called 'Modernism', they would combine the insights of the present with the spiritual depth of the greatest art of the past.

7
Proserpina

Sicut Lilium: when I was a child, a discussion arose in the family about which book of the Bible each of us liked the most. I said the Song of Solomon. This met with irritation. 'It's really only a love song,' I was told.

When I was somewhat older, the subject of Canticles was raised again. By this time, I had read a certain amount of St Bernard of Clairvaux, and other Fathers of the Church, who suggested that the love whose praises were sung in the Song of Solomon might have been an allegory for that of Christ for his church. I have forgotten how it was St Bernard explained such verses as 'Thy two breasts *are* like two young roes that are twins, which feed among the lilies.' But I know that I used similar interpretations to explain the spiritual value of the book as a whole. Again I was advised not to believe such things, and reminded of what surely must be true, namely that Canticles is just a love song.

But I answered back, asking how this might be. For if this book was just the account of the passion of a man for a woman, what did it have to do with 'The Word of God'? If the meaning of the Song of Solomon was not much as St Bernard had described it, then its symbolism was of an irredeemably sensual, even explicitly sexual, kind. 'My beloved put in his hand by the hole of the door, and my bowels were moved for him.'

But if, after all, it was admitted that the Song of Solomon was a human love song that had found its way into scripture through some sort of error, then spectres were raised far graver than those arising from the sins of the flesh . . . For *whose* mistake was it? If it was an error on the part of those who had compiled the good book, then what was left of Divine inspiration? If, on the other hand, it was said that the error had been made by God himself, what was left of the whole grand edifice of faith . . .?

This line of reasoning was not well received. It implied that between

the heady symbolism of the High Church, and atheist sensuality, there was no ground upon which a man might stand. A descent into sensuousness afflicted the representation of the *hortus conclusus* in the Quattrocento itself. It has been pointed out how some fifteenth century Madonnas in gardens are really little different from their worldly equivalents, the ladies in spring and early summer calendar pictures or in illustrations to Boccaccio's *Decameron*. The representations of secluded garden retreats 'have almost as much to say to us of medieval gardening practice as of devout symbolism'. Perhaps this should not surprise us, for as Henry Hawkins, a Jesuit, wrote in the seventeenth century, 'the Garden of Eden, or Terrestrial Paradise, was not so exempt from Sinne, but the place where Sinne began.' The eventual freeing of the Virgin from the charmed circle of her wall, or wattled fence, and the placing of her in a varied landscape, 'offered rich rewards to the senses'. But it also inevitably meant that 'the walled garden was called upon to serve purposes and masters unsuited to it.'

And so it was easy enough for me to understand why Charles Collins had tried unsuccessfully to turn the clock backwards and to deck out the bower of Shelley's 'Sensitive Plant' with all the symbols of a faith which threatened to slide away from him; why he endeavoured to imbue his lilies with the aroma of Lebanon, Nazareth, the annunciation, and the immaculate conception, and why he dressed his lady love in a nun's weeds, and thrust a passion flower in her hand.

It was not only Ruskin who longed for a natural theology of a more this-worldly and scientific kind, for a garden of nature nurtured only by *truth*. The 1840s saw an explosion of interest in natural history, across the religious divides. And Charles Collins's *Convent Thoughts* – with its enclosed garden, its water lilies and its goldfish – certainly has as much to do with Victorian gardening practices as with devout symbolism.

The Victorian world was in the process of transforming the ancient *hortus conclusus* for a modern age. Joseph Paxton's Great Conservatory, built in the late 1830s for the Duke of Devonshire – 'a fairy-tale garden planted in the most excellent taste' – attracted 50,000 visitors every year. The natural history craze brought with it its own institutions, temples, priests and texts. In 1841, the Botanic Garden at Kew was handed over from the Crown to the state, and the first Director, Sir William Hooker, opened a Department of Economic Botany, museums, a Herbarium and a library. John Lindley, Professor

of Botany at University College, London, and author of *Ladies' Botany*, explained: 'The power and wisdom of the Deity are proclaimed by no part of Creation in more impressive language than by the humblest weed that we tread beneath our feet.'[1] The love of flowers was, he said, 'a holy feeling'. Kew, adorned with such features as Decimus Burton's great Palm House, built between 1844 and 1848, became almost a centre of pilgrimage for those who wanted to experience the botanical 'holy feeling'.

For a time, natural theology and natural history remained synonymous. The seven ladies of the Clifford family at Frampton-on-Severn and at Stinchcombe in Gloucestershire who drew 200 local wild flowers known as *The Frampton Flora* were certainly exceptional in the quality of their work, but many men, and especially women, spent much of their spare time gathering wild flowers in the woods which they later painted or pressed.

We need not doubt that the Frampton sisters believed that every plant in creation had a God-given use which benefited man. Those that could not be eaten, or used for medicinal purposes, could be enjoyed for their beauty and the morals they imparted: 'Consider the lilies of the field . . .'

A vast literature, at every level of sophistication, arose for those who wanted to learn how nature, rightly seen, had a religious and moral tale to tell. Louisa Anne Twamley, later Mrs Meredith, was one of many who wrote soppy but successful books like *Flora's Gems* (1836), and *The Romance of Nature* (1837), in which she declared: 'I love flowers as forming one of the sweetest lines in the GOD-WRITTEN Poetry of Nature.'[2]

Of course, it was not just a matter of flowers. Others, like Ruskin, collected fossils and minerals. And, in the mid century, many more became addicted to combing beaches and probing rockpools for sea creatures. The spiritual message of such pursuits was similar. In *Glaucus, or the Wonders of the Shore* (1855), perhaps the masterpiece of the Victorian popular natural history-theology genre, Charles Kingsley explained: 'the naturalist acknowledges the finger-mark of God, and wonders, and worships'.[3]

And so, at just the moment when Collins was painting his nun in an enclosed garden, the craze for Wardian cases, enclosed glass cases in which ferns and other plants were grown in what, today, we would call a 'micro-environment', was reaching its peak.[4] Ward first invented his thoroughly modern and miniature version of the enclosed garden

in 1833, when he successfully planted mosses and ferns in a stoppered jar. He noticed that if the air was changed just occasionally, such environments appeared infinitely self-sustaining. The technique was extensively used by the growing army of plant and flower collectors who scoured the world for specimens: they found it greatly assisted in the transportation of living plants from one environment to another. But the keeping of Wardian cases in the home became enormously fashionable in the 1840s, and was given a further boost when Ward's original jar was shown – eighteen years on, with no water added – at the Great Exhibition of 1851. Wardian cases were made in imitation of everything from Gothic cathedrals to the Crystal Palace. Kingsley, a Christian Socialist, emphasised how they were much better for young ladies than 'fancy work' or 'dreamy idleness'.[5]

Ward had, in fact, experimented with the keeping of animals in enclosed plant cases as early as the 1840s. But it was not until 1850, when Robert Warington set up the first twelve-gallon container of fishes, snails and plants, that the aquarium vogue began to take off. Warington saw his tank as a sort of microcosm of nature itself. He believed it would be indefinitely self-sustaining.[6] Within a couple of years, no self-respecting middle class home was without one. The vogue for aquaria, public and private, was given a further impetus by Philip Henry Gosse. In 1853, Gosse set up the aquarium at the London Zoo, and the following year published the enormously successful *The Aquarium*, to tell everyone how to do it at home. Gosse saw every organism as revelatory of God's 'mighty plan'.

Even the oddest of organisms, for Gosse, could be seen in this way. For example, the rare bladder seaweed, *Cystoseira Ericoides*, showed none of its virtues when taken out of the water: 'But the moment the plant is submerged all its glory returns: the pale olive branches become invested with a most brilliant flush of iridescent light blue, not changeable in tint, though varying in intensity according to the play of light that falls upon it.' Thus, Gosse went on, 'it may be compared to some Christians, who are dull and profitless in prosperity, but whose graces shine out gloriously when they are plunged into the deep floods of affliction.'[7]

Gosse was a Plymouth Brother, and the ethical symbolic order he found in nature is remote from the high sacramentalism of the Tractarians. Though he, a Biblical literalist, would have been appalled at the idea, his attempts to draw human morals from plants and animals have something in common with those shifts which led from

the sacramental to the secular view of nature. Certainly, the 'moral', for many who set up Wardian cases and Warington tanks, was different from that which Gosse would have liked them to draw. For the self-containment of these enclosed environments suggested a world in which growth, propagation and development occurred without any outside, or 'Divine' intervention . . . They implied a view of nature more like Chambers's than Sedgwick's.

We can trace this process of desacralisation through the Victorian cult of the water lily. In 1851, when Collins's picture, filled with its ambivalently spiritual and vegetable lilies, was shown at the Royal Academy, W. J. Hooker published *Victoria Regia, or illustrations of the Royal Water Lily*. This lavish and sumptuously illustrated volume was Kew's attempt to stake a claim in the extraordinary rivalries which had arisen among botanists concerning the sighting, naming and propagating of the giant water lily, now known as *Victoria Amazonica*, but described in the mid nineteenth century as *Victoria Regia*, so as not to upset the sensibilities of the Queen. (It had originally been intended that the word *Amazonica* should refer to the river.)

The giant water lily was first sighted in the early 1840s. Innumerable attempts were made to transport roots or seeds, once even in sealed Wardian cases; but it was not until 1849 that any live seeds reached Kew. Hooker gave one of the plants thus propagated to the Duke of Northumberland at Syon, and the other to the Duke of Devonshire, for whom Joseph Paxton built a special water lily house at Chatsworth. A race then ensued as to who might get a lily to flower first. All this aroused great public attention, and led to the digging of innumerable garden ponds, and a fad for water lilies of all kinds. It also gave rise to an aesthetic craze, and a style of 'water lily' glass and ironware which was abundantly represented among the over-ornate objects at the Great Exhibition itself. Paxton was the first to induce the great lily to bloom. He hoped that, after the Great Exhibition, the Crystal Palace would be converted into a permanent greenhouse, a mechanical *hortus conclusus* for the modern world. In fact, this did not happen, although in 1852 Richard Turner (who had been associated with Decimus Burton in the building of the Palm House) designed the magnificent little Tropical Waterlily House at Kew.

Now it is true that the first discoverer of the giant water lily, H. W. Bates, had fallen on his knees when he saw the flower in the jungles of South America, and expressed aloud 'his sense of the power and magnificence of the creator and all his works'.[8] Even so, it is clear

that the role the giant water lily played in Victorian life had little to do with natural theology. Its symbolism was of a more secular kind. The closest it came to the Virgin Queen of Heaven was *Victoria Regia* . . . and perhaps the Amazons. The water lily style symbolised not the purity of the lily among thorns, but brute competition, between men and in the market place. It was epitomised by those vulgar luxuries which Ruskin so despised.

Nor was it just the water lilies. The opening up of the globe that followed in the wake of Victorian imperial ambitions quickly made some botanists uncomfortably aware that, in fact, the floral world did not even remotely resemble a garden made by God for man. The problem of predatory animals, which so exercised William Buckland and undermined the orthodoxy of his faith, found its equivalent in the vegetable kingdom with the discovery of insectivorous and poisonous plants. 'I do not think we have a right to call any of the works of the Creator nasty,' wrote Charlotte Yonge. 'I am sure we should not if we once looked well into them.'[9] But she hardly sounded convinced.

This desacralisation of the flowers was confirmed by the realisation that beautiful blooms and blossoms had not, as Paley had assumed, been placed there by God to gratify the aesthetic senses of men and women, but rather to attract insects for the processes of reproduction. Even to Phoebe Lankester, wife of Edwin, a professor of Botany, there was something disturbing about what she described, quoting poetry, as the true object for which 'The water-lily to the light/Her chalice rears of silver white.' She tried to swing the whole process back into natural theology. Of the bees, she said: 'We must not consider these little creatures as merely selfish seekers of their own gratification.' They, she explained, 'in common with the whole creation . . . carry out the designs of the Great Architect of all.'[10] But the world of flowers seemed reduced from the realm of beauty and spirit to that of sensuality. In later life, when he realised that knowledge of science would *not* lead men and women to God, Ruskin begged the 'gentle and happy scholar of flowers' to have nothing to do with the 'obscene processes and prurient apparitions' of the secular biologists.[11] To us, such sentiments sound absurd: but Ruskin was drawing attention to the fact that the advance of one way of looking at nature had meant the loss of another. Behind his prudery lay another and deeper fear – that of the loss of enchantment of the world. If even the flowers of the field were functional, then nothing sacred remained in the world of nature.

Of all buildings, Ruskin hated the Crystal Palace, for its empty novelty. He thought Paxton's mechanical glitter was as pernicious as that which had tempted Pugin. Of the Crystal Palace he wrote: 'There is assuredly as much ingenuity required to build a screw frigate, or a tubular bridge, as a hall of glass; – all these are works characteristic of the age; and all, in their several ways, deserve our highest admiration; but not admiration of the kind that is rendered to poetry or to art.'[12] And yet he knew that, in designing the Palace, Paxton had borrowed the giant water lily leaf's structure of longitudinal and transverse supports to give strength. Perhaps this suggested to Ruskin that the leaf structures he so greatly admired were born of nothing more than functional necessity.

8
The Scapegoat

Only a year after Ruskin had dissected the water plantain, he had admitted in a letter to his father that he was having doubts 'something more seriously than usual . . . respecting God's government of this world'. He confessed that the more he investigated the Bible, 'the more difficulties I find, and the less ground of belief'.[1] By 1851, those 'difficulties' had become acute. That year, he wrote to his friend, Henry Acland:

You speak of the Flimsiness of your own faith. Mine, which was never strong, is being beaten into mere gold leaf, and flutters in weak rags from the letter of its old forms; but the only letters it can hold by at all are the old Evangelical formulae. If only the Geologists would let me alone, I could do very well, but those dreadful Hammers! I hear the clink of them at the end of every cadence of the Bible verses – and on the other side, these unhappy, blinking Puseyisms; men trying to do right and losing their very humanity.[2]

By the middle of the century, the very urgency with which it was asserted that every organism in nature symbolised (or, in Ruskin's book, literally revealed) God could be correlated with the dawning realisation that it did not. In some much-quoted stanzas from *In Memoriam*, Tennyson vividly described the shift to a view of nature as violent and competitive. 'Are God and Nature then at strife,/That nature lends such evil dreams?' The poet evoked an image of nature crying from 'scarped cliff and quarried stone', '"a thousand types are gone:/I care for nothing, all shall go . . ."'[3]

Ruskin had first glimpsed an alien, even diabolic, natural world when he saw those 'strings and eels' in the sky at Oxford. The image of nature in his work was to become not so much that of a *hortus conclusus* fashioned by a Divine hand as of a poisoned wilderness, a wasteland, of thistles, thorns and distressed ground. Even the lilies had become 'red in tooth and claw'. Soon after he had written to *The Times* on behalf of the Pre-Raphaelites, he published a pamphlet called 'Pre-Raphaelitism', in which he wrote:

The man who has gone, hammer in hand, over the surface of a romantic country, feels no longer in the mountain ranges he has so laboriously explored, the sublimity or mystery with which they were veiled when he first beheld them, and with which they are adorned in the mind of the passing traveller.[4]

Ruskin complained bitterly that 'where the unlearned spectator would be touched by strong emotion by the aspect of the snowy summits which rise in the distance', the geologically minded man 'sees only the culminating points of a metamorphic formation, with an uncomfortable web of fan-like forms of fissures radiating, in his imagination, through their centres.'[5] Perhaps Paxton was right, and the radiating fan-like forms of mountains, and water plants, had nothing to do with God's signature? In the pamphlet, Ruskin hastened to add that objective scientific knowledge, of course, led to new and ever deeper insights into 'the unity of purpose and everlastingly consistent providence of the Maker of all things' – whatever it might do for emotional life. But, he admitted, 'the sense of loss' was none the less great, for all that.[6]

During the 1850s, cultural life in Britain changed: it started to become, in Ruskin's sense, 'intensely and peculiarly Modernist'. Every aspect of human endeavour seemed to be stamped by what Ruskin called denial of Christ.

* * *

In 1854, Holman Hunt sent *The Light of the World*, his famous painting of Christ knocking at the door, to the Royal Academy Summer Exhibition. Carlyle had condemned the painting as 'Papistical', but on the whole, Catholics did not like it; its iconography was Protestant. The painting evoked controversy; Ruskin again took it upon himself to write to *The Times* in defence. He interpreted the symbolism, but ended by praising Hunt's 'true work', the way in which he represented 'all objects exactly as they would appear in nature'.[7] But did this 'truth' intertwine with the 'truth' of the scriptures? Hunt, whose faith was, if anything, less firmly grounded than Ruskin's, was beginning to doubt it. In any event, he left impetuously for the Holy Land; he seems to have believed that, if not in the fallen world of the English countryside, at least on the sacred soil itself he might find evidences of his Redeemer.

Hunt's friends had tried to persuade him not to go. The Crimean War was being waged over, among other things, a dispute concerning the privileges of Catholic and Orthodox monks at the holy places in

Palestine. But Hunt was nothing if not obstinate. And so he found himself on the shores of the Dead Sea, at Oosdoom, traditionally the site of Sodom, and scene of one of God's most terrible acts of destruction: 'It is black,' he wrote in his diary, 'full of asphalte scum – and in the hand slimy, and smarting as a sting – No one can stand here and say that it is not accursed of God . . .'[8]

There, disrupted by attacks by armed local tribesmen and sedition among his own retinue, Hunt worked at what, when completed, was to be his most disturbing painting, *The Scapegoat*. This desolate picture shows a goat standing in the derelict wasteland of the Dead Sea, surrounded by saline encrustrations, skulls, and bleached camel bones. In an earlier study, Hunt included a rainbow – the sign of God's covenant with man that the flood would not occur again. In the last issue of the Pre-Raphaelite magazine *The Germ*, in 1850, John Orchard makes his principal character, Christian, argue that natural phenomena, like the rainbow, are only beautiful because they 'have a spiritual as well as a physical voice'. Christian continues: 'Lovely as it is, it is not the arch of colours that glows in the heavens of our hearts; what does, is in the inner and invisible sense for which it was set up of old by God, and of which its many-hued form is only the outward and visible sign.'[9] But in the final version of Hunt's picture, the rainbow has been removed – as if Hunt could see no reason to leave any hint of redemption in the landscape itself . . . except, that is, the sprig of meticulously painted olive leaves which pokes into the painting, like an awkward intruder, in the left-hand foreground.

On the journey back from the Dead Sea the goat dropped dead and Hunt had to acquire another to finish his painting. He had brought specimens of salt and mud with him from Oosdoom, so he was able to stand the new goat in a large trayful for realism's sake. Needless to say, the picture is redolent with Biblical types and symbols. The goat represents one of the sacrificial animals which were offered up by the Jews on the Day of Atonement for the annual expiation of sins. Hunt had read a description of these rituals in Leviticus 16, where it is laid down that one goat should be sacrificed in the temple, whereas the other 'shall be presented alive before the Lord, to make an atonement with him and to let him go for a scapegoat into the wilderness . . . And the goat shall bear upon him all their iniquities unto a land not inhabited.'[10] The goat's skull in the background of Hunt's picture is perhaps a reminder of the animal which had already died.[11]

As Hunt knew from his Biblical commentaries, according to the Talmud a fillet of scarlet was attached to the goat's brow – and the priests retained a fragment of it. If their fragment turned white, then they knew that the propitiation had been accepted. As Isaiah put it, 'Though your sins be as scarlet, they shall be as wool.' The scapegoat was widely interpreted as a type of the Saviour, the Vicarious Sacrifice, who died to take away the sins of the world. For Hunt, the anti-type (or that which was predicted by the type) of the red fillet was the crown of thorns – but, even before the painting was shown 'on the line' at the Royal Academy in 1856, Hunt worried about the fact that without that fillet there was nothing immediately to connect his goat either with Jewish or with Christian myths.[12]

And this concerned most of the critics too. Hunt's elaborate references to Judaic rituals and the myths of Christian redemption seemed to them to have been lost in unrelenting naturalism. As a writer in The Times put it, 'Were it not for the title annexed it would be rather difficult to divine the nature of the subject.'[13] According to the Athenaeum, Hunt had painted 'a dying goat which as a mere goat has no more interest for us than the sheep which furnished our yesterday's dinner'.[14] The Art Journal wrote that there was nothing 'allusive to the ceremony of the Atonement, save the fillet of wool on the goat's horns . . . Had the picture been exhibited as affording a specimen of a certain kind of goat from the hair of which the Edomites manufactured a very superb shawl fabric, there is nothing to gainsay this.'[15] Modern criticism remains divided about the merits of Hunt's picture: even so, it has at least tended to concur with the judgement of Hunt's contemporaries about the intractable weight of his 'naturalism'. As George Landow, the expert on Hunt's typology, has put it, in this picture 'Hunt's naturalism has distracted us from his deeper meaning, rather than led us to it.'[16]

Hunt had been to the Holy Land and had scrutinised nature with unrelenting truthfulness: but he had come back not with a 'type' of the Saviour, but rather only with an image of a dying goat, in a lifeless wilderness. This was not, however, Ruskin's view. Ruskin agreed with the general consensus that The Scapegoat was not pictorially successful. But he gave very different reasons for this failure.

In his Academy Notes, Ruskin argued that the picture, 'regarded merely as a landscape, or as a composition,' was 'a total failure'. He was not greatly surprised by this because, he wrote, 'the forms of large distant landscapes are a quite new study for the Pre-Raphaelites, and

they cannot be expected to conquer them at first.' However, Ruskin went on to say that the mind of the artist had been so excited by the circumstances of the scene that, 'like a youth expressing his earnest feeling by feeble verse . . . Mr Hunt has been blinded by his intense sentiment to the real weaknesses of the pictorial expression; and in his earnest desire to paint the Scapegoat, has forgotten to ask himself first, whether he could paint a goat at all.' Ruskin complained that, as a result, there was 'no good hair painting, nor hoof painting' in the picture.[17]

Whatever the validity of Ruskin's reservations, they should provide a caution to those who have suggested that Hunt's typological realism was simply applied Ruskinism, even though that was indeed Hunt's own view of the matter. 'All that the Preraphaelite Brotherhood had of Ruskinism,' he once wrote, 'came from this reading of mine.' We have seen how what particularly attracted Hunt to Ruskin's writing was his detailed analysis of the typological symbolism in Tintoretto's painting of *The Annunciation*. Yet this kind of literary typology was not what was dearest to Ruskin's heart; there is a telling passage in Hunt's account of his 1869 meeting with Ruskin in Venice in which he notes that, even when they looked at the Tintorettos, Ruskin's interest 'was in the aesthetic qualities of the works alone'.[18]

In part this was because Ruskin was, at that time, in a state of unbelief. And yet he had always yearned for an aesthetic rooted rather in the typical beauty of natural forms. And so, even as early as 1856, when he saw *The Scapegoat*, he argued that if only Hunt had paid *more* attention to form and *less* to his pursuit of Biblical types, his painting would have had a greater chance of success. In other words, his response to *The Scapegoat* was consistent with his response to *Convent Thoughts*, but this time around, the argument itself sounded *less* convincing.

For how was poor Hunt supposed to have gone about that sound 'hoof and hair' painting? How could paint be rendered *more* goat-like, without a descent into mundane naturalism? And if Hunt had pressed his picture more, say, towards the condition of photography, would Ruskin then have approved it? There is every reason to doubt it.

When Hunt conceived of painting *The Scapegoat*, he thought about giving the idea to the great Victorian animal painter Edwin Landseer, but eventually decided to execute it himself. Ruskin had once been an admirer of Landseer's work; one of the most famous passages in *Modern Painters* Volume One is his eulogy over Landseer's painting

The Old Shepherd's Chief-Mourner, which shows a sheepdog standing guard beside its master's coffin. Ruskin proclaimed this painting as 'a work of high art' which stamped its author 'not as the neat imitator of the texture of a skin, or the fold of a drapery, but as the Man of Mind'.[19]

Later, Ruskin's attitude towards Landseer cooled. In 1851, the year Ruskin first wrote to *The Times* about the Pre-Raphaelites, one of the most popular paintings at the Royal Academy was Landseer's *The Monarch of the Glen*, his famous portrait of a stag in Scottish mountain scenery. Landseer intended this work to be more than a mere sporting picture. His concerns were more complex than they appear. For example, his obsession with cruelty was not simply a psychological aberration, but may – like Stubbs's fascination with predation or Buckland's zoophagy – also have had much to do with a shift from a beneficent view of nature to a vision of it as 'red in tooth and claw'. Although Landseer depicted his stag with an unflinching attention to detail – even down to the shimmering mucus around its nose – we cannot rule out a grander desire to reconcile a Christian with a 'modern' sense of the natural order. Landseer certainly appears to have wanted to portray the creature as the Lord of its Domain, a conquering son who must yet be sacrificed, a Christ in Glory, or a scapegoat.

But, in Landseer, these references are irrevocably secularised: Landseer's iconography was in the process of becoming anthropomorphic and psychological rather than religious. Surprisingly, from our point of view, Ruskin interpreted this as a slide towards naturalism; he criticised Landseer for what seemed to him a growing interest in animal psychology for its own sake. He did not comment upon *The Monarch of the Glen* at all. In *Modern Painters* Volume Two, he had already written critically of Landseer's depictions of dogs. In Landseer's pictures, Ruskin now argued, 'the outward texture is wrought out with exquisite dexterity of handling, and minute attention to all the accidents of curl and gloss which can give appearance of reality.' But, he complained, 'This is realism at the expense of ideality; it is treatment essentially unimaginative.' He concluded, 'Mr Landseer is much more a natural historian than a painter.'[20]

The difficulty of being true, simultaneously, to higher spiritual values (especially Biblical values) and to nature itself was as much a problem for Ruskin as for Hunt (or Landseer). By the mid 1850s, Ruskin's hope for a new aesthetic, rooted in the spiritual revelations

of the new science, was disintegrating. Ruskin responded by accusing *this* artist of insufficient naturalism, *that* artist of insufficient spirituality. But the real problem lay in the fact that the possibility of an aesthetic grounded in the perfect and truthful fusion of the two had slipped away: the gap between *theoria* and *aesthesis* was getting wider and wider.

9
Our Fathers Have Told Us

This widening dissociation between spirit and matter fuelled Ruskin's psychological problems and led to the delay of *Modern Painters* Volume Three and Volume Four, which were both published in 1856, a full decade after the appearance of Volume Two. In the former, Ruskin plays on the fact that 'nearly all our powerful men in this age of the world are unbelievers'. He comments on how this makes most men and women, 'full of contradiction': 'we are first dull, and seek for wild and lonely places because we have no heart for the garden; and presently we recover our spirits, and build an assembly-room among the mountains, because we have no reverence for the desert.'[1] But Volume Three is itself one of the most contradictory books he wrote.

Some of its themes are familiar enough. For example, he insists again on Turner's scientific attention to detail. Forgetting his first youthful letter in the painter's defence, he writes: '*I* never said that Turner was vague or visionary. What *I* said was, that nobody had ever drawn so well: that nobody was so certain, so *un*-visionary; that nobody had ever given so many hard and downright facts.'[2]

But he now feels it necessary to answer criticisms that 'the love of nature' manifest in Turner, or the Pre-Raphaelites, is 'necessarily connected with the faithlessness of the age'. Rather, he says, it will 'for the first time in man's history . . . reveal to him the true nature of his life, the true field for his energies, and the true relations between him and his Maker.'[3] The one who loves nature most will '*always* be found to have more *faith in God* than the other'.

For example, he analyses the painting of details in medieval pictures, and argues that these painters thoroughly understood 'the central type of all leaves'. They saw:

. . . that a leaf might always be considered as a sudden expansion of the stem that bore it; an uncontrollable expression of delight, on the part of the twig, that spring had come, shown in a fountain-like expiation of its tender green

heart into the air. They saw that in this violent proclamation of its delight and liberty, whereas the twig had, until that moment, a disposition only to grow quietly forwards, it expressed its satisfaction and extreme pleasure in sunshine by springing out to right and left.[4]

He then says that this basic type of leaf was 'modified . . . in a thousand ways by the life of the plant'.[5] He finds it not only in horse-chestnuts and elms, but also, of course, in *Alisma Plantago*, which 'instead of springing out in twigs' expands 'in soft currents, as the liberated stream does at its mouth into the ocean'.[6] This typical form, which, he remarks again, was also common to mountain ranges, had rightly been made the basis of thirteenth century foliate ornament. But was it, as he had once believed, a sign of the finger of God?

Other passages reveal that Ruskin himself is no longer certain. And he is even less certain that this is the sort of knowledge which might be attained through the pursuit of science. Natural science, Ruskin says, 'has hardened the faithlessness of the dull and proud', but 'shown new grounds for reverence to hearts which were thoughtful and humble'. Indeed, he criticises 'the chief narrowness of Wordsworth's mind', that he could 'not understand that to break a rock with a hammer in search of crystal may sometimes be an act not disgraceful to human nature, and that to dissect a flower may sometimes be as proper as to dream over it.' All experience goes to teach that 'the most useful members of society are the dissectors, not the dreamers.'[7] And yet later on these useful dissectors are roundly castigated.

Ruskin again had Buckland and the utilitarians in mind when he launched into a polemic against the pursuit of 'mere material uses', the packing of clouds into cylinders of iron, and the getting of weavable fibres out of mosses, rather than watching them grow. Technology, if not science, is *contrary* to the apprehension of God's revelation of Himself either in the scriptures or his second book, nature. In Job, and the Sermon on the Mount, 'There is no dissection of muscles or counting of elements . . . There is no science, or hint of science; no counting of petals, nor display of provision for sustenance; nothing but the expression of sympathy, at once the most childish, and the most profound – "They toil not".'[8]

An 'ignorant enjoyment', Ruskin ends up arguing, is better than an informed one: 'We cannot fathom the mystery of a single flower, nor is it intended that we should; but the pursuit of science should constantly be stayed by the love of beauty, and accuracy of knowledge

by tenderness of emotion.' There was, Ruskin insisted, 'a science of the aspects of things, as well as of their nature'.[9]

* * *

Volume Four contains a more explicit repudiation of the teachings of both the English and Scottish geologists – and a remarkable regression to Evangelical Biblical literalism. Ruskin now writes that the first chapter of Genesis 'is in every respect clear and intelligible to the simplest reader, except in the statement of the work of the second day'. Attacking the idea of a remote Deity, as put forward by Chambers, Ruskin affirms 'the immediate presence of the Deity and His purpose of manifesting Himself as near us whenever the storm-cloud stoops upon its course.'[10] He warns that a little knowledge can all too easily lead to Atheism, and claims that he wants 'to receive God's account of His own creation as under the ordinary limits of human knowledge and imagination it would be received by a simple-minded man'.[11] He then rejects all idea of interpretation of the Biblical term 'Heavens' as being intended to signify 'the infinity of space inhabited by countless worlds' – a reference to Buckland's later theories. Taking as an example the text 'He bowed the heavens also, and came down; He made darkness pavilions round about Him, dark waters, and thick clouds of the skies,' Ruskin argues that in such passages 'the meaning is unmistakable'. Either the phrase 'He bowed the heavens' means what it says, or it has no meaning at all. He now prefers to accept it as 'pure, plain, and accurate truth'.[12]

He then says that the Bible describes physical acts of creation as they occurred. He refers to the phrase, found in Genesis and in the Psalms: 'His hands prepared the dry land.' Up to that moment, 'the earth had been *void*, for it had been *without form*.' The command was that it should be '*sculptured*'.[13] Thus the first dry land appeared 'in range beyond range of swelling hill and iron rock'.[14] And, as we read the mighty sentence, 'Let the dry land appear,' Ruskin insists:

. . . we should try to follow the finger of God, as it engraved upon the stone tables of the earth the letters and the law of its everlasting form; as, gulf by gulf, the channels of the deep were ploughed; and cape by cape, the lines were traced, with Divine foreknowledge, of the shores that were to limit the nations; and, chain by chain, the mountain walls were lengthened forth, and their foundations fastened for ever; and the compass was set upon the face of the depth, and the fields, and the highest part of the dust of the world were made; and the right hand of Christ first strewed the snow on Lebanon, and smoothed the slopes of Calvary.[15]

And so he comes to conceive of the Alps as a 'great plain, with its infinite treasures of natural beauty and human life, gathered up in God's hands from one edge of the horizon to the other, like a woven garment; and shaken into deep falling folds, as the robes droop from a king's shoulders'.[16]

But there are, Ruskin admits, still problems. He ponders upon how it appears that a torrent (rather than God) has dug its bed a thousand feet into the mountainside. The real question, he suggests, is: 'In what form was the mountain originally raised which gave that torrent its track and power?' He seems unconvinced by his own argument. 'Is this,' he asks, 'the earth's prime into which we are born; or is it, with all its beauty, only the wreck of Paradise?' He then launches into an attack on the gradualists, like Lyell and the Edinburgh geologists, who had argued that the beauty of the mountains was a product of 'destruction and renovation . . . continually proceeding'.[17]

While admitting that questions concerning the effects of development were continually suggesting themselves, and denying that it was possible to give a complete answer to them, he concluded:

For a certain distance, the past work of existing forces can be traced; but there gradually the mist gathers, and the footsteps of more gigantic agencies are traceable in the darkness; and still, as we endeavour to penetrate farther and farther into departed time, the thunder of the Almighty power sounds louder and louder; and the clouds gather broader and more fearfully, until at last the Sinai of the world is seen altogether upon a smoke, and the fence of its foot is reached, which none can break through.[18]

Thus did the finger of God reduce itself to the sound of distant thunder, and his types disappear in the impenetrable smoke which wreathed a Biblical mountain.

＊　　　＊　　　＊

The pursuit of the 'spiritual' and the 'natural' were getting farther and farther apart. Ruskin was struggling in some desperation to hold them together. We know of one painting, at least, which was produced under the direct influence of these new volumes of Modern Painters. John Brett read Volume Four soon after it was published in April 1856, and then left for Switzerland where he painted The Glacier of Rosenlaui, with a Ruskinian attention to detail. In the centre foreground of his picture is a rock of granite, with, lying behind it, a boulder of smooth and sculpted gneiss. The glacier steals up behind them, and in the distance rises a mountain swathed in clouds and mist.

Much has been written about this remarkable painting.[19] Most of it has suggested that here Brett reduced Ruskinism to the depiction of geological specimens, without moral or religious intent. But this may be because we misunderstand the import of what is shown; for Brett has illustrated the vexing subject of the erratic distribution of boulders, of very different geological kinds, which, we remember, both Ruskin and Buckland had at first assumed to be a strong point in favour of a 'scientific' diluvial geology. The disagreement of Buckland's colleagues heralded the end of the pursuit of the Biblical-historical synthesis within the English School. Glaciation theory passed out of fashion; Buckland 'progressed' to more practical problems.

One man, however, carried on studying the dynamics of the movement of ice and glaciers – J. D. Forbes, a professor of Natural Philosophy from Edinburgh. Ruskin had met Forbes in 1844, and promptly developed an obsession with his theories. The study of glaciation appeared to Ruskin to imply an affirmation of that scientific natural theology which his old teachers were in the process of abandoning.

By 1856, the subject was anachronistic – not least because it tended to be associated with the increasingly untenable attempts to contain the evidence of science within that of Biblical geology. But we need not marvel at the fact that *Modern Painters* Volume Four has much to say of the movement of glaciers. Nor that this is the subject which Brett chose to paint, with such unswerving insistence on 'truth', after reading the book. For the chance placement of a gneiss and granite boulder still seemed to Ruskin, at least, to suggest how a geology of change and development might be 'read' as evidence of Divine activity in nature.

<p style="text-align:center">* * *</p>

By 1856, the year that William Buckland died, Ruskin published *Modern Painters* Volumes Three and Four, Brett rushed out to Switzerland, and *The Scapegoat* was hung 'on the line' at the Royal Academy, attempts at a historical synthesis of geological and Biblical knowledge had long since lost credibility among the scientific community. In 1857 Philip Gosse, a member of the Plymouth Brethren, published *Omphalos, or an Attempt to untie the geological knot*. It was perhaps the last informed attempt in that direction – and it came not from the centre, the Broad Church, but rather from the Evangelical fringe, and in this respect had something in common with the arguments of Buckland's early evangelical critics like Bugg.

Gosse based his case on the fact that, in order to exist at all, an organism inevitably contains evidences of its own history; and this must equally have applied to *created* organisms – even though, of course, they had not in fact been through such a history. Gosse refers to the example of the calcareous test, or plated shell-case, of the echinoderm, or sea-urchin. Each plate is comprised of an accreting deposit of calcium, which can be seen to have been laid down evenly in every part of the creature, throughout its life. Gosse reasoned that, even at the moment of their creation, organisms must have embodied similar traces of a history they did not have: after all, there was no evidence that God had created Adam without a navel. Animals, trees and rocks must all similarly have contained traces of an 'invented' past. Do we imagine that a newly created sea-urchin would show no signs of calcium accretion? Or that a newly created oak would contain no rings? And so we should expect *created* rocks to contain fossils and other signs of a history *apparently* reaching back beyond the moment of creation. Gosse suggested that God included fossils in the rocks to test man's faith.

Gosse felt certain that his arguments would find acceptance; and they do, indeed, possess an ingenious (if irrefutable) logic. His book is not as foolish as is sometimes suggested: as Gregory Bateson has observed, Gosse was on to something important about the way in which an organism contained its own time, something which escaped the linear biological chronologies of evolutionary thinkers.[20] Even so, his whole way of thinking read like special pleading. Gosse was pilloried – even by those who shared his faith. *Omphalos* marks the end of a relatively short-lived tradition of scientific natural theology – upon which Ruskin's aesthetics had depended.

10
The Elements of Drawing

In 1856, Ruskin wrote *The Elements of Drawing*, based on his teaching at the Working Men's College. He declared:

Go out into your garden, or into the road, and pick up the first round or oval stone you can find, not very white, not very dark; and the smoother it is the better, only it must not shine. Draw your table near the window, and put the stone . . . on a piece of not very white paper, on the table in front of you. Sit so that the light may come from your left, else the shadow of the pencil point interferes with your sight of your work.[1]

Many things, he said, could not be drawn at all — for example, sea foam. Only the idea of them could be suggested, 'but if you can draw the stone *rightly*, everything within reach of art is also within yours.'[2]

Now few have seen it as even worthy of mention that the stone which Ruskin drew to illustrate this was not *any* round or oval stone, but was rather a fossilised sea-urchin test. Nor does he himself comment on this. He has been much praised by recent commentators for the 'practical' tone of *The Elements*, and for his refusal to engage in speculation or preaching; this book is certainly closer than most he wrote to secular naturalism. But such empiricism, unilluminated by the palpitating presence of the spiritual, was to become the bane of English drawing.

Nor was Ruskin's advocacy of a worldly brand of 'truth' in art associated with any efflorescence of his own draughtsmanship; rather, with the dimming of his belief in the spirituality of nature, art almost seems to have become redundant for him. In 1857 Ruskin sorted out Turner's mildewed drawings in the basement of the National Gallery. This task left him slumped in one of his periodic sexual, spiritual and intellectual upheavals. The following year he left, on his own, for a holiday in Switzerland and Italy, where he wanted to identify and draw the exact spots Turner had painted and the 'modifications' Turner had made to what was before his eyes. But in letters to his father, Ruskin confessed that his drawing was not going well.

In July, Ruskin wrote from Isola Bella, and described a mountain chapel where he went every evening to draw the garden, 'and the white lily growing on a rock in the midst of it . . . and the deep purple mountains encompassing it'.[3] But he admitted he was 'frightfully & hopelessly beaten'. In part, he blamed the priest for cutting the white lily 'to present to the Madonna one festa day – not knowing that it was just the heart of my subject.' But he also knew he could not draw because of changes within himself – and that this time dissection of a plant was not going to help him. The previous four years had, he wrote, completed a change which had begun a decade before; he could now even sympathise with his father's indifference to mountains. Even Hospenthal and St Gothard – 'snow, gentians, and all' – seemed 'melancholy & even "dull"'. He wrote that he had 'nearly given up climbing the hills', finding 'the sweetest views are from the turnpike road'. But the 'climax of all conceivable change' was that he was looking forward to leaving the mountains, and going down to 'see the palace' at Turin.[4]

There he underwent his 'unconversion', remarked before, and an awakening to 'splendour, and lordly human life', epitomised in the sensual painting of Veronese, which convinced him 'that things done delightfully and rightly were always done by the help, and in the Spirit, of God'.[5] Even when he advocated 'magnificent Animality', Ruskin wanted to link this with spiritual affirmation; but this became increasingly difficult to sustain. That same year he wrote to his friend Charles Norton: 'To be a first-rate painter – you mustn't be pious, but rather a little wicked and entirely a man of the world.' *Theoria* was collapsing into *aesthesis* . . . behind which lay an engulfing abyss of meaninglessness. From Turin, he wrote about an abandoned palace on a hill, surrounded by a 'labyrinthine garden' with fountains, all left 'in utter loneliness and decay'. He described it as 'like a lesson of the passing away of all things founded on the pursuit of mere pleasure'.[6] The *hortus conclusus* had become a forsaken garden.

* * *

Nor was this just Ruskin's problem. William Dyce had briefly converted to Pre-Raphaelitism from a German-Nazarene inspired aesthetic. But in the late 1850s Dyce's painting began to show an irreconcilable division between the 'spiritual' and the natural. Dyce created a hieratic and iconic fresco, *The Holy Trinity and Saints*, for Butterfield's All Saints' Church in Margaret Street; no picture could

have been more explicitly 'religious', or less 'Pre-Raphaelite'. But at the same time that he was working on this fresco, Dyce painted *Pegwell Bay: A Recollection of October 5th, 1858*, a picture which reveals why he now felt that the study of nature had so little to teach about God's revelation of himself.

The landscape of Pegwell Bay, with its chalk cliffs and abundance of fossils, intrigued Dyce. His painting shows a group of women and children hunting for specimens on the seashore; but he does not ask us to believe that they are tracing the finger-marks of God in his second book. The sky is an ominous grey. The dull cliffs lower. Each individual depicted in the painting seems insulated within her own space. None is looking at another. Over the heads of all of them passes the comet, symbol of impending doom and disaster. (Donati's comet, first identified in June 1858, was at its brightest on the date in the title.) Even before Dyce had completed the picture Darwin had published his *Origin of Species*.

<p style="text-align:center">*　　*　　*</p>

The end to Ruskin's hopes for 'scientific Gothic' was signalled by the affair of the Oxford Museum. Ever since his undergraduate days, he had campaigned for the teaching of natural sciences in Oxford. In the third volume of *The Stones of Venice* he complained bitterly that, until the last year or two, 'the instruction in the physical sciences given at Oxford consisted of a course of twelve or fourteen lectures on the Elements of Mechanics or Pneumatics, and permission to ride out to Shotover with the Professor of Geology'. Ruskin argued that this deprived men of the 'perpetual, simple, and religious delight in watching the processes, or admiring the creatures, of the natural universe'.[7]

And so he supported Henry Acland, a Reader in Anatomy, in his struggle to get the natural sciences fully accepted by the Oxford authorities. Acland and Ruskin had been friends since they were both undergraduates, when, according to Ruskin, they 'went hunting for infusiora in Christchurch meadow streams'. After many battles, Acland succeeded in getting a School in Natural Science established in Oxford in 1848. He began a campaign for a great museum equipped with 'all such appliances as may be found necessary for teaching and studying the Natural History of the Earth and its inhabitants'.[8] In 1854 Acland finally received authorisation to organise an architectural competition for the museum; inevitably, this became a focus for a

Victorian 'Battle of the Styles' – and the winning of it a matter of urgency for the Gothic party.

For us, the separation between the Gothic and science has been reinforced by a century of modernity, during which the Gothic has seemed to be associated with a longing for a medieval past. But this was not how the matter appeared to the Victorians: the protagonists of Gothic argued not only that there was an affinity between the style and the buildings of Oxford, but also that Gothic was appropriate for a museum of science. As G. E. Street, one of the great Gothic Revival architects, put it, 'Surely where nature is to be enshrined, there especially ought every carved stone and every ornamental device to bear her marks and to set forth her loveliness.'[9]

Although Ruskin had reservations about Deane and Woodward's design, he was delighted when the prize was awarded to the Irish architects. Their museum for Trinity College, Dublin, was close to Ruskin's architectural principles. In the event, the Oxford Museum was the first major example of secular Gothic since the new Palace of Westminster – which had been disowned, not only by Ruskin, but by most Gothic Revivalists. Building of the Oxford Museum began in 1855; and the work on its structure was largely finished within two years. But difficulties of a technical and administrative kind attended the construction. Its style also caused confusion among commentators, who detected all manner of influences, from Veronese Gothic and Venetian to early English decorated. To the inhabitants of Oxford colleges, it seemed almost absurdly *modern*.

This was especially true of the ornamentation of the building. Inside, the main court contains an arcade of two colonnades, the plan for which was drawn up by John Phillips, Oxford's Professor of Geology. The original scheme was to display all the natural orders of botany in the capitals, and the geological epochs in the columns. Each column is cut from a different stone: those on the ground floor are fashioned from the igneous rocks, and those in the upper corridor from the sedentary. There were, in all, 192 capitals and corbels, of which some forty-six were carved by two enthusiastic workmen, the O'Shea brothers – whom Deane and Woodward had brought over from Ireland – between 1858 and 1860, before lack of funds brought this work to a halt. The brothers used to arrive at the museum armed with specimens of plants, provided for them from the botanical gardens by John Phillips.

One of the most striking features of the interior is the glass and iron

roof – made by a Mr F. A. Skidmore of Coventry, an ironmaster with an interest in ecclesiology. The intention was to construct a roof which was *not* simply functional, but rather followed those allusively beautiful proportions of which Ruskin had written so much, and also formed part of the overall natural-historical ornamental scheme. The first roof was made entirely out of glass and wrought-iron, and supported with rows of iron shafts, the spandrels of which were leafy branches. It collapsed.

The second version was more successful. Cast-iron was used for almost everything except the wrought-iron leafy spandrels, which, in Acland's words, represented 'large interwoven branches, with leaf and flower, of lime, chestnut, sycamore, walnut, palm, and other trees and shrubs, of native or of exotic growth; and in various parts of the lesser decorations, in the capitals, and nestled in the trefoils of the girders, leaves of elm, briar, water-lily, passion-flower, ivy, holly, and many others'.[10] Ruskin designed six spandrels himself.

Beyond this, it has proved rather difficult to establish how far Ruskin's involvement with the design of the building went. Eva Blau has shown that he had little to do with the overall plan.[11] He designed one of the outer windows, and on 18 April 1856 he visited the site to exhort the workmen. In the course of a long speech, he told them that God had implanted in man a love of natural history, reflected in his interest in 'the variety and beauty of the handiworks of nature wherever they were beheld'. He went on to say that this had a dual importance for those engaged in architectural work. They had not only to appreciate the beauties of nature, but also to interpret them to others. He said that 'skilful imitation of a natural object, such as a leaf or a flower, often awakened admiration where the object itself failed to excite a corresponding feeling.'[12]

Whatever Ruskin's involvement, the museum closely followed his general principles – about everything from ornament to labour; it is the nearest architecture ever got to 'scientific Gothic'. But, in 1858, he grew ever more disillusioned with the work. He wrote in disgruntled fashion to Acland: 'I was in hopes from the beginning that the sculpture might have been rendered typically illustrative of the English Flora: how far this idea has been as yet carried out I do not know; but I do know that it cannot be properly carried out without a careful examination of the available characters of the principal genera such as the architects have not hitherto undertaken.'[13]

In a further letter, sent to Acland early the following year, he

stressed how the museum was 'literally the first building raised in England since the close of the fifteenth century, which has fearlessly put to new trial this old faith in nature'; but that old faith was, of course, failing him. Just as with Hunt's painting, Ruskin responded by arguing that there was something wrong with the work itself. The ornamentation of the museum was not 'a representation of what Gothic work will be when its revival is complete'.[14] This as yet unrealised Gothic work would involve 'the expression not only of natural form, but of all vital and noble natural law'. The truth of decoration was never to be measured by its imitative power, but by its suggestive and informative power. He described how in one of the spandrels of the ironwork of the roof, 'the horse-chestnut leaf and nut are used as the principal elements of form'. 'They are not ill-arranged,' he wrote, 'and produce a more agreeable effect than convolutions of the iron could have given, unhelped by any reference to natural objects.' Nevertheless, he could not call this 'an absolutely good design'. The reason was that imperfect expression had been given to the 'peculiar radiant or fanned expansion, and other conditions of group and growth in the tree; which would have been just the more beautiful and interesting, as they would have arisen from deeper research into nature, and more adaptive modifying power in the designer's mind, than the mere leaf termination of a riveted scroll.'[15]

Again, however, one suspects that whatever the ironwork had in fact been like, Ruskin would have felt dissatisfied; Ruskin's disillusionment with the idea of a modern Gothic in general, and the museum in particular, was propelled by his loss of faith in the immanence of God within natural forms. Looking at the museum, others, too, began to realise the incompatibility between the Gothic and the modern. *Building News* insisted that its glass and iron roof would not 'convert the world to a belief in the universal applicability of Crystal Palace architecture Gothicised'.[16]

* * *

The Oxford Museum had been conceived in the early 1850s, almost as a secular cathedral to natural theology. But by the end of the decade, the beliefs which it celebrated were themselves dying. Men and women seemed to have to decide between ecclesiology and science – even if they were neither Tractarians nor Atheists. Ironically, the notorious debate between the great Evangelical preacher Bishop Samuel Wilberforce and Thomas Huxley on Darwin's theories took

place in the museum in 1860. But for Ruskin, and for many of his contemporaries, there were even greater stumbling blocks to belief.

In *Modern Painters* Volume Three, Ruskin assailed German Biblical critics – picking out for ridicule the radical Hegelians Baron von Bunsen and David Strauss, whose *The Life of Jesus: A Critical Treatment* had been translated into English by George Eliot in 1846. Ruskin said that he was 'brought continually into collision with certain extravagances of the German mind' by his own 'pursuit of Naturalism as opposed to Idealism'. (He found such Hegelian phraseology as 'a finite realization of the infinite' 'considerably less rational than "a black realization of white"'.) He tried to dissuade 'simple and busy men, concerned much with art, which is eminently a practical matter, and fatigues the eyes', from 'meddling with German books', which would just fatigue them even more, not, he said, because he feared inquiry into the grounds of religion, but because there were better ways of spending one's time, and even of facing one's doubts about Christianity.[17]

But these passages seem to protest too much; his own swelling doubts and his love of 'truth' drew him towards critical theory – if not idealist philosophy. Four years after Ruskin's 'un-conversion', Bishop Colenso of Natal began to publish his volumes on the Pentateuch, drawing on the German critics. Colenso was assailed by Tractarians and Evangelicals alike, and he ran into deep trouble with the ecclesiastical authorities. The Colenso affair dragged on for years.[18] Ruskin seems to have identified with the unfortunate Bishop. He came to believe that he was the only honest prelate in Christendom.

The end of all the hopes on which Ruskin's early work had been based came with the publication of *Essays and Reviews* – a book in which a group of distinguished Oxford clerics looked sympathetically upon new critical approaches to scripture and ridiculed the old natural theology. The most important essay was by Benjamin Jowett, the eminent Professor of Greek, who on first reading *Modern Painters* had declared Ruskin 'a child of genius'. But the message of Jowett's essay was 'Interpret the Scripture like any other book'; he was hostile to the traditional techniques of preachers and warned against the practice of drawing arbitrary parallels between one part of scripture and another. Jowett closed the book of the waning tradition of typological thinking, and argued in favour of a concept of 'progressive revelation'. Modern criticism, he hoped (as it happens, naively), would restore the true meaning of the Biblical texts: 'Its beauty will be freshly

seen, as of a picture that has been restored after many ages to its original state.'[19]

The only lay contributor to the volume was Charles Goodwin, who showed how Buckland – and others who had attempted to accommodate science to the Pentateuch, like Hugh Miller and Archdeacon Pratt – had engaged in untenable torturing of meaning. Ruskin had also reached this conclusion, but Goodwin did not advocate a return to Biblical literalism. Rather, he argued that the scriptures and faith itself could only be defended by allowing science its autonomy.[20]

To most men and women, even to most Christians, today, *Essays and Reviews* reads platitudinously: these authors were trying to propose a new Broad Church orthodoxy which might replace the discredited wreck of traditional natural theology. Their success perhaps accounts for the sense of *déjà vu*, even of banality, the book exudes today. But to those living through this sea-change such ideas were anything but familiar. The reaction against *Essays and Reviews* exceeded the reaction against *Origin of Species* – if only because these ideas seemed to come from the intellectual heartland of the church itself. Two of the contributors, Rowland Williams and Henry Wilson, were accused and tried for denying the inspiration of scripture. Though they were acquitted on the grounds that the Thirty-Nine Articles did not define inspiration, Tractarians, led by Pusey, and Evangelicals came together in a holy alliance to protest against the acquittal. Like the Colenso affair, *Essays and Reviews* remained a source of scandal and controversy for several years.

In 1851, Ruskin had argued for just such a militant pan-Protestant alliance as was now emerging against *Essays and Reviews*, but he had wanted to see it directed against the Papacy, not modern thought. A decade later he wanted no part in such a thing. His sympathies lay not only with Colenso, but also with Williams and Wilson. And yet, if Ruskin knew it would be impossible for him to revert to Biblical Protestantism, equally he knew he could not throw in his lot with any of the new scientific parties.

On receiving a copy of *On the Origin of Species*, Adam Sedgwick wrote to Darwin (who had once been his pupil), 'Tis the crown and glory of organic science that it *does*, through *final cause*, link material to moral . . . You have ignored this link; and, if I do not mistake your meaning, you have done your best . . . to break it.' Sedgwick went on to say that were it possible to break it, which he thanked God it wasn't, 'humanity . . . would suffer a damage that might brutalize it,

and sink the human race into a lower grade of degradation than any into which it has fallen since its written records tell us of its history.'[21] Ruskin, too, was aware of what might happen if the 'link' to which Sedgwick referred was broken. For one thing, as he himself was now experiencing in his responses to art and architecture, there could not be an appeal beyond *aesthesis* to *theoria*.

* * *

Early in *Modern Painters* Volume Five, first published in 1860, Ruskin declared that the main aim of the book, 'from its first syllable to its last', was the declaration of 'the perfectness and eternal beauty of the work of God'. He claimed to test 'all work of man by concurrence with, or subjection to that'.[22] But much of what follows indicates this was just self-exhortation. For this volume of *Modern Painters* is stamped by the belief that lower nature offers no revelation and 'the directest manifestation of Deity to man is in His own image, that is, in man.'[23] Ruskin said it could not be supposed 'that the bodily shape of man resembles, or resembled, any bodily shape in the Deity'. Rather 'the soul of man is a mirror of the mind of God. A mirror, dark, distorted, broken, use what blameful words you please of its state; yet in the main, a true mirror, out of which alone, and by which alone, we can know anything of God at all.' All the power of nature, Ruskin now argued, 'depends on subjection to the human soul'. Man, he wrote, 'is the sun of the world; more than the real sun. The fire of his wonderful heart is the only light and heat worth gauge or measure. Where he is, are the tropics; where he is not, the ice-world'.[24] Little wonder, given this great shift in his views, that, for the time being at least, he should have abandoned the search for Divine proto-types and should have begun to focus, more exclusively than previously, upon that 'dark mirror' of the human soul itself.

II

Unto This Last

For many men and women, including Ruskin, the withering of natural theology in the middle of the last century resembled the Fall. The eating of the fruit of the Tree of Knowledge brought with it expulsion from a beneficent natural world where all was good, into a land of 'thorns also and thistles': it meant a shift away from interest in the beauty and sufficiency of nature towards a focus upon an issue which pressed insistently for attention: the way in which an ever-increasing number of men and women had to engage in abject toil in order to acquire the means of subsistence.

For the Biblicists this was not unexpected: 'Cursed is the ground for thy sake; in sorrow shalt thou eat of it all the days of thy life.' And yet, for a new breed of political economist, man seemed to be making himself anew, in his own image, through his own labour; in this brave new world, the curse of Adam was forgotten, and, increasingly, the description of economic exchange came to be seen as synonymous with that of human relations themselves. The new 'model' was accepted not only by the economic apologists for capitalism but also by the majority of those who opposed themselves to the existing economic order – especially Socialists. Ruskin refused to adopt this view, and poured scorn upon political economists and their Socialist critics alike.

For Ruskin believed that the human soul subverted all the political economists' calculations without their knowledge. He argued that the largest quantity of work was done not by those 'curious engines for pay', as described by the political economists, nor 'under pressure', nor 'by help of any kind of fuel which may be supplied by the chaldron'. On the contrary, he wrote, 'it will be done only when the motive force, that is to say, the will or spirit of the creature, is brought to its greatest strength by its own proper fuel: namely, by the affections'.[1]

He instanced the master-servant relationship and that of the military

commander to his men as examples of human relationships in which the affections were motive powers, and ignored every other condition of political economy:

Treat the servant kindly, with the idea of turning his gratitude to account, and you will get, as you deserve, no gratitude, nor any value for your kindness; but treat him kindly without any economical purpose, and all economical purposes will be answered; in this, as in all other matters, whosoever will save his life shall lose it, whoso loses it shall find it.[2]

The point which Ruskin often made was that an ethical culture was necessary for the functioning of political economy: and that there was no point in discussing economic life unless one first looked at the morals and affections which informed it. The operations of markets could be good or bad, depending upon who was engaged in them, how, and to what ends. He never opposed himself to commercial life, as such, but only to *mercenary commerce*. He likened government to the brain, labouring to the limbs, and mercantile life, 'presiding over circulation and communication of things' to the heart itself, 'and if that hardens, all is lost'.[3] (He came to oppose the charging of interest of any kind.) A deep moral onus lay on the merchant, who has 'to understand to their very root the qualities of the thing he deals in, and the means of obtaining or producing it; and he has to apply all his sagacity and energy to the producing or obtaining it in perfect state, and distributing it at the cheapest possible price where it is most needed'.[4] These are the authentic tones of the honest sherry merchant's son.

In *Unto This Last* (1860), Ruskin emphasised how unsatisfactory was any economic analysis which measured utility only by capacity to satisfy desire or serve a purpose – and did not inquire what sort of desire, or what sort of purpose. For Ruskin, cost and price were merely commercial conditions, the former being synonymous with the quantity of labour required to produce something, the latter with the quantity of labour its possessor would take in exchange for it. But value was that which availed towards life, 'the life-giving power of anything', 'the absolute power of anything to support life'. 'If the whole of England were turned into a mine,' he asked, 'would it be richer or poorer?'[5]

Nothing illustrates Ruskin's idea of value better than his discussion of the value of land. This was, he wrote, firstly, 'as producing food and mechanical power'; but he also said that secondly it consisted in

land, 'as an object of sight and thought, producing intellectual power'. In short, value in land lay in part in its beauty:

> . . . united with such conditions of space and form as are necessary for exercise, and for fullness of animal life . . . Such land, carefully tended by the hand of man, so far as to remove from it unsightliness and evidences of decay, guarded from violence, and inhabited, under man's affectionate protection, by every kind of living creature that can occupy it in peace, is the most precious 'property' that human beings can possess.[6]

Ruskin's view of value, property, and wealth, therefore, could be summed up in his famous declaration: 'THERE IS NO WEALTH BUT LIFE. Life, including all its powers of love, of joy, and of admiration.'[7] He rejected the idea that the 'inhumanity of mercenary commerce' was a natural condition of life, and pointed rather to those signs of help, co-operation, and altruism which he saw in the world around him. In *Modern Painters* Volume Five, that quality of leaf radiation, upon which Ruskin had remarked so frequently before, becomes associated not so much with a type of Divine beauty, as with a natural model of social life:

> For there is a strange coincidence in this between trees and communities of men. When the community is small, people fall more easily into their places, and take, each in his place, a firmer standing than can be obtained by the individuals of a great nation. The members of a vast community are separately weaker, as an aspen or elm leaf is thin, tremulous, and directionless, compared with the spear-like setting and firm substance of a rhododendron or laurel leaf.[8]

The laurel and rhododendron, Ruskin argued, were like the Athenian or Florentine republics; but the aspen was like England – 'strong-trunked enough when put to proof, and very good for making cartwheels of, but shaking pale with epidemic panic at every breeze.' Nonetheless, the aspen has the better of the great nation, 'in that if you take it bough by bough, you shall find the gentle law of respect and room for each other truly observed by the leaves in such broken way as they can manage it'. But, Ruskin added, 'in the nation you find every one scrambling for his neighbour's place'.[9]

'Government and co-operation are in all things the Laws of Life', Ruskin wrote, 'Anarchy and competition the Laws of Death.'[10] There are those who have chosen to see in such remarks a kind of proto-Socialism. But, as Robert Hewison has pointed out, Ruskin came closest to announcing his political objectives when he described the goal of the Guild of St George, which he was later to found, as 'The

old Feudal system applied to do good instead of evil – to save life, instead of destroy. That is the whole – in the fewest words.'[11] Ruskin firmly rejected the idea that the essence of human freedom lay in political freedoms, or economic freedoms; he was sceptical concerning all kinds of Socialist programme, and all quests for political equality. 'If there be any one point insisted on throughout my works more frequently than any other,' he wrote, 'that one point is the impossibility of Equality.' His continual aim had been to show 'the eternal superiority of some men to others, sometimes even of one man to all others; and to show the advisability of appointing such persons or person to guide, to lead, or on occasion even to compel and subdue, their inferiors according to their own better knowledge and wiser will'.[12]

Such passages have chilling resonances today; but it would be wrong to assume from such writing that Ruskin had no interest in human freedom. Rather, for him, the *locus* of such freedom did not lie where both the apologists for and opponents of capitalism have endeavoured to place it. In his book *John Ruskin's Labour*, P. D. Anthony, Professor of Industrial Relations at Cardiff University, writes that Ruskin

is saying that the real cause of injustice and its highly probable consequence in social upheaval is not the inegalitarian advantage that one class enjoys over another, it is not extreme states of political suppression, it is not slavery nor authoritarian government: it is the nature of the work that men have to spend their lives engaged upon.[13]

Ruskin believed that the political programmes which working men were being persuaded to adopt would have no effect on changing those things which caused them to espouse them: namely on the degraded character of their own work, and their own lives. But his view of the value of human labour was ambivalent: labour, for Ruskin, was intimately associated with his conception of the Fall; 'It is only for God to create without toil,' he once wrote, 'that which man can create without toil is worthless.' And this association was, if anything, intensified by his deepening disillusionment with the natural world, and his discovery of its malevolence. Labour, for Ruskin, was, quite literally, 'the quantity of "Lapse", loss, or failure of human life, caused by any effort'. Ruskin insisted that labour was usually confused with effort itself, or the application of power (*opera*); but, he said, 'there is much effort which is merely a mode of recreation, or of pleasure.' He maintained that the most beautiful actions of the human body, and the highest results of the human intelligence, were conditions, or achievements, 'of quite unlaborious, – nay, of recreative, – effort'.

But labour itself was the *suffering* in effort: 'It is the negative quantity, or quantity of de-feat, which has to be counted against every Feat, and of de-fect, which has to be counted against every Fact, or Deed of men. In brief, it is "that quantity of our toil which we die in".'[14]

Ruskin's conception of human labour was associated with the value he placed upon the weaknesses and imperfections in great art, which he tells us is *never* 'perfect', or finished, like machine work. He says that mechanical labour is destructive and degrading not simply because it is joyless, but because it allows no room for this *lapse*. Men are not cogs and compasses, meet only for precision labour. If they are treated as if they were:

All their attention and strength must go to the accomplishment of the mean act, the eye of the soul must be bent upon the finger-point, and the soul's force must fill all the invisible nerves that guide it, ten hours a day, that it may not err from its steely precision, and so soul and sight be lost at last.[15]

This 'degradation of the operative into a machine' was, for Ruskin, a greater crime than economic exploitation, or the absence of all political freedoms. He wrote:

We have studied and much perfected, of late, the great civilized invention of the division of labour; only we give it a false name. It is not, truly speaking, the labour that is divided; but the men: – Divided into mere segments of men – broken into small fragments and crumbs of life; so that all the little piece of intelligence that is left in a man is not enough to make a pin, or a nail, but exhausts itself in the making of the point of a pin or the head of a nail.

Such points and heads Ruskin saw as being polished with the 'sand of human soul'.[16]

And so, against modern capitalism, Ruskin raised up the example of the Gothic, which became for him a sort of paradigm of that world in which the worker finds spiritual meaning and a sense of unity, like all the individual leaves in community on the tree. ('No Gothic,' he remarked, 'is either good or characteristic, which is not foliated either in its arches or apertures.') He commanded:

Go forth again to gaze upon the old cathedral front where you have smiled so often at the fantastic ignorance of the old sculptors: examine once more those ugly goblins, and formless monsters, and stern statues, anatomiless and rigid; but do not mock at them, for they are signs of the life and liberty of every workman who struck the stone; a freedom of thought, and rank in scale of being, such as no laws, no charters, no charities can secure; but which it must be the first aim of all Europe at this day to regain for her children.[17]

As Kristine Garrigan has put it, for Ruskin, a great Gothic cathedral 'stands not only figuratively, but also literally, for the spiritually unified society, in which each member's creativity however minor or imperfect is respected and welcomed'. This, she says, 'is how Ruskin "sees" a building in its entirety: not as a structural enclosure of space but as a symbolic shelter for mankind's noblest aspirations'.[18]

It is, I think, easy to see from all this how Ruskin came to those emphases which once so scandalised twentieth century architectural thinkers: for example to his view that 'the principal part of architecture is ornament'. In the early Ruskin, ornament is man's homage to God's creation, a sign, always, of his delight in God's work, rather than his own. This view never entirely disappears – but with the wobbling of the edifice of his natural theology, Ruskin increasingly saw ornament as that element in labour which could not be reduced to practical necessity, which freed itself from the demands of economics and function. 'In my works on architecture', he once wrote, 'the preference accorded finally to one school over another is founded on a comparison of their influences on the life of the workman.' Ornament, for Ruskin, was not a decorative, added extra; rather it is the guarantee of the integrity of labour – the means by which the workman simultaneously gave expression to his human soul, glorified God, and entered into the affective life of his whole community. Healthy ornament thus functioned as a sign of that freedom Ruskin regarded as most worth having. If Ruskin admired the imperfections and idiosyncrasies of the Gothic, he equally despised more regulated architectural styles.

But Ruskin was not against functional constructions for the new age: he repeatedly argued that railway stations and bridges should *not* be ornamented. He preferred King's Cross to St Pancras: he was a functionalist to the extent that he believed buildings should be well-proportioned and do the jobs they were designed for. But it would be wrong to see in this, as some have tried to see, the seeds of an incipient modernism; for Ruskin insisted that such practical matters were not architecture, and drew attention to the 'difference between a wasp's nest, a rat hole, or a railway station', and architecture, which, he felt, should be expressive of man's highest spiritual endeavours.

It is frequently suggested that there is something recidivist in Ruskin's view of economic and social life; he has been accused of 'medievalising' and of ignoring the economic and 'functional' realities of the modern world. As an historical interpretation, Ruskin's account of Gothic is barely tenable; he underestimated the degree of division

of labour that applied in medieval times and wrote about specialist craftsmen – almost proto-professionals – as if they were everyday labourers. Nor did he understand the industrial revolution of the twelfth and thirteenth centuries which made the building of the great cathedrals possible. Yet, for Ruskin, Gothic was not a simple historical category. Rather, it was as much a perception of how things might be: a memory of the future, a vision of human life and labour, to be opposed to the realities of the nineteenth century, and, let it be said, of what came to pass in the twentieth century.

Needless to say, by the 1920s Ruskin's attitudes towards work and architecture were considered by many fit only to be dismissed as, in Nikolaus Pevsner's phrase, 'negative and reactionary',[19] or, as Herbert Read described them, 'the grossest illusions and prejudices'.[20] In the 1960s, as students, we felt that the modernist aesthetic seemed to coincide with the politics of Marxism, then so very much in vogue. We were, one could say, more right than we realised, because, at that time, the link between Marxism and art still brought to the minds of most people that conflict between modernism and Socialist Realism which had played such an influential role in Soviet cultural history. But, thanks to the meticulous research of Margaret Rose, we now know that this was not how Marx himself viewed the matter.[21] For Marx was rather a belligerent opponent of the spiritual, religious and romantic art of Germany and of England. He wished to replace such 'Pre-Raphaelite' thinking with a conception of artists who made common cause with scientists as 'a vanguard of producers', who had an important role to play in developing the economic productivity of a nation. In this, as in so much else, Saint-Simon and Marx flaunted the worldly tastes of the 'bourgeoisie' to which they opposed them-selves: and they stood in sharp opposition to all for which Ruskin argued.

'Aesthetic problems,' writes Mikhail Lifshitz in his classic study of *The Philosophy of Art of Karl Marx*, 'occupied a conspicuous place in Marx's early intellectual life.'[22] Marx 'progressed' from youthful romanticism to Hegelian idealism; but, unlike Hegel's, Marx's Hellenism was of a kind which stressed what he believed to be the 'realism' and rationalism' of the Greek democratic republics, and saw their abstract ideals as restraints on material development. Thus, for Marx, *'The historical limitation of ancient sculpture was not its adherence to life, its corporeality, but on the contrary, its escape from life, its retreat into empty space.'*

Inevitably, Marx had an especial contempt for the arts of Christendom. We do not possess the text of the 'Left Hegelian' critique of Christian art which he wrote in the early 1840s; but the thrust of his thought, at this time, has been reconstructed from the numerous extracts, marginal notes, and glosses which have remained. Marx approved of those writers, like Charles Debrosses, who identified religious expression in art with 'fetishism' and, as he saw it, inhibition of sensuous aesthetic development. Debrosses noted, for example, that even after the art of portraying the human body in sculpture had made considerable progress, 'religious worship remained faithful to the shapeless old stones'.[23]

All this predictably went with a strident distaste for the whole world of the Gothic. Marx responded warmly to any passage which interpreted a display of imaginative or spiritual symbolism – for example in angels' wings, or the monstrous features of gargoyles – as unwarranted fetishism. He extracted those authors who emphasised the crudeness, ugliness, and distortions of Christian art; he liked to characterise the Gothic as a reproduction of 'Asiatic barbarism' on a new level of sophistication. He dutifully copied out a passage from a book by Johann Grund concerning Gothic sculpture, which expressed sentiments almost the reverse of Ruskin's response to the old cathedral front:

Sculpture lived mainly from the aims of architecture. Statues of saints filled the interior and exterior walls of buildings; in their multiplicity they expressed the excess of worship: small in appearance, lean and angular in shape, awkward and unnatural in pose, they were below any real artistry, just as man, their creator, was below himself.

Grund argued, and Marx noted, 'Christian architecture sought exaggeration and loftiness; yet it was lost in barbaric pomp and countless details.' It was also excessively and sentimentally attached to the Madonna.

On the basis of such notes, and on hints liberally scattered through Marx's articles for the *Rheinische Zeitung*, Margaret Rose shows just how hostile Marx was to the 'medievalism' which was so popular in both Prussia and, in a less idealist version, in Britain, in the 1840s. Rose suggests that had Marx's treatise on Christian art and religion been completed, and survived, it would have developed these themes about the way in which Christian culture had been based on the persistence of 'primitive fetishism', and had thus been a movement away from the standard of civilisation of the Hellenic world rather

than a progression beyond it. In practical terms, this meant opposition to the German Nazarene painters, and, when he was in England, to the Pre-Raphaelites; all this may help to explain an enigmatic, and much-quoted, passage from Marx's *Grundisse* in which he accorded (improbably) a freshness and innocence to the Greeks as the children of humanity.

Marx's hostility to Christian art was inseparable from one of the central concepts of his writing: that of 'fetishism'. He complained that Christianity encouraged people to worship the material aspects of things, while endowing them with the qualities of man himself. He could not, of course, say of God; for Marx believed himself to be standing on the further shore of Atheism, which he dismissed as a meaningless denial of an unreality. Atheism, he argued, was a negation of God, an assertion of the existence of man; but Socialism had no need of such mediation: 'Its starting-point is the *theoretically and practically sensuous consciousness* of man and of nature as *essential beings*.'

And so Marx tended to identify art with technical skill, the triumph over all forms of 'spiritual' expression (he would have said 'superstition'), and the emancipation of the senses. Inevitably, all this set him in steadfast opposition to 'romantic culture' – though, of the British writers, it was Carlyle rather than Ruskin who was named in his attacks.

Just as Marx had seen the Gothic as a continuation of Asiatic fetishism, so he saw within capitalism a further extension of this primitive phenomenon, this time in the form of fetishism of commodities; through this concept, Marx referred to the way in which capitalist production appeared to set the product up above the producer, and to invest it with qualities at once magical and seemingly tyrannical. In his famous *Economic and Philosophical Manuscripts* of 1844, Marx argued that an animal was 'immediately one with its life activity'. But, by contrast, man can make his life activity into an object of will – and this was why a man's activity, unlike that of other creatures, could be described as 'free'. The problem, as Marx then saw it, was that the 'estranged labour' characteristic of a system of private property and capitalist production stood this on its head, so that man became compelled to make his life activity 'a mere means for his existence'. 'Private property has made us so stupid and one-sided that an object is only *ours* when we have it, when it exists for us as capital or when we directly possess, eat, drink, wear, inhabit it, etc., in short when we

use it.' A dealer in minerals, according to Marx, 'sees only the commercial value, and not the beauty and peculiar nature of the minerals; he lacks a mineralogical sense' . . . which, for Marx, was identical with an aesthetic, or fully human sense.[24]

Marx looked to the day when men and women would escape from the limitations of such property-produced fetishisms, through the supersession of private property itself. 'The supersession of private property', he wrote, 'is . . . the complete *emancipation* of all human senses and attributes; but it is this emancipation precisely because these senses and attributes have become *human*, subjectively as well as objectively.'[25] Only with the abolition of private property could the eye become a *human* eye, and its object a social or human object, 'made by man for man'; in these changed circumstances, 'The *senses* have therefore become *theoreticians* in their immediate praxis.'

In the future Marx envisaged, work itself would become increasingly aesthetic, in a world in which the senses themselves had become 'theoreticians'; work would partake of the nature of *Selbstbetätigung*, a free play of physical and psychic faculties. Or, to use Ruskin's terminology, the supersession of *theoria* would lead to the fully human elevation of *aesthesis*; the only obstacles in the way of this triumph of *aesthesis* were private property, the division of society into classes and capitalist production.

Notoriously, Marx believed that the development of the productive forces was such that it would inevitably lead to the transformation he had envisaged; in his later work, the evocative descriptions of *Selbstbetätigung* and so forth give way to a preoccupation with the economic and political structures and processes through which the great change would be brought about – hence his fidelity to a Saint-Simon's avant-garde, technist, and 'productivist' conceptions of the artist's role; in the jargon of mature 'Marxism', the artist (like the scientist) had a part to play in assisting and accelerating the conflict between 'the material productive forces of society' and 'the existing relations of production', which would bring about social revolution and initiate the new era.

The aesthetic ideas of the early Marx thus became dissolved into the technist visions, and political programmes, of later Marxism. If, for Ruskin, labour was bound up with human lapse, and de-feat, with, in another terminology, the Fall, for Marx, and especially for Engels, it was a potential source of *triumph* over nature, a means by which nature could be reduced to human ends. The animal, Engels once

wrote, merely uses external nature and brings about changes in it simply by the fact of being there. But because man could make nature serve his ends (or so Engels thought) he possessed the power to *master* it. 'This,' he said, 'is the final, essential distinction between man and the other animals, and again it is labour that brings about this distinction.'[26]

Engels thought that the more human beings removed themselves from animals, 'the more accurately does the historical result correspond to the aim laid down in advance'. And so he looked forward to a time when 'The seizure of the means of production by society eliminates commodity production and with it the domination of the product over the producer.' With 'consciously planned organisation', Engels thought, 'the struggle for individual existence' supposedly came to an end. Only then, he argued, did man finally separate 'from animal conditions of existence' and attain to 'really human ones'. 'The conditions of existence environing and hitherto dominating humanity,' Engels wrote, 'now pass under the dominion and control of humanity, which now for the first time becomes the real conscious master of nature.'[27]

The Storm-Cloud of the
Nineteenth Century

While the Marxists dreamed of triumph *over* nature, Ruskin brooded on the failure *of* nature. The 1860s were a peculiarly bleak time in his spiritual life. As death approached, John James, his father, was himself afflicted by crippling religious doubts. Ruskin tried his best to console him; but the last letter he wrote to his father before the latter's death was accusatory. Ruskin complained that his own feelings for mountains, cathedrals and pine forests were such that he thought he must be dying. He bitterly accused his parents of having pampered him to such a degree that they had 'thwarted' him 'in all the earnest fire of passion and life'. About Turner, Ruskin continued, 'you indeed never knew how much you thwarted me – for I thought it my duty to be thwarted – it was the religion that led me all wrong there . . .'[1]

Between 1858 and 1874, Ruskin abandoned conventional Christianity; his faith at this time seems to have consisted of a shaky affirmation of the existence of God, and ethical beliefs in social kindness and justice; Ruskin's ideas apparently had something in common with Auguste Comte's 'Religion of Humanity', although he strenuously denied any similarity. Ruskin's scepticism concerning the scriptures was now openly proclaimed. In 1864 he told a Manchester audience: 'The Word of God, by which the heavens were of old, and by which they are now kept in store, cannot be made a present of to anybody in morocco binding.'[2] In *Time and Tide* (1867), Ruskin admitted that he quoted the Bible only because it had been 'the accepted guide of the moral intelligence of Europe for some fifteen hundred years'; he himself now deduced principles of action 'first from the laws and facts of nature'.[3]

But what principles did nature suggest? Those laws of beauty and of help which Ruskin derived from the study of nature seemed as deeply threatened as precepts derived from the Bible itself. Modern

science, which he had once hoped would reinforce Revelation, now seemed to him to be associated not so much with natural history and spiritual life as with technology and death. In the 1860s, Ruskin developed a hatred of optical instruments, violators of that human 'science of appearances' through the pursuit of which a man might feel that nature reflected back to him something of himself.

Fear and a literal trembling came to haunt his writing; Ruskin began to doubt whether there were natural beauties, expressive of transcendent reality, and natural law. Perhaps such things were chimeras and illusions, no more able to be set down within a morocco binding than the allusive Word of God. And then, in 1870, his mother died; it was as if the sun and the moon had been extinguished. Soon after, he moved to Brantwood, a house overlooking Lake Coniston, in the Lake District, where he became ever more tormented by that sense of the failure of nature that had dogged him since he had first been subsumed by religious doubts.

'Of all the things that oppress me,' he wrote to his friend Charles Norton, 'this sense of the evil working of nature itself – my disgust at her barbarity – clumsiness – darkness – bitter mockery of herself – is the most desolating.' He went on to say that he had been very sorry about the death of his old childhood nurse, 'but her death is ten times more horrible to me because the sky and blossoms are Dead also'.[4] About this time Ruskin became friendly with two sisters, Mary and Susan Beever, who lived in The Thwaite, in Coniston: Ruskin doted upon them, describing them as 'queens' who inhabited a garden 'Paradise'. His letters to them were later collected under the title *Hortus Inclusus*. Ruskin wrote especially frequently to Susie Beever, and to her he confided: 'Everything that has happened to me (and the leaf I sent you this morning may show you it has had some hurting in it) is *little* in comparison to the crushing and depressing effect on me, of what I learn day by day as I work on, of the cruelty and ghastliness of the *nature* I used to think so Divine.'[5]

Ruskin began to keep notes of what he took to be changes in the weather from the early spring of 1871 onwards; he became convinced that he could detect the presence of a storm-cloud, which lowered ominously in the sky, often accompanied by a plague wind of diabolic aspect. By the late 1870s, such references were frequent. For example, on 11 July 1879 Ruskin recorded that there had been a little sun and

'sweet sky', and he had been able to see 'the blue-bells first out in the garden, and walk to meet the poney – and gather strawberries for tea in my own garden'.[6] But the following day, he noted: 'Perpetual darkness – and yesterday the old diabolic trembling blight.'[7] On 16 July, he remarked that the previous day had been a good one – and he had begun to write the second volume of *Proserpina*, his book about flowers. But the entry for 17 July describes how the previous evening had become 'the blackest . . . the devil has yet brought on us, – utterly hellish, and the worse for its dead quiet – no thunder or any natural character of storm . . . the black *shaking* was worst of all'.[8] Nonetheless, Ruskin recorded that he had got some 'good botany, digging and drawing done'. He also noted that on 18 July he had painted his first cranberry blossom; but the following day brought 'A morning of blackest and foulest fog – London November, with crashing rain at intervals, much discomposes me.' The blackness continued, 'quite hellish, as I work – and, curiously, the sound of railway twice louder than usual in the stillness of it'.[9] The diabolic weather became more frequent; by 3 August, Ruskin was beginning to think that the sky's anger was directed against himself. It was, he wrote, 'of the very worst fiendish sort, all the leaves quivering and shuddering, the lake dirty brown – the sky and hills dirty gray. Wind due North, where it ought to be crystal-clear. An angry and lurid coppercoloured sunset, yesterday foretold it.'[10]

In a letter to Susan Beever he asked whether she had seen the white cloud that stayed quiet for three hours over the summit of the mountain known locally as 'The Old Man'. It was, Ruskin wrote, 'one of the few remains of the heaven one used to see – the heaven one had a Father in, not a raging enemy'.[11] The vile weather continued: Ruskin found his ability to draw natural forms slipping away from him; he was 'beaten by a bud of milkwort'. And thunderstorms became, 'like railway luggage trains – quite ghastly in its mockery of them – the air one loathsome mass of sultry and foul fog like smoke'.[12] Ruskin sunk into 'distrust of Nature, and God – and all things'. On 17 August 1879 he found 'the roses in the other garden, putrefied into brown sponges, feeling like dead snails – and the half ripe strawberries all rotten at the stalks'.[13]

By 1880, after recording 'wild wind and black sky, – scudding rain and roar – a climate of Patagonia instead of England', he confessed himself 'disconsolate – not in actual depression, but in general hopelessness, wonder, and disgust that ever yet in my life, that I remember,

as if it was no use fighting for a world any more in which there could be no sunrise'.[14] This 'demon-blackness' deepened. Three years later, we find him 'utterly horror-struck and hopeless about the weather. The Plague wind now *constant* and the sun virtually extinguished.'[15]

Soon after, Ruskin went public concerning his observation of such phenomena with two lectures delivered at the London Institution in February 1884 called 'The Storm-Cloud of the Nineteenth Century'. Ruskin recommended to his listeners, if they wanted to see what the sun looked like through the plague cloud, 'to throw a bad half-crown into a basin of soap and water': he described the effects of the new weather as 'Blanched Sun, – blighted grass, – blinded man.'[16]

E. T. Cook and Alexander Wedderburn, editors of the Library Edition of Ruskin's works, are at pains to emphasise the empirical basis of Ruskin's observations; and there is no doubt that the blast furnaces at Barrow and Millom polluted the air with soot and smog. But Ruskin himself detected, or so he thought, these malign phenomena even among the Alps. Later commentators have preferred to identify his 'storm-cloud' and 'Plague Wind' with a gathering psychological depression which was to end in madness. And yet neither the rational nor the psychological accounts seem sufficient.

Ruskin himself associated the storm-cloud with the Franco-German campaign of 1870, 'which was especially horrible to me, in its digging, as the Germans should have known, a moat flooded with waters of death between the two nations for a century to come'.[17] The changes in the weather, in other words, had something to do with the murderous, evil and blasphemous actions of men. Or, as Ruskin put it, 'If . . . you ask me for any conceivable cause or meaning of these things – I can tell you none, according to your modern beliefs; but I can tell you what meaning it would have borne to the men of old time.' He went on to say that, for the previous twenty years, England 'and all foreign nations, either tempting her, or following her, have blasphemed the name of God deliberately and openly; and have done iniquity by proclamation, every man doing as much injustice to his brother as it is his power to do'.[18] He remarked that in such moral gloom, every seer of old predicted physical gloom, '"The light shall be darkened in the heavens thereof, and the stars shall withdraw their shining."' All Greek, Christian and Jewish

prophecy, according to Ruskin, insisted on the same truth 'through a thousand myths'. He added that 'the Empire of England, on which formerly the sun never set, has become one on which he never rises.'[19]

13
Of Dabchicks and Pigs' Wash

There were those who sought to avoid the wilderness into which Ruskin's ideas seemed to have descended through the cult of aestheticism; they rooted aesthetic experience in the human subject rather than in an increasingly alien natural world. As Ian Small, the literary critic, has pointed out, aestheticism had its parallels in the world of science; in the 1850s and 1860s a group of British psychologists – including Herbert Spencer, Alexander Bain and James Sully – began to argue that the mind perceived the exterior world as a series of *impressions*. And so, Small says, there arose 'a body of new scientific opinion prepared to treat aesthetic response entirely in isolation from any other consideration – ethical or perceptual':[1] the new science seemed to favour the pursuit of *aesthesis* to the detriment of *theoria*.

Ruskin became splenetic if anyone linked him with aestheticism; after his reconversion to Christianity, he believed that aestheticism poisoned and degraded. A few years after the Whistler affair, he revised the lectures on Greek and English birds he had first delivered at Oxford in 1873. In the improbable context of a talk on 'The Dabchicks', he inserted a round condemnation of the 'abysses, not of analytic, but of dissolytic, – dialytic – or even diarrhoeic – lies, belonging to the sooty and sensual elements of . . . London and Paris life'.[2]

Forgetting all about his own 'unconversion' in Turin twenty years earlier, or what he had believed when he had addressed the Metaphysical Society in 1871, Ruskin raged that *Modern Painters* Volume Two ought sufficiently to have demonstrated that he knew what *aesthesis* was long before the cult of aestheticism, and had always recognised it as 'pigs' flavouring of pigs'-wash'.[3]

These cruel remarks were intended for Walter Pater, whose *Studies in the History of the Renaissance* had been published in 1873. As a young man, Pater had admired Ruskin; in *The Renaissance* he did not

mention him by name, but used him throughout as an adversary. The book has been called 'Ruskin inverted'. For Ruskin, the Renaissance was the beginning of decay and corruption; but the very moment in Venice's history which Ruskin designates the city's fall, Pater sees as its literal rebirth. For him, the Renaissance was man's reassertion of himself, a 'rehabilitation of human nature, the body, the senses, the heart, the intelligence'.[4] That which seemed decadent to Ruskin appealed to Pater as a sign of the freedom of the spirit in the face of modern life – and he intended his analysis of the Renaissance to provide a parallel to Victorian England.

Modern thought, for Pater, was 'distinguished from ancient by its cultivation of the "relative" spirit in place of the "absolute"'.[5] His writing is stamped by the ready acceptance of relativism, a feeling of existing within that flux into which old values, and old certainties, have disintegrated. 'For us,' he writes at the end of his essay, supposedly on Winckelmann, 'necessity is not, as of old, a sort of mythological personage without us, with whom we can do warfare. It is rather a magic web woven through and through us, like that magnetic system of which modern science speaks, penetrating us with a network, subtler than our subtlest nerves, yet bearing in it the central forces of the world.' The question, for Pater, is whether art can represent men and women in these 'bewildering toils' in such a way as to give the spirit 'at least an equivalent for the sense of freedom'.[6]

Writing, elsewhere, of the difference between William Morris's *Defence of Guenevere*, published in 1858, and *The Earthly Paradise*, which began to appear in 1868, Pater commented that in the latter there was 'no delirium or illusion, no experiences of mere soul while the body and the bodily senses sleep, or wake with convulsed intensity at the prompting of imaginative love; but rather the great primary passions under broad daylight as of the pagan Veronese'.[7] This transition, so fateful for Ruskin, was for Pater one of the laws of the human spirit, of which the Renaissance itself was but the supreme instance: 'Just so the monk in his cloister, through the "open vision", open only to the spirit, divined, aspired to, and at last apprehended, a better daylight, but earthly, open only to the senses.' Pater remarks that complex and subtle interests, which the mind spins for itself, may occupy art and poetry or our own spirits for a time; 'But sooner or later they come back with a sharp rebound to the simple elementary passions – anger, desire, regret, pity, and fear; and what corresponds to them in the sensuous world – bare, abstract, fire, water, air,

tears, sleep, silence, and what De Quincey has called the "glory of motion".[8]

Pater's aestheticism then was secular, but not the 'pigs' wash' Ruskin liked to imply; for it was tinged in every cadence with the fragrance of fading religion. *Marius the Epicurean* opens with a description of the pockets of pagan resistance to triumphant Christianity. But Pater, like Marius, his hero, was determined to supersede that contradiction between the Hellenes and the Hebrews. Nothing angered Ruskin more than the sight of caryatids on a Christian church. 'It would have been better,' he once wrote, 'to have worshipped Diana and Jupiter at once than have gone through life naming one God, imagining another, and dreading none.'[9] Marius rediscovered in Christianity all that he had found to be good in Paganism, symbolised for him by 'the fragments of older architecture of the mosaics, the spiral columns' of which Christian catacombs were composed. Pater was attracted by the sensuality, rather than the spirituality, of the Gothic world; and he regarded Morris as 'this Hellenist of the Middle Age, master of dreams, of sleep and the desire of sleep – sleep in which no one walks, restorer of childhood to men – dreams, not like Galahad's or Guenevere's, but full of happy, childish wonder as in the earlier world'.[10]

But, unlike Morris, Pater never came to see the Socialist movement as the ultimate emancipator of the senses. Ruskin accused the aesthetes of treating the arts as 'ticklers and fanners of the soul's sleep'; but for Pater, aesthetic response seemed almost a mode of spiritual life. All art, for him, aspired not only to the condition of music, but also to that of the Saviour. Pater looked to art to provide beauty and meaning in life. The hope, for Pater himself, was that his own modern paganism might incorporate what had been best in Christianity; especially, perhaps, the glories of its aesthetic achievements.

Pater was an agnostic who attempted, unsuccessfully, to be ordained into the Anglican Church, and who punctiliously attended chapel in Brasenose College, Oxford; in his autobiographical sketch, 'The Child in the House', the hero, Florian Deleal, also an unbeliever, 'began to love, for their own sakes, church lights, holy days, all that belonged to the comely order of the sanctuary, the secrets of white linen and holy vessels, and fonts of pure water; and its hieratic purity and simplicity became the type of something he desired always to have about him in actual life'.[11] In other words, his attitude resembled that of those whom Ruskin had so cruelly accused of being lured into the

Romanist church 'by the glitter of it, like larks into a trap by broken glass'. But for Pater, this glitter itself contained redemptive power.

Max Beerbohm, the precocious *belle-lettrist* and caricaturist, once pointed out that aestheticism emerged as a movement at the time when, thanks to the eloquent atheist Member of Parliament, Charles Bradlaugh, who refused to take the oath in the House of Commons, 'the existence of God' became 'a party question'.[12] Aestheticism was the spray thrown up by the long-withdrawing roar of the Sea of Faith; but it was also shot through with the intimations of a new moral order, whose laws have no roots in scripture or nature.

Indeed, Wilde, like most of the aesthetes, accepted, if he did not embrace, the seemingly amoral universe revealed by modern science:

> ... we are part
> Of every rock and bird and beast and hill,
> One with the things that prey on us, and one with what we kill.[13]

But aesthetic experience raises man above this brutality. In 'The Critic as Artist' Wilde makes one of the disputants say: 'Aesthetics are higher than ethics. They belong to a more spiritual sphere. To discern the beauty of a thing is the finest point to which we can survive. Even a colour-sense is more important, in the development of the individual, than a sense of right and wrong.' 'Ethics,' Gilbert instructs Ernest, 'like natural selection, make existence possible. Aesthetics, like sexual selection, make life lovely and wonderful, fill it with new forms, and give it progress, and variety and change.'[14]

Aestheticism then was not, as it was sometimes later portrayed, about the segregation of art into a neat compartment among all the other aspects of life; it involved, rather, a view of life itself, it was an attempt to reconstitute art, or at least aesthetic experience, *as a* religion, or a spiritual order. If Marx, and the Marxists, had endeavoured to reduce *theoria* to *aesthesis*, Pater and the aesthetes endeavoured to raise *aesthesis* to the condition of *theoria*.

Where Ruskin's tastes are stamped by moral earnestness and religious passion, and Morris's by their close political equivalents, Pater opted rather for ornamented tedium, punctuated by aesthetic sensation. The idea of the writer as *engagé*, by reason of love, religion or politics, was alien to him. He spent much of his life secluded within an Oxford house run for him by his reticent unmarried sisters. He was certainly homosexual by inclination, but not, it seems, in practice.

His writing, too, as Iain Fletcher has said, 'seems to lie in a twilight

of categories between criticism, *belles lettres*, classical scholarship, the *journal intime* and the philosophic novel'.[15] His *Studies in the History of the Renaissance* bears little resemblance to what a modern art historian might write: '"To see the object as in itself it really is",' he writes, 'has been justly said to be the aim of all true criticism whatever; and in aesthetic criticism the first step towards seeing one's object as it really is, is to know one's own impression as it really is, to discriminate it, to realise it distinctly.'[16] Pater explains that the objects with which aesthetic criticism deals – 'music, poetry, artistic and accomplished forms of human life' – are receptacles of powers or forces: like the products of nature, they possess so many virtues or qualities. It is the job of the critic to inquire into the nature of these virtues and qualities, to ask, 'What is this song or picture, this engaging personality presented in life or in a book, to *me*? What effect does it really produce on me? Does it give me pleasure? and if so, what sort or degree of pleasure? How is my nature modified by its presence, and under its influence?' The answers to these questions, Pater says, 'are the original facts with which the aesthetic critic has to do'.[17]

Thus, for Pater, the first requirement of the critic was not knowledge, nor even philosophical understanding of aesthetics, but rather 'a certain kind of temperament, the power of being deeply moved by the presence of beautiful objects'.[18] In his once notorious conclusion to the book, he describes what this temperament is like; 'To burn always with this hard, gemlike flame,' he wrote, 'to maintain this ecstasy, is success in life':

> Well! we are all *condamnés* as Victor Hugo says: we are all under sentence of death but with a sort of indefinite reprieve – *les hommes sont tous condamnés à mort avec des sursis indefinis*: we have an interval, and then our place knows us no more.[19]

Some, says Pater, spend this interval in listlessness, some in high passions, but the wisest, at least among '"the children of this world"', in art and song. For, Pater argues, our one chance lies in 'expanding that interval, in getting as many pulsations as possible into the given time'. The best way of ensuring this is through 'the poetic passion, the desire of beauty, the love of art for its own sake'. For art, says Pater, 'comes to you proposing frankly to give nothing but the highest quality to your moments as they pass, and simply for those moments' sake'.[20]

In a way which almost seems to prefigure existentialism, Pater

conceives of the individual human subject as surrounded by a miasma of impressions, which it surveys from behind a wall of personality. 'Experience,' he writes, 'already reduced to a swarm of impressions, is ringed around for each one of us by that thick wall of personality through which no real voice has ever pierced on its way to us, or from us to that, which we can only conjecture, to be without. Every one of those impressions is the impression of an individual in his isolation, each mind keeping as a solitary prisoner of its own dream world.'[21]

Under these circumstances, we have to be forever curiously testing new opinions and courting new impressions. Aesthetic impressions are of peculiar importance to Pater, because they are one of the few remaining means through which we can hope to transcend this prison of the self; he even argues that there is 'some close connection between what may be called the aesthetic qualities of the world about us and the formation of moral character'. Pater's theory of aesthetic expression, rather than of aesthetic response, reflects this view. Thus he writes:

That the mere matter of a poem, for instance its subject, namely, its given incidents or situation – that the mere matter of a picture, the actual circumstances of an event, the actual topography of a landscape – should be nothing without the form, the spirit of the handling, that this form, this mode of handling, should become an end in itself, should penetrate every part of the matter.[22]

This, Pater says, is what all art constantly strives after, and achieves in different degrees. Inevitably, such thinking was bound up with a peculiarly modern preoccupation with the objects of art and the world. 'Each art,' Pater taught, 'has its own peculiar and untranslatable sensuous charm, has its own special responsibilities to its material.'[23]

In Pater's view, we apprehend the aesthetic qualities of the world, and of works of art, through neither the intellect nor the senses, or on their own, but rather through a faculty Pater calls 'imaginative reason'. He stresses that 'art addresses not pure sense, still less the pure intellect, but the "imaginative reason" through the senses.' Art, says Pater, is always striving 'to get rid of its responsibilities to its subject or material; the ideal examples of poetry and painting being those in which the constituent elements of the composition are so welded together that the material or subject no longer strikes the intellect only: nor the form, the eye or the ear only; but form and matter, in their union or identity, present one single effect to the "imaginative reason", that complex faculty for which every thought

and feeling is twin-born with its sensible analogue or symbol.'[24]

It is this faculty of 'imaginative reason' which, in Pater's system of things, replaces Ruskin's *theoria*. And yet, ultimately, for all the Platonic resonances in his thought, Pater remains a materialist: he emphasises the finite biological conditions of our existence, the fact that it is through the senses we experience a common world, at least for an interval, after which we simply cease to be. Pater may have regarded religion as the custodian, or curator, of 'imaginative reason', yet he himself never seems to have regarded this faculty as anything other than specifically *human*.

If, for Pater, aesthetic experience needed to cling to the numinous to ensure its own existence, with Whistler we find a much sharper and harsher break: the severance between art and moral, or spiritual, life is, for the first time in English culture, pressed to extremes. Whistler, it should be said, was an American, with a predilection for contemporary Parisian tastes and no deep grounding in, or understanding of, European aesthetic traditions. Concerning Pater, Ruskin held his peace: but Whistler went too far. In 1877, Ruskin wrote an issue of *Fors* in which he returned to a familiar theme – namely that no art of man is possible 'without those primal Treasures of the art of God'. In the course of his argument, Ruskin proclaimed that he had seen, and heard, much of Cockney impudence; 'but never expected to hear a coxcomb ask two hundred guineas for flinging a pot of paint in the public's face'. With remarkable perspicacity, Ruskin remarked: 'Landscape, and living creatures, and the soul of man, – you are like to lose them all, soon.'[25] This issue of *Fors* led to a notorious libel suit, as a result of which Whistler was awarded a farthing damages.

Now it has sometimes been remarked as strange that the protagonist of Turner should have developed such an antipathy to the creator of the *Nocturnes*, which have been seen as echoing the appearance of Turner. And yet we should not forget that, if Whistler's painting involved any appeal to Turner, it was to those abstracting aspects of the late Turner for which Ruskin had the least respect. Moreover, Whistler's sensibility, even more than his style, differed from that of Turner: for Whistler, an American, imported into British art theory a hedonistic and sensual conception of aesthetic life.

In Whistler's writing we find no appeal to religion, and indeed no concept of imaginative reason, and a denial of the significance of the representational and symbolic dimensions of art. For Whistler, influenced by scientism, art seemed to be a matter of sensation alone;

and so, for Ruskin, he seemed to reduce the feelings of the beautiful to those sensations which we share 'with spiders and flies'.

Whistler complained that 'The people have acquired the habit of looking not *at* a picture, but *through* it, at some human fact, that shall, or shall not, from a social point of view, better their mental or moral state.'[26] But he himself denigrated such 'literary' points of view: all that seemed to matter was 'the amazing invention that shall have put form and colour into such perfect harmony'.[27] Thus Whistler said: 'Art should be independent of all clap-trap, should stand alone, and appeal to the artistic sense of eye or ear, without confounding this with emotions entirely foreign to it, as devotion, pity, love, patriotism, and the like.'[28] Such sentiments, Whistler insisted, had no kind of concern with art, and that, he explained, was why he insisted on calling his works 'arrangements' or 'harmonies'.

Here, then, we have the radical rupture with the universe of Pater, and, of course, with Ruskin: for Pater remained faithful to Ruskin to the degree that, for him, the aesthetic was a domain of human experience which, though closely related to simple sensations and impressions, was ultimately irreducible to them. For although Pater refused any appeal to divine, supernatural, or 'spiritual' elements, yet he recognised the proximity of art to that which men and women have historically endeavoured to express through their religious beliefs and practices. For all Pater's incipient relativism, art never entirely subsumed ethics in his way of thinking, and there are moments when he feels compelled to appeal to ethics to validate art. Thus he remarks that the distinction between great art and good art depends not on that question of form upon which he has elsewhere placed such emphasis, but rather on whether such art 'be devoted further to the increase of men's happiness, to the redemption of the oppressed, or enlargement of our sympathies with each other, or to such presentment of new or old truth about ourselves and our relation to the world as may enable and fortify us in our sojourn here'[29] – which, but for the absence of any specific reference to the divine, is very much as Ruskin himself might have said. What took art beyond the domain of mere impression, in Pater's thought, was its association with the critical faculty of 'imaginative reason' which, though he never fully explained it, seemed linked to a process of symbolic transformation.

For Whistler, art was altogether a more mundane thing: it had no connection with the great themes of human life; it was, in essence, a matter of retinal and auditory effects pursued for their own sakes,

though why some such effects were more pleasing than others, or, indeed, why any of them appeared pleasing at all, were not matters Whistler endeavoured to explain. Art, for Whistler, was something set apart, something ultimately self-referential.

And yet, before we blame Whistler for so much that was to come later, we must note a difference between his provocative talk about art and his practice as a painter. For, whatever he *said*, Whistler never was, nor ever really approached, the position of a formal abstractionist. 'Take the picture of my mother,' he once wrote, 'exhibited at the Royal Academy as an *Arrangement in Grey and Black*. Now that is what it is. To me it is interesting as a picture of my mother; but what can or ought the public to care about the identity of the portrait.'[30]

None other than that belligerently sensualist aesthete Algernon Charles Swinburne was the first to point out the discrepancy between what Whistler advocated and what he in fact did. Swinburne himself purported to believe that 'The one fact for (art) which is worth taking 'account of is simply mere excellence of verse or colour, which involves all manner of truth and loyalty necessary to her well-being.' But Swinburne noted of Whistler's paintings that they contain many qualities 'which actually appeal to the mind and heart of the spectator'. It would, said Swinburne, be quite useless for Whistler to protest that he never meant to put 'intense pathos of significance and tender depth of expression into the portrait of his own venerable mother'. For, he says, the scandalous fact remains that he has done so; and this, I think, is not to be denied.

Nor is it just a case of the sensitive expression in Whistler's portraits; for he always relied upon nature, however much he transformed her. Whistler explained this by arguing that the artist looks on nature 'with the light of the one who sees in her choice selection of brilliant tones and delicate tints, suggestions of future harmonies'.[31] Nonetheless, it remains true that Whistler never saw such 'future harmonies' *except* through natural form; indeed, Whistler attended to certain kinds of effects over and above other kinds of effects, apparently because they evoked certain emotional resonances in him; and these, by and large, were the effects he tried to reproduce in his paintings.

For example, Whistler objected to the way in which tourists would pick out a detail – say a traveller on the top of a mountain – while failing to respond to the dignity of the snow-capped summit. Ruskin, of course, was drawn to both detail *and* cloud-swathed, misty peaks.

Whistler seemed to relish ambiguously cloudy scenes of engulfment where the self and objects in the world seemed to dissolve into the same flux. He wrote:

And when the evening mist clothes the riverside with poetry, as with a veil and the poor buildings lose themselves in the dim sky, and the tall chimneys become campanali, and the warehouses are palaces in the night, and the whole city hangs in the heavens, and fairy-land is before us – then the wayfarer hastens home; the working man and the cultured one, the wise man and the one of pleasure, cease to understand, as they have ceased to see, and Nature, who, for once, has sung in tune, sings her exquisite song to the artist alone, her son and her master – her son in that he loves her, her master in that he knows her.[32]

Whistler denied it was of any significance that his forms represented objects in the world; moreover, he seemed oblivious of the way in which those forms might also be expressive of his own inner sentiments, his longing for an affective union with that world. Even so, there is every indication that such power as his paintings possess is heavily dependent on the way in which he was able to hit upon forms which give a concrete embodiment to that relationship. Indeed, Whistler's rhetoric notwithstanding, it might be said that – to use Pater's categories – Whistler's pictures appeal not so much to mere 'impressions' (deriving from arrangements of pure colour and tone), but rather, through their peculiar union of form and content (or 'matter' in Pater's sense), aspire to that 'imaginative reason' by which mere sensation is transformed; another way of putting this might be to say that Whistler's talk about art refuses any understanding of the role of imagination and symbolisation in the creation of a successful picture; but his paintings rely heavily on both.

* * *

I first came across the aesthetes when I was an adolescent at a time when my own religious belief was beginning to falter. Beneath the castellated Gothic Revival architecture of a minor public school on the edge of Epsom downs, a few of us, rebels and misfits to a man, surreptitiously read such books as *The Green Carnation*, William Gaunt's *Aesthetic Adventure*, a racily readable account of the *fin de siècle* sensibility, and Huysmans's *A Rebours* – the epitome of that Parisian *libertinage* so despised by Ruskin and Holman Hunt. My first encounter with left-wing politics was through Oscar Wilde's *The Soul of Man Under Socialism* – a book which looks forward to the

establishment of Socialism because it 'would relieve us from that sordid necessity of living for others'.

The spell of Wilde fell upon me; and when I went to Cambridge in 1964 I did not find it entirely strange that the Gothic crockets were awash with the fumes of marijuanah, the sights of psychedelia, and the disconnected sounds of Ravi Shankar and *Sergeant Pepper's Lonely Hearts Club Band*. And, retrospectively, the tragedy of those two 'moments' ran a similar course, too. For, at the end of the nineteenth century, the pursuit of *aesthesis* ended in despair; Wilde trod the road to Reading Gaol. 'Lilies that fester . . .' The hedonism of the 1960s similarly petered out in unprepossessing court cases, like the trial of *Oz* magazine's 'School Kids' issue, and a general disillusionment with those libertarian values we had so enthusiastically pursued only a few years before.

My brands of 'art for art's sake', ancient and modern, were crumbling even before they destroyed themselves on the reefs of politicisation which swept through the colleges in the late 1960s and early 1970s. Certainly, by the time I left Cambridge in 1968, I was inclining towards hard-core 'political' magazines, like *Black Dwarf* and *Seven Days*, which, between 1971 and 1972, failed to shake the world. We kept our distance from the waning and increasingly decadent and masturbatory world of *Oz*, *Friends*, the *International Times* and what have you, although we faithfully recorded their trials and tribulations in our publications, believing that in some vague and unspecified way they were part of the solution, rather than the problem.

The new New Left subscribed, increasingly, to a Marxist conception of art, in which the celebration of the new productive forces almost entirely replaced any sense of aesthetic sensibility. Even if it was sometimes remembered that the early Marx, at least, had offered a vision of a new sensuous aesthetic relationship between man and the world, that vision was regarded as of ever diminishing significance. Indeed, Althusser, and like-minded French mechanical 'structuralists', gained such a philosophical ascendancy in Marxist circles that belief in an 'epistemological break' – or a definitive rupture between the thinking of the early and the 'mature' Marx – became almost *de rigueur*. In this situation, Walter Benjamin's dream of the destruction of the aesthetic aura, and the melting down of the old bourgeois forms into an 'incandescent liquid mass', came to capture the imagination of the young. But the enthusiasm with which I embraced such credos had, at least, been tempered by that chance encounter with Ruskin's

theories. And through him, slowly, I was to discover the limits not only of aestheticism, but also of those materialist and productivist aesthetics into which the aestheticist position so often transmutes.

14
An Earthly Paradise?

It was not only in the late 1960s that aestheticism, having slipped the leash of religion, sought to acquire a new yet more mundane theoretic content by attaching itself to the secular faith of Socialism. Among those who tried, unsuccessfully, to bring about a marriage between art and Socialism was another of Ruskin's followers – William Morris.

In 1984 a William Morris commemorative exhibition was held in London. In the catalogue, Ray Watkinson wrote that, as we went round the exhibition, 'Ruskin will be at one elbow, Marx at the other.'[1] If Ruskin's ideas and those of Marx had anything in common, it was the fact that they were both enemies of the existing order. But the aesthetics of Marx and Ruskin are irreconcilable. For Ruskin, even when plunged into religious doubt, never ceased to teach that medieval man had found freedom in that very 'fetishistic' work whose final overthrow Marx so resolutely awaited; and Ruskin preached the necessity of reverence for that natural order whose subjection to man's will Marx and Engels identified with the emancipation of humanity.

And yet Morris did try to weld the teachings of Ruskin and those of Marx into a single system. When I was a student, dining every night surrounded by the refurbishments of Morris, Marshall, Faulkner and co. in Peterhouse Great Hall, it was tacitly assumed that Morris was a kind of filter, or conduit, who had strained the dross out of Ruskin and passed on the residue to a secular, modern, and (as it was seen in those days) Marxist order. For many, Morris was a 'pioneer of modern design' – that is of those 'productivist' aesthetics for which Marxism provided the theoretical justification. More recently, E. P. Thompson has argued that Morris may be assimilated to Marxism only through a process of self-criticism and reordering within Marxism itself. According to this view, Morris brings to the Marxist tradition from the English Romantic tradition the conscience, aesthetic and ethical which Marxism otherwise lacked.[2]

The first of these positions exercised me as a student; but deeper study of Morris soon convinced me it was wrong, and, under Thompson's influence, I progressed to a version of the second. Today, I believe that neither of these 'readings' of Morris will do. Morris was a fine lyric poet, and a marvellous pattern-maker; he was among the latest, and arguably one of the greatest, embodiments of the medieval artist. But his thinking was based on a more serious contradiction than that commonly attributed to him by his critics (i.e. his espousal of Socialism while ministering to the 'swinish luxury' of the rich). For Morris appealed to the arts of *theoria* in order to justify the spread of *aesthesis*: he invoked the glories of the Gothic to celebrate a sensualist aesthetic: he spoke as if socialism could render agonising on Dover Beach, Pegwell Bay, or the shores of Lake Coniston, superfluous. No wonder that those who have come after have made of his work whatever they have wished.

<p align="center">* * *</p>

'How deadly dull the world would have been twenty years ago but for Ruskin!' wrote Morris in 1894, two years before his death. 'It was through him that I learned to give form to my discontent.'[3] Admirers of Morris, suggests Jennifer Harris in her study of his Medievalism, are sometimes unwilling to admit the extent of his debt to Ruskin. But, she says, 'it would be difficult to find many points in his work, from his interest in calligraphy to architectural conservation, which were not previously covered or at least suggested somewhere in Ruskin'.[4] Nor was Morris stinting in his acknowledgement of Ruskin's influence.

Perhaps their most fundamental similarity lay in the fact that, from the beginning, Morris's ideas were rooted in a response to the world of nature. Like Ruskin, Morris is haunted by a dream of Eden. Yet Paul Meier, a French Marxist, rightly distinguished between Ruskin's view of nature and his disciple's. According to Meier, Alpine torrents were, for Ruskin, 'iridescent sinews of a divine essence', but, for Morris, 'the banks of the Thames' were 'filled with the simple delight of an angler'.[5] However uncongenial Meier's dogmatism may be, it is impossible to contest his view that Morris leaves Ruskin with creation, original sin, and 'divine finalities', and is himself 'satisfied with "pleasure" and "contentment in this world"'. For Morris, Meier remarks, 'the sensual love of nature, source of all art, was of more importance than religious passion': but the question remains whether

Ruskin's 'religious passion' or Morris's 'sensual love' led to the more realistic vision of man's relationship to nature.

Morris's view of the world may be distinguished from that of Marx in that he appeared to accept Ruskin's arguments about the nature of Gothic. In 1888, five years after his conversion to Socialism, Morris looked back over the successes and failures of the Gothic Revival and argued that, by 'a marvellous inspiration of genius', Ruskin had 'attained at one leap to a true conception of medieval art which years of minute study had not gained for others'.[6] Morris cited, in particular, the chapter 'On the Nature of Gothic and the Function of the Workman therein' from *The Stones of Venice*. Towards the end of his life, Morris issued an edition of this chapter as a pamphlet and described it as one of the few necessary utterances of the nineteenth century. Ruskin, Morris wrote elsewhere, had 'showed us the gulf which lay between us and the Middle Ages. From that time all was changed; ignorance of the spirit of the Middle Ages was henceforth impossible, except to those who wilfully shut their eyes.' Morris insisted that the essence of Ruskin's teaching was, 'like all great discoveries', simple enough: 'It was really nothing more recondite than this, that the art of any epoch must of necessity be the expression of its social life, and that the social life of the Middle Ages allowed the workman freedom of individual expression, which on the other hand our social life forbids him.'[7]

Morris may have become a Marxist, yet at the root of Marxism lay a contempt for the Gothic conception of art and of labour; Morris's vision of realised Communism is, in effect, of the Gothic without God. Morris was a less faithful disciple of Ruskin's aesthetic ideas than he liked to pretend. 'Art,' Morris once wrote, 'is man's expression of his joy in labour. If they are not Professor Ruskin's words they embody at least his teaching on this subject.' Morris went on to insist that no truth more important had ever been stated; 'for if pleasure in labour be generally possible, what a strange folly it must be for men to consent to labour without pleasure; and what a hideous injustice it must be for society to compel most men to labour without pleasure'.[8]

But how true was it, in fact, to say that the phrase 'joy in labour' is an embodiment of Ruskin's teaching? Ruskin (unlike Marx) saw in the variety and idiosyncrasies of Gothic architecture a guarantee of the life and labour of every workman who struck the stone. For Ruskin, the 'glory of Gothic architecture' resided in the fact 'that every jot and tittle, every point and niche of it, affords room, fuel,

and focus for individual fire'.[9] And yet it would be wrong to reduce this to a defence of 'freedom of individual expression', let alone of pleasure in labour. Morris's interpretation of Ruskin brings to mind the objections Ruskin himself voiced concerning the decorative work freely executed by the O'Shea brothers on the Oxford Museum. Ruskin explained that he had never meant that 'you could secure a great national monument of art by letting loose the first lively Irishman you could get hold of'. For Ruskin – though *not* for Morris – 'All noble art is the expression of man's delight in God's work; not his own.'[10]

Of course, Ruskin has plenty to say about the role of joy and pleasure in ornamental work; but it is inconceivable that he would have identified art with joy in labour. For, with the phrase, 'If they are not Professor Ruskin's words ...', Morris conjures away the whole heavy depth of Ruskin's labour, 'the suffering in effort', and 'that quantity of our toil which we must die in'. Morris does not seem to have thought about what Ruskin wished to teach his Oxford students when he took them road-building. 'That which man can create without toil,' Ruskin wrote, 'is worthless.'[11]

Just before his death, Morris admitted: 'Apart from the desire to produce beautiful things, the leading passion of my life has been and is hatred of modern civilization.'[12] Morris makes it clear that his principal reasons for espousing Socialism were *aesthetic*. He explains how the study of history and the love and practice of art forced him into hatred of civilisation, 'which, if things were to stop as they are, would turn history into consequent nonsense, and make art a collection of the curiosities of the past which would have no serious relation to the life of the present'.[13]

He went on to explain that 'the consciousness of revolution' had prevented him, 'luckier than many others of artistic perceptions', from 'crystallizing into a mere railer against "progress" on the one hand, and on the other from wasting time and energy in any of the numerous schemes by which the quasi-artistic of the middle classes hope to make art grow when it has no longer any root'.[14] Thus, he says, he arrived at 'practical' Socialism.

Morris's most consistent vision of what he hoped would issue forth from this is *News from Nowhere*, in which he paints a picture of a future Communist society in which the inhabitants 'live amidst beauty without any fear of becoming effeminate', and enjoy a 'second childhood of the world'.[15] England, which was once 'a country of huge

and foul workshops and fouler gambling-dens, surrounded by ill-kept, poverty-stricken farms, pillaged by the masters of the workshops', has become transformed into 'a garden, where nothing is wasted and nothing is spoilt, with the necessary dwellings, sheds, and workshops scattered up and down the country, all trim and neat and pretty'.[16] Old Hammond, the commentator on this utopia, observes that its inhabitants 'should be too much ashamed' if they 'allowed the making of goods, even on a large scale, to carry with it the appearance, even, of desolation and misery'.[17] The difference between town and country has grown less and less: even in central London, each house stood 'in a garden carefully cultivated, and running over with flowers. The blackbirds were singing their best amidst the garden-trees, which, except for a bay here and there, and occasional groups of limes, seemed to be all fruit-trees: there were a great many cherry-trees, now all laden with fruit: and several times as we passed by a garden we were offered baskets of fine fruit by children and young girls.'[18]

All signs of pain, poverty, and ruin – even 'tumble-down pictur-esque' – have been eradicated; Hammond explains that, like 'the medievals', the inhabitants 'like everything trim and clean, and orderly and bright; as people always do when they have any sense of architec-tural power; because then they know that they can have what they want, and they won't stand any nonsense from Nature in their dealings with her'.[19]

This not standing of 'any nonsense from Nature' is everywhere much in evidence; revolution has brought with it not just a better ordering of social and economic life, but general *happiness* and benefi-cence; '*all* work is now pleasurable'; even middle-aged women show no signs of ageing: indeed 'almost all our women are both healthy and at least comely' – and we hear nothing of those who are not. Though it is England, the sun is always shining, and no one seems to be ill, insane or even deeply troubled; we are back in Holman Hunt's Pre-Raphaelite orchards of the early 1850s; only this time there is no death's-head moth, no hint of sin or an impending Fall.

The abolition of private property has eliminated evil of every kind. Crime has been reduced to 'a mere spasmodic disease, which requires no criminal law to deal with it'; the greater part of violent crime in past days was, apparently, merely a derivative of 'the laws of private property'; even vicious acts which sprang from 'the artificial perversion of the sexual passions' were, at bottom, caused by 'the idea (a law-made idea) of the woman being the property of the man, whether he

were husband, father, brother, or what not'.[20] Divorce courts have
been abolished: 'property quarrels being no longer possible, what
remains in these matters that a court of law could possibly deal with?'
All the institutions of government, education, law, authority, art and
punishment have withered away; the Houses of Parliament have
become a 'storage place for manure'.[21]

In Morris's utopia, high culture and the fine arts have disappeared
too: 'what used to be called art . . . has no name amongst us now,
because it has become a necessary part of the labour of every man
who produces'.[22] But everything, and everyone, is encrusted with
radiantly coloured adornments and dressed in clothes which, for a
nineteenth century observer, suggest those of the fourteenth century.
The people, we are told, are 'beauty-loving'; the evocation is of a
modern Gothic world – but without God. A great hall in
Hammersmith Broadway is built in 'a splendid and exuberant style
of architecture, of which one can say little more than it seemed . . .
to embrace the best qualities of the Gothic of northern Europe with
those of the Saracenic and Byzantine, though there was no copying of
any one of these styles'.[23] Every page flashes with 'damascened steel',
'filigree silver-work', 'breeches of worsted velvet', rich mosaics, and
'the gleam of gold and silk embroidery', 'lead-glazed pot-ware',
'elegantly-built much ornamented houses', even a Golden Dustman
of Hammersmith. For Morris, the purpose of post-revolutionary life
is *aesthesis*, or decoration for its own sake. 'The energies of mankind',
we are told, are chiefly of use to them for ornamental activity: 'for in
that direction I can see no end to the work, while in many others a
limit does seem possible'.[24]

* * *

In one sense, of course, it comes as a shock after all this to find William
Morris proclaimed as one of the pioneers of Modern Design, as
Nikolaus Pevsner described him in his book of that name published
in 1936. According to Pevsner, William Morris was 'the true prophet'
of the twentieth century because he believed that art should not be
for a few, but for all. 'We owe it to him,' Pevsner wrote, 'that an
ordinary man's dwelling-house has once more become a worthy object
of the architect's thought, and a chair, a wall-paper, or a vase a worthy
object of the artist's imagination.'[25] Here, for Pevsner, resided the
'fundamental meaning' of Morris's life and work. Unfortunately,
Morris was held back from the full realisation of this meaning of his

life by something Pevsner describes as his 'historicism', or the way in which Morris 'remained committed to nineteenth century style and nineteenth century prejudices'. He suffered, Pevsner thought, from an unfortunate 'hatred towards modern methods of production' and tended to look back to the medieval world, rather than towards the 'progressive' era of complete mechanisation. The full implications of that era were, in Pevsner's view, only to be realised by another generation of German and American architects who were prepared to 'progress' beyond Morris, and the English Arts and Crafts Movement, by declaring their faith in a machine-based aesthetic. Thus, Pevsner reasoned, 'Morris had started the [modern] movement by reviving handicraft as an art worthy of the best men's efforts.'[26]

For more than forty years, this sort of interpretation of Morris was not just commonplace, but orthodox; it was the received wisdom of authors as diverse as Gillian Naylor, the historian of the Arts and Crafts Movement, and Ray Watkinson, Communist, craftsman and scholar of Morris's design theories. Morris was almost universally regarded as a proto-modernist who was fulfilled by the arrival of the Bauhaus. 'Stylistically,' Watkinson wrote, 'the characteristic Bauhaus product was utterly alien to anything of Morris's own production; but it was made in his spirit.'[27]

Gillian Naylor and myself were among the first to challenge this argument, which was presented in the catalogue to the Institute of Contemporary Arts' 1984 exhibition *William Morris Today*, a disgracefully biased exhibition for which, as it happens, Watkinson was largely responsible. Naylor argued that the 'style' of the modern movement as interpreted by Pevsner would 'of course, have been rejected by Morris'; she suggested that, with his love of the imagination, he would have preferred Surrealism.[28]

I also argued that in design terms Morris was not just anti-modern, he was profoundly *reactionary*, and therein lay his strength.[29] Later I pointed to the way Pevsner contrasted Morris's chintz, *Honeysuckle*, with a silk shawl exhibited at the Great Exhibition by the now forgotten E. Hartneck, a Frenchman. Pevsner claimed that the dependence of Morris on past styles had been exaggerated.[30] There was, he believed, a 'fundamental novelty' to *Honeysuckle*, exemplified in its clarity and sobriety. He said that this 'revival of decorative honesty' counted for 'far more than any connexion with bygone styles', and dismissed the shawl as a 'thoughtless concoction' and as 'bad imitation vulgarizing eighteenth century licence'.[31]

There were problems with Pevsner's reasoning. Morris designed *Honeysuckle* in 1876 – the year when, as it happens, he made his first designs for woven fabrics. He had just been appointed an Examiner of students' work in the South Kensington Museum; thanks to the researches of the late Peter Floud, we now know not only that he took advantage of the opportunity to study the medieval textiles there, but even which examples he was looking at and when.

Floud demonstrated how, between 1876 and 1883, most of Morris's print designs were based on rigid 'turn-over' patterns – where the motifs form mirror-images on either side of a vertical axis. He argued that in that period Morris abandoned the 'naturalism' of his earlier work in favour of 'the use of conventional symbols derived from a study of historic textiles'.[32]

In relation to Morris's contemporaries, his approach to pattern-making was conservative; it was based on a refusal of what nineteenth century industrialism had to offer. The work of a younger generation of designers, like Lewis Day and Christopher Dresser, was becoming more and more abstract and divorced from existing precedents. They were consciously designing for industrial production. When he made *Honeysuckle*, Morris intended to teach them a lesson about the qualities of what they were jettisoning.[33]

Honeysuckle did not even show that unity of form and mechanical process characteristic of modern design. For the 'turn-over' type of pattern Morris exploited here was appropriate for weaving, but not for block-printing. It is most unlikely that Morris would have used a 'turn-over' pattern for a block-printed chintz unless he had woven textiles in mind. Unlike Floud, I believed that *Honeysuckle* was a magnificent design, justifying the view of those who have claimed Morris was the greatest pattern-maker to have arisen in the West since the decline of Gothic. But, I argued, there was nothing *progressive* about this pattern, and no way in which, visually at least, it might be said to have prefigured modern design: 'decorative honesty' can no more be identified with eradication of decoration than financial probity can be identified with burglary.

Morris's reactionary design aesthetics could be correlated with his views about the necessary relationship between art and labour. Many nineteenth century design theorists were preoccupied by the idea of discovering a 'scientific' form of ornament, which could be applied, like a transfer, to a range of products and materials – thus increasing their price. (In other words, they saw the roots of ornament in

economic rather than in 'natural' life.) In his *Principles of Decorative Design* of 1873, Thomas Dresser argued that, in the hands of one man, a given amount of clay could be turned into flowerpots worth eighteen pence a cast, whereas, in the hands of another, it could be turned into valuable vases, 'worth five pounds, or perhaps fifty'. The dream was to invent machines that could produce £50 vases on every throw – hence the encrustrations of high Victorian design; mechanical ornament seemed to be an alchemical stone which could invest clay and iron with a price far beyond that of gold. Both Dresser and Morris saw through this and reasoned, as Ruskin had done before them, that mechanical ornament was a dead and valueless accretion. Dresser went on to lay the ground rules of modern machine aesthetics; but Morris argued that a machine could make anything – except a work of art. He celebrated true ornament as the material embodiment of 'joy in labour' and of 'man's delight in beauty'. 'All the heaped-up knowledge of modern science, all the energy of modern commerce, all the depth and spirituality of modern thought,' he wrote, 'cannot reproduce so much as the handiwork of an ignorant, superstitious Berkshire peasant of the 14th century; nay of a wandering Kurdish shepherd.'[34]

The 'pioneer' modernists, however, including most of those among them who were Socialists, pursued some version of 'productivist' aesthetics. They developed variants of those aesthetic ideas held by the more 'avant-garde' industrial producers. Indeed, by the end of the century, European architects like Otto Wagner and Adolf Loos were identifying the eradication of ornament with cultural advancement. Wagner anticipated a 'coming Naissance' of 'horizontal lines such as were prevalent in Antiquity, table-like roofs, great simplicity and an energetic exhibition of construction and materials'. He celebrated the growing use of iron in architecture. For Loos, too, engineers were 'our Hellenes. From them we receive our culture.'[35] Notoriously, he equated ornament with crime, and condemned it because it seemed to him to be an instance of regressive sensuality which modern man – unlike children, primitive peoples, aristocrats and criminals – could well do without. But he also opposed ornament on economic grounds. 'If I pay as much for a smooth box as for a decorated one,' Loos reasoned, 'the difference in labour time belongs to the worker. And if there were no ornament at all – a circumstance that will perhaps come true in a few millennia – a man would have to work only four hours instead of eight, for half the work done at present is still for ornamentation. Ornament is wasted labour.'[36]

I came to think it absurd to claim Morris, a Gothicist, as a forerunner of all this. He retained enough of Ruskin *never* to reduce the value of a man's labour to economics. And yet, recently, I have begun to wonder whether there was not, after all, *something* in Pevsner's 'reading'. For Morris was at least a 'modernist' in Ruskin's sense of the word. 'Modernism,' he believed, 'began and continues, wherever civilisation began and continues to *deny* Christ.' And a denial of the spirituality of nature and of art lies at the core of Morris's teaching; Morris, in effect, wants the aesthetic pleasures of the Gothic world without the burdens of the faith through which they were created. But if beauty is just a matter of pleasure and efficiency, then logic will inexorably dictate a 'look' much more like modernism than like Gothic.

*　　*　　*

We must now return to the commonplace judgement that, compared to Ruskin, the religious fantasist, Morris was the greater 'realist', with a sounder grasp of 'practical' necessities. After his death Morris was remembered as a late Victorian romantic, a pioneer of the Arts and Crafts Movement, and a utopian Socialist of a peculiarly English persuasion. In the 1930s, when he was revalued as a pioneer modernist, Morris's writing in general, and *News from Nowhere* in particular, were acclaimed as 'pure' Marxist texts – and much was made of the exclusion from the collected edition of Morris's writing of some of his political tracts and journalism. The Marxist view of Morris was first crudely, but vociferously, advanced by Robin Page Arnot. Of course, claimed Arnot, Morris had been a great artist and craftsman; but *'neither his art nor his craftsman's work can be truly understood, nor can the whole man be understood, unless he is seen as he really was, as a revolutionary Socialist, fighting for the overthrow of capitalism and for the victory of the working class.'* For Arnot, *'the essence of* News from Nowhere *is the insistence on the necessity of an armed rising and bitter civil war as the only path to Socialism for the working class.'*[37] (Arnot's italics.) This sort of 'reading' of Morris was advanced by the first edition of E. P. Thompson's biography, published in 1955, and was reinforced by a spate of similarly minded volumes – like Meier's – which assured those who read them that they could take Morris seriously because, despite Engels' comments to the contrary, he was a true Marxist.

Understanding of Morris began to change with the break-up of the

Marxist-modernist hegemony over cultural life in the late 1970s; in a second edition of his biography, published in 1977, Thompson said that the 'claiming' of Morris for this or that tendency had less purpose than he had himself once supposed. The important question might be not whether Morris was or was not a Marxist, but whether he was a Morrisist; 'and if he was, whether this was a serious and coherent position in its own right?'[38]

Thompson then argued strongly against those who had interpreted Morris as a Romantic who had 'superimposed' elements of Marxism which he had failed to integrate. He referred to a 'narrowing ortho-doxy' in the Marxist tradition generally; and to the rise of determinism and positivism. He went on to say that what might be involved in 'the case of Morris' was the whole problem of the subordination of the imaginative and utopian faculties within the Marxist tradition; Thompson referred to the 'lack of a moral self-consciousness or even a vocabulary of desire' within Marxism. Morris's writing provided 'an education of desire' and a vindication of utopianism and 'set it free to walk the world once more without shame and without accu-sations of bad faith'.[39] Morris, Thompson now claimed, might be assimilated to Marxism only in the course of a process of self-criticism and reordering within Marxism itself. Or rather, he explained, Marx-ism required 'less a re-ordering of its parts than a sense of humility before those parts of culture it can never order'. After all, '"Marxism", on its own, we now know, has never made anyone "good" or "bad" . . . So what Marxism might do, for a change, is sit on its own head in the interest of Socialism's heart.'[40]

All this seemed congenial to me as I shook off the tatters of Marxist and modernist modes of thinking and, for a short time, I preferred to call myself, après Thompson, a 'Morrisian', rather than a Marxist. But I soon began to realise that if Morris was to be distinguished from Marx, that distinction lay almost entirely in what he owed to Ruskin; that Thompson was, in effect, pointing towards those aspects of Ruskin's thinking which Morris had refused to jettison despite his encounter with Marxism. The question then arose in my mind as to how, and in what ways, that encounter with Marxism had, as it were, *improved* Morris's Ruskinism.

Take first their respective views of *nature*. Morris's thinking, and his aesthetics, involved the view (shared by both Marxists and 'pro-gressive' industrialists) that, having dispensed with God, man might expect to triumph over nature, and mould it to his needs, with

impunity. Morris's Socialist thinking is permeated by the idea that all the impediments to human happiness are bound up in the institution of private property and the class structure deriving therefrom. In Morris's imagination, social revolution restores a primal state of bliss and beauty, in which the sun, literally, always shines. Is this really, as Thompson claims, the education of desire? Ruskin was at least well aware that man could not eat of the Tree of Knowledge without paying a very high price; if one embraced a secular and scientific concept of the natural world, one had to be prepared to risk losing the consolations of beneficence. Even when shaken by religious doubts, Ruskin never assumed that man could simply expel God and proceed to build for himself that kind of earthly paradise which Morris described in *News from Nowhere*.

Most commentators have praised Morris for his more 'progressive' attitude towards industrialisation and new technologies. Machines, for Morris, could do anything except aesthetic work. Ruskin took a more pessimistic view; for him there was something terrible in the process of industrialisation itself, something which deprived men and women of that which made labour meaningful, and, ultimately, seemed to upset the unity between man and the natural world. It is simply wrong-headed to celebrate *News from Nowhere*, and to dismiss 'The Storm-Cloud of the Nineteenth Century' as some sort of by-product of industrial pollution, or as paranoid delusion. Indeed, even if we cannot accept the technological premises of Ruskin's argument, we who live in the shadow of the mushroom cloud of the twentieth century, and in the era of Chernobyl, acid rain, and clouds of poisonous gas, ought, perhaps, to be able to recognise the prophetic realism of his imagination. Development of the forces of production did not lead, in the 1950s, or at any other time, anywhere, to the creation of societies which resembled bucolic, richly ornamented, garden cities.

Gregory Bateson, the anthropologist, who was not himself a religious man, once argued that the loss of the idea of the immanence of God within nature carried with it a threat which went beyond merely intellectual, or even spiritual, *angst*. Bateson argued that if you projected the idea of God beyond creation, and set him against it, if you came to see yourself in the role of a god, in relation to nature, then 'you will logically and naturally see yourself as outside and against the things around you'. And, he maintained, if you arrogate all mind to yourself, then you will come to see the world as somehow

mindless, and therefore unworthy of moral, ethical, or aesthetic consideration. 'The environment will seem to be yours to exploit.' He added that if this is 'your estimate of your relation to nature *and you have an advanced technology*, your likelihood of survival will be that of a snowball in hell'.[41]

For Ruskin, modern productive process meant man's abrogation of God's role: to labour without effort was God's prerogative, not man's. We may smile at such formulations, but, whatever their limitations, we ought perhaps to admit that they are more 'realistic' than Morris's identification of art as joy in labour. Ruskin's sense of labour as also deriving its meaning from that 'suffering in effort' which it involves certainly seems closer to common experience; and Morris's facile identification of work and pleasure does, despite his strictures, seem to glide irresistibly towards a celebration of industrial process – as the practitioners of the Bauhaus perceived. As P. D. Anthony argued, Ruskin's view of labour throws the gravest doubt over the social and political solutions which Morris (and others) espoused for the emancipation of working men and women. As Anthony observes, there is formidable evidence, increasingly acknowledged even by Socialist theorists, to suggest Ruskin's scepticism about Socialist programming was right:

The achievements of Socialism in the advanced industrial countries have gone a great way to achieve its political objectives in terms of birth, wealth and privilege, but the condition of the working man seems somehow to be unchanged.[42]

Morris longed to retain the consolations of the Gothic response to art, labour and nature. Indeed, his vision resembled that of the early Ruskin in that he had a conception of the whole world as an aesthetic object: of that world rendered beautiful, and reconciled to the men and women who lived within it. But Morris believed that the restoration of this beneficent nature could be brought about only by the advent of Socialism – even though he understood that this would involve the intensification of those productive forces which were destroying what was left. At times, this led Morris almost to celebrate the onset of a new 'barbarism' which, he believed, would bring about the death of 'architecture, sculpture, painting, with the crowd of lesser arts that belong to them' leading to 'this dead blank of the arts'.[43] But nature would persist and bear witness against man, that 'he has deliberately chosen ugliness instead of beauty, and to live where he is strongest

amidst squalor or blank emptiness'. And so, he said, 'if the blank space must happen, it must, and amidst its darkness the new seed must sprout'.[44] But what would this 'new seed' look like? Morris had only the models of medieval romance, courtly love, Christian faith, and Gothic workmanship. To many, including Ruskin, it must have seemed inherently improbable that these things could be born anew in a modern, technological society dedicated to the pursuit of secular ends: the 'dead blank' was more likely to remain across the face of human culture, whether or not Socialism was achieved.

Morris himself came to realise this. By the end of his life, after wasted years in the Socialist sects, Morris was distanced from the movement and disillusioned by it. He returned to the beauties and pleasures of anachronistic craftsmanship. Ruskin himself had never entertained such fantasies concerning the aesthetic or spiritual effects of the industrial process: the new steel and glass buildings he had recognised all along as 'eternally separated from all good and great things by a gulf which not all the tubular bridges nor engineering of ten thousand nineteenth centuries cast into one great bronze-foreheaded century will ever over-pass one inch of'. He also forewarned an audience of young architects: 'You shall draw out your plates of glass, and beat out your bars of iron till you have encompassed us all . . . with endless perspective of black skeleton and blinding square.' Today, we are more likely to be struck by Ruskin's prophetic vision of the only 'genuine and legitimate style' of the twentieth century (as Pevsner described the modern movement), rather than to be seduced by Morris's sentimental, aestheticised and impossible dream of how nature might be transformed through the memory of a Socialist future.

15

The Spiritual in Art

'I say,' wrote Ruskin, 'that a change took place, about the time of Raphael, in the spirit of Roman Catholics and Protestants both; and that change consisted in the *denial* of their religious belief . . .'[1] He emphasised that the 'great and broad fact which distinguishes modern art from old art' was 'that all ancient art was *religious*, and all modern art is *profane*'.[2] This could not be a matter of degree: 'Ancient art was religious art, modern art is profane art; and between the two the distinction is as firm as between light and darkness.' From this distinction 'are clearly deducible all other essential differences between them'.[3]

But wherever art descended from *theoria* towards *aesthesis* there was a tendency for the grand illusions of painting to vanish altogether. For the aesthetes, art came to resemble other forms of human experience, or behaviour. Similarly, in Morris's utopia 'art' was dissolved into the general productive process; thus began the assault on the 'specialness' of art, and its associations with the spiritual, talent, quality and genius. Aesthetic experience became reduced to *Selbstbetätigung*: Marx's free play of physical and psychic faculties. Even after Wilde returned to a Christological aesthetics, at the end of his life, he acclaimed Christ as an artist, solely on his perception of the way in which he had *lived*.[4]

But not everyone in late nineteenth century England condoned this slide from the high ground of *theoria* to the sensuality of *aesthesis*. P. T. Forsyth, for one, saw the dilution of art that had resulted from the cult of beauty as an end in itself, and wrote that the true taste for art would never be aroused again 'till we can set people free from the paralysing fear of going a jot beyond the direct and immediate consciousness of the artist at his work'.[5] Forsyth argued that 'the great spiritual products of an age or civilisation reflect something much more than their artist or even their art'.

'The possibility of Art,' he wrote at the very beginning of the

twentieth century, 'depends on a people's idea of God . . . Art depends on Religion . . . Our Religion depends on our thought of God. One way of thinking about God makes Art impossible, another makes it inevitable.'[6] Forsyth prized 'Art chiefly as it can speak to the soul'. Art, for Forsyth, could not revive Religion; but 'Religion can revive and regenerate Art . . . Give us power in the Spirit, and then Art will come; but the taste for Art will not arrest the decay of the Spirit.'[7]

For Forsyth, the weakness of British art was synonymous with the weaknesses of 'our Anglo-Saxon Theism', which he regarded as 'imperfectly Christianised as yet by the principle of Incarnation'. He criticised what he called 'our mechanical and outward view of Revelation', and went on to say that 'A distant God, an external God, who from time to time interferes in Nature or the soul, is not a God compatible with Art, nor one very good for piety.'[8] He argued that if there was 'no Divine Spirit in Nature, but only a curse upon it', then Art was not possible in 'any noble way'. All beautiful work, Forsyth argued, following Ruskin himself, depended upon 'the hope of resurrection'.[9]

It seemed improbable to Forsyth that great Christian art would ever again be realised 'till the condition of its existence in the Middle Ages is again realised, and we possess a theology which is not only tolerated by the public intelligence, but is welcome for the life, commanding for the reason, and fascinating for the imagination of the age'.[10] In the meantime he looked to the work of, among others, Holman Hunt, who had done what no other artist had ever done for Christianity; he had shown that it is not necessary for an artist, who is also a Christian, to be a Catholic: Hunt, he said, was 'inspired by the spirit of the Resurrection rather than of the Crucifixion'.[11] In Hunt's work 'the Resurrection spirit' characteristic of the Reformation was at last making itself felt 'in our reformed souls' treatment of nature'.[12]

Forsyth argued that, in Hunt's Protestantism, art 'humanised itself', without losing its spiritual dimension. Such painting 'aims not at an abstract, but at a concrete ideal. It is concrete spirituality'. Forsyth then gives an exposition of *The Scapegoat* which is a *tour de force* of twentieth century art criticism. 'What we have in this picture,' he writes, '. . . is, first, the glory of nature in its rich hills; second, at its very feet, the curse upon nature, in the Dead Sea and the dying goat; and third, in the rainbow, the redemption from the curse into a heavenly glory and promise above all telling, even by the promise and glory of nature in her flush.'[13] He adds that, 'as an age we have lost

the care or power to realise man's spiritual curse, we have lost the imagination for spiritual depths'. As he reveals in his analysis of Hunt's picture *The Curse of Labour*, Forsyth shares Ruskin's sense not only of fallen nature, but of the *lapse* involved in labour itself. But Hunt has succeeded in doing what no painter has ever done before. He has 'made the groaning of the innocent creature a solemn symbol, nay more, an *organic part* of the great and guiltless sorrow which bears and removes the curse of the world'.[14]

Forsyth's interpretation depended upon his understanding of the rainbow, 'the symbol of the Encircling Father . . . full of promise for a new heaven and a new earth, wherein dwelleth righteousness and there is curse no more'.[15] For Forsyth, the rainbow indicated that 'with all this Salt ooze and lifeless waste the curse is not complete, nor the dreariness raised to the agony of utter woe'.[16] The rainbow testified that 'Another life than mere glow of nature must redeem the mysterious curse upon nature.' Without the rainbow, the vital elements of redemption and of resurrection were absent: and yet Forsyth bases his entire thesis on the small study for *The Scapegoat*: he either does not know, or chooses not to point out, that one of the most significant differences between the sketch and the final version was, as we have seen, the omission of the rainbow. What else was left but 'the curse unspeakable, the intolerable weight, and the agonised sin-bearing of all the dull, weary and evil world'?[17]

'Our artistic effort,' Forsyth commented after considering the limitations of Hunt's depictions of Christ himself, 'must now be rather to represent the divine man than the human God.'[18] Yet how was that to be done? For, without the promise of the rainbow, what was left except the naked shingles of the world? As early as the 1860s, in Britain, Georgiana Houghton and others associated with the spiritualist movement had produced fully abstract pictures in an attempt to tear back the veils of the material and to see again what Hunt seemed to have lost sight of when he erased the rainbow. Other and more significant British artists were coming to believe that the theoretic dimension could better be achieved by mythic, or yet more completely *abstract* means than by unrelenting attention to *natural* form.

* * *

One day in 1873 George Frederic Watts and John Ruskin met outside Burlington House, during a winter exhibition of Italian old masters. Not for the first time, they began to argue. Ruskin claimed the Italian

masters of the High Renaissance were all wrong, because they did not paint what they saw; thus they violated truth. Then, pointing at a 'scavenger's heap of mud lying at the foot of a grimy lamp-post', Ruskin shouted at Watts, 'Paint that as it is . . . that is truth.'[19]

When Ruskin returned to the Bull Hotel in Piccadilly, he wrote an angry letter to Watts, whom he accused of being 'paralyzed' by his love of the Greek style and of never having made 'an entirely honest, completely unaffected study of anything'. Ruskin told him, 'You fancy you see more than I do in Nature – you still see less, for I, long ago, learned how impossible it was to draw what I saw – you still struggle to do so; that is to say, to draw what you like in what you see without caring about what others like – or what God likes.'[20]

We don't know how Watts replied; but he was probably not as upset as the letter might seem to warrant. Watts had long been a thorn in the side of Ruskin's theories. In 1848, the year the Pre-Raphaelite Brotherhood was founded, Ruskin was still writing about Watts as 'to my mind the only real painter of history or thought we have in England'.[21] But Watts was looking for a way beyond history painting.

Like Hunt, he had read the first volume of *Modern Painters*, and in response he painted a remarkable series of 'higher landscapes' which show how thoroughly he had grasped what Ruskin believed to be the essence of Turner's painting. J. E. Phythian has vividly described *After the Deluge*, 'where above the waters there is a glory of misty, golden light encircling the sun, which is the symbol as it is the agent of the Deity'.[22] And yet such pictures came to Watts to seem too remote from human values. Watts admired Turner, but he put him on a 'lower level' than Michelangelo, Raphael and Titian. Watts himself was undoubtedly guilty of that abstract Theism of which Forsyth complained; his beliefs were those of a Deistic humanist. He retained some remote belief in God as the ultimate cause of the universe, but, having no sense of God's immanence within his world, was relatively unaffected by the findings of modern science. Watts retained scant respect for incarnational Christianity of any kind, and none for the institutions of the modern church; thus the only way to speak of eternal truths was through allegories, the first of which, *Time and Oblivion*, was painted in 1848. Ruskin, who was also looking for the best way in which the 'theoretic' dimension might be realised in art, was duly impressed. He borrowed the enormous picture to hang in his home.

Soon after, Ruskin wrote to Watts to tell him that he had got his

flora all wrong – and quoted the Bible to prove it: 'Forget me nots do not grow on graves: *anywhere* but on a grave. Neither do they grow among thorns, but by sweet, quiet streams and in fair pastures (Psalm XXII 2–3).'[23] Watts eventually came to realise that Ruskin did not really admire *Time and Oblivion*, and so he asked for it back. And then came the Pre-Raphaelites, who, under Ruskin's guidance, could be more or less relied on not to misplace their forget-me-nots.

Watts tried to explain to Ruskin that he shared his belief that art must be *true*; but he did not go along with Ruskin's 'near-sighted' reading of what truth was. 'My own views,' Watts wrote to his truculent friend, 'are too visionary, and the qualities I aim at are too abstract, to be attained, or perhaps to produce any effect if attained.'[24] He added that his instincts caused him to strive after things that were 'hardly within the province of art, things that are rather felt than seen'. Privately, he complained that Ruskin 'had no apprehension of "abstract form"'.[25]

But Watts was not impervious to Ruskin's criticism. After a visit to Venice in 1853, Watts wrote to Ruskin, 'I can better understand why I fail.' The 'glowing and gorgeous' painters of the Venetian School had 'rendered Nature as I feel her – as I too would render her – but my imagination is not vivid, nor my memory powerful'.[26] In the late 1850s, as Ruskin's faith faltered, and he warmed to lordly human life, he never lost an opportunity to urge the worldly splendours of the Venetians upon Watts. No painter could have admired Titian more than Watts, who even affected the Italian master's appearance, but his sensibility was always remote from Titian's full-blooded sensuousness.

In later life, however, as he was afflicted by the pestilential vision of nature, Ruskin felt better able to acknowledge Watts as a painter of 'the spiritual truth of myths'. Watts wrote that a picture of the kind he painted should not be looked upon 'as an actual representation of facts, for it comes under the same category of dreams, visions, aspirations, and we have nothing very distinct except the sentiment, the thought, which the artist produces by the whole effect'.[27] Watts had in mind such pictures as *The Rider on the White Horse* (1881); but his craving to express those truths that nature could not reveal took him beyond the illustration of mythic subject matter, and brought him to the brink of abstraction, a decade before Kandinsky reached the same point.

For, in the 1850s, while the Pre-Raphaelites had pursued the *cul-de-sac* of an ever more exacting truth to an ever more worldly Nature,

Watts was conceiving of the idea which Mary, his second wife, was to describe as 'the ambition of one half of his life and the regret of the other half'.[28] In Italy, he had seen and admired the Sistine Chapel. He wanted to do 'for modern thought what Michael Angelo did for theological thought'.[29] Thus Watts came to conceive of 'The House of Life'. At first he envisaged an actual building, the ceiling of which would be 'covered with the uniform blue of space'. Giant frescoes, beginning with *Time and Oblivion*, would illustrate the history of the 'progress of man's spirit' from 'the hunter stage', to 'the preaching of Peter the Hermit', and beyond. But he soon came to realise that the House would never be built; as Mary wrote: 'in his mind the scheme became more abstract, and less realistic and historic'. The vast allegoric paintings into which he poured so much of his time in his later years were the nearest he got to a realisation of the scheme.

Watts attached himself to willing patrons, and pursued his high-minded aims in relative isolation from the harsh, commercial imperatives of the Victorian art world. The public knew him largely as a painter of portraits of eminent men until his first London one-man exhibition was held in 1881 at the Grosvenor Gallery – just two years before William Morris became a Socialist. Watts was revealed as a neglected master, one of the few painters of his day whose works had somehow broken through the mud of materialism, to touch upon the loftiest of spiritual themes. 'It has,' wrote Cosmo Monkhouse, 'been the strange fortune of Mr Watts, who has never disguised the didactic aim of his art, to have been more or less exempted from the general condemnation which some modern critics have for many years distributed impartially on all painters whose art is not entirely for "art's sake". He is still regarded by most of these as a true artist; an artist as it were in spite of himself.'[30]

Watts's appeal was almost universal in the closing years of the nineteenth century. In 1884 a vast exhibition of his work opened at the Metropolitan Museum in New York, where it was seen by half a million visitors. Watts was spurred by fame. Many of his best-known images, like *Mammon* (1885) and *Hope* (1886), belong to this period. Hope sits, in Watts's words, 'on a globe with bandaged eyes, playing on a lyre which has all the strings broken but one'.[31]

George Moore, who was associated with the aestheticism of the New English Art Club, dismissed Watts as 'a sort of modern Veronese in treacle and gingerbread';[32] but this was an exceptional view. Roger Fry, a sounder judge of pictorial form, compared Watts favourably

with Whistler, and expressed the belief that, in the future, Watts would be accorded 'a place by the side of Titian . . . little short of the summit of human achievement in the arts'.[33] So far, this has not happened. Too much continues to be made of Watts's self-evident flaws, especially his tendencies to rhetoric and vacuousness.

In his brilliant study of Watts, G. K. Chesterton argued convincingly that, despite the commonplace criticism, Watts was in fact the anti-thesis of the literary painter. Chesterton pointed out that a picture like *Hope* just was *not* exhausted by reference to the word 'hope'; in front of such paintings the viewer could discern something 'for which there is neither speech nor language, which has been too vast for any eye to see and too secret for any religion to utter, even as an esoteric doctrine'. He says that this 'something' is made manifest through Watts's forms and technique, which 'almost startlingly correspond to the structure of his spiritual sense'.[34]

Long before I read Chesterton on Watts, I was fumbling, in my own muddled way, towards similar conclusions. When I first saw Watts's work in any quantity, at the 1974 Whitechapel Art Gallery exhibition, I noted how Watts was 'floundering towards a universally comprehensible sublimity in paint', and in this respect I was reminded of the work of the American abstractionist Mark Rothko; but I felt that Watts's allegoric pictorial conventions did not allow him to give expression to his sense of 'ultimate reality', whereas Rothko's more abstract means did.[35]

Today, I am by no means so certain. The fact is that Watts did stretch beyond the brink of abstraction. For example, in 1902 Watts painted *The Sower of the Systems*; the subject was suggested to him by reflections of his night-light playing on his bedroom ceiling. This picture is yet another attempt to convey his vision of the moment of creation of the cosmos, or, if you will, 'ultimate reality'. But the allegorical forms and figures have disappeared. Mary Watts described it as 'an attempt to paint an unpaintable subject'.[36] The colour is deep blue; the figure seems impelled forward while 'stars, suns, and planets fly from hands that scatter them as seeds are scattered'.[37]

Watts himself once likened his attempts at giving his ideas utterance and form to the drawing of a child, 'who, being asked by his little sister to draw God, made a great number of circular scribbles, and putting his paper on a soft surface, struck his pencil through the centre, making a great void'.[38] He added that the result was 'utterly absurd as a picture', but said, 'there was a greater idea in it than in

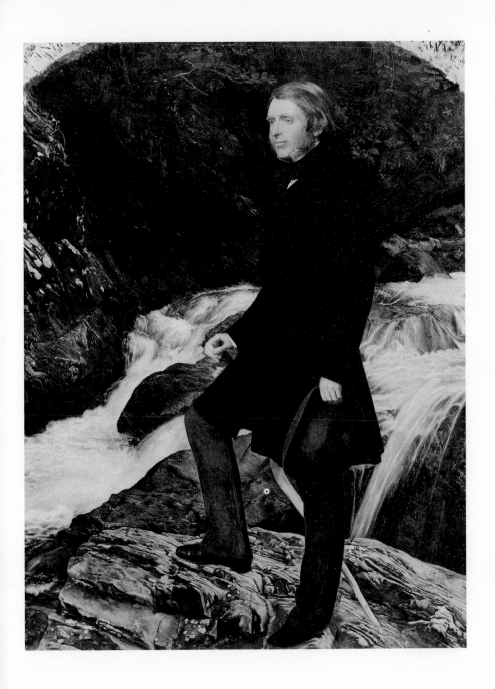

1 John Everett Millais: *John Ruskin*, 1873.
Private collection.

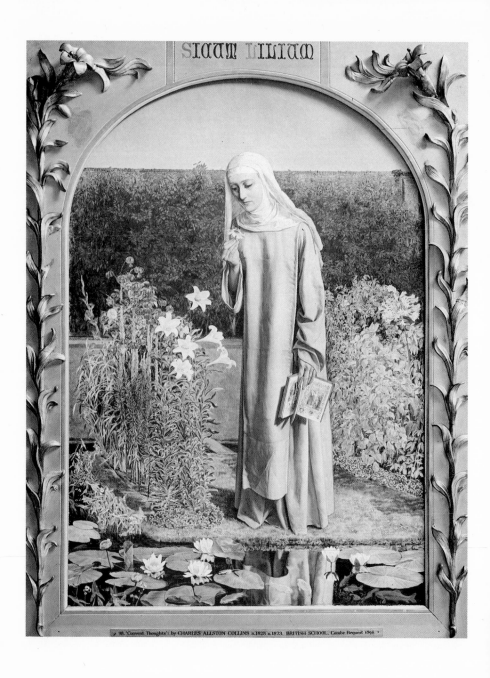

2 Charles Collins: *Convent Thoughts*, 1851.
The Ashmolean Museum, Oxford.

'... as a mere botanical study of the water lily and
Alisma ... this picture would be invaluable to
me, and I heartily wish it were mine.'

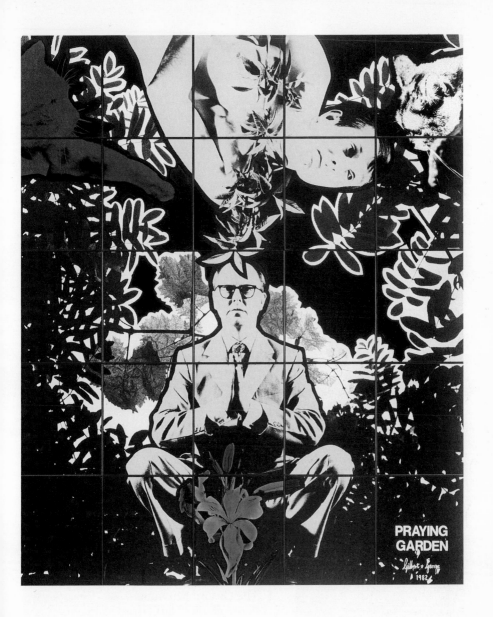

3 Gilbert and George: *Praying Garden*, 1982.
The artists' collection.

An obsessive preoccupation with personal
depravity . . .

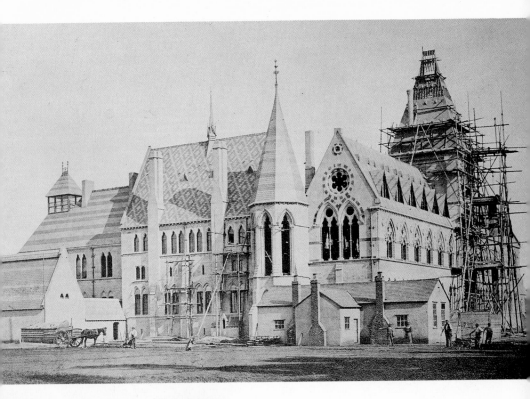

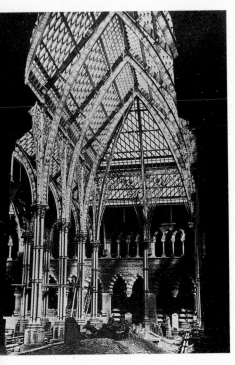

4 The Oxford Museum under construction.
Photo credit: The Oxford Museum.

Ruskin went down to the site to exhort the
workers.

5 The Oxford Museum.
Photo credit: The Oxford Museum.

'Crystal palace architecture Gothicized'?
Mr Skidmore's iron vaulting later
collapsed.

6 William Morris: *Honeysuckle*, original
watercolour design for chintz.
Birmingham City Art Gallery.

Pevsner found 'novelty' in Morris's
medieval design.

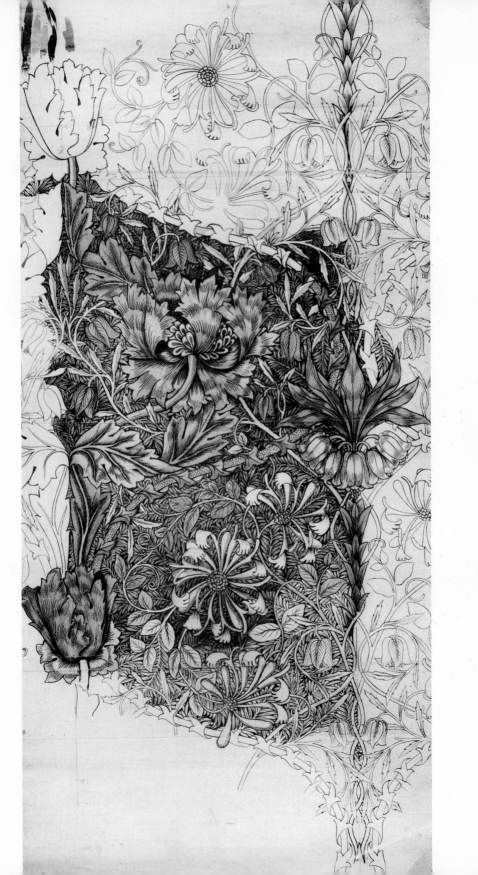

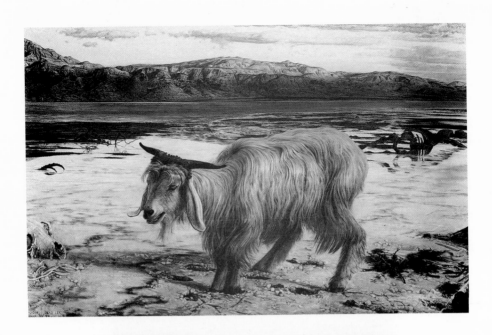

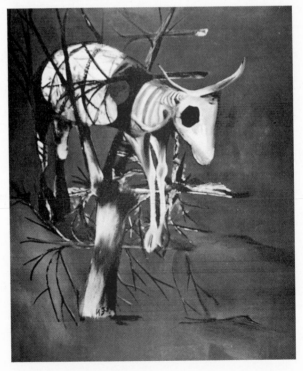

7 William Holman Hunt: *The Scapegoat*, 1854.
Lady Lever Art Gallery, Port Sunlight.

8 Sidney Nolan: *Ram Caught in Flood*, 1955.
The artist's collection.

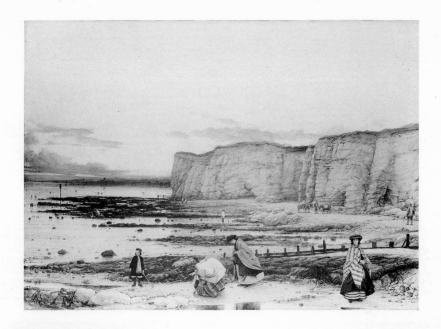

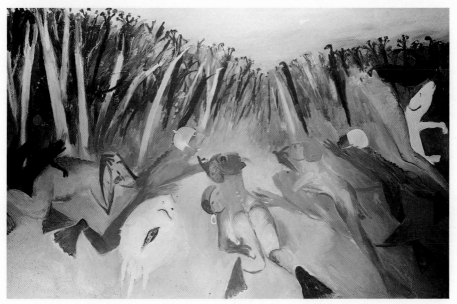

9 William Dyce: *Pegwell Bay, A Recollection of October 5th, 1858,* ?1858-60.
The Tate Gallery.

Looking for fossils beneath Donati's comet.

10 Arthur Boyd: *Bathers with Skates and Halley's Comet,* 1985.
Photo: Fischer Fine Art.

The comet passes by, unnoticed.

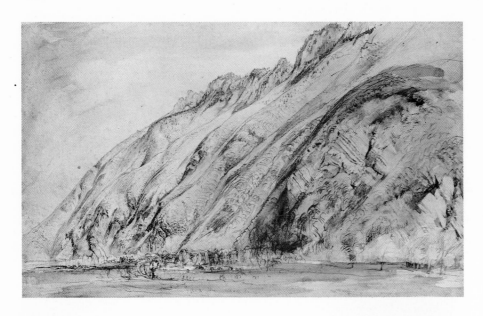

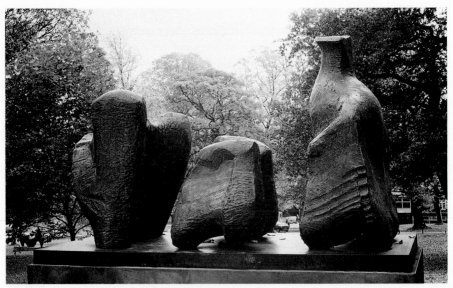

11 John Ruskin: *The Mountains of Villeneuve*
 (near the eastern end of Lake Geneva), 1846.
 The Ruskin Galleries, Bembridge, Isle of Wight.

 Imbued with the forms of the women he never knew?

12 Henry Moore: *Three-Piece Reclining Figure No. 1*, 1961-2.
 The Tate Gallery.

 The reclining woman as rocky landscape was
 one of Moore's favourite themes.

Michael Angelo's old man with a long beard'.[39] To his contemporaries
– and, in a sense, to Watts himself – the idea of 'a great void' as the
pictorial means to Divine revelation was infantile and incomprehen-
sible. But Turner had already comprehended it . . . especially in those
late pictures which so distressed Ruskin. And Kandinsky, Malevich,
Mondrian, and, especially perhaps, Rothko, would have known
exactly what Watts meant.

* * *

There are many for whom the achievements of the French School in
the later nineteenth century will belie much that is being argued here.
For were not the triumphs of French art, at least, based upon a proud
elimination of *theoria*, and the pursuit of sensuousness and *aesthesis*?
The superiority of French art to that of Britain, or indeed any other
nation, in the later nineteenth century is not to be denied. Even so,
we have suffered from art historical accounts of European painting.
Such approaches have built into them the rhetoric that 'advances' in
art were all made by an avant-garde which was European, and
committed to secularisation and 'progress', whether of a bourgeois or
a Socialist kind. This 'reading' of the art of the last one and a
half centuries tends to place a disproportionate emphasis on formal
novelties – regardless of their true value or significance. (Hence the
fêting of the arrival of new techniques, media and materials simply
because they are new.)

But even in revolutionary Europe, many of the great nineteenth
century painters, although they were subsequently marshalled into the
modernist cause, can best be understood as *reactionaries*, as men in
revolt *against* modernity, rather than as the 'avant-gardists' they were
later described as being. At the very least, many of the finest French
painters accepted modernity with bitterness and resentment rather
than with any celebratory relish. Their intellectual attitude was closer
to that of Maurice Cowling than to Nikolaus Pevsner; they believed
there could be no originality except on the basis of tradition.

Even the voluptuous beauty of Auguste Renoir's painting depended
upon his *refusal* of the modern age, and his revival of an image of
paradise, which he associated with the female body. Renoir looked
back not just to his beloved eighteenth century painters, but beyond,
to the era of the crafts and the cathedrals. He despised a civilisation
he perceived of as annihilating whole forests every day to produce
newspapers he did not consider worth reading. In old age, at a time

when Futurists and other 'progressives' were pursuing the technical and destructive potentialities of the new era, Renoir ironically recommended the abolition of the aeroplane, and the replacement of firearms by bags of pepper.[40]

'Among civilised people,' he once wrote, 'it is the conception of the Divine which has always implied the idea of order, hierarchy and tradition.' That idea he valued greatly. He dreaded the advance of Socialism and nurtured a hazy vision of old France as a serene, rural society governed by God, in which everyone knew his, or especially *her*, place. Renoir once said that he wanted to create an 'earthly paradise' through his paintings – which has led to comparisons between Renoir's vision and that of William Morris.[41] But Renoir was hostile to secularism and revolutionary Socialism alike, and is best understood as a nostalgic, rural conservative. Indeed, Renoir's hedonism notwithstanding, the parallels with Ruskin are surprisingly close. Renoir's defence of 'irregularity', and the beauty and freedom of pre-industrial work, could have come out of *Stones of Venice*. 'God, the King of artists,' remarks Renoir, 'was clumsy.' And he saw in the clumsy variety of divine handiwork the proto-type for what the artist did. 'I am not God the Father,' Renoir once wrote. 'He created the world, and I am content to copy it.'[42] Renoir differed from Ruskin principally because he despised what he conceived of as the meanness and Puritanism of Protestantism. According to his son, Jean, he often spoke of 'that state of grace which comes from contemplating God's most beautiful creation, the human body'.[43] For Ruskin, the human body usually had to be projected into the mountain or the cathedral front before he could accept it.

Those artists whose visions were of a more secular character than Renoir's were often just as conservative – in both a cultural and political sense – as he was. In the early history of the modern movement, no painter is held in higher esteem than Edgar Degas, whose drawings the painter Ron Kitaj once described as 'the best ever made, except maybe for those of Rembrandt and the late Michelangelo'.[44] By temperament, politics and social position, Degas was a downright reactionary; a Royalist and misogynist, Degas even supported the anti-Dreyfusard cause.

Some historians of modern art have tried to argue that Degas's painting was somehow at odds with the other values by which he lived. R. H. Wilenski, one of the first British historians of the modern movement in French painting, wrote that although Degas always

spoke 'as a royalist and an extreme reactionary' and as someone 'unaffected by social progress', in his art he was profoundly influenced by the spirit of French democracy and more especially by its Parisian forms'.[45] Wilenski insisted that the art of Degas was 'in no sense or degree acceptant and *vieux-régime*; its essence was its modernity'.[46]

But where is the evidence of this? There was no greater influence on Degas than Ingres. Degas's draughtsmanship was certainly original, but its originality depended upon his acceptance of, indeed his submission to, tradition. 'That's my idea of genius,' Degas commented when he acquired a study of a woman's hand by the master in the late 1880s, 'a man who finds a hand so lovely, so wonderful, so difficult to render, that he will shut himself up all his life, content to do nothing else but indicate finger-nails.' Drawing was the key to Degas's art; at no time did his work show any trace of social concern: his paintings of laundresses, magnificent as they are, are devoid of pity, or any suggestion that the lot of these women might be, let alone ought to be, improved.

Degas's relationship to the painter's skill and knowledge was always more like that of a gardener (one who tends, trains, cultivates and explores new varieties) rather than of a revolutionary (one who eradicates, or uproots). 'Art,' he once said, 'does not progress, but repeats itself. If you must needs have a comparison, let me tell you that, in order to produce good fruit, you must grow it on a trellis. We stand there in our lives, our arms stretched and our mouths open, in order to catch anything that passes by or that surrounds us, and to live by it.'[47]

For many, Cézanne was the father of modern painting; but he rather saw himself as doing Poussin over again – only this time from *nature*. And for him, nature was 'the spectacle that the *Pater Omnipotens Aeterne Deus* spreads out before our eyes'. Certainly, Cézanne made use of an original 'language' of pictorial forms: but he did so in order to speak of his spiritual vision of men and women reunited with the world which they inhabited. Like the later and unjustly derided paintings of Renoir, Cézanne's *Grandes Baigneuses* evoke the imagery of the body as mountain and cathedral: the terrain within which we can become reunited with the ground of our being.[48]

'I want to paint men and women,' van Gogh once wrote, 'with that something of the eternal which the halo used to symbolise, but which we now seek to counter through the actual radiance of colour vibrations.'[49] And as for Rouault, he spoke about himself almost as

if he *was* The Christ: 'I am the silent friend of all those who labour in the fields; I am the ivy of eternal wretchedness clinging to the leprous wall behind which rebellious humanity hides its vices and its virtues alike.' But, he added, 'Being a Christian in these hazardous times, I can believe only in Christ on the cross.'[50]

Historians of modernism, especially *American* historians of modernism, invariably travesty the way in which abstraction arose in painting – not least because they wish to associate it with the dawn of a twentieth century vision: yet it is clear that such a construction accords neither with the historical facts nor with the self-conception of many of the 'pioneer' abstract painters. Kandinsky's *Blue Rider* differed from Watts's *The Rider on the White Horse* largely because Kandinsky was, in every sense, of more conservative and *orthodox* disposition. Indeed, the 'pioneer' European abstractionists were not only repeating something which Georgiana Houghton and others associated with the British spiritualist movement had experimented with half a century before in their aesthetics,[51] they were as reactionary as Cardinal Newman, who also stressed the gulf that divided the material from the spiritual world, insisting (against Ruskin) that the two could not be joined through the evidence of worldly vision alone. Remember Newman's description of 'what we see' as 'a screen hiding from us God and Christ, and his Saints and Angels'? And his earnest desire and prayer 'for the dissolution of all that we see, from our longing after that which we do not see'?[52] This, I believe, was Kandinsky's project too.

Like the English abstractionists of the 1860s, Kandinsky had links with spiritualist cults, in his case Theosophy; and yet, as Paul Overy has rightly emphasised, Kandinsky's pursuit of transcendental abstraction should also be seen as part and parcel of his *Christian* orthodoxy. In his *Reminiscences*, Kandinsky recalled the sense of desolation he had felt during a brief period of unbelief in his youth. 'Man,' he wrote, 'is often like a beetle, kept on its back; he waves his little arms in silent longing, grasps at every blade that anyone holds out to him, steadily believing he will find salvation in the blade.' He continued:

In the days of my 'unbelief' I asked myself: who is holding me on my back? Whose hand is holding the blade before me and then snatching it away again? Or am I lying on the dusty, indifferent earth on my back and grasping after the blades that grow about me 'of their own accord'? How often did I feel this hand on my back and then another pressed itself upon my eyes, so that I found myself in the darkness of the night while the sun shone.[53]

The 'meaning' of Kandinsky's life and work lay, in effect, in his longing to walk in, and see by, the light of his spiritual sun. For, like Newman, he believed that the appearances of the physical world obstructed the perception of the spiritual domain. 'The veiling of the spirit in the material,' Kandinsky complained, 'is often so dense that there are generally few people who can see through to the spirit',[54] whether through art or religion. He argued that there could be whole epochs in which the spirit was disavowed: the nineteenth century was one such. People had become blinded by matter.

Kandinsky had been brought up in the Orthodox faith, which laid a particular emphasis on the Divine glory which is *other than* and *lies behind* the sordid reality of the physical, natural and material worlds. 'Behind the veil of Christ's bleeding and broken flesh,' writes Timothy Ware, 'Orthodox still discern the Triune God. Even Golgotha is a theophany.'[55] Here, of course, Kandinsky could – and I believe *did* – draw heavily upon the iconic traditions and conventions of the Eastern church, which were always focused more upon transfiguration than on visible realities.

In the first *Blaue Reiter* exhibition, Kandinsky exhibited the painting now known as *All Saints 1*; this jewel-like work on glass proclaimed his preoccupation with the glory of martyrhood, and the theme of the redemption of the world through Christ. Kandinsky's 'discovery' of abstraction was associated with his desire to intensify his expression of what he conceived of as spiritual realities freed from corporeal veils. As Hans K. Roethel has written, the numerous variations and versions of *All Saints* Kandinsky produced at this time 'demonstrate the process of formal abstraction and what may be called the spiritualization of the content'.[56]

In many ways, Kandinsky's transcendentalism can be seen as a reaction against the secularising immanence of the Protestant church and a Catholicism constrained by the heavy hand of *Syllabus Errorum*, and the redefinition of the doctrine of Papal infallibility. These teachings were designed to batten down the hatches of dogma against any intrusions of fresh insight. It was not surprising that Kandinsky began to look towards 'the forms of occultism, spiritualism, monism, the "new" Christianity, and religion in its broadest sense'.[57]

The main idea Kandinsky borrowed from Theosophy was something absent from Liberal Protestant or Catholic teaching: namely the hope which Annie Besant expressed repeatedly in *The Evolution of Life and Form* and other works, that, in contrast to the 'materialist'

science of the nineteenth century, 'modern science' was coming round to confirming eternal religious truths. The resemblances between Kandinsky's theories and practices and, say, Besant's talk about 'vibrations', or her ideas about rising 'from the concrete to the abstract' (which she illustrates with the example of the archetypal triangle) have been remarked before. But Kandinsky seems also to have responded to Besant's conception of the transcendence of 'the "I", the separated self', and its mergence 'in the uniting aspect of the Deity', a union which, she suggested, could only be completed when the concrete had been superseded.[58]

Kandinsky belonged to a much wider movement of the early years of this century, which, far from being 'modernist', was, in essence, a counter-reformation directed against the worldliness of nineteenth century faith, a counter-reformation stamped by a yearning for the lost sense of a *Mysterium Tremendum*, which, if it was not to be found in the glory of mountain ranges, might at least be sought in the quivering blankness of space. For example, soon after Kandinsky wrote *Concerning the Spiritual in Art*, Rudolf Otto, an Austrian theologian, published his extraordinary book *The Idea of the Holy*, in which he complained that even religious people had 'shut their eyes to that which is quite unique in religious experience' – that is, to the whole domain of what he called 'the numinous'. He believed that there was something ineffable about the concept of holiness, something 'wholly other' and irreducible; he drew a comparison between religious experience of the numinous and aesthetic experience of the beautiful, and he implied that the relationship between the two was more than mere analogy.

Otto's book contains a fascinating account of the expression of the spiritual in art. He appears to have known nothing of Kandinsky or his friends; even so, this stiff professor and member of the Prussian Parliament was unmoved by the aesthetics of natural theology. Rather, he believed in the power of the abstract to convey numinous experience. Otto knew a great deal about the art and religions of Asia. He seems to have had Chinese painting in mind when he wrote: 'Not only are there pictures upon which "almost nothing" is painted, not only is it an essential feature of their style to make the strongest impression with the fewest strokes and the scantiest means, but there are very many pictures – especially such as are connected with contemplation – which impress the observer with the feeling that the void itself is depicted as a subject, is indeed the main subject of the picture.'[59]

Otto argued that this pictorial emptiness was similar to the 'void' spoken of by the mystics. For, Otto wrote, '"void" is, like darkness and silence, a negation, but a negation that does away with every "this" and "here", in order that the "wholly other" may become actual'.[60]

Not only Kandinsky, but also Mondrian and Malevich, would have seen themselves as *making actual*, within the picture-space, a representation of this 'wholly other' – a thoroughly unmodern, even anti-modern thing to do. As we shall see, even Cubism itself is better understood as a late attempt to articulate a transcendentalist aesthetic rather than as a new 'scientific' materialism in art for the twentieth century.

The modernist appropriation of history was disastrous when applied to the story of British art: it is, I think, a sobering experience to read again Roger Fry's reflections on British art, compiled in the 1930s, and to see revealed there the extreme hostility to all attempts to appeal to the theoretic faculty through the pursuit of natural form. For Fry, even Turner had not 'probed further than the first gasp of wonder'; Turner was 'Poussin at second hand'[61] and so on. In some ways, Fry was more sympathetic to Constable – but only because he skated over the 'natural theology' which is at the core of Constable's vision. Fry praised Constable because he electrified Paris with paintings whose colours 'held the key to the later developments of European art'.[62] And neither Turner nor Constable seemed to Fry as interesting as Bonnington, who confined himself to his *petites sensations*.

And yet even here we have to be careful: for although Fry wrote this way in the 1930s, he was not, as he is sometimes portrayed, a formalist, who insisted only upon the material qualities of a work and the pleasurable sensations to which these gave rise. If Fry was converted to the idea of 'significant form' it was because, like the ageing Watts, he, too, came to believe that the abstract elements of a picture, rather than its likeness to nature, were the means through which art's spiritual truths and sense of ultimate reality were conveyed. Although Fry and Clive Bell gave primary attention to the visual, they did not think, any more than Walter Pater had done, that the question of value in art could be reduced to sensation, form and pleasure. Rather, they seem to have believed that those combinations of colours and lines which gave rise to aesthetic emotion provided an avenue to spiritual experience of a kind which the imitation of natural form could not. As Fry put it, art was 'one of the essential modes of our

spiritual life'. For Bell, too, art had 'to do with the spiritual life, to which it gives and from which . . . it takes'. He valued aesthetic rapture because it waged a war against naturalism and materialism; the materialistic conception of the universe could not explain that disinterestedness characteristic of aesthetic contemplation. Art offered 'emotional confidence, that assurance of absolute good, which makes of life a momentous and harmonious whole'. He held that '"significant form" was form behind which we catch a sense of ultimate reality' – and he made it clear that it was for these qualities, and not for his 'techniques', that he so greatly admired Cézanne. Art, for Bell, was 'an expression of that emotion which is the vital force in every religion'. Art and religion were 'manifestations of "man's religious sense" . . . his sense of ultimate reality'.[63]

At first, Fry and Bell's theories constituted a view of art which glowed with the fading penumbra of the theoretic. 'I think then,' wrote Fry, 'we are all agreed that we mean by significant form something other than agreeable arrangements of form, harmonious patterns, and the like. We feel that a work which possesses it is the outcome of an endeavour to express an idea rather than to create a pleasing object.'[64] Fry concluded by saying that, personally, he always felt that it implied the effort on the part of the artist to bend our emotional understanding by means of his passionate conviction to some intractable material which is 'alien to our spirit'.[65]

Bell once discussed the response to a sculpture representing Christ, by Jacob Epstein. The critics had focused upon such questions as: 'Has Mr Epstein done justice to the character of Christ?' or 'What was His character?' 'Was Christ intelligent or was He something nobler, and what has Mr Epstein to say about it? Was He disdainful or was He sympathetic? Was He like Mr Bertrand Russell or more like Mr Gladstone? And did Mr Epstein see Him with the eyes of one who knew what for ages Christ had meant to Europe, or with those of a Jew of the first century? . . .'[66] But Bell swept such issues aside: '. . . it mattered not a straw whether this statue, considered as a work of art, represented Jesus Christ or John Smith'. And yet Bell's own emphasis on 'purely aesthetic qualities' was *not* on the grounds of the autonomy of art, nor yet of personal pleasure: about Mr Epstein's sculpture, Bell insisted, the important thing to discover was whether, and in what degree, it possessed 'these permanent and universal qualities'.[67] The 'significant forms' of art were thus to reveal what, in Bell's view, could no longer be readily seen in representations of

the face of Christ Himself. Or, as Forsyth had put it, 'Our artistic effort must now be rather to represent the Divine man than the human God.'

16
Love's Meine

All this has taken us a long way from the dissection of *Alisma Plantago* leaves and the meaning of Collins's *Convent Thoughts*; but perhaps not *that* far. The young Ruskin, too, had been determined to demonstrate that the presence of the Divine within nature could be revealed through the study of esoteric form. But, in contrast to the abstractionists, he believed that the artist arrived at those forms through the study of nature; after natural theology had failed, his return to faith involved increasing sympathy for mythic painting.

These days, early Ruskin is out of fashion: the Ruskin revival has involved a revaluation of his later works, especially *Fors Clavigera*, the eccentric periodical letter which, from 1871, he published for working men – and which some scholars now acclaim as his master-piece – and his bewildering 'scientific' writings of the 1870s. These include *The Eagle's Nest*, a series of lectures on the relationship between natural science and art; *Love's Meine*, a study of the birds; *Proserpina*, on flowers; and *Deucalion*, a collection of his writings on rocks and stones.

All of these books defy categorisation: in them science, natural history, etymology, mythology, theology, moralising and autobio-graphy are intimately and inextricably intertwined. It would be thank-less to try to summarise their contents; but it is clear what Ruskin was attempting: since 1860, the advance of science seemed to detach men and women from nature; Ruskin wanted to compile a new sort of taxonomy whose categories were imaginative rather than scientific, in the orthodox sense. He wanted to reconstruct a spiritual realism.

These later works are not entirely coherent. Ruskin did not know *how* to re-establish those links between sense and transcendence which he believed modern science to have severed. He shifted the 'symbolic orders' through which he tried to apprehend nature. Large parts of

these books draw upon a private, psychosexual symbolism, which, had it erupted half a century later, would have been identified as 'Surrealist': after the death of Rose La Touche in 1875, her name and her flower, and all manner of associations concerning both, formed a disconcerting, subterranean *leitmotif* which ran through much of Ruskin's ruminations. So thorny, twisted, beautiful, and over-burdened with hermetic associations did this trail of provocative symbolism become that, to us, it seems almost to cry out for psychoanalytic interpretation. To make his points, Ruskin drew not only on his own knowledge of natural history and the Bible, but also upon Greek myths and heraldry ... at times, it seems, upon almost anything which could help him to re-establish that spiritual *rapport* with nature which he believed secular, modern science had destroyed.

Ruskin recognised that the scientific attitude had involved men and women in a tremendous aesthetic and ethical *loss*: the quest for the underlying structures and essences of things had not confirmed their Divine origins, but had rather deposited men and women in a bleak and competitive wilderness. And so he came to reaffirm 'a science of aspects'; 'Art,' he wrote, 'has nothing to do with structures, causes, or absolute facts; but only with appearances.'

This was not a defence of 'Impressionism': Ruskin wanted to rediscover the moral and spiritual dimensions of nature. Thus, in *Deucalion*, he remarked on the fact that the idea of a contest between good and evil spirits for the soul and body of man formed the principal subject of all the imaginative literature of the world; this, Ruskin said, 'has hitherto been the only explanation of moral phenomena'. He agreed (with prophetic perspicacity) that this was 'no more a certain or sufficient explanation than the theory of gravitation is of the construction of the starry heavens'. But, he added, the idea of this contest 'reduces farther towards analysis of the facts known to us than any other'.[1]

Ruskin went on to say that he had long thought that the myths – allegorical fables or stories – in which the belief about a contrast between good and evil was represented were 'incomparably *truer*' than the Darwinian, 'or any other conceivable materialistic theory'. He described these myths as 'instinctive products of the natural human mind, conscious of certain facts relating to its fate and peace'. This, he explained, was why he had decided to republish the second volume of *Modern Painters* in 1883:

From *Modern Painters* Volume Three

which, though in affected language, yet with sincere and very deep feeling, expresses the first and foundational law respecting human contemplation of the natural phenomena under whose influence we exist, – that they can only be seen with their properly belonging joy, and interpreted up to the measure of proper human intelligence, when they are accepted as the work, and the gift, of a Living Spirit greater than their own.[2]

We may take as an example of Ruskin's science of aspects the contrast he draws in *Proserpina*, first published in 1875, between what he calls the 'Apolline' and the 'Arethusan' leaf-forms – essentially a distinction between leaves which have branched veins and irregular, jagged edges, and those whose veins seem to flow uninterruptedly towards the apex of the leaf. He reproduces the figures of *Alisma* and elm leaf he had first given in *Modern Painters* (see figs 3 and 4, p.162) and argues – 'scientifically' enough – that the branched (or Apolline) leaves 'are fed chiefly by rain; the unbranched (or Arethusan) by dew – or moisture they can gather for themselves out of the air, or else by streams and springs'. Hence, he explains, the verse in Deuteronomy which reads: 'My doctrine shall drop as the rain; my speech shall distil as the dew: as the *small* rain upon the tender *herb*, and as the showers upon the grass.'[3]

This time, there is no question of the *dissection* of *Alisma*, the precise measurement of its curves, or the enumeration of the proportions of its stem. He does emphasise that the form of the leaf is characteristic of other natural structures, pointing out how, if the leaf were a lake of the same shape, and its stem the entering river, 'the lines of the currents passing through it would . . . be nearly the same as that of the veins in the aquatic leaf'. But this association of *alisma*-like leaves – including, he says, grasses and lily leaves – with fountains and dew, suggests to him the name by which he feels they ought to be known.

You know that Cora, our Madonna of the flowers, was lost in Sicilian Fields: you know, also, that the fairest of Greek fountains, lost in Greece, was thought to rise in a Sicilian islet; and that the real springing of the noble fountain in that rock was one of the causes which determined the position of the greatest Greek city of Sicily. So I think, as we call the fairest branched leaves 'Apolline', we will call the fairest flowing ones 'Arethusan'.[4]

The logic of all this is too dense to unravel here: it depends upon Ruskin's previously established associational links between different myths and orders of flowers. For example, he associated the story of Demeter and her daughter Proserpine (or Cora) with ideas about the earth mother, the origin of life, and the 'receiver of all things back at

last into silence'; in his new mythic taxonomy, he therefore attributed the annual plants to Cora. Arethusa concerns the lost fountain, described by Strabo, which reappeared in the island of Ortygia, and whose sweet waters led to the founding of Syracuse. Ruskin reminded his readers that the Apolline leaf was the central type only of land leaves, and was, within certain limits, of a fixed form: '. . . while the beautiful Arethusan leaves, alike in flowing of their lines, change their forms indefinitely, – some shaped like round pools, and some like winding currents, and many like arrows, and many like hearts, and otherwise varied and variable, as leaves ought to be, – that rise out of the waters, and float amidst the pausing of their form'.[5]

Ruskin records that the next entry he made in the manuscript of *Proserpina*, after writing all this, was on Easter day, 1875, and, reading it back, he rebuked himself roundly for 'confusing the water-lily leaf, and other floating ones of the same kind, with Arethusan forms'. He claimed that the former, 'as they lie on the water surface, do not want strong ribs to carry them'. (But he also quoted the opposing observation of a 'botanical friend' – 'You should see the girders on under-side of the Victoria Water-lily, the most wonderful bit of engineering, of the kind, I know of.') And then, after a stream of other associations, commented, 'So . . . you must not attach any great botanical importance to the characters of contrasted aspects in leaves which I wish you to express by the words "Apolline" and "Arethusan"; but their mythic importance is very great.'[6]

What follows is an extraordinary exposition of the fable of Apollo and Daphne, which merges into a new interpretation of the Garden of Eden. Ruskin recounts how Daphne, pursued by Apollo, cried to her mother, the Earth, which opened and received her, 'causing the laurel to spring up in her stead'. And so, Ruskin says, 'Wherever the rocks protect the mist from the sunbeam, and suffer it to water the earth, there the laurel and other richest vegetation fill the hollows, giving a better glory to the sun itself.' He goes on to say that the leaf, in its connection with the river, 'is typically expressive, not, as the flower was, of human fading and passing away, but of the perpetual flow and renewal of human mind and thought, rising "like the rivers that run among the hills"'.[7]

Ruskin then links the fable of Apollo and Daphne to the story of the Garden of Eden, or, in Hebrew, the Garden of Delight. He makes the point that no flowers are specifically mentioned in Genesis, and argues that the trees in Eden could not have been watered by the rivers

alone. 'No storm-clouds were there, nor hidings of the blue darkening veil; but there went up a *mist* from the earth, and watered the face of the ground, – or, as in Septuagint and Vulgate, "There went forth a fountain from the earth, and gave the earth to drink".'[8]

Finally, the Arethusan leaf-type, of *alisma* and laurel, leads him to the observation:

... we continually think of that Garden of Delight, as if it existed, or could exist, no longer; wholly forgetting that it is spoken of in Scripture as perpetually existent; and some of its fairest trees as existent also, or only recently destroyed.[9]

Ruskin goes on to argue that wherever a nation rises into 'consistent, vital, and, through many generations, enduring power, *there* is still the Garden of God; still it is the water of life which feeds the roots of it; and still the succession of its people is imaged by the perennial leafage of trees of Paradise. Could this be said of Assyria,' he asks, 'and shall it not be said of England?' And so, dazed perhaps, we are back in the *hortus conclusus*, with its sealed fountain ... a garden not threatened by mathematics or scientists' knives.

Throughout these books, Ruskin returns to the theme that cutting things up, and killing them, is a hindrance rather than a help towards an aesthetic or spiritual response to nature. He urges young painters to 'give up that hope of finding the principle of life in dead bodies'. There is nothing to be learned from 'the morgue, brothel, and vivisection-room'. All true science, as opposed to modern science, 'begins in the love, not the dissection of your fellow-creatures; and it ends in the love, not the analysis, of God'.[10] He urges upon artists the study of theology and heraldry rather than anatomy.

'Among the new knowledges which the modern sirens tempt you to pursue the basest and darkest is,' he says, 'the endeavour to trace the origin of life, otherwise than in love':

All nature with one voice – with one glory, – is set to teach you reverence for the life communicated to you from the Father of Spirits ... The song of birds, and their plumage, the scent of flowers, their colour, their very existence, are in direct connection with the mystery of that communicated life: and all their strength, and all the arts of men, are measured by, and founded upon, their reverence for the passion, and their guardianship of the purity, of Love.[11]

Repeatedly, Ruskin revealed his impatience with Darwin; his assaults were often misplaced. For example, the thrust of the anti-Darwinian polemic in *Love's Meine* (first printed in book form in 1872) appears to be against the idea of the inheritance of acquired

characteristics, and would therefore have been more appropriately aimed at Lamarck. Nonetheless, Ruskin was acutely aware of weaknesses in Darwin's arguments, which, today, would be acknowledged even by those who accept his general theories. These concern Darwin's understanding of the role of what Ruskin called love – or 'The Law of Help' – (and modern biologists call altruism) and beauty in the natural world.

For example, Ruskin wanted to demonstrate that the beauty of flowers was not simply a matter of sexual propagation. The flower, he said, 'exists for its own sake, not for the fruit's sake. The production of the fruit is an added honour to it – is a granted consolation to us for its death. But the flower is the end of the seed, – not the seed of the flower . . . It is because of its beauty that its continuance is worth Heaven's while.'[12] Now, to our ears, this must sound almost as perverse as Gosse's argument concerning the fossils: and yet, like Gosse, Ruskin was on to something which the evolutionary biologists ignored. Darwin himself once remarked that whenever he saw the peacock's tail it made him feel sick. And Ruskin is aware that theories of the survival of the fittest and sexual selection are inadequate when we are confronted with many of those aspects of the world we might describe as aesthetic. Darwin's ignorance of good art, Ruskin says, 'is no excuse for the acutely illogical simplicity of . . . his talk of colour in the *Descent of Man*':

Peacocks' tails he thinks, are the result of the admiration of blue tails in the minds of well-bred peahens, – and similarly, mandrills' noses the result of the admiration of blue noses in well-bred baboons. But it never occurs to him to ask why the admiration of blue noses is healthy in baboons, so that it develops their race properly, while similar maidenly admiration either of blue noses or red noses in men would be improper, and develop the race improperly . . . And when he imagined the gradation of the cloudings in feathers to represent successive generation, it never occurred to him to look at the much finer cloudy gradations in the clouds of dawn themselves; and explain the modes of sexual preference and selective development which had brought *them* to their scarlet glory, before the cock could crow thrice.[13]

A modern biologist would *not* agree with the drift of Ruskin's thought: he would however assent that there was something about such things as peacocks' tails, birdsong, patterning in nature, and the sounds produced by the humpback whale, which had hitherto eluded the explanations of conventional science.

Our modern biologist would be even more likely to agree with

Ruskin's argument that the operations of nature were not built on competition alone. The validity of Ruskin's argument was recognised even in his own time – if only by eccentric commentators like Patrick Geddes, who, whatever his confusions and failings, was among the first men of science to observe the importance of co-operation in the evolutionary process. After noting 'the general correspondence in principle and detail between biological principles on the one hand, and Mr Ruskin's most "unpractical" teaching on the other', Geddes remarked, ironically, that the shout of sentiment *versus* science, with which Ruskin had for so many years been assailed, did after all accurately enough describe the controversy:

The inductive logic and statistics, the physics and chemistry, the biology and medicine, the psychology and education were all essentially on the side of Mr Ruskin; while on the other were too often sheer blindness to the actual facts of human and social life – organism, function, and environment alike – concealed by illusory abstractions, baseless assumptions, and feeble metaphors . . . and frozen into dismal and repellent form by a theory of moral sentiments which assumed moral temperature at its absolute zero.[14]

This is to exaggerate the significance of Ruskin's ideas. Nonetheless, as Patrick Bateson wrote recently in his article 'The Biology of Co-operation', 'The message from biologists to the wider world should not be that the exclusive motive behind all relationships is incorrigible selfishness.' He went on to say that if biological thinking is needed to direct attention to aspects of human nature, it should point

to collective action, mutual help and trust just as much as it does to conflict over resources, deceit and individual ambition. The picture we should have of ourselves is richer and more complex than that suggested by a model for human society of ruthless competition or, indeed, one of idealistic collectivism.[15]

Or, as E. O. Wilson has recently argued, 'biophilia', or love of life, may itself be part of human genetic inheritance.[16]

Ruskin would certainly have agreed.

Karl Barth and the Death of God

The ideas of Ruskin's final years did not represent a 'return' to the natural theologies of his youth; rather he attempted to elaborate an aesthetic and spiritual response to a world in which a conventional God seemed to play an ever diminishing role. Mainstream Protestant thinking was to follow a very different direction; it would not, I think, have surprised Ruskin to learn that the theological thinker who appeared to demonstrate most convincingly the *impossibility* of *theoria* was heir to that tradition of German idealist thought which he so despised. And yet the thought of Karl Barth and the thought of Ruskin had much in common: both were men of formidable intellect, Evangelicals, of a Biblical cast of mind. But, if the later Ruskin was struggling to find a way in which he could love nature in the absence of God, that hiddenness of God's revelation of Himself and the *fallen* character of the world became the basis of Barth's theology (and of much twentieth century Protestant thought).

There seem to be no indications that Barth, who was born in Basle in 1886, at a time when Ruskin was ensconced in Brantwood, and his public life was coming to a close, knew about Ruskin. After the publication of Barth's commentary on St Paul's Epistle to the Romans in 1918, he began to cast a long shadow over Protestant theology in the West, at just the time when Ruskin's reputation was beginning to wane; indeed, Barth's theology became known as 'neo-Orthodoxy'. And, as late as 1961, I went to boarding school for the first time with a copy of *Dogmatics in Outline* among the cans of condensed milk and the new rugger boots in my tuckbox.

Barth's thought was a response to what he perceived as the failure of the natural theologies of the nineteenth century, and was directed towards a rediscovery of God's revelation of Himself after all the obscuring veils of natural theology, indeed of religion itself, had been cleared away.

'We begin,' Barth once wrote, 'by stating that religion is unbelief.

It is a concern, indeed, we must say it is *the* one great concern, of godless man.'[1] And yet Barth was not a foe of religion; least of all did he see himself as a proto-modernist theologian, who wished to dissipate the doctrines of incarnation, redemption and salvation into the 'ethical earnestness' of liberal, humanist anthropology. On the contrary, Barth was the relentless opponent of all 'Pelagianism', that is, of all attempts to deny the doctrine of original sin. Nor, he insisted, did what he said about 'religion' involve 'any human renunciation of human values, any contesting of the true and the good and the beautiful', which, he believed, were revealed in 'almost all religions'. His aim was, at once, more terrible and awe-inspiring than intellectual iconoclasm. For Barth believed that, in his judgement on religion, he was reiterating the judgement of God Himself. In religion, Barth said, 'man bolts and bars himself against revelation by producing a substitute, by taking away in advance the very thing which has to be given by God'.[2] And art, of course, could not hope to do any better.

Barth shared that longing which so many in the nineteenth century had felt for God; but, simultaneously, he distinguished sharply between God and the various forms of knowledge and experience (whether aesthetic, pietistic, cultural, scientific or rational) in which ideas about Him were expressed. Barth referred to a *dies ater*, a black day, at the beginning of August 1914, when ninety-three German intellectuals published an endorsement of the military policy of Kaiser Wilhelm II and his councillors, on which he found the names of almost all the theological teachers whom he had respected.[3] As far as he was concerned, 'there was no more future for the theology of the nineteenth century'.

Barth's own 'crisis theology' insisted that God was the subject, not the object, of experience: religion, Barth argued, was 'the most dangerous enemy a man had on this side of the grave' – because it expressed man's faith in himself, the very antithesis of the revelation of God, as witnessed in the New Testament, as the one who acts for us and on us. He described God as wholly other and utterly transcendent. God was hidden as much as he was revealed even in his one moment of self-revelation, in The Christ.

Barth's conception of The Christ explicitly swept aside all those 'readings' which had so preoccupied the painters and writers of the nineteenth century, including Holman Hunt and Oscar Wilde: 'He is not a genius,' Barth wrote, 'He is not a hero or leader of men. He is

neither poet nor thinker.' In Jesus, he insisted, 'revelation is a paradox, however objective and universal it may be'.[4] That the promises of God had been fulfilled in Jesus Christ was not, and never would be, 'self-evident truth', since in Jesus that faithfulness appeared 'in its final hiddenness and its most profound secrecy'. Barth declared what Ruskin had discovered: 'The truth, in fact, can never be self-evident, because it is a matter neither of historical nor of psychological experience . . . Therefore it is not accessible to our perception.'[5] In Jesus, Barth argued, 'God becomes veritably a secret: He is made known as the Unknown . . . He becomes a scandal to the Jews and to the Greeks, foolishness. In Jesus the communication of God begins with a rebuff, with the exposure of a vast chasm, with the clear revelation of a great stumbling block.' To believe in Jesus was, for Barth, 'the most hazardous of all hazards'. As The Christ, He brought the world of the Father. 'But we who stand in this concrete world know nothing, and are incapable of knowing anything, of that other world.'[6]

So much for *The Scapegoat*. But Barth would have been, if anything, even more sceptical concerning the 'transcendent' claims of abstraction. Of the effects of religion, he wrote:

Once the eye . . . has been blinded, there arises in the midst between here and there, between us and the 'wholly other', a mist or concoction of religion, in which, by a whole series of skilful assimilations and mixings, more or less strongly flavoured with sexuality, sometimes the behaviour of men or of animals is exalted to be an experience of God . . . The mist envelopes us, so that we cannot see clearly. It is 'a tiny mist between God and man' which soon becomes a veritable sea of clouds.

So much for Watts and Kandinsky!

Barth was also scathing about any attempt to 'prove' the existence of God from the experience of man; he would have regarded Ruskin's experiments with canal plants as blasphemous presumption. Otto's appeal to *The Idea of the Holy* in human experience would have cut no ice with him. Although Barth himself was a great lover of music and the arts, he argued the impossibility of the expression of the spiritual – as opposed, that is, to the religious – in art at all. He spoke of a *diastis*, or great divide, beween human culture and God. The attempt to confine God to some human institution or agency was anathema to him. All that art could hope to do was, perhaps, like John the Baptist in Grunewald's Isenheim altarpiece (a picture by

which Barth was preoccupied), to witness to the (partial) revelation God had made of Himself in the person of Jesus Christ.

Barth's attitude to contemporary criticism, scholarship and science was, in many ways, comparable to Newman's. His uncompromising refusal of the idea that the natural or the human could speak of the Divine meant that he felt less threatened by the 'advances' and contradictions of modern thought than, say, Ruskin. And yet his whole purpose was to indicate the fallibility and the *limits* of such thinking, to put an end to the 'old refined intelligent culture' of the nineteenth century, with all its 'progressive' tendencies, its faith in human reason, human culture, or the knowledge of God acquired through the strivings of human piety.

The impact of Barth's vision no doubt owed much to the moment when it was unleashed upon the world. In 1918 progressive rationalism, and an easy identification of the purposes of God with the evolution of man and the world, were exploded fallacies. Barth gave voice to a theology towards which many, who did not necessarily share his particular sectarian position, had been groping. 'As I look back upon my course,' he wrote concerning the first publication of *The Epistle to the Romans*, 'I seem to myself as one who, ascending the dark staircase of a church tower and trying to steady himself, reached for the banister, but got hold of the bell rope instead.'⁷ To his horror, Barth added, he had then to listen to what the great bell had sounded over him, and not over him alone.

The work on which Barth spent most of his life after *The Epistle to the Romans* was his *Church Dogmatics*, whose twelve volumes amount to more than six million words; God, the *Totaliter Aliter* may have been hidden as much as He was revealed in His one moment of revelation in The Christ: nonetheless, there was, it seems, quite a bit that merely human reason might say concerning him after all.

'I am an avowed opponent of all natural theology,' Barth once said. And 'natural theology' emerges as the main polemical enemy in Barth's *Church Dogmatics*. Barth extended the idea of 'natural theology' to encompass *any* claim to know *anything* about God through the application of worldly knowledge of any kind. 'Ever since about 1916,' he wrote, 'when I began to recover noticeably from the effects of my theological studies and the influences of the liberal-political pre-war theology, my opinion concerning the task of our theological

generation has been this: we must learn again to understand revelation as *grace* and grace as *revelation* and therefore turn away from all "true" or "false" *theologia naturalis*, natural theology, by ever making new decisions and being ever converted anew.'

And so Barth's conception of natural theology was much broader than, say, that of William Paley, with his argument from design in nature. Barth extended the idea to *any* belief that human knowledge could 'find' God in incarnation. This was the root of Barth's dispute with Emil Brunner, the greatest of his 'conservative' disciples who appeared, to Barth, to give credence to the idea of 'general revelation'. There was, Barth insisted, no *Anknüpfungspunkt*, or point of contact, between God's revelation and man's natural experience, his knowledge of the material and empirical worlds. Although Brunner agreed in his *Natur und Gnade* (1934) that 'saving grace' came through The Christ alone, he demurred from that absolute severance between the natural and the Divine upon which Barth insisted. Barth held that the Divine image had been obliterated by the Fall, and, in 1934, he roundly denounced Brunner in a bitter pamphlet entitled *Nein!* Brunner continued to maintain that, though the content of the image of God in man had been lost through the Fall, its form had been preserved. Barth saw this as a step back towards Pelagianism. But Brunner's was a view which at least would have rendered Ruskin's conception of theoretic art tenable.

* * *

It is as well to pause, and to see how far we have travelled from the early Ruskin, the Ruskin of natural theology, prior to the advent of the storm-cloud. For Ruskin, the 'subject matter' of the theoretic faculty was, 'in all cases ... something Divine; either the approving voice of God, the glorious symbol of Him, the evidence of His kind presence, or the obedience to His will by Him induced and supported'.[8] All these subjects of contemplation were, for Ruskin, 'such as we may suppose will remain sources of pleasure to the perfected spirit throughout eternity. Divine in their nature, they are addressed to the immortal part of men'.[9]

Towards the end of his working life, Ruskin's thought lost any Christological emphasis it might have possessed: he would *not* any longer have defined modernism as the 'denial of Christ'. Indeed, he seemed to draw close to thinking that his ideas about 'objective' (or natural) beauty and co-operative morality could be sustained without

the idea of a conventional Christian God. One of the last passages he was to write was an addition, in 1888, to *Modern Painters*:

The claim ... of the Personal relation of God to man, as the source of all human, as distinguished from brutal, virtue and art ... must be carefully and clearly distinguished by every reader who wishes to understand either *Modern Painters* or any of my more cautiously written subsequent books, from the statement of any Christian doctrine as commonly accepted ... Man's use and purpose ... is to be the witness of the glory of God, and to advance that glory by his reasonable obedience and resultant happiness. Nothing is here said of any tradition of Fall, or of any scheme of redemption; nothing of Eternal Punishment, nothing of Immortal Life. It is assumed only that man can love and obey a living Spirit; and can be happy in the presence and guidance of a Personal Deity, otherwise than a mollusc, a beetle, or a baboon.[10]

Needless to say, as the twentieth century progressed, such ideas seemed to lose all their currency in intellectual life: even devout Christians denied that there was any spiritual gain to be derived from the aesthetic contemplation of nature – or of art. Hans Küng, a Catholic theologian deeply influenced by Barth, could write, in 1981, that art was no longer regarded as religion, 'as absorption of man into the Divine world, as man's supreme purpose'. Art, Küng says, 'has now become the expression of man's estrangement, his isolation in the world, of the ultimate futility of human life and the history of humanity'. For Küng, art is seen 'no longer against a pantheistic but *against a nihilistic background*'. It is, for him, 'this nihilistic background which enables us to raise the question of art and meaning today in a wholly new, an ultimate radicalness':

The sea drunk up (a bleak emptiness), the horizon wiped away (a living space without prospects), the earth unchained from its sun (an abysmal nothingness); with these three powerful metaphors Nietzsche a hundred years ago clear-sightedly announced the advent of nihilism – today often so banal, ordinary, superficial – in order to ask: 'Is there still any up or down? Are we not straying through an infinite nothing? Do we not feel the breath of empty space? Has it not become colder? Is not night continually closing in on us?'[11]

Modern Protestantism and modern Catholicism alike thus came close to elaborating a conception of God which projected him not only far beyond his fallen world, but out of reach of the strivings, or indeed the imagination, of any human soul. Predictably, Barth's more 'radical' followers ended up by proclaiming the literal 'Death of God',

and an earthly 'Wasteland' ominously similar to the Godforsaken world of Ruskin's middle years ... and utterly different from that view of nature celebrated in his later works.

18

Black Skeleton and Blinding Square

One of the images from the thirteenth century which is best known today is the frontispiece of a *Bible Moralisée*, compiled between 1220 and 1250, now in the Austrian Library in Vienna, which reveals God as the great Geometer, creating the world with his dividers. With 'the Death of God', and what seemed like his final disappearance from that which he was once believed to have created, the avant-garde usurped his place, seized the instruments proffered by modern technology, and announced its intention to recreate the world in its own image.

The idea of the avant-garde could be traced back to the middle of the nineteenth century; but the age of the avant-garde arrived with the twentieth century. Only in retrospect did the term become applied to *all* those who, in cultural life, expressed their opposition to academic tradition. This has led to deep confusion: for example, in the nineteenth century, Nazarenes, Gothic Revivalists, Pre-Raphaelites and Symbolists all split off from the prevailing orthodoxy. Many of these were later claimed by twentieth century apologists for modernity; Timothy Hilton, who, as the most distinguished of the recent biographers of Ruskin ought to have known better, has described the Pre-Raphaelites as 'an avant-garde' group. They were in fact openly and consciously *reactionary*: therein lay their aesthetic strength.

Much of the greatest art of the nineteenth century filtered its ideas of the future through a longing for what had been lost, for a world, usually Christian, where art was enmeshed with spiritual beliefs and values, and could claim to have deep tendrils in the life of a community wider than that of artists. Ruskin, of course, grasped this fully; he would never have entertained the idea that the Pre-Raphaelites were 'avant-garde'.

The essence of 'vanguardism' was a preoccupation with the future to the exclusion of the past; a definition of experience which was so

formulated as to include matter but to *exclude* the spirit; and a celebration of the productive power of mechanism rather than of nature herself. Avant-gardism was also 'internationalist' rather than nationalist, preferring rhetorics of global domination and ultimate, homogenous avant-garde supremacy, to those aesthetic tastes which valued specific, particular, and parochial phenomena. The avant-gardist lacked those 'theoretic' penumbra which hung around the taste of the aesthetes from Pater to Fry, at least the early Fry. Rather, he indulged in a bombastic contempt not only for the bourgeois forms of art, but for aesthetic and spiritual experience themselves.

If the high art of eighteenth and early nineteenth century painting had been based on 'natural theology', that of the modern movement wanted to root itself in a secular, scientific materialism: and Marxist and modernist art historians (the two often co-existed in the same individual) naturally tried to interpret the past in the light of their understanding of the present. Writing in 1933, Max Raphael (who was both Marxist and modernist) argued that Courbet was the first avant-gardist by reason of his 'materialism',[1] his refusal of the transcendental and metaphysical, what Berger later called his acceptance of the *force of gravity*. (Imagine how absurd one of Courbet's women would have looked with angel's wings!) Cézanne allegedly introduced into this materialist perspective a dialectical element. Cubism supposedly combined these two elements to become 'the only example of dialectical materialism in painting'.

Once, I believed such arguments: now I find them too pat for words. If we regard the 'theoretic' as well as the formal or aesthetic qualities of his work, then Cézanne was, in his way, as *reactionary* a painter as the Pre-Raphaelites: he, too, was seeking to reintroduce a lost spiritual dimension into art. And as for the Cubists, thanks to the patient and painstaking researches of Tom Gibbons, we now know for certain that what they were attempting had nothing to do with either science or dialectical materialism. For in 1980 Gibbons showed that, far from being 'materialists', the Cubists produced pictures which were informed by transcendentalist, spiritualist and millenarian thinking.[2] No wonder then that a critic like Leo Steinberg should detect a flickering of Gothic light in Cubist paintings: they were more about the preservation of a Gothic sensibility than the celebration of modernity.[3]

The Italian Futurists, however, could not be seen in such a light.

Marinetti held that to admire an old picture was to pour sentiment into a funeral urn, 'instead of hurling it forth in violent gushes of action and productiveness'.[4] Predictably, on a visit to England, Marinetti urged his audience: 'Disencumber yourselves of the lymphatic ideology of your deplorable Ruskin ... with his hatred of the machine, of steam, and electricity' and his mania 'for antique simplicity'.[5] Marinetti accused Ruskin of wanting to get back into his cot again. Such technism led, as it often does, to Marinetti's belief that every work of art must bear 'the stamp of aggressiveness'. 'We will glorify war,' he declared, 'the only true hygiene of the world.' War, for Marinetti, was beautiful because it 'initiates the dreamt-of metalisation of the human body'.[6]

Marinetti became a Fascist. But very similar attitudes were held by the Russian avant-garde, many of whom espoused Communism and celebrated the productivist aesthetics of Karl Marx with a vengeance. 'Art,' wrote Rodchenko, 'has no place in modern life ... Every cultured modern man must wage war against art, as against opium.'[7] The same ideas were rife among Dadaists and Surrealists; one Dada slogan poem proclaimed: 'Down with art/Down with bourgeois intellectualism/Art is dead/Long live the machine art of Tatlin.'[8] The avant-garde took its standards from an artless future, and worshipped the apparition of 'black skeleton and blinding square'. Socialism and mechanism were often the means of bringing these things about; thus, in 1931, Aragon, the Surrealist poet, could write:

> The universe must hear
> a voice shouting the glory of materialist dialectics
> marching on its feet on its thousands of feet
> shod in military boots
> on its feet magnificent as violence
> holding out its host of arms bearing weapons
> to the image of victorious Communism
> Glory to materialist dialectics
> and glory to its incarnation
> The Red
> Army
> etc., etc., etc.

This poem was criticised by André Breton, but nonetheless caused him to observe: 'We need not maintain that we are therefore the last adherents of "art for art's sake" in the pejorative sense in which this conception deters those who abide by it from action with a view to

anything but the production of the beautiful.' Breton went on to
say that the Surrealists had never ceased to attack such a conception
or to demand 'that the writer, the artist participate actively in
the social struggle'. The avant-garde indubitably hoped that this
'social struggle', and the Communism in which they so vainly
believed it would result, would provide a substitute for that sense of
community of which the modern artist was otherwise so brutally
deprived.

Many avant-gardists themselves endeavoured to define the modern
movement – as Ruskin had done – as, first and foremost, the
pursuit of an aesthetic which refused religion and the spiritual life.
Only, for them, as for Marx, this was modernity's triumph; the
Surrealists, for example, seemed to wish to retain those worlds of
symbolism and iconography which had informed the religious art of
the past – but to imbue them with secular, sensual and subjective
meaning.

Modernism's theoreticians often spelled out secularisation as the
shibboleth of the movement. R. H. Wilenski, one of the first historians
of modernity in painting, was at the forefront of those who, in the
1930s, conspired successfully to suppress Ruskin's reputation. His life
of Ruskin set out to illustrate 'the perpetual rationalisations of his
self-indulgence, and the influence on his thought and conduct of the
mental malady that steadily destroyed him as the years went on' –
which Wilenski diagnosed as a form of manic-depressive delusion.[9]
And yet his own book on *The Modern Movement in Art* reinstates,
in no uncertain terms, Ruskin's sharp distinction between religious
art and the art of the modern movement. Indeed, for Wilenski,
that which was decisively new and original about modernity was its
secularity. Art produced in the service of some religion, he argued,
was in a class by itself, albeit a class which included 'the great majority
of works of art in the world'.[10]

R. H. Wilenski emphasised how religion once embraced many other
areas of human experience and activity besides art. He cited Emile
Male, the great authority on French Gothic, who pointed out that the
art of the early Gothic cathedrals 'was the mirror not only of the
religious, but also the mirror of the scientific and the moral concepts
of the medieval Christian world, of that world's experience of past
and contemporary history, and of its perception of architectural
form'.[11]

But, in Western Europe, 'especially since the middle of the Italian

Renaissance, a very large number of works of art have been produced which have not been called forth by their service of a religion'. The modern movement, for Wilenski, was 'simply the latest attempt to solve the fundamental problem of all intelligent Western European artists since the High Renaissance, the problem, that is, of finding a justification for artistic work and a criterion of its value other than the justification and criterion afforded by the service of some religion'.[12]

Wilenski pointed out that the disappearance of the idea of religious service as the fundamental *raison d'être* of art was looked on by most art critics 'as an event of great benefit to the European artist'. But, despite his commitment to the modern movement, he expressed his belief 'that the change meant no increase of freedom; that no sooner had the artist shaken off the chains that bound him to the service of religion than he felt the need of other chains to provide security and peace of mind'.[13]

Nikolaus Pevsner tried to demonstrate what the chains that bound the modern artist were. For Pevsner, this century's style, like that of any other, was in no sense simply 'functional', but rather issued forth from faiths and beliefs. The 'modern movement' in architecture, he argued, 'in order to be fully expressive of the twentieth century' had to possess 'the faith in science and technology, in social science and rational planning, and the romantic faith in speed and the roar of machines'.[14]

For Pevsner, 'the recovery of a true style' indicated the 'return of unity' throughout society, too. (In this sense, he believed, the modern movement had more in common with the Gothic than with the 'historicist' eclecticism of the Victorians.) But the basis of this unity was no longer that of religious belief, but rather scientific materialism – the triumphant new credo of the twentieth century. The 'pioneers' of modernity discovered 'the immense, untried possibilities of machine art'.[15] If Pevsner believed that William Morris had 'laid the foundation of the modern style', he went on to say that 'with Gropius its character was ultimately determined'.[16]

In 1909, Gropius had worked out a memorandum on mass-production of small houses. Pevsner's praise for Gropius's achievement knew no bounds. His book *Pioneers of Modern Design* ends with a notorious and direct comparison of the 'Model Factory' and the discovery of the Gothic:

Never since the Sainte-Chapelle and the choir of Beauvais had the human art of building been so triumphant over matter. Yet the character of the new buildings is entirely un-Gothic, anti-Gothic. While in the thirteenth century all lines, functional though they were, served the one artistic purpose of pointing heavenwards to a goal beyond this world, and walls were made translucent to carry the transcendental magic of saintly figures rendered in coloured glass, the glass walls are now clear and without mystery, the steel frame is hard, and its expression discourages all other-worldly speculation.[17]

In one sense, there was nothing new about the contrasts and comparisons Pevsner drew between modern buildings and cathedrals. Ruskin had already said of the Crystal Palace that one had 'a natural tendency to look also to the apse of this cathedral of modern faith to see the symbol of it, as one used to look to the concha of the Cathedral of Pisa for the face of Christ, or to the apse of Torcello for the figure of the Madonna'.[18] He asked his readers if they recollected what occupied the place of these in the apse of the Crystal Palace. It was, he recalled:

The head of a Pantomime clown, some twelve feet broad, with a mouth opening from ear to ear, opening and shutting by machinery, its eyes squinting alternately, and collapsing by machinery, its humour in general provided for by machinery, with the recognised utterance of English Wisdom inscribed above – 'Here we are again'.[19]

The clowns were to come into their own when the more 'scientific' attractions of the modern faith had passed out of fashion. But Pevsner went on to say of Gropius's factory that it was 'the creative energy of this world in which we work and which we want to master, a world of science and technology, of speed and danger, of hard struggles and no personal security' that was glorified in Gropius's architecture. And, Pevsner added, 'as long as this is the world and these are its ambitions and problems, the style of Gropius will be valid'.[20]

Naturally, many scientists – who, after all, had much to gain from such rhetoric – entered fully into the spirit of this new and modern aesthetic. C. H. Waddington's *The Scientific Attitude*, first published in 1941, enjoyed an enormous success as a Pelican book. In his chapter 'Art Looks to Science', Waddington argued that artists had no choice but to identify themselves with the material values of contemporary science. Modernity, for him, was synonymous with the acceptance of this 'scientific attitude', whether one was a geologist, a geneticist, a painter, or an architect. Waddington's interpretation of what this

meant for aesthetic life remains chilling. He argued that, separated from traditional culture, the 'man of today' was really no different from a rat.

'Dig [the man of today] out from under the thatched roof of a faked rusticity,' Waddington wrote, 'disinter him from the palm-girt halls of the Hotel Splendide . . . release him from a row of back-to-backs in Shoreditch, and he will be found to be a creature who thrives in light and air, provided he gets the efficient heating and sanitation which modern engineering can provide.'[21] The 'scientific' solution to the problem of art and aesthetics, therefore, was to demolish thatched houses and Hotel Splendides, and to build tower-blocks – with efficient heating and sanitation, of course – as quickly as possible. Waddington declared that even though 'America is far ahead of us', the prospects 'look good'.[22]

Many artists and architects in England, especially in the 1930s and 1940s, went along with the belief that adoption of a 'scientific attitude' necessitated acceptance of the international modernist style. (Although, as we shall see, more concluded that there was nothing the artist could learn from the way the scientist viewed the world.) At the core of that aesthetic was a belief in modern materials and standardised rectilinear forms; the importance Waddington placed on right-angles is emphasised by his juxtaposition of two plates, one of which shows – in the words of his caption – 'An idealised Victorian road, with the lamp posts and the convenience as curly as the horses' manes.' Curls and curves were, in Waddington's book, bad, unscientific things. Plate 12, however, shows a modern road junction. 'The "furniture", beacons, traffic lights and so on, might have come out of a Léger painting,' comments Waddington. 'Besides giving us the trivial commands to stop and go, they are continually quietly reminding us that if we want to get anything done it is best not to say it with flowers, certainly not with cast-iron ones.'[23] Ruskin, I feel sure, would immediately have noted that the only interesting and beautiful forms in the photograph are the irregular trees in the background. But Waddington was quite blind to such things. 'The artist and the architect,' he wrote, 'have a special responsibility. It is their duty to sum up and define a way of life . . . The architect who wished to build for a scientific and sceptical age had to, whether he liked it or not, find out what was left when scepticism had done its worst.'[24]

And what was left for art, it seemed, was not very much. Productivist

and materialist 'aesthetics' – machine art – involved the elimination of all that had previously been considered as art. 'Modern buildings,' wrote J. M. Richards in 1940, 'are not enriched with conventional ornament because their parts are made by machines, and applied ornament is not the machine's method of beautification.'[25] Herbert Read went even further. The machine, he wrote in 1934, had 'rejected ornament'; and the machine had everywhere established itself.

We are irrevocably committed to a machine age – that surely is clear enough now, nearly a century after the publication of *The Stones of Venice*. The cause of Ruskin and Morris may have been a good cause, but it is now a lost cause.[26]

And what was to happen to, say, easel painting in this brave new world of the machine? 'No harm would be done to art, in any vital sense of the word,' Herbert Read wrote, 'if all this vast machinery of life-classes and antique classes were abolished.'[27] The art schools were 'only perpetuating a defunct tradition'. He accused them of 'luring thousands of young men and women into an obsolete vocation where they can only experience poverty, disillusion, and despair'.[28] In the modern utopia, easel paintings were fine 'as tokens of regard to your friends', or as a way of making 'a little pocket money by this private hobby'. But, wrote Read, 'you will not any longer, if you are a reasonable person, expect your fellow-tax-payers to support you while you indulge in an activity which no longer has any economic sanction'.[29]

Children in schools should be taught not picture-making, but 'the techniques of production': 'Then we can safely teach them how to use tools and machines, because with sensitive fingers and vivid minds they will be incapable of producing or consuming the hideous things they are content with now.' Some children, Read argued, could be taught to be 'specialists in design – to be industrial designers and architects'. Others could be given commissions 'as specific and detailed as those the medieval artist received' – only of a modern, mechanical kind. 'And then, in good time, an art as great as medieval art will take shape.'[30]

At the core of the modern enterprise, then, lay a hankering after a thoroughgoing *materialist aesthetic*, an aesthetic which substituted the myth of man's mechanical triumph over nature for the myth of God's immanence within it. In fact, the avant-garde programme became, in effect, 'official' arts policy. But the triumph of the

movement led not, as Read had hoped, to a new art, in its own modern way as great as medieval art, but rather to 'a dead blank of the arts', to the aesthetic wastelands of late and post-modernism, echoing to the vacuous slogan of Ruskin's clown: 'Here we are again.'

The Art of England

Pevsner and co. may have liked to see the modern movement as a universal style, the equivalent of the Gothic without God, but England put up a deep resistance to modernity. Although he passed out of fashion in the early twentieth century, Ruskin's legacy lived on, even among those who disavowed him. No great army of footsoldiers marched willingly, or even unwillingly, in the wake of the avant-garde, which was largely confined to quarrelling sects. The best art in Britain this century has depended for its originality on its denial rather than on its espousal of modernity.

The paradoxes of British art are enmeshed with those of Britain's history. To many, ours has seemed a literary culture, where word has had precedence over image. To understand the roots of this bias, one has only to stand in the magnificent Lady Chapel at Ely Cathedral. Of the thousands of early fourteenth century carvings which once adorned this building, only one now survives, under the centre canopy of the second window on the north side. The rest were pulverised in 1539, at the time of the Reformation. That brutal end to Gothic traditions of art and craftsmanship had an inhibiting effect on the development of British art.

It was not only a matter of the vicissitudes of religious belief, for Britain was the first nation to change from feudalism to capitalism; indeed capitalism developed in the countryside before the grand explosion of the Industrial Revolution. Here there was no violent confrontation between an *ancien régime* and an emergent bourgeois industrial class. The modern British ruling élite was created by a strange process of amalgam, in which all manner of rural and aristocratic cultural mores persisted. The bourgeoisie (if such our heterogeneous élite could be called) was thus lacking in those visions of a new order so characteristic of the European revolutionary imagination.

This goes some way towards explaining that 'failure in our culture

as a whole', as Roger Fry described it, 'whereby our governing classes, who alone have exercised patronage in the past, have been led to adopt a contemptuous and unimaginative attitude towards the visual arts – so that the typical English patron came to regard the artist merely in his capacity of ministering to his desire for prestige, by painting images of himself and his family'.[1] And yet we have already seen how Fry was strangely blind to the achievements of Turner: he failed to understand how what is excluded from one channel tends to surge through any other that is open to it. In Britain, the aesthetic imagination flowed most intensely into those forms of painting which may, originally, have been intended to minister to a desire for prestige: here landscape painting, and painting based upon imaginative response to natural form, flowered as it did nowhere else.

Of course, other nations had their traditions of topographic and also of idealised landscapes – on both of which the British were to draw; but only in this country did landscape painting come to be the vehicle for that combination of noble sentiments, religious and empirical truths which Ruskin spent so much of his life endeavouring to understand. This, I think, is what Ruskin meant when he wrote so perceptively that: 'The English School of Landscape, culminating in Turner, is in reality nothing else than a healthy effort to fill the void which destruction of Gothic architecture has left.'

Equally, it must be said that this peculiar natural, religious, social and political history has often been associated with the persistence of British cultural pastoralism: that is, with an image of the future as somehow identical with an idealised memory of the rural past. This has been held to be the source of all manner of ills by commentators of both the left and the right. For example, Perry Anderson of the *New Left Review* argued that this history inhibited the development of a radical bourgeois culture in Britain – even in the twentieth century. Such a culture was, he argued, inserted artificially into our national life through the processes of immigration of European intellectuals, among whom he cites the case of Pevsner himself. This absence of an intellectual centre, posited upon a sense of the future rather than of the past, inhibited, in Anderson's view, the development of an indigenous Marxism: when Socialism came, it was of a Morrisian, and often explicitly *Christian* kind.[2]

But 'progressivists' of the right are often equally hostile to this legacy of England's cultural history. Indeed, in his book, *English*

Culture and the Decline of the Industrial Spirit, Martin J. Weiner tried to explain Britain's failures in manufacturing in the 1970s on the grounds that the British middle classes were, from their beginnings, absorbed into 'a quasi-aristocratic élite, which nurtured both the rustic and nostalgic myth of an "English way of life"'. He complained that this process led to an unfortunate transfer of energies away from the creation of wealth towards 'a pattern of industrial behaviour suspicious of change, reluctant to innovate, energetic only in maintaining the status quo'.[3]

Anderson and Weiner would no doubt agree in their judgement of Ruskin, who clearly articulated all which they both believe embodies the peculiar failings of the British. But this attitude to modernity – informed yet reluctant, and ultimately profoundly conservative – has in fact been one of the great, if often disguised, strengths of our national cultural life in the twentieth century, and has certainly accounted for those efflorescences of English art which occurred, as it were, against the grain of the modern movements.

For Fry and Clive Bell, Pre-Raphaelitism counted for nothing; Bell described the movement as being 'of utter insignificance in the history of European culture'. And yet this was not the judgement of the French. In 1859 no less an authority than Charles Baudelaire began his extended review of the Paris salon with a paean of praise for a long list of British artists who were not, to his regret, represented, including Holman Hunt. Baudelaire acknowledged that there was something bizarre about British painting; but he recognised that it possessed certain qualities which French art did not. In particular, he described the British as 'enthusiastic representatives of the imagination and of the most precious faculties of the soul'.[4]

This 'otherness' of English art was also acknowledged by Ernest Chesneau, who argued that such strengths derived from its insularity. 'Nothing,' Chesneau wrote, 'can break through this peculiarity of the English people.' He added that 'at the expense of this exclusiveness ... the English school has become a truly national art'.[5] In the following decade, Robert de la Sizeranne, who translated Ruskin for French readers, noted something similar. 'There are,' he wrote, 'German, Hungarian, Belgian, Spanish, Scandinavian painters, but there is an English school of painting.'[6]

Beside this praise of discerning French critics for the particularity of English painting we need to place the deliberately defensive stance of the British concerning what was happening in French art. Repeatedly,

Ruskin and Hunt complained of its sensuousness. For Ruskin, 'the general tendency of modern art under the guidance of Paris' was summed up in the sentence: 'I take no notice of the feelings of the beautiful we share with spiders and flies.' When he wrote a brief introduction to Chesneau's book, he remarked that if British art had once been too insular, it now suffered from the reverse characteristic. British artists were, as he saw it, in danger of losing their national qualities to become 'sentimentally German, dramatically Parisian, or decoratively Asiatic'.[7] Not long afterwards, Hunt pronounced against the 'degrading pretensions' and 'poisonous influence' of Impressionism. He warned that this Parisian '*libertinage*' was threatening 'the true British distinction of art'.[8]

The *separateness* of the two cultures was in fact something concerning which Chesneau would have agreed. English art, he commented, 'is the exact reverse of our own . . . They cannot be weighed in similar scales, because they tend to such different orders of expression'.[9] And yet, for Bell and Fry, late Victorian painting could only be reformed by a process of national renunciation, by an acceptance not merely of the superiority of the French School, but also of its exclusive claims to attention and imitation.

'At any given moment,' wrote Bell, 'the best painter in England is unlikely to do better than a first-rate man in the French second class. Whistler was never a match for Renoir, Degas, Seurat, and Manet; but Whistler, Steer, and Sickert may profitably be compared with Boudin, Jongkind, and Berthe Morisot.'[10] The points of comparison are instructive: the only painters worthy of consideration were those who in some way or other had absorbed the French aesthetic, an aesthetic which, by this time, Bell believed to be based on industrialism and democracy.

In his *Pioneers of Modern Design*, Pevsner also persistently implied that the British had proved unable to 'progress' out of what he regarded as 'historicism'. In comparison with Germany, he argued, Britain was a class-ridden nation, impeded by elements of an *ancien régime* from full acceptance of the democratic and abstracted forms of the machine aesthetic.

But today, on the other side of the failed modernist experiment, matters begin to appear rather differently: it is becoming increasingly evident that those who achieved something in British art this century have tended to show in their work a sense of continuity with a *British* tradition.

This has been obscured by the fact that the history of art has, until recently, largely been written by those who believe that the story which they have to tell is the story of the advance of modernism: that modernism was the only path to the good, the true, or the beautiful in our century. For them, British art has often seemed recalcitrant, or intransigently minor: they have responded either by dismissing or by denigrating it. Alternatively, they have sought to assimilate it to a *modern* tradition to which it clearly does not belong.

Take the celebrated case of British sculpture in the earliest years of this century: according to one account, this was a sweeping away of Victorianism, and a great upsurge of the modern spirit. In fact, it makes greater sense to see the sculpture of Jacob Epstein, Henri Gaudier-Brzeska, Eric Gill and Henry Moore as a reactionary movement, comparable to Pre-Raphaelitism in painting. Far from celebrating the world of machinery, these artists were interested in the idea of organic form; the forms of work which they wished to revive were those of the pre-Renaissance craftsmen. The roar and romance of machines meant little to them; they were more concerned to bring back direct carving and the claw chisel. Above all, their work arose in revolt against Hellenism, and the secular and modern aesthetics which were associated with it: they longed for a sculpture which possessed the spirituality and vitality of 'primitive' men and women.

Let us consider Gaudier-Brzeska. After he came to Britain in 1907, he studied Ruskin and nature, and spent as much time as he could drawing in the English countryside and the Bristol Zoo. According to one of his friends, he had 'a special passion for pen and ink pictures of bits of old churches, and Ruskin was his guide'.[11] In 1910, Gaudier-Brzeska was whirled into the Vorticist movement. The Vorticists were the nearest England came to a continental avant-garde grouping. Even then he wrote, in characteristically Ruskinian terms, 'Sculptural energy is the mountain.'[12] Almost all the significant artists involved with Vorticism, even Wyndham Lewis himself, were later to repudiate its mechanistic obsessions. For Gaudier-Brzeska, this volte-face had taken place even before the First World War, in which he was to die.

So often, Gaudier-Brzeska's attitudes echo those of Ruskin. 'When I face the beauty of nature,' he once wrote, 'I am no longer sensitive to art.' Gaudier-Brzeska also retained a Gothic sense of work: 'The sculpture I admire is the work of the master craftsmen. Every inch of

the surface is won at the point of the chisel – every stroke of the hammer is a physical and a mental effort.'[13] Gaudier-Brzeska died at the Front in 1914. The letters he wrote back to the Vorticist magazine, *Blast*, show how his sense of the spirituality of nature consoled him in the face of the terror of the machinery of war. 'The burning shells, the volleys, wire entanglements, projectors, motors, the chaos of battle, do not alter in the least the outline of the hill we are besieging. A company of partridges scuttle along before our very trench.'[14] This was a very long way from Marinetti's anti-Ruskinism and celebration of the aesthetics of war.

It is often said that Gaudier-Brzeska's great contribution to the modern movement was his discovery and practice of the doctrine of truth to materials, which was to have such a deep effect on what came after. But there was nothing modern about such an aesthetic idea. 'Touching the false representation of material,' wrote Ruskin in *The Seven Lamps of Architecture*, '. . . all such imitations are utterly base and inadmissible.'[15]

Or take Eric Gill, one of the finest stone- and letter-cutters of our century. Again, the historians of art like to say that Gill's contribution to the modern movement in sculpture was his revival of direct carving. But what was, in any meaningful sense, 'modern' about that? If Gill looked back critically on the Gothic Revival, it was because he believed that the movement had betrayed the spirit of holiness which informed the medieval world. Gill converted to Catholicism: his complaint against Ruskin was that, in his thought, he had represented a slide towards pantheistic immanence, secularism and aestheticism. He wanted to reverse the aesthetic history of the preceding century, to reinstate an idea of beauty as synonymous with 'the worship of God which a man displays in his work'.[16]

Nor can Jacob Epstein be said to have been a modernist in Ruskin's or Pevsner's sense. Indeed, it is hard to think of any judgement on Epstein further from the truth than Simon Wilson's that Epstein was 'the father of modern British sculpture and, more generally, one of the pioneers of modern sculpture in the whole Western world'. Epstein despised the Futurists. He recorded how at 'an exhibition of Futuristic Art', Marinetti 'turned up with a few twigs he had found in Hyde Park, and a tooth-brush and a match-box tied together with string. He called this "The New Sculpture", and hung it from the chandelier.' Epstein commented that this was the beginning of those 'monkey tricks' we see elaborated in Paris, London and New York.[17]

It is true that Epstein was himself briefly swept into the Vortex when he made *The Rock-Drill*, in his own words 'a machine-like robot, visored, menacing, and carrying within itself its progeny, protectively ensconced'. This 'sinister figure of today and tomorrow . . . the terrible Frankenstein's monster we have made ourselves into'[18] was mounted on a real mechanical drill. But after the war Epstein rebelled against such imagery and mutilated the sculpture.

Although he adhered to no religion himself, Epstein remained a deeply, if eclectically, religious man. He certainly wanted his sculpture to be expressive of spirit, soul and imagination as well as of flesh. The masterpieces of his later years made use of specifically Christian imagery and traditions. The beautiful *Madonna and Child* he modelled for a convent in London's Cavendish Square was once described by Arnold Haskell, with only slight exaggeration, as 'one of the finest religious sculptures to have been made in England since the Reformation'.[19] Surely the greatest of all his works was the war memorial he made for the Trades Union Congress building in London not long before his death. This majestic sculpture of a woman with her dead son is a variation on the *pietà*. As Evelyn Silber has convincingly demonstrated, 'Epstein's exemplars for architectural sculpture were the cathedrals and churches of medieval France and fifteenth century Florence.'[20] If Epstein was indeed a pioneer of modern sculpture, then modernity was of a very different character from that suggested by Pevsner and others.

But the figure who towers across British sculpture in the twentieth century is undoubtedly Henry Moore. Again, it has often been said that Moore was the quintessential *modern* sculptor: but his imagination, too, can more convincingly be seen as a radically conservative opposition to modernity. Among early influences on Moore were his mother's back (he used to massage her body), the landscape of Yorkshire, and the Gothic sculpture in churches near his family's home in Castleford. Moore told me that his father, who worked for a mining company, introduced him to Ruskin's work. The recurring themes of his life's work were the mother and child, and the reclining figure – in which imagery of the woman and the natural world were fused together. From the modern movement, Moore seemed to take only the idea of 'transformation'; but, as he well knew, this was something which had a long history within English, Romantic concerns. Like Ruskin, he found in the lowlands 'a spirit of repose', but saw 'the fiery peaks' as 'heaving bosoms and exulting limbs'.

As a young man, Moore read Roger Fry, and came to believe that formal relationships in art were the means to spiritual truths. In the beginning, Moore borrowed from Gaudier-Brzeska the idea of truth to materials, and from Gill and Epstein the notion of direct carving. On his first visit to Europe, he wrote to William Rothenstein, complaining of 'the widespread avoidance of thinking and working in stone – and the wilful throwing away of the Gothic tradition – in favour of a pseudo Greek'. Moore wrote that he was 'beginning to get England into perspective', and added that he thought he would return 'a violent patriot'. After praising the 'paradise' of the British Museum's collection of 'primitive' sculptures, he commented on 'how inspiring is our English landscape', adding that he had a great desire, 'almost an ache for the sight of a tree that can be called a tree – for a tree with a trunk'.[21]

Even when, after the Second World War, he began to look on the Greek achievement more favourably, he did so in that romantic and syncretic way which had informed, say, Walter Pater's imaginative reason. Like Pater, too, Moore's imagination seemed to require a penumbra of religious association: some of his finest works, like the Northampton *Madonna*, were made for churches. He insisted that formal devices had to be expressive of moral and spiritual life if the art was to be of any stature.

Of course, the emphasis upon *abstraction* in the work of all these sculptors has sometimes been cited as that which is uniquely and characteristically *modern* about what they did. But Wilenski himself believed that the modern sculptor was seeking those regular and geometric forms which underlay the ragged and tangled diversity of nature. 'Take, for example, the flower umbel (*Coronilla Coronata*) . . . What could be less free and ragged than its form? And how after looking at it can one describe the geometry of a rose-window in a Gothic cathedral as "untrue to nature"?'[22]

R. H. Wilenski acknowledged that this 'abstract' aspect of the new sculpture had been foreshadowed by Ruskin. 'The purest architectural abstractions', Ruskin wrote, 'are the deep and laborious thoughts of the greatest men.' But we can go further than this: for, if Wilenski is right, the sculptural movement in Britain in the early decades of the twentieth century can be seen as having almost the same aim as that posed by Ruskin in *Modern Painters* Volume Two, where he searched for those formal relations and proportions which could reach beyond literary symbols and allusions to reveal ultimate truths. Certainly,

Wilenski saw the abstract element in the new sculpture in that way. In *The Meaning of Modern Sculpture* he argued that the modern sculptor had arrived at 'the concept of the universal analogy of form, the concept of all human, animal and vegetable forms as different manifestations of common principles of architecture, of which the geometric forms in their infinity of relations are all symbols; and at the concept of the meaning of geometric relation as the symbolisation of this analogy of form'.[23] If this had little to do with the demand for 'pure forms', pleasing for their own sake, it had nothing to do with a 'machine aesthetic' either.

A similar argument can be applied to much of the best British painting of our century. A painter like Stanley Spencer was, self-evidently, Pre-Raphaelite in his preoccupations – concerned not just with the spiritual but also with the Biblical, yet obsessed, like his forebears, with the representation of contemporary life. Spencer's art was never in greater danger than when he felt threatened by unbelief; then the only love he could see in nature was a sort of generalised sexuality – of the kind Ruskin had dreaded.

To the detriment of his reputation among art historians, Spencer, however, has always been seen as a British eccentric rather than as a modernist. That is not so with Paul Nash; he has often been presented, and indeed, at times, chose to present himself, as a modernist and a Surrealist. And yet the logic of Nash's vision can much better be understood in terms of English Romantic traditions, Pre-Raphaelitism, and his continuing search for the revelatory power of forms themselves. Nash's art began in his obsession with Rossetti. 'I turned to landscape,' he wrote, 'not for the landscape's sake but for the "things behind", the dweller in the innermost: whose light shines thro' sometimes.'[24] Interestingly, Nash wrote of his experiences on the Ypres salient – which he painted so vividly – in phrases reminiscent of Holman Hunt's entries in his diary when on the shores of the Dead Sea; 'the black dying trees ooze sweat and the shells never cease. It is unspeakable, godless, hopeless.'[25] Perhaps his most compelling image was *Totes Meer* – literally a Dead Sea, albeit without a scapegoat of wrecked German aircraft. But such intimations of salvation and redemption which Nash offers did not come about through the awkward insertion of olive leaves or rainbows. Rather, he realised a 'redemption through form', which is perhaps why his *Totes Meer* lacks the compositional awkwardness of Hunt's original. All this, of course, flowered magnificently into the great visionary landscapes

of Nash's last years, like his *Landscape of the Vernal Equinox* of 1944.

It is possible to detect very similar preoccupations in the work of a painter who, like Spencer, self-consciously insulated himself from modernist influence: L. S. Lowry. Like Nash, Lowry had virtually an obsession with Rossetti. Lowry himself began as a nature painter, stamped by a marked sense of man's fallen condition. 'When I was young,' Lowry once told Maurice Collis, 'I did not see the beauty of the Manchester streets. I used to go into the country painting land-scapes and the like. Then one day I saw it. I was with a man in the city and he said, "Look, it is there." Suddenly I saw the beauty of the streets and the crowds.'[26] But Lowry was never interested in social realism. Industrial dereliction and urban decay were what the war-torn landscape was to Nash – a fallen *locus*, within which he could bring a kind of redemption through aesthetic means. Characteristically, Lowry's stick-men are organised into rhythmic patterns across a milky-white, engulfing ground. 'Natural figures would have broken the spell of it, so I made them half unreal . . . Had I drawn them as they are, it would not have looked like a vision.'[27]

Like so many of the outstanding British artists of our century, Lowry pursued his own course. So did David Bomberg, whose parallels with Nash are perhaps more immediately apparent. For Bomberg's imagination was also transformed by his experiences at the Front: he had also been a Vorticist, but the war put an end to his celebration of mechanical form. As he later put it, 'The strength that gave the cave-dwellers the means to express the spirit of their life is in us to express ours. We have no need to dwell on the material significance of man's achievement, but with the approach of the scien-tific mechanization and the submerging of individuals we have urgent need of the affirmation of his spiritual significance and his individuality.'[28]

But what did authentic expressions of the spirit actually *look like* in a modern secular age? Bomberg seems to have followed the example of many nineteenth century painters – including Holman Hunt – in his belief that a trip to the Holy Land might help him to resolve this problem. While there, his work had a strangely topographic and Pre-Raphaelite quality, as if he too believed for a time that simply by the intensity of his scrutiny he could see beyond the appearances of things. Indeed, it has been remarked how very closely Bomberg's masterpiece of these years, *Mount of Olives* (1923), resembles the

masterpiece of Thomas Seddon, Holman Hunt's travelling companion on his trip to the Holy Land, *Jerusalem and the Valley of Jehoshaphat* (1854).[29]

Later, Bomberg came to see the limitations of this sort of aesthetic. He often spoke of the decline of British art after Constable and Turner. 'The writings of Ruskin and the painting of the Pre-Raphaelite Brotherhood,' he said, '. . . could not effectively stem the deterioration, though it (*sic*) did reveal the decadence of official art and perform, in a short time, the enormous task of driving a wedge into the Temple of Indolence in the Citadel of Sterility.'[30]

Bomberg came to believe that Ruskin had failed to understand that, in his late paintings, Turner was engaged in what he, Bomberg, called a search for 'the spirit in the mass'. Unlike the modernists, he saw Cézanne as having, in a sense, furthered this project in France. And he devoted the last part of his life to attempting to find a way of drawing, painting and teaching which could give expression to this yearning.

At this time, Bomberg drew heavily upon the ideas of George Berkeley, Bishop of Cloyne. Like Pater after him, Berkeley had been troubled by the fragmented view of the world presented to us through unstructured sense perception; this seemed to Berkeley, and to Bomberg too, a chimerical nightmare threatening dissolution. But Bomberg was fascinated by Berkeley's idea that gravitational forces attested to the existence of God. For Berkeley, as Roy Oxlade, one of Bomberg's pupils, has put it, God 'is seen as the absolutely necessary unifying principle'.[31] He argues that Bomberg shared this belief and that his aesthetic depended upon it.

Because Bomberg wanted an art of *theoria* rather than of *aesthesis*, he taught that the eye itself was stupid. He yearned for an aesthetic which began with the evidences of the eye, but rose from such origins to apprehension of the revelation of God himself. Like Ruskin, Bomberg became fascinated with flowers, rocks and the great cathedrals. Also like Ruskin, Bomberg was never entirely at home with the painting of the human figure . . . or outstanding at human relationships. Both men were haunted by their sense of an imminent *failure of nature*, associated with the advance of technology, war, unbelief and spiritual decay.

But it is in the exultant hope with which, when they were feeling well, they approached the rocky masses of mountain scenery that Bomberg and Ruskin seem to draw closest to each other. 'Gradually,'

Bomberg once explained, 'we were brought to comprehend how the part was not the organic whole and how the organic whole was part of the mystery of the mass.'[32] Similarly, Ruskin advised his readers that if they desired to perceive the 'great harmonies of the form of a rocky mountain', they should not ascend its sides. 'All is there disorder and accident,' he wrote, 'or seems so; sudden starts of its shattered beds hither and thither; ugly struggles of unexpected strength from under the ground, fallen fragments, toppling one over another into more helpless fall.'[33]

And so, he recommended:

Retire from it, and, as your eye commands it more and more, as you see the ruined mountain world with a wider glance, behold! dim sympathies begin to busy themselves in the disjointed mass; line binds itself into stealthy fellowship with line; group by group, the helpless fragments gather themselves into ordered companies; new captains of hosts and masses of battalion become visible, one by one, and far away answers of foot to foot, and of bone to bone, until the powerless chaos is seen risen up with girded loins, and not one piece of all the unregarded heap could now be spared from the mystic whole.[34]

There could hardly be a more precise description of what Bomberg meant when he spoke of the search for 'the spirit in the mass', or, indeed, of what he succeeded in revealing in his last paintings of the landscape around Ronda in Spain.

Today, the stature of Bomberg's achievement has, at last, been recognised. But towards the end of his life he was a lonely and cantankerous figure, supported only by a small group of dedicated pupils and followers. In fact, his ideas had more than a little in common with those of Graham Sutherland, whom Douglas Cooper once described as 'the most distinguished and the most original English artist of the mid-twentieth century'.[35] 'For Sutherland,' John Hayes wrote, 'landscape and all its elements bear the impress of the divine creation of which he seeks to catch a reflection.'[36]

Sutherland began his career as a pastoral etcher, very much in the tradition of Samuel Palmer, from whom he learned the idea of transformation. But in 1929 his work began to change, under the influence of a personal tragedy – the death of his only son at the age of three months. Whatever remained of glowing pastoralism disappeared five years later when he visited the landscape around Milford Haven in Pembrokeshire for the first time. Pembrokeshire became his personal Dover Beach or Pegwell Bay. There, in his own

words, he began to learn painting. He responded immediately to what, in a letter to Colin Anderson, he called the 'exultant strangeness' of the place, which, despite its 'magical and transforming' light possessed 'an element of disquiet'. It was, he wrote, 'no uncommon sight to see a horse's skull or horns of cattle lying bleached on the sand'. He noted too 'the twisted gorse on the cliff edge . . . twigs like snakes, lying on the path, the bare rock, worn, and showing through the path, heath fires, gorse burnt and blackened after fire', and 'mantling clouds against a black sky'.[37]

Sutherland found in Pembrokeshire a metaphor for a rocky, spiky, ominous and even hostile image of nature – a fallen world rather than a garden created by God for man. But this did not lead him to the brink of spiritual desolation and despair. Ruskin had noted his own response to the 'thorniness and cruelty' of some 'waste and distressed ground' near Malham Cove, where the leaves had perished, 'but the thorns were there, immortal and the gnarled and sapless roots, and the dusty treacheries of decay'. But it was precisely through contemplating such a scene that Sutherland found a spiritual vision appropriate to his century . . . a vision only intensified by his experiences as an official war artist.

After the war, Canon Hussey, that most perceptive of patrons, invited Sutherland to undertake an 'Agony in the Garden' for his church, St Matthew's, in Northampton, for which Moore had already made his *Madonna*. Sutherland preferred the idea of a Crucifixion and, while brooding on this theme of the vicarious sacrifice, the scapegoat, he started to draw thorn bushes, intent on their structure as they pierced the air. As he did this, 'The thorns rearranged themselves, they became, whilst still retaining their own pricking, space-encompassing life, something else – a kind of "stand-in" for a Crucifixion and a crucified head.'[38] Ruskin once associated 'morbid love of thorny points, and insistence upon jagged or knotted intricacies of stubborn vegetation'[39] with the gloomier forms of Catholic asceticism, which so emphasised the transcendence of God that it separated him entirely from the fallen world. During the late 1950s and the 1960s, Sutherland became increasingly interested in modern European art; he began to spend much of his time abroad, and lost touch both with Pembrokeshire and with English cultural traditions. Despite Douglas Cooper's enthusiasm for Sutherland's 'European' phase, few today would deny that cultural 'internationalism' hindered rather than helped his development. Indeed, it was only after 1967, when he

returned to Pembrokeshire again for the first time since the war, that Sutherland was able to regain contact with the very sources of his imaginative and spiritual life.

I am not implying that all significant British artists looked back to Ruskin: for some, however, the influence was certainly direct. John Piper once said that he produced his great drawings of the mountains of Wales in the 1940s with one eye on *Modern Painters* and the other on the hillsides themselves. But even for those who had never read Ruskin, the painting of Turner, Pre-Raphaelitism, and the aesthetic problems with which Ruskin concerned himself were of enduring and transforming significance. The continuing desire for an art of *theoria* rather than *aesthesis* is self-evident in a painter like Cecil Collins, who has always seen art in terms of its traditional function as 'a channel of grace': indeed, his painting seems almost self-consciously reminiscent of the famous closing sequence of *Modern Painters* Volume Two, in which Ruskin evoked Fra Angelico's 'angel choirs . . . with the flames on their white foreheads waving brighter as they move, and the sparkles streaming from their purple wings like the glitter of many suns upon a sounding sea . . .' – except that, as we might perhaps expect in our century, Collins's angels are usually of a more fallen character. In *The Vision of the Fool* (1944), Collins wrote: 'And the human heart will find no meaning in life until it returns to eat of the source from which it came; and that source is the Eternal Person of all persons – God. For there is no meaning in life or art excepting that which springs from the immortal surreality of that Eternal Person.'[40]

A similar vision is also manifest in an artist like Winifred Nicholson, who was once presented as an interesting, if minor, member of the modern movement. Winifred's grandfather was George Howard, Earl of Carlisle, a friend and associate of the Pre-Raphaelite painters. She grew up in a world in which exhibiting at the Royal Academy was the thing to do. She herself, however, was drawn towards Christian Science. Her first mature painting was a delicate study of a pot of *Mughetti*, or lily of the valley, wrapped in tissue paper, standing on a window-sill. These flowers 'held the secret of the universe'.[41] Such flower pictures became an obsession.

For Nicholson, *colour* was the means she hoped would carry her beyond mere appearance: she became fascinated by 'unknown colour', those hues which lay just beyond the range of the visible spectrum: she seems almost to have believed that their realisation in paint could

reveal the presence of God in the world. If Nicholson's sensibility diverges from that of Ruskin and the Pre-Raphaelites, it does so *not* in the direction of 'the modern', but rather in that already mapped out by Georgiana Houghton, who painted spiritualist abstractions in the 1860s.

* * *

The outbreak of the Second World War was associated with the unleashing of a neo-Romantic sensibility which had never been far from the surface in British painting and sculpture. The best artists at the end of the 1930s and throughout the 1940s – Moore, Sutherland, Piper, and even Nicholson and Barbara Hepworth – consciously averted their eyes from the preoccupations of European modernism. Their work is stamped by a recognition of indigenous tradition, and of indigenous landscape: but it is not nostalgic; rather, the threatened and injured land emerges, again, as a metaphor, a wasteland redeemed through the aesthetic processes themselves.

One critic who understood this sensibility in the 1930s was Kenneth Clark. After he had written *The Gothic Revival*, with the intention of damning the theorists of the style, he became – as we have seen – persuaded by that which he had set out to ridicule. Clark soon rediscovered Constable and Palmer, and became the patron of Moore, Sutherland and Piper, and the most influential opponent of the modernist aesthetic in our national cultural life.

Ruskin believed that you could not get good art and architecture 'merely by asking people's advice on occasion'. Such things, he insisted, were produced 'by a prevalent and eager national taste, or desire for beauty'. There can be no doubt that such a 'prevalent and eager national taste' arose in the 1940s. As John Rothenstein once put it, with the onset of war 'the public seemed to be quite suddenly transformed'; he referred to 'an unprecedented demand for opportunities of seeing works of art which there was, at first, no adequate means of satisfying'.[42] Rothenstein attributed this demand to 'the enhanced seriousness of the national temper'. Certainly, this transformation occurred just as our artists were abandoning any 'avant-garde' preoccupations they might have possessed, and replenishing their imaginations in the British and European traditions. As Grey Gowrie has written of Nash's and Moore's contributions, in particular: 'In an age when patriotic art has been, with a few exceptions,

synonymous with bad art, (their) war work ... celebrated England by making her travail universal.'[43]

During the war, the gulf that had separated the contemporary artist from the public seemed to close; exhibitions of contemporary painting attracted crowds beyond all expectations. CEMA, the wartime Committee for the Encouragement of Music and the Arts, distributed great quantities of lithographs by contemporary artists – some 35,000 by the end of 1944 – for exhibition in factories, armed forces centres and so forth. And quite unprecedented numbers of popular books about contemporary art – like the Penguin Modern Painters series, under the general editorship of Kenneth Clark – began to be sold.

'War,' Ruskin once provocatively observed, 'is the foundation of all the arts'; and the simple, if unpalatable, fact is that during the war, and in the years which immediately followed it, there was a renaissance of the arts in Britain. This period saw the creation of Henry Moore's shelter drawings and his Northampton *Madonna*; the compelling drawings which Piper made of the Snowdonia ranges; Sutherland's paintings of Pembrokeshire; and those great carvings of Hepworth, and pictures of Nicholson, inspired by their rediscovery of natural form; it saw, too, Victor Pasmore's pictures of the hanging gardens of Hammersmith, and his attempt to find the underlying forms of nature in the extraordinary pictures painted after his conversion to 'abstraction'. It also witnessed the creation of the greatest of Bomberg's paintings, and the emergence of the evil genius of Francis Bacon, who had abandoned a career as a designer of modernist furniture (of which Pevsner and Herbert Read would have approved) to paint images of irredeemably fallen men and women, living in a world in which Cimabue's *Crucifixion* was, according to Bacon, of no greater significance than an image of a worm crawling down a cross.

In the words of Robert Ironside, a critic and painter who, in 1949, was the first to use the term 'neo-Romanticism', this new sensibility was 'in part a reaction from the ideas of Roger Fry, a return to freedom of attitude more easily acceptable to the temper of our culture, a freedom of attitude that might acquiesce in the inconsistencies of Ruskin but could not flourish under the system of Fry'.[44] This new movement was stamped by a growing recognition of the futility of comparing the British achievement with the French, or of assimilating it to internationalism.

For example, in 'A View of English Painting', which appeared in *New Writing* in 1947, Keith Vaughan (himself a painter) attempted

to trace a British Romantic spirit from the Celts and Saxons right through to Sutherland. He, too, placed great emphasis on Palmer and Constable. 'The French,' Vaughan wrote, 'regard Constable as the father of impressionism, but I cannot see that Constable is really increased by that honour. There was a great deal more than impressionism in the best of his work.'[45] Of course, Vaughan greatly respected Picasso; but he argued, as I would, that his real value for British artists should be to cause them to look anew at the achievements of their own indigenous tradition. Vaughan believed that Sutherland 'was an established successor to Palmer' before he discovered French painting, and that he was 'the first painter to relate the full discoveries of the twentieth century in France to the English Romantic tradition'. 'In painting, as in most other civilized activities,' Vaughan argued, 'we learn much from France, but our roots are not there; and I would plead that we become not over-fascinated with her genius to the neglect of fertile ground nearer home.'[46]

A body of critical literature grew up around this neo-Romantic sensibility. In *Art and Social Responsibility: Lectures on the Ideology of Romanticism*, first published in 1946, Alex Comfort wrote that the whole doctrine of Romanticism was one of 'preparation to survive the decay stage of civilisation, with its attendant conscription, repression and terrorism'.[47] He argued that history, in most European countries, had already driven underground most of the work which remained 'human and responsible'. 'This,' he wrote, 'is less true of English than of most European societies, because in England the deterioration of responsibility, while enormously celebrated by the war, is far in the rear of the general tendency of European barbarisation.'[48]

Similarly, Jacquetta Hawkes's *A Land*, published in 1951 for the Festival of Britain, was a celebration at once geological, social and cultural, of Britain as a land 'as much affected by the creations of its poets and painters as by changes of climate and vegetation', possessed of a unity 'just beyond the threshold of intellectual comprehension'.[49] *A Land* ended with an evocation of 'those mountains that can symbolize the foundations both of our consciousness and of this land'.

Most notable of such books, however, was Kenneth Clark's *Landscape into Art*, first published in 1949, in which he wondered whether landscape painting might not exist 'as something complementary to the art of slide-rule and lathe' – something for which, given the fact

that we were constrained to live in the modern world, we might crave all the more hungrily. And yet, in the end, Clark's verdict for the future of landscape painting was surprisingly pessimistic:

Can we escape from our fears by creating once again the image of an enclosed garden? It is a possible way of life: is it a possible basis for art? No. The artist may escape from battles and plagues, but he cannot escape from an idea. The enclosed garden of the fifteenth century offered shelter from many terrors, but it was based on a living idea, that nature was friendly and harmonious. Science has taught us that nature is the reverse: and we shall not recover our confidence in her until we have learnt or forgotten infinitely more than we know at present.[50]

The Triumph of Late Modernism

'We are still,' Ruskin wrote in 1884, 'I fear, a long way behind the time – but it will come – when governments will recognise and cultivate the essential genius of their people.' That time seemed, briefly, to have come in Britain after the Second World War. One of the first acts of the post-war welfare state was to transmute CEMA into the Arts Council of Great Britain; John Maynard Keynes, the architect of the Council, described its purpose as 'to create an environment, to breed a spirit, to cultivate an opinion, to offer a stimulus to such purpose that the artist and the public can each sustain and live on the other in that union which has occasionally existed in the past at the great ages of a communal, civilized life'.[1]

In a review of an exhibition called 'Art in 1946 and After', M. H. Middleton predicted that although Britain might be shedding 'the political commitments of a great world power', she seemed destined 'to hold a position of leadership we have never previously known as the artistic centre of the world'. Such views were not only received wisdom: they also seemed to be fully justified by the achievements of our finest artists – achievements which were promoted, with exemplary panache, throughout Europe, America and Australia by the British Council. In 1946 an exhibition of modern British pictures was sent abroad for the benefit of 'friends and allies': Nash's visionary *Landscape from a Dream* and Moore's shelter drawings had a great impact in war-torn Europe. While the sentiments of the international avant-garde were inappropriate to the times, the finest examples of the English neo-Romantic sensibility were greeted, literally, with worldwide acclaim.

Also in 1946, major exhibitions of contemporary British art – including a Henry Moore retrospective – toured America where they had a considerable impact on artists like Mark Rothko and Arshile Gorky.[2] Two years later, Moore won the international prize for sculpture at the Venice Biennale, where his works were exhibited

alongside Turner's landscapes, and in 1949 he was given a major retrospective in the Musée d'Art Moderne in Paris – an unprecedented event for a living British artist. Nor was it just Moore: in 1950 Barbara Hepworth's sculptures were exhibited in Venice, beside Constable's paintings; and, in 1952 and 1954, Graham Sutherland's and Ben Nicholson's exhibits at the Venice Biennale were almost universally praised.

The Tate Gallery celebrated the coronation of Elizabeth II with exhibitions of Gainsborough and Sutherland, two painters, as Philip James said in the catalogue, 'who were incontestably English in their style and vision'; and who were 'both exponents of the true native tradition which springs from an obsession with the English landscape'.[3] The continuities of English art – Moore and Turner, Hepworth and Constable, Sutherland and Gainsborough and, indeed, Palmer – were thus widely acknowledged; but it was also recognised that, at this time, no other nation could exhibit a remotely comparable strength in the visual arts: Parisian hedonism had been extinguished by the Second World War. And, understandably, there seemed to be something broken, fearful, and hopeless about the art of 'aftermath'. America had not experienced the testing crucible of war; many of the European avant-garde had transplanted themselves there at the outset of the conflict: and the old-fashioned modernist ethic, discredited in Europe and displaced in Britain by a resurgent English Romantic art, lived on in lower Manhattan.

Here a 'theoretic' and Romantic art thrived which showed disconcerting superiority to anything that was happening elsewhere in the West. And yet, in less than a decade, everything had been lost. The history of public art in this country from the late 1950s until the early 1980s was one of the triumph of the empty; the institutions for public patronage of the arts, founded or expanded with such confidence in the immediate post-war years, seemed to lose all discrimination. Art education itself was discredited; and the 'art world' became almost entirely divorced even from a public interested in other aspects of cultural life.

So what had happened to that great dream envisaged by Keynes? In 1957 David Bomberg died in obscurity: that same year, Richard Hamilton announced that we lived in an age when Pop art was 'Popular (designed for a mass audience), Transient (short-term solution), Expendable (easily forgotten), Low cost, Mass produced, Young (aimed at youth), Witty, Sexy, Gimmicky, Glamorous, Big

Business.'[4] Hamilton himself began to produce shabby pictures like $he, which identified modern woman with the 'cool' images of her projected in advertisements, and declared his preference for admass rather than real landscape.

And so Pop art was to be one way in which the British tradition was submerged beneath the clownish cries of 'Here we are again'. An American version of a bankrupt modernism was to be another. In 1956 René d'Harnoncourt, then Director of the Museum of Modern Art in New York, complained about the lack of active interchange in the visual arts which, he said, 'are among the best media for the communication of ideas between nations'. He hoped that a show he had organised for the Tate Gallery would rectify the situation by making 'modern American art better known in Britain'.[5] But within three years, the story had become one of the dominance and superior 'avant-garde' character of the American School. Even *The Times Literary Supplement* announced that 'the flowering of the American imagination' had been 'the chief event in the sphere of living art since the end of the First World War',[6] while another article in the same issue declared that 'the current style of painting known as Abstract Expressionism radiates the world over from Manhattan Island, more specifically from West Fifty-Third Street, where the Museum of Modern Art stands as the Parthenon on this particular acropolis'.[7]

Official taste in Britain succumbed without a murmur to these twin tides of commercial or Pop art and Americanism. In his autobiography, Kenneth Clark described his period as Chairman of the Arts Council from 1953 to 1960. He wrote that, apart from dispensing glasses of sherry to the directors of the various departments, 'a chairman's duty was to whitewash the decisions of his administrative officials when they were discussed by the Board. This is the bureaucrat's dream . . . It did not suit me at all.'[8]

With the expansion of State patronage, those men of vision, like Clark himself, who had been involved in establishing the institutions were quietly phased out of any position of influence, and a new class of younger 'administrative officials' came to hold power within a growing art bureaucracy. They were chiefly interested (as officials always are) in the advancement of their own careers in the 'international art world'.

Inevitably, they looked for a lead to America – and especially they looked to the criticism of Clement Greenberg, who believed, as he put it in 1948, 'that the main premises of Western art have at last migrated

to the United States, along with the center of gravity of industrial production and political power'.[9]

* * *

Greenberg was, without doubt, the most able Marxist critic of our century, the critic who most rigorously endeavoured to elaborate an aesthetic of pure *aesthesis*, stripped of any theoretic dimension. Early in his career, he marvelled that the same civilisation could produce a painting by Braque and a *Saturday Evening Post* cover. He argued that the true function of the avant-garde was not to 'experiment', but to find a path along which it would be possible to keep culture *moving* in the midst of ideological confusion and violence. 'Retiring from public altogether', Greenberg wrote, 'the avant-garde poet or artist sought to maintain the high level of his art by both narrowing and raising it to the expression of an absolute in which all relativities and contradictions would be either resolved or beside the point. "Art for art's sake" and "pure poetry" appear, and subject matter or content becomes something to be avoided like a plague.'[10]

The choice, he believed, was not between the old and merely the new, 'as London seems to think' – but between the bad, up-to-date old and the genuinely new. 'The alternative to Picasso is not Michelangelo, but kitsch.' He argued that capitalism in decline found that whatever of quality it was still capable of producing almost invariably became a threat to its own existence:

Advances in culture, no less than advances in science and industry, corrode the very society under whose aegis they are made possible. Here, as in every other question today, it becomes necessary to quote Marx word for word. Today we no longer look toward socialism for a new culture – as inevitably as one will appear, once we do have socialism. Today we look to socialism *simply* for the preservation of whatever living culture we have right now.[11]

For Greenberg, Romantic art, indeed theoretic art of any kind, could only be construed as part of 'a campaign against modern art' and 'the fag end of a boring, very great, and violent war'. In 1944 he argued that the '"romantic" revival in paintings', and the resurgence of interest in 'Pre-Raphaelism' (as he called it) stood historical Romanticism on its head:

For it does not revolt against authority and constraints, but tries to establish a new version of security and order. The 'imagination' it favors seems conservative and constant as against the 'reason' it opposes, which is restless, disturbing, ever locked in struggles with the problematical.[12]

According to Greenberg, 'reason' led to convictions, activity, politics, adventure: 'imagination' to sentiment, pleasure and certainties. He argued that the new 'Romanticism' gave up experiment and the assimilation of new experience in the hope of bringing art back to society, which, he wrote, had itself been 'Romantic' for quite some time in its hunger for immediate emotion and familiar forms.

Inevitably, holding such views, he was an uncompromising opponent of the work of Henry Moore, and indeed of the British School in general. Greenberg criticised Moore's large figures, 'invariably reclining and almost invariably derived from the female form' and insisted (again quite accurately) that 'the final effect . . . somehow discounts the presence of modernist calligraphy and detail, to leave one with the impression, hard to define but nevertheless definite, of something not too far from classical statuary'.[13] He noted Moore's 'curvilinear monotony and water-silk surfaces', and accused him of lacking strong, original sensations.

In an essay on 'The New Sculpture' he revealed the roots of his antipathy to Moore. 'Originally the most transparent of all the arts because the closest to the physical nature of its subject matter,' he wrote, 'sculpture now enjoys the benefit of being the art to which the least connotation of fiction or illusion is attached.'[14] To painting, 'no matter how abstract and flat', there still clung something of the past 'simply because it is painting and painting has such a rich and recent past'. The new sculpture (unlike Moore's) had 'almost no historical associations whatsoever – at least not with our own civilization's past – which endows it with a virginity that compels the artist's boldness and invites him to tell everything without fear of censorship by tradition'.[15] All he needed to remember of the past, Greenberg claimed, was Cubist painting, and all he needed to avoid was naturalism.

In 1949 Greenberg described the modern movement as 'Our Period Style', a style which, he claimed, was manifesting itself in '"International Style" architecture, Cubist and post-Cubist painting and sculpture, "modern" furniture and decoration and design'.[16] True avant-garde painting and sculpture had succeeded in becoming 'nothing but what they do, like functional architecture and the machine, they *look* what they *do*. The picture or statue exhausts itself in the visual sensation it produces.'[17]

Greenberg was in agreement with Pevsner and Waddington when

he insisted that 'the highest aesthetic sensibility rests on the same basic assumptions . . . as to the nature of reality as does the "advanced" thinking contemporaneous with it'.[18] And, for him, the most 'advanced' thinking was modern scientific materialism. Thus, although Greenberg wished to defend the domain within which aesthetic experience took place, he believed that such conservation involved the acceptance of change. His quarrel with 'neo-Romantics' concerned their endeavour to locate aesthetic experience within the domain of the spiritual. He criticised even Jackson Pollock for his 'Gothickness'; he wanted an aesthetic dependent upon nothing but sensation and materials. For Greenberg, as for Pater, music was a paradigm – but because it was the most completely *sensuous* of the arts. 'But the other arts can also be sensuous,' he wrote, 'if only they will look to music, not to ape its effects but to borrow its principles as a "pure" art which is abstract because it is almost nothing else except sensuous.'[19]

And so Greenberg came to believe that the greatest painting of his day was 'uninflated by illegitimate content – no religion or mysticism or political certainties'. There was 'nothing left in nature for plastic art to explore'. Nowhere do we find the view more clearly stated that the avant-garde artist should not endeavour to seek the Divine in nature, but should, himself, seek to displace God:

The avant-garde poet or artist tries in effect to imitate God by creating something valid solely on its own terms, in the way nature itself is valid, in the way a landscape – not its picture – is aesthetically valid; something *given*, increate, independent of meanings, similars or originals.[20]

Content, Greenberg said, 'is to be dissolved so completely into form that the work of art or literature cannot be reduced in whole or in part to anything not itself'. But, he continued:

the absolute is absolute, and the poet or artist, being what he is, cherishes certain relative values more than others. The very values in the name of which he invokes the absolute are relative values, the values of aesthetics. And so he turns out to be imitating, not God – and here I use 'imitate' in its Aristotelian sense – but the disciplines and processes of art and literature themselves. This is the genesis of the 'abstract'.[21]

Greenberg was insistent that modernist abstraction had nothing to do with natural form. He criticised Kandinsky because, in his painting, the integrity of the picture 'depends on the integrity of an illusion'. It was essential to his argument that the 'non-representational tendency of Cubism' (a movement, in his eyes, untainted with the quest for the

spiritual) was 'a by-product and not the aim of its reconstruction of the picture surface'. Kandinsky's failure to discern this had 'led him to conceive abstractness as a question down at bottom of *illustration*': Greenberg rightly perceived that Kandinsky was guilty of Romanticism, as he understood it.

The correct understanding of Cubism, the acceptance in full of its logic, led other artists to 'resign themselves to the non-representational and the inviolability, more or less, of the plane surface.'[22] Thus, Greenberg wrote, 'one of the most epochal transformations in the history of art was accomplished':

> The deeper meaning of this transformation is that in a period in which illusions of every kind are being destroyed the illusionist methods of art must also be renounced. The taste most closely attuned to contemporary art has become positivist, even as the best philosophical and political intelligence of the time.[23]

Greenberg later argued that his charge was descriptive, not prescriptive. But in 1944 he clearly announced: 'Let painting confine itself to the disposition pure and simple of color and line, and not intrigue us by associations with things we can experience more authentically elsewhere. The painter may go on playing with illusions, but only for the sake of satire.'[24]

Such ideas can be seen as the last in a line of writing about art which can be traced back to Ruskin – though Greenberg once told me that he had never *read* Ruskin. In Greenberg's thought, *aesthesis* makes complete its triumph over *theoria*. His aesthetic is what William Morris's ought to have been if he had eschewed ideas of the Gothic, the spiritual and the natural, as his intellectual and political stance would seem to have demanded... Indeed, if Morris had been an American (i.e. had known no indigenous Gothic tradition), his aesthetic may have ended up very close to Greenberg's.

And yet we can see what a loss was involved if, for example, we contrast Morris's conservative, Gothic and reactionary *Honeysuckle* with the 'new', anti-natural, and wholly sensuous painting *Omega IV*, produced by Morris Louis, the artist who was perhaps the most deeply influenced by Greenberg. Of course, *Omega IV* is a painting and not a chintz: and yet Greenberg's insistence upon the materiality of the medium was such that Louis, under his influence, treated painting as a matter of the decorous application of a substance to a surface – and no more; that is, as synonymous with the staining of

fabrics. Since the imitation of nature had become an irrelevance, Louis showed no grasp of natural form, nor of its representation through drawing. Louis's decorative elements were merely gorgeous dribbles. He effectively worked outside tradition. He had a new and synthetic acrylic paint, a fast-drying (and fast-fading) substance invented for him, and he deployed a technique of pouring the paint across the surface in a way which eliminated references back to the human being who made the work.

<p align="center">* * *</p>

There were, even in America, those who opposed themselves vigorously to Greenberg's aesthetic teaching: in 1957 the critic Robert Rosenblum wrote a persuasive paper, 'British Painting vs. Paris', in which he argued (as Ruskin had done before him) that Whistler had deflected British painters from their Romantic and Pre-Raphaelite inheritance. It was, Rosenblum wrote, 'hardly a surprise' that the most 'pungent and distinctive' contemporary British painters – Bacon and Sutherland – were the ones who owed the least to School of Paris values and the ones whose eccentric, individual art was 'the very opposite of that compromise with traditional, impersonal attitudes which produced the sequential achievements of modern French painting'.[25]

Britain's younger art administrators, however, tended to the view that the only work worth emulating was that which belonged to the modernist tradition – a tradition which they, like Greenberg, believed had migrated to New York, from Paris. In the 1960s the effects of such thinking had a distorting, even devastating effect upon British art. Painting and sculpture – or at least those examples seemingly preferred by the institutions of art – came to demonstrate a *kenosis*, or a self-emptying of all their theoretic content. The work of Anthony Caro provides a characteristic instance; a sometime assistant of Henry Moore, he was 'converted' through his contact with Greenberg and American 'post-painterly' abstract painters to a 'radically abstract' form of sculpture based upon the pleasing arrangement of brightly coloured, pre-constituted, industrial elements. Caro developed that complete break with the past which Greenberg had advocated; his sculpture possessed no relationship to human or natural form, indeed no imagery as such at all. Greenberg, or rather those practitioners who followed him, brought about the

destruction of *theoria*; those who came after proceeded to destroy *aesthesis* as well.

'Sculpture', Caro said, 'can be anything.' And his followers took this literally, proclaiming any object, or activity, a sculpture. When I first met John Berger, he was vociferously opposed to American influence on British art: yet since he too was an enemy of art which appealed to the spiritual imagination, the effect of his criticism was an almost identical endorsement of the *status quo*. Berger's first critical writings, in the 1950s, were social realist in orientation; he supported painters like John Bratby, Edward Middleditch and Jack Smith, whose work he improbably interpreted as 'realist'. Like Greenberg, Berger also elaborated a 'materialist' and, as we have seen, erroneous reading of Cubism; unlike Greenberg, however, he praised Cubism not so much for its pictorial innovations as (following Max Raphael) for what he took to be its relationship to science and 'dialectical materialism'.

Berger argued that the cultural changes accompanying the arrival of modernism were not just a question of improved technologies, such as faster transport, quicker messages, a more complex scientific vocabulary, larger accumulations of capital, wider markets, international organisations and so on. They also, and more significantly, involved the completion of the 'process of the secularisation of the world'. 'Arguments against the existence of God,' Berger wrote, 'had achieved little. But now man was able to extend *himself* indefinitely beyond the immediate: he took over the territory in space and time where God had been presumed to exist.'[26] However, he simply failed to understand that Cubism was more a *resistance* to such modernisation than a celebration of it; more, as Tom Gibbons, an art historian from Western Australia, has demonstrated, an attempt to re-open that space in which God and 'the spirit' were presumed to exist than to close it altogether.

Berger, like Greenberg, was predictably antagonistic towards Moore and the great British Romantic tradition of post-war art; he was especially enraged when his 'realist' protégés changed direction. Jack Smith went on to produce works like his epic *Creation and Crucifixion*, and Middleditch, too, revealed himself as a poetic painter of nature rather than of the kitchen sink. Berger noisily dissociated himself from his erstwhile colleagues; by the late 1960s he had adopted those 'technist' aesthetics which were to prove so attractive to both Marxists and monetarists alike.

'It is necessary,' Berger wrote, 'to see works of art freed from all the mystique which is attached to them as property objects. It then becomes possible to see them as testimony to the process of their own making instead of as products; to see them in terms of action instead of finished achievement.'[27] Berger believed that this change of emphasis had already deeply affected art. 'From Action Painting onwards artists have become more and more concerned with revealing a process rather than coming to a conclusion.'[28]

And so museums, Berger argued, should not be 'depositories of so many unique sights or treasures', but rather living schools, 'with the very special advantage of dealing in visual images, which, given a simple framework of historical and psychological knowledge, can convey experience far more deeply to people than most literary and scientific expositions'.[29] 'Museums will finally be forced to recognise their century', he wrote, presuming that this (rather than the conservation of the inheritance of other centuries) is what museums ought to be doing.

In an essay on museums, Berger argued that 'the purely aesthetic appeal and justification of art' was based on less than a half-truth. 'Art must also serve an extra-artistic purpose.'[30] But, for him, that 'extra-artistic purpose' was *not* the life of the spirit, or a man's moral being.

The diminution of art, first to the merely 'aesthetic', and then through its dissolution into other forms of life, was indeed leading to that 'dead blank of the arts'. For, with the elimination of aesthetic values, the Marxist and Tory Party approaches to art dissolved into an indistinguishable *mélange*. The anti-aesthetic policies for which Walter Benjamin had argued in the 1930s, and which Berger had promulgated in the 1960s and 1970s, became, in effect, the house style of successive governments. But it was left to Mrs Thatcher's government to implement a right-wing version of the anaesthetics outlined in Berger's *Ways of Seeing*.

If this sounds unfair, consider, for a moment, the resemblance between the views of Norman Tebbit, former Chairman of the Tory Party, and John Berger, on the question of the female nude in art. During a public debate about whether there should be Page Three pin-ups in popular newspapers, Tebbit made a widely reported observation to the effect that middle-class people could see spicier pictures of naked women on art gallery walls, and he really couldn't see that there was any difference between such things and a *Sun* Page Three

girl. In *Ways of Seeing*, Berger goes to great lengths to elaborate the same argument – even pressing his point home by juxtaposing a detail from Ingres and a 'girlie' pin-up.

The government made known its desire to replace Fine Art courses with design-orientated teaching, focusing on the ever proliferating new media; indeed, the Tory Party would appear to have espoused productivist aesthetics of exactly the kind the left had been advocating for years. If Berger had waged an ideological war against the museums, Thatcher's government put this struggle on a more 'practical' basis, in the form of the financial deprivation with which her administration afflicted the national museums and collections. The Director of the National Gallery recently compared the government's policies towards the museums with the dissolution of the monasteries in the sixteenth century – which had such inhibiting and far-reaching effects on the British visual tradition. Indeed, the modern *Conservative* Party seemed intent upon anything *but* conserving. If Mrs Thatcher espoused Victorian values, they were *not* those of Ruskin, who took the view that government ought to be 'simply a conservative power, taking charge of the wealth entrusted to it', and who saw one of its primary tasks as the creation of a 'permanent and continually accumulating store, of great intrinsic value, and of peculiar nature', that is, of great works of art.

Apparently blind to the distinction between spiritual and commercial values, Berger had stressed the continuity between Western oil painting and what he called 'publicity'. In his book *Educating for Art*, Rod Taylor drew attention to the corroding effects of Berger's influence, and argued that the popularity of *Ways of Seeing* had damaged the cultural continuity upon which aesthetic life depended. According to Taylor, Berger had undermined art teachers' attitudes to gallery visiting, and had debunked not just Kenneth Clark, but any notion of 'civilisation' in terms of 'a chain of great works stretching through the centuries'.[31] Taylor went on to say that, in practice, no 'alternative form of art appreciation' had arisen to replace that thus deposed: the effects of *Ways of Seeing* had simply been to reinforce the advancing philistinism of our age.

Berger's *Ways of Seeing* was, in effect, part of that whirlwind of cultural vandalism which prepared the way for that condition of artistic desolation, often called 'post-modernism', which was reflected in *State of the Art*, a series of television programmes, travelling exhibitions and a book, which appeared in 1987. Sandy Nairne, who

organised it all and went on to become Director of Art for the Arts Council of Great Britain, paid homage to Berger, but went much further in his repudiation of aesthetics and his reduction of art criticism to the fashionable 'deconstruction' of the times. Nairne expressed the view that aesthetic value was reducible to 'prevailing criteria', which were 'constantly shifting and contested, not through any formal agreements or disagreements, but through gradual and constant changes of opinion and precedent'.[32]

This was post-modernism: the passing of modernism was not just the waning of a style, of a way of building or painting. It was bound up with the passing of the beliefs that had informed the style, with the rise of scepticism about a triumph over nature, and a recognition of the limits of that disillusioned materialism embodied in phrases like Pevsner's 'faith in science and technology'.

The post-modernists began to say that the certainties of modernism – its meta-narratives, in Jean-François Lyotard's overused phrase – could only be replaced by self-conscious incredulity about everything. Post-modernism knows no commitments: it takes up what one of its leading exponents, Charles Jencks, once called 'a situational position', in which 'no code is inherently better than any other'.[33] The west front of Wells Cathedral, the Parthenon pediment, the plastic and neon signs of Caesar's Palace, Las Vegas, even the hidden intricacies of a Mies van der Rohe curtain wall: all are equally 'interesting'. And so we are left with a shifting pattern of changing strategies and substitutes, a shuffling of semiotic codes and devices, varying ceaselessly according to audience and circumstance. Thus was authenticity dissolved.

It was in this climate that 'artists' like Julian Schnabel and Gilbert and George came to thrive. In their contempt for high art and aesthetic values, their ignorance concerning the art of the past, the vulgarity and technism of their imaginations, Gilbert and George – avowed admirers of Mrs Thatcher – nonetheless reflect all the central themes of *Ways of Seeing*: indeed, they have filled the museums with their equivalent of those 'pin-boards' which, according to Berger, should replace the historic collections. There are, say Gilbert and George, *après* Berger, 'far too few living artists who have the idea of making art for the people. They just do art for the art world.'[34] Painting, they say, 'is either playing with some funny colours or it's caricature'. 'What is the most modern and effective way of speaking today?' Gilbert once asked an interviewer. 'Photopieces. Photopieces are

fantastic. There is no better form on earth at the moment. Why carve, why paint a figure, when you can take a shot? Absolutely no valid reason . . . As for drawing, we know where the best drawings are: they are on toilet walls.'[35]

'To be born a woman,' Berger wrote, 'has been to be born, within an allotted and confined space, into the keeping of men . . . *men act* and *women appear*. Men look at women. Women watch themselves being looked at.'[36] Gilbert and George express similar sentiments about the Western tradition of oil painting. 'Traditionally, it has been women illustrated and men wanking, looking. The popular understanding of the nude in art is a naked lady on a bed . . . If you open any one of hundreds of magazines on sale and see pictures of women, the message – for men – is always the same: that one day, if they're lucky, they'll get one of those beautiful girls.'[37]

Oil painting, Berger had argued, was, 'before it was anything else', a celebration of private property. It was, he said, a mistake to think of 'publicity' supplanting the visual art of post-Renaissance Europe; 'publicity' (or advertising) was the last, moribund form of that art.[38] Gilbert and George, it might be said, happened because the art establishment believed Berger's thesis. 'In a sense,' writes Roger Scruton, 'theirs is the culmination of the advertiser's art and the realisation of every advertising agent's dream – to devise an advert which *sells itself*, for which no product is even necessary, and which, rejoicing in the assumed dignity of art, is wrongly imagined to be a bargain at whatever price.' Scruton commented on the fact that, despite Gilbert and George's stated commitment to 'beauty' in their work, they used the word to mean its opposite: 'Where there is an absence of beauty, impossibility of beauty, the overthrow of beauty's empire, there Gilbert and George stand drivelling their ritual paean of the beautiful, uttering the word in the same tone of voice as they utter "shit", "fuck", "cock", and "buggery".'[39]

Post-modern art has become attractive to today's *nouveau riche*, as Sandy Nairne uncritically explains, through its 'incorporation . . . into the ethos of fashionable consumerism'. Indeed, he tells us that influential international collectors on a grand scale, like Charles and Doris Saatchi, are closely linked with 'an international network of taste and fashion'[40] which is, of course, quite indifferent to the overt political message of the work. For example, the Saatchis – who sold the Tory Party on the slogan 'Labour Isn't Working' – nonetheless have large holdings of the work of Leon Golub, an American Marxist

artist who specialises in painting huge and brutish pictures of American mercenaries engaged in torture and rape. 'These damn paintings', Golub once wrote to me about his own work, 'get uglier all the time, uglier in human time, uglier in intention, to take over the ugliness that is the political reality of these common circumstances.'[41]

And he was right.

The Glare of the Antipodes

Even in the early 1970s, I had found myself doubting the 'logic' of this late modernist aesthetic, and I began to awaken to another 'way of seeing', as, I began to realise, Berger himself had done. Do you know those great Gothic pictures which show, in the distance, a mountain range, in the middle-ground, a wilderness, and in the foreground an enclosed garden, or *hortus conclusus*? I rediscovered every element of such paintings. From Berger himself I learned about the mountains.

Writing of 'Swiss Life of the Olden Times', Ruskin once commented: 'I used to go to Switzerland quite as much to see this life, and the medieval strength that had won it, as to see the Alps themselves.'[1] The mountain ranges and the village communes that were scattered across them fused in his mind into an alternative to modern industrial society. In the 1970s – before I had read these parts of Ruskin – I visited Berger in the village where he was then living in Haute Savoie, close to the Swiss border. I remember how, when I first arrived, I was still almost blind to mountain scenery; it neither moved nor exhilarated me. But Berger opened my eyes. I discovered he was like Walter Benjamin in more ways than I had imagined. Once, I stood with him outside the chalet where we were all staying, and we looked down the valley sweeping away before us. We listened to the cowbells chiming and echoing all around. 'You know what it's like?' Berger said. 'It's like limbo. I could live here forever.'

Our talk was endlessly of painters – of Courbet, Millais, Chardin, Vermeer, Hals, Rembrandt, Le Nain, Bomberg, and even Mark Rothko . . . and never once did he say anything about the relationship between their work and modern advertising, nor did he ever describe them as manufacturers of portable capital assets. One day he got down a bundle of his own drawings, and showed me how he had struggled to sketch the mountains.

I was reminded of Gaudier-Brzeska's 'Sculpture is the mountain',

of Henry Moore's Grampian women, of Ruskin's own 1846 drawing *The Mountains of Villeneuve (near the eastern end of Lake Geneva)*, and, above all, of David Bomberg's search for 'the spirit in the mass'. Later, I looked up Berger on Bomberg. Naturally, he had assured his readers that Bomberg's 'idealism' was so foreign to his own way of thinking that he could not accept 'its validity or usefulness'. But, even back in the 1950s, he had added, he could see that it was 'perhaps a partial rationalization of the very special kind of poetic awareness that Bomberg had enjoyed and suffered'.[2] He explained that the image that constantly recurred to him when he looked at Bomberg's paintings was 'that of a veil, a curtain, a tent – and each of these in the Old Testament sense of a landscape being possessed by being covered'. He even quoted the Bible: 'Enlarge the place of thy tent, and let them stretch forth the curtains of thine habitations: spare not, lengthen thy cords and strengthen thy stakes,' adding that he almost believed that those could have been Bomberg's artistic instructions to his intimate pupils.

Even in Berger's eyes, it seemed, Bomberg's painting was *not* 'before it was anything else . . . a celebration of private property'. For Bomberg, Berger agreed, oil painting had been something at once more nomadic and, dare one admit it, more *spiritual*. I began to realise that despite *Ways of Seeing* Berger was by no means committed to that monocular vision: rather, like Ruskin, he was immersing himself in the life of the alpine peasantry. He wanted to enter into what, to Marx, would have been merely 'rural idiocy' – the peasant's deeply conservative view of the world. In particular, he began to celebrate the peasant's cyclical view of time – his refusal of linear or progressive history and of the very idea of progress, upon which, of course, Marxism depends.

Berger's letters, over the years, contained many references to shifts in his 'metaphysical' thinking. By 1980, he was writing to me that we, on the left, had failed to 'examine the phenomenon of grace'. But these were matters he chose to explore largely in private. When I began to express an interest in Ruskin and to voice my doubts about 'materialist' aesthetics more publicly, he accused me of the unforgivable crimes of 'betrayal of Marxism' and 'Pre-Raphaelitism'. But, by 1985 – the year in which he made these 'charges' in a lengthy and uncomfortable telephone call (the last time we spoke to each other), he himself had written that the aesthetic emotion before nature was analogous to that of God in the first chapter of Genesis: 'And He saw that it was good':

Yet we do not live in the first chapter of Genesis. We live – if one follows the Biblical sequence of events – after the Fall. In any case, we live in a world of suffering in which evil is rampant, a world whose events do not confirm our Being, a world that has to be resisted. It is in this situation that the aesthetic moment offers hope. That we find a crystal or a poppy beautiful means that we are less alone, that we are more deeply inserted into existence than the course of a single life would lead us to believe . . .

The notion that art is the mirror of nature is one that only appeals in periods of scepticism. Art does not imitate nature, it imitates a creation, sometimes to propose an altenative world, sometimes simply to amplify, to confirm, to make social the brief hope offered by nature. Art is an organized response to what nature allows us to glimpse occasionally. Art sets out to transform the potential recognition into an unceasing one. It proclaims man in the hope of receiving a surer reply . . . the transcendental face of art is always a form of prayer.[3]

Which is all, so to speak, very *un-Marxist*, and profoundly *Pre-Raphaelite*, and almost as Ruskin himself might have put it. I am left brooding upon the fact that if he had said such things in *Ways of Seeing*, rather than what he did say, he might have done something to spare us from that cultural climate which gave rise to Gilbert and George.

* * *

Let us turn now to the wilderness. We have seen how, in *Landscape into Art*, Kenneth Clark stressed the fact that with the advance of modern science, nature appeared inconsistent and lacking in unity. This inconsistency was compounded by 'chiliasm', or a belief that the end of the world might be at hand. With the then recent experience of global war, and the arrival of nuclear weapons, such concepts no longer seemed like mere fantasies. As P. T. Forsyth had put it, a culture which believed in the text 'Cursed be the ground' could not create art.

Thus Clark echoed Ruskin at his bleakest. 'That harmony is now broken,' Ruskin said at one of his moments of deepest despair, 'and broken the world around: fragments still exist, and hours of what is past still return, but month by month the darkness gains upon the day, and the ashes of the Antipodes glare through the night.'[4] But, in his later work, Ruskin was looking for a new kind of aesthetic rooted in nature, which was not so much orientated towards the creativity of God, as grounded on man's relationship to the natural world he inhabited. I believed that truly 'post-modern' painting in a sense takes up where Ruskin tentatively abandoned these themes: it re-enthuses

the ancient elements of Gothic landscape painting – the wilder-
ness, the mountain range and the *hortus conclusus* – with a new
life.

'Desert,' Ruskin once wrote, '– whether of leaf or sand – true
desertness is not in the want of leaves, but of life. Where humanity is
not, and was not, the best natural beauty is more than vain. It is
even terrible; not as the dress cast aside from the body; but as an
embroidered shroud hiding a skeleton.'⁵ 'The ashes of the Antipodes'
... 'true desertness' ... We know from Clark's autobiography that
he revised *Landscape into Art* for press on a voyage to Australia soon
after the end of the Second World War. It is interesting to speculate
upon how different the book might have been if he had waited until
the return journey before making the final corrections; for in Australia
Clark found not only a new landscape but also a new landscape
painting – which seemed to reach beyond the impasse suggested in
the conclusion to *Landscape into Art*. When Clark got back to England
he began to tell incredulous friends 'that Australia was about to add
something entirely fresh to contemporary painting'.⁶

Australia is a disconcerting place – especially for those, like the
British, whose cultures embody a history of the idea that the natural
world is a garden made by God for man: for Australia appears as a
giant *memento mori*, a desert land, littered with skulls and carcasses, a
land whose roots lie in the lives of those who were literally *condamnés*,
fallen men and women who knew the *lapsus* in labour, *in extremis*.

Australia's first white painters were drawn from the ranks of British
convicts, naturalists and colonialists, who found it hard to make sense
of this vast and desolate island, at the wrong end of the earth, where
only a thin coastal ribbon was fertile. They gazed with incomprehen-
sion on what has been called 'a second and separate marsupial crea-
tion'. Often, they portrayed gums and acacias as if they were English
oaks, and the bush as a woodland glade. For many years they ignored
the wasteland which made up most of the continent.

The painters of the 'Heidelberg School' – named after a district near
Melbourne which is so fertile and beautiful it has been dubbed 'the
Barbizon and Fontainebleau of Australia' – conveyed in their paintings
a sense of harsh, bright light and vast open spaces, absent from
European painting. But they were pastoral Impressionists, who
yearned for an image of an Antipodean Eden, bathed in what Arthur
Streeton, the greatest of them, described as the 'copper and gold . . .
all the light, glory and quivering brightness'.⁷

By the 1930s, this Australian Impressionism had largely degenerated into mannerism, but the painting of the Australian landscape was revived by the discovery – or rather the *transplanting* into the Australian situation – of the Romantic (as opposed to the sensuous Impressionist) tradition. For example, Lloyd Rees, born in Brisbane in 1895, combined a sense of detail with an imaginative grasp of the Gothic sublimity of the wilderness. Rees once described how, as a young man, after seeing a set of Turner prints and reading a book by Ruskin on Turner, he moved round Brisbane 'in a sort of golden haze, seeing it in terms of Turneresque visions'. He added that 'the grandeur of Ruskin's prose was as much responsible for this as were the Turner prints'.[8] Rees became one of Australia's finest painters: and yet no artist could have worked more uncompromisingly within the framework of a Ruskinian aesthetic.

In the early 1920s, Rees made a remarkable study – from second-hand sources – of Chartres Cathedral, and then drew and painted some of the Gothic Revival cathedrals of Australia. His work developed into intensely detailed studies of rocks in which, as in Ruskin's own drawing, the dry stones begin to cry out and quiver with that life with which the artist invests them. Rees's more recent work resembles the intense visions of Turner's later years.

The change that took place in Australian landscape painting in the 1940s resembled that which occurred in the British tradition itself in the transition from, say, Pre-Raphaelitism to Paul Nash. Russell Drysdale was perhaps the first Australian to see that there was something to be learned from mid-century English neo-Romantic art which could not be learned from the art of the nineteenth century or from European modernism. In the work of Henry Moore and Graham Sutherland from the 1940s he saw the imagery of an injured and war-torn nature, somehow healed and redeemed by the aesthetic moment itself. Drysdale realised that, in Australia, the metaphor of war and ruin was unnecessary for the depiction of the wasteland; it was present, as it had been for Holman Hunt on the shores of the Dead Sea, within the geography itself. And so he used the novel landscape forms of the English artists as the starting point for his own vision of tortured trees, rocks and skulls against backgrounds of burning red sky or searing expanses of red-brown sand.

A group of younger artists, gathered around the oddly named *Angry Penguins* magazine, were also becoming interested in the symbolic possibilities of the Australian landscape. Foremost among them was

Sidney Nolan. His first pictures were abstract, but he soon began to combine an interest in child art with a sense of the limitless vistas of the Wimmera Plains, where he was posted during the war. Eventually he became best-known for his pictures based on the life of Ned Kelly, the son of a transported Irish convict, who became a notorious bushranger. As Nolan once put it, Kelly's was 'a story arising out of the bush and ending in the bush'.[9] In Nolan's pictures, Kelly becomes the emblem of man at odds with both the social and natural worlds.

When Kenneth Clark visited Australia, he picked out Nolan's paintings in an otherwise tedious exhibition of Australian landscape painting which he was shown in Sydney. Much to the irritation of his hosts – as Nolan was then little-known – Clark sought him out, bought a picture (the first of many), and encouraged him to come to England. It was as if Nolan's work had suggested a route beyond that impasse Clark had described at the end of *Landscape into Art*, a way of painting which acknowledged the alienness and intractability of the land, yet nonetheless found living values there. Until the end of his life Clark remained convinced that when the 'didactic snobbery' of modernism had subsided, Nolan's true stature would be recognised.[10]

Soon after his meeting with Clark, Nolan spent a year wandering through Queensland, painting the outback and the colonial architecture of the goldrush towns. Later, inspired by the achievements of the early explorers, he flew over the central desert and painted the stark, almost lunar wilderness as seen from above, from the plane window. He also produced a series of 'drought' pictures based on the mummified corpses of sheep and cattle. Oddly, these are far from macabre; Nolan's easily flowing ripolin paint makes that transformation of symbol into form almost decorative – like a crucifix worn round the neck of a beautiful woman. A vision of the desert *as Paradise* was to be the great achievement of Nolan's later years.

I began to understand Clark's views when, in 1982, I went to Australia for the first time myself, and found a way of staring at what Hunt had glimpsed on the shores of the Dead Sea, and yet not despairing.

I became especially interested in the work of Arthur Boyd,[11] one of whose early pictures (painted in 1947–48) shows *The Expulsion* of Adam and Eve from the Garden of Eden into the Australian bush. In Boyd's Biblical pictures, Australia seems to provide a 'fallen'

background to the events depicted, as 'naturally' as, for the Italian painters, the Tuscan hills provided the ineluctable setting for the life of Christ. Pictures like *Skull-headed Creature over Black Creek* seem directly to echo Holman Hunt; like the Pre-Raphaelites, Boyd adopts what Brian O'Shaughnessy called 'medieval space'. O'Shaughnessy explains that by this he means a conception of space like that revealed 'in medieval towns and buildings and paintings'. Such space, he says, is 'organic' and 'unfolds itself like a story' – rather than offering us a vista or a view.[12]

In 1959, Boyd left Australia to settle in England. There, in the era of all that Pop silliness, he painted his great pictures on the theme of Nebuchadnezzar and the fiery furnace – of man surviving in an intolerable environment.[13] Later Boyd acquired a cottage in Ramsholt, on the Deben estuary – an eery and windswept part of East Anglia. There is something medieval about this landscape, something kissed by the mask of death. Even the *Shell Guide* says that, in the land between the Ramsholt Arms and the church, 'the narrow valley of a tributary stream now blocked by the strengthened river wall, lies waste under sorrel and ragwort, smelling of death when myxomatosis comes'.[14] Boyd looked at the landscape – now rendered evil and defiled, the cradle of cruise missiles and the American airforce – acknowledged its fall, and still found a terrible beauty there: the beauty that Breughel had glimpsed, or even Bosch in the garden of delights.

Eventually, Boyd acquired two properties on the Shoalhaven River in New South Wales, and in the 1970s he began painting the Australian landscape once again. His paintings of the 1980s are among his greatest: one, *Bathers with Skate and Halley's Comet* (1985), unconsciously echoes William Dyce's *Pegwell Bay*. Perhaps the finest of these recent works is based on *The Scapegoat* itself; it shows an Australian soldier, half-fused with the sacrificial goat, wearing the crown of thorns on its head, and set against the roseate glow of the dawn above the Deben River, with the tower of Ramsholt Church in the background.

'In Australian landscape painting,' wrote Kenneth Clark, 'as in all great landscape painting, the scenery is not painted for its own sake, but as the background of a legend and a reflection of human values.'[15] Paradoxically, the Australian vision of man's struggle to come to terms with a hostile environment seems to have acquired an almost universal significance in our troubled century. As T. S. Eliot wrote in

The Waste Land: '(Come in under the shadow of this red rock),/And
I will show you something different . . .' And yet such imagery would
be of no interest if it did not transcend the presentation of the 'cursed'
ground.

The idea of the transformation of the desert played a central part
in Fred Williams's late pictures of the Pilbara region in the north-west
of Australia: it emerges also, in a less formal and abstract way, in
Nolan's *Paradise Garden*, a work based on botanical studies, consist-
ing of hundreds of small panels of flower plant forms. This great and,
I believe, underestimated work, was loosely inspired by an experience
Nolan had in 1967 when, on a visit to the desert, he saw seeds which
had lain dormant, in some cases for years, burst into abundant and
colourful life after torrential rains: *Paradise Garden* is his testimony
to a vision of the desert as Eden, to, if you will, the image of the
wasteland, acknowledged, transfigured and redeemed by a myriad of
flowers into a new garden of delights.

* * *

Even the image of the garden itself was not yet dead. As I sloughed
off late modernism in the early 1970s, Adrian Berg gave me new
insights. Berg lived and worked at the top of the house at 8 Gloucester
Gate, overlooking the gardens in Regent's Park, where at that time I
too was living. At night we could hear the wolves howling in the zoo.
Berg had studied at the Royal College of Art at a time when Pop Art
was beginning to emerge in the 1960s; some articles had related
his work from that time to Marshall McLuhan's, and to Richard
Hamilton's idea of a 'media landscape' which had somehow defini-
tively displaced the real thing. In fact, Berg was always more interested
in what science might reveal about the processes and structures of
nature. For example, he once painted a picture based on Martin
Gardner's observation, 'The logarithmic spiral is intimately related to
the Fibonacci series (1, 1, 2, 3, 5, 8, 13, 21, 34 . . .), in which
every term is the sum of the two preceding terms.' Gardner added:
'Biological growth often exhibits Fibonacci patterns.'[16]

But, in the long winter of 1971, Berg looked out of his window at
the whiteness of the snow covering everything, and he abandoned his
search for the essences of things and started to paint the trees in
Regent's Park, as seen through the window of his studio. He divided
his canvas surface in ways that allowed him to depict the changes in
his perception of the leaves and branches of the trees through time.

He was, he once explained, interested in 'shaming the senses' into a more truthful account of the external world.[17] Berg was the son of a once-renowned psychoanalyst, and was nothing if not sceptical about religion. His pictures were certainly modern: indeed, they showed an almost obsessive concern with the fragmentation of contemporary consciousness and its splitting up into a series of fleeting impressions. 'Time was,' Berg once wrote, 'when a painter could with a title evoke whole mythologies, whether Christian or pagan. Now he has only fragments of a mythology, called art or science or, on this green island, nature.'[18] And yet he was also a traditional painter – someone who believed that the pursuit and practice of *painting* was worthy of a man's best efforts; someone who thought that he could give of his best by gazing again and again at the same parochial scenes.

Quite suddenly, Berg's painting effloresced into a series of great works of the gardens of England – paintings of the Punchbowl in Windsor Valley Gardens, of Kew, the Pinetum at Nymans, and Syon Park. *Sheffield Park* was his masterpiece: a work which in its complexity and richness seems to reach beyond the evidence of the senses to an image of our relationship to the natural world itself.

There were, of course, many other painters who, against the odds, seemed able to root their desire to create major pictures in an imaginative response to the natural world. And many of them suggest a way through the dilemma described in *Landscape into Art*. They reflect the mood evoked by Gregory Bateson, who shared Clark's pessimism concerning modern man's sense of alienation from the natural world. Yet Bateson believed, as he put it, that 'there is at least an impulse still in the human breast to unify and thereby to sanctify the total natural world of which we are'.[19] That impulse – whether or not we believe in God – may point beyond the impasse of post-modernism.

Conclusion
The Blind Watchmaker and
the *Hortus Conclusus*

Let us now return to the point from which we set out, to Charles Collins's *Convent Thoughts*, and Ruskin's response to it in 1851. I have tried to show how when Ruskin wrote to *The Times* about this picture, he was attempting to evade the perils of aesthetic Puseyism and of Atheism. By praising the painting of the leaves and plants, and ignoring or denigrating the heavy Tractarian symbolism of the picture, Ruskin hoped to lay the roots of a Protestant aesthetic anchored in nature and truth. In his mind was the memory of his dissection of *Alisma Plantago*, which had restored his waning faith in natural theology.

At this time, Ruskin still believed 'that what we call theology, if true, is a science; and if false, is not theology'.[1] The core of his interpretation of Turner's 'realism' was his belief that the distinction between natural science and theology was illogical, 'for you might distinguish indeed between natural and unnatural science, but not between natural and spiritual, unless you had determined first that a spirit had no nature'.[2] The dread of his middle years was that modern scientists might, in fact, have determined that, a spirit having no nature, nature had no spirit.

Our argument throughout this book has been haunted by the imagery of Matthew Arnold's Dover Beach, the long withdrawing roar of the Sea of Faith and the exposure of the 'naked shingles' of the world. From the mid nineteenth century onwards, the study of nature risked descent into the darkling plain of utter meaninglessness; pursuit of the natural sciences no longer seemed to offer a means through which artists might hope to arrive at spiritual truths, or, come to that, at aesthetic beauties. That 'disassociation of sensibility' which was so to trouble T. S. Eliot in the following century was everywhere apparent; the world seemed to have lost its enchantment and to have become *mundane*. Eventually, it seemed that art could only sustain

its transcendental dimension through the pursuit of abstraction. And, as the twentieth century progressed, even this became increasingly associated with what Ruskin would have dismissed as *aesthesis*.

Many twentieth century artists – and more twentieth century theorists – entered fully into this disillusionment and conspired with scientists to remake this disenchanted world in the bleak image of contemporary scientific thought. Some artists and architects went along with the belief that adoption of 'the scientific attitude' necessitated acceptance of an international modernist style. More, perhaps, concluded there was nothing the artist could learn from the way the scientist viewed the world.

Take the case of Victor Pasmore; after earlier experiments with abstraction, Pasmore, encouraged by Kenneth Clark, became a 'realist' artist in the 1930s; he was a founder member of the Euston Road School and was concerned with the recording of objective appearances. In the early 1940s, he began to long to give expression to more than the appearances of things. He produced delicate and sinuously romantic paintings of the hanging gardens of Hammersmith. In 1947, however, he underwent another dramatic conversion and his pictures became abstract once again. At first, they were based on principles not dissimilar from those expressed in the second volume of *Modern Painters*; influenced by J. W. Power, Pasmore believed that 'the compositions of all great works were based on the repetition and twisting of the same form throughout the composition'.[3] At this time, he was still making abstracted drawings of the rocks, waves and clouds at Porthmeor Beach; he, too, seemed to be seeking those fundamental forms which held the key to the beauty of nature. But they eluded him as they had Ruskin; Pasmore never returned to an aesthetic rooted in appearance; rather, he became seduced by a 'straightened up' version of constructivism. The waves and spirals gave way to rigid and unequivocally 'modernist' reliefs. In 1955, Pasmore also became involved as Consulting Director of Urban Design for Peterlee new town, near Newcastle. The link with Ruskinian aesthetics disappeared from his work.

Pasmore was one of the founders of 'Basic Design', a new way of teaching art which, in the late 1940s, began to replace traditional methods of art education. 'Basic Design' predictably originated in a department of industrial design, at the Central School of Art; the new philosophy promised a new art for a new age. In the beginning, Basic

Design involved some residual studies of natural history, for example of the forms of crystals, and of D'Arcy Thompson's morphological theories; but these were soon forgotten. The idea came to persist among artists that a 'scientific aesthetic' was synonymous with a neat, 'rational', rectilinear and constructive art.

But I have tried to indicate that in Britain, despite all this, another tradition persisted, one which struggled to maintain an imaginative and spiritual response to natural form in ways which cannot be dismissed as sheer nostalgia. Many scientists now seem to be aware that their research has implications for art and architecture of very different kinds from the 'straightened up' world that C. H. Wadding-ton and his contemporaries proposed.

E. O. Wilson, the Harvard socio-biologist, has drawn attention to the way in which the advance of modernity has come close to the destruction of man's sense of unity with nature. Far from advocating that art should reflect this aspect of science, he rather insists that the 'fiery circle of disciplines' can only be closed if movement occurs, as it were, at both polarities: 'if science looks at the inward journey of the artist's mind, making art and culture objects of study in the biological mode, and if the artist and critic are informed of the mind and the natural world as illuminated by scientific method'.[4] Today, we are ever discovering more of mind in nature, and also of the natural history of mind itself.

<p style="text-align:center">* * *</p>

Let us look first at mind and beauty in nature; the material basis of Platonism, if you will! In his outstanding study of the decorative arts, Ernst Gombrich remarks on the fact that so deeply ingrained is our tendency to regard order as the mark of an ordering mind that we 'instinctively react with wonder whenever we perceive regularity in the natural world';[5] for example, a 'fairy ring' of mushrooms growing in a perfect circle still seems to us to imply some supernatural agency. But Gregory Bateson has suggested that it is perhaps in the nature of mind itself to see things the wrong way round; nature may not be the product of an ordering or creative mind ... but our ordering and creative minds are certainly the products of nature; it is therefore perhaps not so surprising that there should be innumerable correspondences between the two – and that nature should so often have seemed to men and women to suggest a First Cause, a thinking *Primum Mobile*. As Bateson himself put it:

The man who studies the arrangement of leaves and branches in the growth of a flowering plant may note an analogy between the formal relations between stems, leaves, and buds, and the formal relations that obtain between different sorts of words in a sentence.[6]

Perhaps Ruskin was not, after all, merely foolish when he felt that analysis of the water-plantain leaf had revealed to him something of what he took to be the workings of the Divine mind.

Order, as Bateson put it, is often seen as a matter of dividing and sorting. For such operations, we need something like 'a sieve, a threshold, or, *par excellence*, a sense organ'. It is therefore, he says, 'understandable that a perceiving Entity should have been invoked to perform this function of creating an otherwise improbable order':

All this speculation becomes almost platitude when we realize that both grammar and biological structure are products of communicational and organizational process. The anatomy of the plant is a complex transformation of genotypic instructions, and the 'language' of the genes, like any other language, must of necessity have contextual structure. Moreover, in all communication, there must be a relevance between the contextual structure of the message and some structuring of the recipient. The tissues of the plant could not 'read' the genotypic instructions carried in the chromosomes of every cell unless cell and tissue exist, at that given moment, in a contextual structure.[7]

And so some modern scientists have rehabilitated the idea – at the centre of the early nineteenth century natural theology – that 'mind', proportion and beauty are evidenced in nature; but unlike the natural theologians, they do not argue that this inevitably leads to a belief in God.

Another example of all this is the growing understanding of the way in which intricacy and complexity emerge from simplicity. 'If there is a deep message that a scientist should convey to a non-scientist,' writes Peter Atkins, a physical chemist from Lincoln College, Oxford, 'it is that the principal achievement of fundamental science is the revelation that simplicity can have consequences of extraordinary complexity, a revelation achieved by science's ability to trace the route through which these simplicities tangle into testable, observable complexities.'[8]

Atkins is the author of a fascinating, if ultimately infuriating, book, *The Creation*, which attempts to offer a reductionist, 'scientific' sketch of the way that matter emerged out of nothing and the world subsequently evolved. Following the Second Law of Thermodynamics, Atkins places all the emphasis upon 'the extraordinary creative,

constructive characteristic of chaos'. He argues that rapid disinte-
gration in one place will lead to an increase of structure in another;
or, as he puts it, 'a surge of chaos there may effloresce into a cathedral,
a symphony, or a deed here'.[9] It is possible to question this relentless
pursuit of scientific determinism into realms over which it has no
dominion and yet still to retain a perception of the truth upon which
Atkins is insisting: namely that science, today, can reveal – and indeed,
with the aid of modern computers, *reproduce* – the way in which
natural forms of extreme complexity can emerge out of the combi-
nation and recombination of elements of extreme simplicity.

The problem of 'complex design' which Atkins addresses has always
been the most cogent argument in favour of Divine creation and
against evolutionary theory – ever since William Paley insisted that
just as a watch implied the existence of a watchmaker, so the world
implied the existence of God. To many, it has hitherto seemed simply
impossible that nature, in all its complexity and interconnectedness,
could have come about through 'blind chance'; this is an argument
which Richard Dawkins, a friend and colleague of Atkins, takes
seriously in his book *The Blind Watchmaker*. Dawkins maintains that
although 'blind chance' can explain nothing, the concept of 'tamed
chance' explains a great deal, perhaps everything, and certainly those
'organs of extreme perfection', like the human eye, which even devout
Darwinians have hitherto regarded as being something of a problem.
Or, as he puts it, 'Provided we postulate a sufficiently large series of
sufficiently finely graded intermediates, we shall be able to derive
anything from anything else without invoking astronomical
probabilities.'[10] And modern computer technology again enables the
contemporary biologist to illustrate rather than simply to postulate
such a hypothesis.

For C. H. Waddington's generation – the scientists and pioneer
'modernists' of the 1930s – the idea of a scientific aesthetic seemed to
depend upon science's ability to simplify complexity; whereas today's
scientists are suggesting that what is exciting about 'post-modern'
knowledge is the way in which we are beginning to understand how
complexity arose out of simplicity.

Benoit B. Mandelbrot, the Harvard mathematician, has recently
argued that, despite all science's great descriptive triumphs, it has
never been able to grasp those aspects of the world which both children
and primitive peoples see first. He says that when we look at nature,
we see extraordinarily complicated shapes – like trees, mountains,

clouds, and so forth; but science and geometry have traditionally concentrated on very simple shapes, like spheres, cones, cylinders, cubes and circles. And so, Mandelbrot argues, science has hitherto proved unable to describe the shapes of most interest to the individual. 'Mountains,' he says, 'are not cones. Clouds are not spheres. Coastlines of islands are not circles; rivers don't flow straight down. Lightning is not straight.'[11] The shapes with which nature presents us are very different from those with which the traditional geometer concerned himself; in pre-scientific theories of creation, there is a wider appreciation of forms. Mandelbrot makes much of that illustration to which we have already referred which forms the frontispiece of a famous thirteenth century *Bible Moralisée* which reveals a familiar image of God as the Great Geometer creating the world with his dividers; but, he stresses, the illustrator has emphasised three different kinds of form in this newly created world, 'circles, waves and "wiggles"'. He goes on to say that circles and waves have benefited from colossal investments of effort by man and that they form the very foundation of mathematical science. 'In comparison,' he adds, '"wiggles" have been left almost totally untouched.' He claims to have conceived and developed an entirely new geometry of nature which is capable of describing many of the irregular and fragmented patterns around us; this geometry, he says, 'reveals a totally new world of plastic beauty' whose aesthetic implications appear boundless.[12]

The core of Mandelbrot's argument concerns the identification of a new family of shapes to which he has given the name 'fractals'. These involve chance, but, he claims, both their regularities and their irregularities are statistical. His geometry takes as its starting point one of the oldest poetical and philosophical intuitions, the principle of self-similarity, namely that each part of the world replicates the whole.

His reasoning is sometimes obscure and can be hard for the non-mathematician to follow, but F. J. Dyson has provided a clarifying exposition. Dyson points out that classical mathematics had its roots in the regular geometric structures of Euclid and the continuously evolving dynamics of Newton. But, he says, modern mathematics began with Cantor's set theory and Peano's space-filling curve. Historically, the revolution was forced by the discovery of mathematical structures that did not fit the patterns of Euclid and Newton. At first these new structures were regarded as 'pathological' or a 'gallery of monsters', akin, according to Dyson, 'to the cubist painting and atonal

music that were upsetting established standards of taste in the arts at about the same time'. In the beginning, the mathematicians who created these monsters regarded them as important in showing that the world of pure mathematics contained a richness of possibilities going far beyond the simple structures that they saw in nature. And so modern mathematics came to maturity in the belief that it had completely transcended the limitations imposed by its natural origins. But, following Mandelbrot, Dyson says that nature today seems to be playing a joke on the mathematicians.

'The nineteenth century mathematicians,' he writes, 'may have been lacking in imagination, but Nature was not. The same pathological structures that the mathematicians invented to break loose from nineteenth century naturalism turn out to be inherent in familiar objects all around us.' Mandelbrot maintains that scientists will be 'surprised and delighted to find that not a few shapes they had to call *grainy, hydra-like, in between, pimply, pocky, ramified, seaweedy, strange, tangled, tortuous, wiggly, wispy, wrinkled*, and the like, can henceforth be approached in rigorous and vigorous quantitative fashion'.[13]

This surprise and delight need not necessarily be confined to scientists. Mandelbrot has made many references to the aesthetic implications of his work. 'The property of scaling that characterizes fractals,' he has written, 'is not only present in Nature, but in some of Man's most carefully crafted creations.' But, he explains, this property is absent in much of the architecture of the modern movement: 'a Mies van der Rohe building,' he writes, 'is a scalebound throwback to Euclid, while a high period Beaux Arts building is rich in fractal aspects'.[14] And, he might have added, a Gothic cathedral is even more so. Mandelbrot points to what he describes as a 'surprising kinship' between his computer-generated fractal forms and the sorts of shapes to be found in old master painting and pre-modernist architecture; because fractal geometry arose from an attempt to imitate nature, in order to guess its laws, 'fractal art' – unlike the rectilinear shapes of high modernity – is readily accepted, and acknowledged as beautiful; it is not truly unfamiliar.

Mandelbrot feels that he has come close to a scientific identification of those shapes which, in religious thinking and natural theology of all kinds, have been described as 'the signature of God'. I do not possess the necessary higher mathematics to form an evaluation of his 'discoveries', but I have been deeply struck by the fact that his fractal

geometry seems similar in its aesthetic implications to the arguments Ruskin put forward to explain the similarities of form between leaf structures, estuaries, mountain ranges, Gothic ornament and roof vaults. He, too, seems to have intuited a 'grammar' of nature which, he felt, was somehow reflected in the greatest artistic and architectural achievements. Mandelbrot recognises the blow he has dealt to the pride of the modern mathematicians and claims he has confirmed Pascal's observation that imagination tires before nature does. 'I show,' he writes, 'that behind (the mathematicians') very wildest creations, and unknown to them and to several generations of followers, lie worlds of interest to all those who celebrate Nature by trying to imitate it.'[15] Ruskin, of course, advised the young artist to 'go to Nature in all singleness of heart' and to 'walk with her laboriously and trustingly, having no other thoughts but how best to penetrate her meaning, and remember her instruction; rejecting nothing, selecting nothing, and scorning nothing; believing all things to be right and good, and rejoicing always in the truth'.[16] Once these words seemed to signify the depths of aesthetic conservatism; but research like Mandelbrot's may be confirming the accuracy of Ruskin's aesthetic intuitions.

<p style="text-align:center">* * *</p>

Let us turn now to the natural history of mind. In earlier articles and books, I have tried to explore the biology of human imagination and to investigate why the aesthetic impulse is disinterested and plays into that unchallenged arena between objective and subjective which Winnicott described as the 'potential space'.[17] I do not wish to tramp over familiar territory here. But, to all this, we may add some new arguments put forward from the new biology as expounded by E. O. Wilson and others. Wilson's argument is that the urge to affiliate with other forms of life is to some degree innate, hence *Biophilia*, the title of one of his most recent books. He claims that this urge to affiliate with other forms of life has been violated by the development of technology, the destruction of the natural environment, and the emergence of a phenomenon which has been described as that of 'the machine in the garden'. 'The natural world,' writes Wilson, 'is the refuge of the spirit, remote, static, richer even than human imagination. But we cannot exist in this paradise without the machine that tears it apart. We are killing the thing we love, our Eden, progenitrix, and sibyl.'[18] All this, of course, might have been Ruskin himself; and

Wilson insists – as Ruskin would have done – that this expansion of the wasteland poses a dilemma for us as much 'in the realm of spirit' as it does in 'the shrinking environment'. Or, as Ruskin put it:

Nor is the world so small but that we may yet leave in it also unconquered spaces of beautiful solitude; where the chamois and red deer may wander fearless, nor any fire of avarice scorch from the Highlands of Alp, or Grampian, the rapture of the heath, and the rose.[19]

Wilson argues that the study of aesthetics takes us to the central issue of biophilia – and he recommends a study of the nature of the environment in which the brain evolved. He points out that our species spent two million years on the savannas, park-like grasslands punctuated by patches of woodland; and 'certain key features of the ancient physical habitat match the choices made by modern human beings when they have a say in the matter'.[20] In other words, the scientific (or rather modernist) planners might have relegated men and women to sanitised machines for living in, but today's 'post-modern' scientists are suggesting that the impulse within us which causes us to protest at such conditions is, if anything, rather more susceptible of scientific explanation. 'Is the mind,' asks Wilson, 'predisposed to life on the savanna, such that beauty in some fashion can be said to lie in the genes of the beholder?'[21]

If Wilson is right, this may explain not only a predilection among peoples of all cultures for gardens but also the great antipathy which builds up against the cubes and tower-blocks of modern architecture. For we have proved remarkably resilient to the conditioning which the modernist environment tries to exert upon us. The anger in the human soul rises up against the tower-blocks; and almost every reform movement in art and architecture is spearheaded by the cry 'Back to nature'. Ruskin once wrote that we are forced, 'for the sake of accumulating our power and knowledge', to live in cities:

. . . but such advantage as we have in association with each other is in great part counterbalanced by our loss of fellowship with Nature. We cannot all have our gardens now, nor our pleasant fields to meditate in at eventide. Then the function of our architecture is, as far as may be, to replace these; to tell us about Nature; to possess us with memories of her quietness; to be solemn and full of tenderness, like her, and rich in portraitures of her; full of delicate imagery of the flowers we can no more gather, and of the living creatures now far away from us in their own solitude.[22]

C. H. Waddington would have viewed such sentiments with derision; but the aesthetic implications of today's 'scientific attitude', it

seems, are uncannily similar to those of Ruskin. In the post-modern age, science is rediscovering the aesthetic and spiritual meanings of nature – and Ruskin's dream of a natural theology without God is becoming a reality. This need not surprise us: 'The role of science, like that of art,' writes E. O. Wilson, 'is to blend exact imagery with more distant meaning, the parts we already understand with those given as new into larger patterns that are coherent enough to be acceptable as truth.'[23] Ruskin would certainly have agreed.

<center>* * *</center>

I now have a confession to make . . . A shocking confession. When I began my research on this book, I took Ruskin at his word; he said he had never seen the leaf of *Alisma Plantago* 'so thoroughly or so well drawn' as in Charles Collins's *Convent Thoughts*. And I didn't question it. He should have known what he was talking about; after all, he had, as he explained to the readers of *The Times*, a 'special acquaintance' with the plant; he had dissected *Alisma* and built a theory of Gothic upon it. But, it seems, I was much too credulous; for, as far as I can make out today, there is no *Alisma Plantago* in *Convent Thoughts*; the border plant growing in clumps on the left-hand side of the pond is clearly and unmistakably *Sagittaria sagattifolia*, whose arrow-shaped leaf with its bifurcated tails is of quite a different shape from *Alisma*; *Sagittara sagattifolia* certainly could not have served as a proto-type for the Gothic. The shape of its leaves is not remotely like the flowing forms Ruskin reproduced in *Modern Painters* and *Proserpina*.

I can only suppose that Ruskin had seen the painting at the Royal Academy, but wrote his letter to *The Times* in defence of the Pre-Raphaelites from memory; he had, so to speak, the sinuous forms of *Alisma* upon the brain. And he worked up his erroneous recollection with his usual uncompromising dogmatism, convincing himself of the rightness of his judgement. In one sense, of course, Ruskin's error confirms the interpretation we have placed on his aesthetic ideas. Why should such a skilled amateur botanist have mistaken *Sagittaria sagattifolia* for *Alisma Plantago* unless the latter had some special and distracting significance for him? What is rather more remarkable is that, to the best of my knowledge, this error has, hitherto, gone unremarked to this day. That is certainly a sign of the times; perhaps it indicates just how indifferent we have become to whether a work of art stands in *any* kind of relationship to truth.

NOTES

LE: The Library Edition of The Works of John Ruskin, edited by E. T. Cook and Alexander Wedderburn, in thirty-nine volumes, London, 1903–12.

INTRODUCTION: MODERN PAINTING

1.) *The P.R.B. Journal: William Michael Rossetti's Diary of the Pre-Raphaelite Brotherhood, 1849–1853*, ed. William Fredeman, Oxford, 1975, p.97.
2.) 'Julian Schnabel', catalogue, Tate Gallery, London, 1982, p.10.
3.) Quoted in Suzi Gablik, *Has Modernism Failed?*, London, 1984, p.91.
4.) 'Gilbert and George: The Complete Pictures, 1971–1985', catalogue, London, 1986, p.xiv.
5.) Ibid., p.xiii.
6.) Ibid., p.xx.
7.) 'The Case of Julian Schnabel' in 'Julian Schnabel', catalogue, Whitechapel Gallery, London, 1986, pp.9–19.
8.) Carter Ratcliffe in 'Gilbert and George: The Complete Pictures', op. cit.
9.) LE XII, pp.320–1.

CHAPTER ONE: PRAETERITA IN EDEN

1.) LE XXXV, p.21.
2.) Ibid., pp.44–5.
3.) LE V, p.365.
4.) Ibid.
5.) LE XXVIII, p.345.
6.) Ibid., p.354.
7.) LE II, p.330.
8.) LE XXXV, p.311.
9.) Ibid., p.314.
10.) Letter to Dr Henry Acland, quoted in Virginia Surtees, *Reflections of a Friendship: John Ruskin's Letters to Pauline Trevelyan, 1848–1866*, London, 1979, p.270.
11.) Letter to Dr F. J. Furnivall, quoted in J. Howard Whitehouse, *Vindication of Ruskin*, London, 1950, p.28.
12.) LE XVIII, pp.133–4.
13.) LE XVII, p.144.
14.) See Van Akin Burd, *John Ruskin and Rose La Touche: Her Unpublished Diaries of 1861 and 1867*, Oxford, 1979.
15.) LE XVII, p.421.
16.) LE XXV, p.247.
17.) 'Ruskin and the Science of *Proserpina*', in *New Approaches to Ruskin*, ed. Robert Hewison, London, 1981, p.153.
18.) LE XXXIII, p.340.
19.) LE XXXV, p.560.
20.) For Arthur Severn's own account of these events, see *The Professor: Arthur Severn's Memoir of John Ruskin*, ed. James S. Dearden, London, 1967.

21.) W. G. Collingwood, *The Life of John Ruskin*, fifth edition, London, 1905, p.407.

CHAPTER TWO: *TWO PATHS IN THE POLITICAL ECONOMY OF ART*
1.) LE XVI, p.134.
2.) Ibid., p.21.
3.) Ibid., p.60.
4.) Ibid., p.xxv.
5.) Kenneth Clark, *Ruskin Today*, London, 1964, p.xi.
6.) Bernard Williams, review of *Religion and Public Doctrine in Modern England*, Vol. I, *London Review of Books*, Vol. 3, No.6, April, 1981.
7.) Maurice Cowling, *Religion and Public Doctrine in Modern England*, Cambridge, 1980, p.xvi.
8.) Ibid., p.xii.
9.) Marshall McLuhan and Quentin Fiore, *The Medium is the Message*, Harmondsworth, 1967.
10.) Harold Rosenberg, *The Case of the Baffled Radical*, Chicago and London, 1985, p.65.
11.) See Walter Benjamin, *Illuminations*, London, 1970, pp.219–53.
12.) John Berger, *Ways of Seeing*, Harmondsworth, 1972, p.32.
13.) Ibid., p.108.
14.) Kenneth Clark, *Civilization*, London, 1969, pp.329–30.

CHAPTER THREE: *A VIEW FROM THE EAGLE'S NEST*
1.) LE I, p.191.
2.) LE III, p.639.
3.) Ibid., p.25.
4.) Ibid., p.616.
5.) Ibid., p.465.
6.) Ibid., p.464.
7.) Ibid., p.465.
8.) Ibid.
9.) Ibid., p.425.
10.) Ibid., p.427.
11.) Ibid., p.148.
12.) Ibid., p.493.
13.) Ibid., p.403.
14.) Ibid., p.289.
15.) Ibid.
16.) Ibid., p.610.
17.) Ibid., p.254.
18.) Ibid.
19.) Ibid, p.631.
20.) Stephen Neill, *The Interpretation of the New Testament, 1861–1961*, Oxford, 1964, p.31.
21.) LE V, p.36.
22.) LE II, p.407.
23.) *The Ruskin Family Letters*, Vol. II, ed. Van Akin Burd, Ithaca and London, 1973, p.436.
24.) Ibid., p.463.
25.) Ibid., pp.462–3.
26.) Joan Abse, *John Ruskin*, London, 1980, p.42.

27.) Timothy Hilton, *John Ruskin: The Early Years*, Newhaven and London, 1985, p.49.
28.) *The Ruskin Family Letters*, op. cit., p.493.
29.) Abse, op. cit., p.47.
30.) Arthur O. Lovejoy, *The Great Chain of Being*, New York, 1960, p.184.
31.) Soames Jenyns, *A Free Inquiry into the Nature and Origin of Evil*, London, 1957.
32.) Nicholas A. Rupke, *The Great Chain of History*, Oxford, 1983, p.21 ff.
33.) William Buckland, *Geology and Mineralogy Considered with Reference to Natural Theology*, Bridgewater Treatise, London, 1836.
34.) John Henry Newman, *Parochial Sermons*, London, 1839, Vol. IV, No.13, p.239.
35.) Ibid.
36.) John Henry Newman, *Fifteen Sermons Preached Before the University of Oxford*, London, 1872, p.194. See also Newman's discussion of natural and revealed religion in 'An Essay in Aid of a Grammar of Assent', London, 1871.
37.) *The Ruskin Family Letters*, op. cit., p.590.
38.) LE I, p.210.
39.) *Charles Kingsley: His Letters and Memories of his Life*, ed. Mrs Kingsley, London, 1899.
40.) Buckland, op. cit., Vol. I, p.134.
41.) *The Ruskin Family Letters*, op. cit., p.584.
42.) E. O. Gordon, *Life and Correspondence of William Buckland*, London, 1884, p.81.
43.) Rupke, op. cit., pp.105–7.
44.) Quoted ibid., p.107.
45.) Adam Sedgwick, *A Discourse on the Studies of the University*, 1833, Victorian Library edition, Leicester, 1969, p.22.
46.) Ibid., p.23.
47.) J. W. Clark and T. M. Hughes, *The Life and Letters of the Reverend Adam Sedgwick*, 2 vols, Cambridge, 1890, Vol. I, pp.515–16.
48.) Preface to J. W. Salter, 'A catalogue of the collection of Cambrian and Silurian fossils contained in the Geological Museum of the University of Cambridge', Cambridge, 1873.
49.) Sedgwick, op. cit., p.17.
50.) Ibid., p.18.
51.) Ibid.
52.) In John Hudson, *Complete Guide to the Lakes*, 1843, quoted in Colin Speakman, *Adam Sedgwick: Geologist and Dalesman*, Heathfield, 1982, p.137.

CHAPTER FOUR: AESTHESIS VERSUS THEORIA

1.) LE IV, p.42.
2.) Ibid., p.36.
3.) Ibid., p.33.
4.) Ibid., p.64.
5.) Ibid., p.265.
6.) Ibid., p.91.
7.) Ibid., p.112.
8.) Ibid., pp.107–8.
9.) Ibid., p.151.
10.) Ibid., p.xl.
11.) LE XVI, p.197.
12.) LE XXXIV, p.107.

13.) LE IV, p.8
14.) Ibid.
15.) LE XXV, p.127.
16.) LE IV, p.8.
17.) Ibid., p.57, n3.
18.) Ibid., pp.142–3.
19.) Ibid., p.143.
20.) Ibid.

CHAPTER FIVE: NATURE AND THE GOTHIC

1.) Robert Chambers, *Vestiges of the Natural History of Creation*, London, 1890.
2.) Quoted Speakman, op. cit., p.106.
3.) Ibid., p.105.
4.) LE VIII, pp.xxv–xxvi.
5.) Ibid., p.xxvi.
6.) Basil Clarke, *Church Builders of the Nineteenth Century*, London, 1938, p.158.
7.) Paul Johnson, *British Cathedrals*, London, 1980, p.267.
8.) For Charles Jencks, see p.213, below.
9.) Kenneth Clark, *The Gothic Revival*, second edition, London, 1950, p.9.
10.) Ibid., p.2.
11.) Ibid., p.265.
12.) Charles L. Eastlake, *A History of the Gothic Revival in England*, London, 1872, p.266.
13.) See Michael McCarthy, *The Origins of the Gothic Revival*, New Haven and London, 1987.
14.) Georg Germann, *Gothic Revival*, London, 1972, pp.30–1.
15.) The extent of Pugin's contribution remains contentious.
16.) Clark, op. cit., p.191.
17.) LE V, pp.428–9.
18.) LE IX, p.437.
19.) J. M. Neale and Benjamin Webb, introduction to translation of Willielmus Durandus, *Rationale Divinorum Officiorum*, London, 1843, quoted Clark, *The Gothic Revival*, p.142.
20.) Basil Clarke, op. cit., p.87 ff.
21.) E. T. Cook, *The Life of John Ruskin*, Vol. I, second edition, London, 1912, p.212.
22.) Quoted ibid., p.213.
23.) Collingwood, op. cit., p.109.
24.) LE VIII, p.143.
25.) Ibid., pp.168–9.
26.) LE IX, p.268.
27.) Ibid.
28.) LE XII, p.25.
29.) Ibid., pp.25–6.
30.) Ibid., p.26.
31.) Ibid., p.27.
32.) Eastlake, op. cit., p.271.
33.) Quoted in LE XVI, p.xliv.
34.) Eve Blau, *Ruskinian Gothic: The Architecture of Deane and Woodward, 1845–1861*, Princeton, 1982, p.47.

CHAPTER SIX: PRE-RAPHAELITISM

1.) LE XXXIV, p.155.
2.) LE XII, p.xlv.
3.) *Household Words*, 15 June 1850.
4.) Holman Hunt, *Pre-Raphaelitism and the Pre-Raphaelite Brotherhood*, Vol. I, London, 1905, pp.194–5.
5.) See Malcolm Werner's entry on *Christ in the Carpenter's Shop* in 'The Pre-Raphaelites', catalogue, Tate Gallery, London, 1984, pp.76–7.
6.) Alastair Grieve, 'The Pre-Raphaelite Brotherhood and the Anglican High Church', *Burlington Magazine*, Vol. III, 1969, pp.294–5.
7.) See Grieve, 'Style and Content in Pre-Raphaelite Drawings 1848–50', in *Pre-Raphaelite Papers*, Tate Gallery, London, 1984, p.29, and S. C. Carpenter, *Church and People, 1789–1889*, London, 1933, p.196 ff.
8.) Grieve, 'The Pre-Raphaelite Brotherhood', op. cit., p.294.
9.) LE XII, p.320.
10.) Ibid., p.321.
11.) Ibid., p.557.
12.) *The Complete Poetical Works of Percy Bysshe Shelley*, ed. Thomas Hutchinson, London, 1960 edition, p.591.
13.) See Nicolette Scourse, *The Victorians and their Flowers*, London, 1983, p.49.
14.) See Malcolm Werner's entry on *Convent Thoughts* in 'The Pre-Raphaelites', op. cit., pp.87–8.
15.) 'See Julian Treuherz's 'The Pre-Raphaelites and Medieval Illuminated Manuscripts', in *Pre-Raphaelite Papers*, op. cit., pp.153–69; Treuherz has identified the source of the missal held by the nun as a late fifteenth century Book of Hours from the Soane Museum, which Collins probably learned about through Henry Noel Humphrey's *The Art of Illumination and Missal Painting*, published in 1849.
16.) 'The Pre-Raphaelites', op. cit., p.87.
17.) LE XII, p.327.
18.) Ibid.
19.) Ibid., pp.321–2.
20.) Ibid., p.322.
21.) Ibid., p.157.
22.) Ibid., p.160.
23.) LE V, p.173.
24.) Ibid., pp.174–5.
25.) Ibid.
26.) Ibid., pp.175–6.

CHAPTER SEVEN: PROSERPINA

1.) Quoted Scourse, op. cit., p.51.
2.) Louisa Twamley (later Mrs Meredith), *The Romance of Nature*, London, 1837.
3.) Charles Kingsley, *Glaucus, or the Wonders of the Shore*, London, 1855.
4.) For the origins of the Wardian cases craze see Nathaniel Bagshaw Ward, *On the Growth of Plants in Closely Glazed Cases*, London, 1842.
5.) Kingsley, op. cit.
6.) See Warington, 'Notice of Observations . . .', *Quarterly Journal of the Chemical Society of London*, 1850, pp.52–4.
7.) Philip Gosse, *The Aquarium*, London, 1854, p.100. For further information on the aquarium craze, see Gosse, *The Aquarium*, second edition, London, 1856, and *A Handbook to the Marine Aquarium*, London, 1856, Shirley Hibberd's

many and various books, especially *Rustic Adornments for Homes of Taste, and Recreation for Town Folk in the Study and Imitation of Nature*, London, 1856, and George Sowerby's *Popular History of the Aquarium of Marine and Freshwater Animals and Plants*, London, 1857.

8.) Quoted Scourse, op. cit., p.111.
9.) Charlotte M. Yonge, *The Herb of the Field*, London, 1853.
10.) Quoted Scourse, op. cit., p.65.
11.) LE XXV, p.391.
12.) LE XII, p.419.

CHAPTER EIGHT: THE SCAPEGOAT

1.) LE XXXVI, p.90.
2.) Ibid., p.115.
3.) *Poems of Alfred Lord Tennyson*, ed. Charles Tennyson, London, 1954, p.321.
4.) LE XII, pp.391–2.
5.) Ibid., p.392.
6.) Ibid.
7.) Ibid., p.331.
8.) Quoted in Judith Bronkhurst, '"An interesting series of adventures to look back on", William Holman Hunt's visit to the Dead Sea in November 1854', in *Pre-Raphaelite Papers*, op. cit., p.120.
9.) In *The Germ*, reprinted Oxford, 1984, p.xi.
10.) For a discussion of the influence of the illustrations in Hunt's Bible on this picture see Jeremy Maas, *Holman Hunt and the Light of the World*, London, 1984, p.83 ff.
11.) For a discussion of this and other matters relating to Hunt's picture, see Judith Bronkhurst's entry on the Manchester version of the picture in 'The Pre-Raphaelites', op. cit., pp.153–4.
12.) For Hunt's own views on *The Scapegoat* see his *Pre-Raphaelitism*, op. cit., Vol. I, pp. 446–7, 456, 508–10; Vol. II, p.106 ff.
13.) Quoted in 'William Holman Hunt', catalogue, Walker Art Gallery, Liverpool, 1969, p.43.
14.) *Athenaeum*, 10 May 1856, p.589.
15.) *Art Journal*, II, 1856, p.170.
16.) George P. Landow, *William Holman Hunt and Typological Symbolism*, New Haven and London, 1979, p.111.
17.) LE XIV, pp.61–3.
18.) Hunt, op. cit., p.263 ff.
19.) LE III, p.88.
20.) LE IV, p.302n.

CHAPTER NINE: OUR FATHERS HAVE TOLD US

1.) LE V, pp.323–4.
2.) Ibid., pp.173–4.
3.) Ibid., pp.379–80.
4.) Ibid., p.264.
5.) Ibid., p.265.
6.) Ibid.
7.) Ibid., p.359.
8.) Ibid., p.385.
9.) Ibid., p.387.
10.) LE VI, p.110.

11.) Ibid., p.111.
12.) Ibid., p.109.
13.) Ibid., p.116.
14.) Ibid.
15.) Ibid., pp.116–17.
16.) Ibid., p.119.
17.) Ibid., p.177.
18.) Ibid., p.179.
19.) See Kenneth Bendiner, *An Introduction to Victorian Painting*, New Haven and London, 1985, pp.47–63.
20.) Gregory Bateson, 'On Empty-Headedness among Biologists and State Boards of Education', in *Steps to an Ecology of Mind*, London, 1973, pp. 313–15.

CHAPTER TEN: THE ELEMENTS OF DRAWING
1.) LE XV, pp.49–50.
2.) Ibid., p.49.
3.) *John Ruskin: Letters from the Continent, 1858*, London and Toronto, 1982, p.77.
4.) Ibid., p.75.
5.) LE XXXV, p.496.
6.) LE XVI, p.193.
7.) LE XI, pp.258–9.
8.) Quoted Blau, op. cit., p.50.
9.) George Edmund Street, *An Urgent Plea for the Revival of True Principles of Architecture in the Public Buildings of the University of Oxford*, Oxford and London, 1853, p.17.
10.) Henry Acland and John Ruskin, *The Oxford Museum*, London, 1859, p.31.
11.) Blau, op. cit., pp.63–7.
12.) LE XVI, p.436.
13.) Ibid., p.216.
14.) Ibid., p.233.
15.) Ibid, pp.234–5.
16.) Quoted Blau, op. cit., p.81.
17.) LE V, p.425.
18.) See Carpenter, op. cit., pp. 441–6, 491, and 503–5.
19.) Benjamin Jowett, 'On the Interpretation of Scripture', in *Essays and Reviews*, London, 1860, pp.330–433.
20.) Charles Goodwin, 'On the Mosaic Cosmogony', ibid., pp.207–53.
21.) Quoted Clark and Hughes, op. cit.
22.) LE VII, p.9.
23.) Ibid., p.259.
24.) Ibid., p.262.

CHAPTER ELEVEN: UNTO THIS LAST
1.) LE XVII, pp.29–30.
2.) Ibid., p.31.
3.) Ibid., p.222.
4.) Ibid., p.40.
5.) Ibid., p.153.
6.) Ibid., p.155.
7.) Ibid., p.105.
8.) LE VII, p.41.

9.) Ibid., p.42.

10.) LE XVII, p.75.

11.) Quoted Robert Hewison, *Art and Society: Ruskin in Sheffield, 1876*, London 1981, p.16. Hewison's important lecture was one of the first studies to question conventional socialist appropriation of Ruskin.

12.) LE XVII, p.74.

13.) P. D. Anthony, *John Ruskin's Labour*, Cambridge, 1983, p.57.

14.) LE XVII, pp.182–3.

15.) LE X, p.192.

16.) Ibid., p.196.

17.) Ibid., p.193.

18.) *Ruskin on Architecture: His Thought and Influence*, 1973.

19.) *Pioneers of Modern Design*, Harmondsworth, 1968 edition, p.133.

20.) Herbert Read, *Art and Industry*, London, 1934.

21.) See Margaret A. Rose, *Marx's Lost Aesthetic*, Cambridge, 1984.

22.) Mikhail Lifshitz, *The Philosophy of Art of Karl Marx*, Pluto edition, London, p.12.

23.) Karl Marx, *Early Writings*, Harmondsworth, 1975, p.353.

24.) Ibid., p.352.

25.) Ibid.

26.) Karl Marx and Frederick Engels, *Selected Works*, Vol. II, Moscow, 1951.

27.) *Socialism Utopian and Scientific*, Peking, 1975, p.97.

CHAPTER TWELVE: THE STORM-CLOUD OF THE NINETEENTH CENTURY

1.) LE XXXVI, p.461.

2.) LE XVIII, p.67.

3.) LE XVII, pp.350–1.

4.) LE XXXVII, p.30.

5.) Ibid., p.154.

6.) Helen Gill Viljoen, *The Brantwood Diary of John Ruskin*, New Haven and London, 1971, p.181.

7.) Ibid.

8.) Ibid., p.182.

9.) Ibid., p.183.

10.) Ibid., p.188.

11.) LE XXXVII, p.297.

12.) Viljoen, op. cit., p.191.

13.) Ibid., p.194.

14.) Ibid., p.226.

15.) Ibid., p.301.

16.) LE XXXIV, p.40.

17.) Ibid., p.33.

18.) Ibid., p.40.

19.) Ibid., p.41.

CHAPTER THIRTEEN: OF DABCHICKS AND PIGS' WASH

1.) Ian Small, *The Aesthetes: A Sourcebook*, London, 1979, pp. xiv–xv.

2.) LE XXV, p.122.

3.) Ibid.

4.) There is little doubt that Ruskin in fact learned from Pater; for example, Pater's first essay on Botticelli appeared in the *Fortnightly Review* in 1870; Ruskin's

first reference to Botticelli was made the following year. See LE IV, p.355.

5.) 'Coleridge's Writings', in *Walter Pater: Essays on Literature and Art*, ed. Jennifer Uglow, London, p.1.
6.) 'Winckelmann', Uglow, op. cit., p.37.
7.) 'Aesthetic Poetry', Uglow, op. cit., p.99.
8.) Ibid.
9.) LE IX, p.356.
10.) Uglow, op. cit., p.99.
11.) 'The Child in the House', in *Miscellaneous Studies*, Caravan Library edition, 1928, p.166.
12.) Quoted Small, op. cit., p.201.
13.) Ibid., p.133.
14.) Ibid., p.98.
15.) *Walter Pater*, London, 1959, p.5.
16.) Modern Library edition, New York, n.d., p.xxv.
17.) Ibid., p.xxvi.
18.) Ibid., p.xxvii.
19.) Ibid., p.198.
20.) Ibid., p.199.
21.) Ibid., p.196.
22.) Ibid., p.111.
23.) Ibid., p.107.
24.) Ibid., p.114.
25.) LE XXIX, p.162.
26.) 'The Ten O'Clock Lecture', in *The Gentle Art of Making Enemies*, London, 1890, p.138.
27.) Ibid., p.147.
28.) Ibid., pp.127–8.
29.) 'Style', in *Appreciations*, Pocket Edition, 1924, p.36.
30.) Whistler, op. cit., p.128.
31.) Ibid., p.145.
32.) Ibid., p.144.

CHAPTER FOURTEEN: AN EARTHLY PARADISE?

1.) 'William Morris Today', catalogue, Institute of Contemporary Arts, 1984, p.17.
2.) See *William Morris: Romantic to Revolutionary*, second edition, London, 1977, passim, especially p.807.
3.) 'How I Became a Socialist', in *Collected Works of William Morris*, Vol. XXIII, London, 1915, p.279.
4.) Joanna Banham and Jennifer Harris (eds), *William Morris and the Middle Ages*, Manchester, 1984, p.6.
5.) *William Morris: The Marxist Dreamer*, Vol. I, London, 1978, p.125.
6.) *Collected Works of William Morris*, op. cit., Vol. XXII, p. 323.
7.) Ibid.
8.) Ibid., Vol. XXIII, p.173.
9.) LE X, p.188.
10.) LE IX, pp.70, 253.
11.) Ibid., p.454.
12.) *Collected Works of William Morris*, op. cit., Vol. XXIII, p.280.
13.) Ibid.
14.) Ibid., pp.280–1.
15.) *News From Nowhere*, Thomas Nelson edition, 1941, pp.101, 187.

16.) Ibid., p.101.
17.) Ibid.
18.) Ibid., p.58.
19.) Ibid., p.102.
20.) Ibid., pp.112–13.
21.) Ibid., pp.79, 46.
22.) Ibid., p.183.
23.) Ibid., p.35.
24.) Ibid., pp.47–8.
25.) Nikolaus Pevsner, *Pioneers of Modern Design: From William Morris to Walter Gropius*, revised edition, Harmondsworth, 1960, pp.22–3.
26.) Ibid., p.38.
27.) *William Morris as Designer*, London, 1967, p.78.
28.) 'William Morris Today', op. cit., pp.81–6.
29.) Ibid., pp.90–3.
30.) Peter Fuller, 'The Search for a Postmodern Aesthetic', in *Design After Modernism*, ed. John Thackara, London, 1988, pp.117–34.
31.) Pevsner, *Pioneers of Modern Design*, op. cit., pp. 53–4.
32.) 'Dating Morris Patterns', *The Architectural Review*, CXXVI, July, 1959, pp.14–20.
33.) For a recent discussion of these issues, see Linda Parry, *William Morris Textiles*, London, 1983.
34.) *Collected Works of William Morris*, op. cit., XXII, p.8.
35.) Quoted Pevsner, *Pioneers of Modern Design*, op. cit., p.30.
36.) 'Ornament and Crime', in 'The Architecture of Adolf Loos', Arts Council catalogue, London, pp.100–03.
37.) *William Morris: A Vindication*, London, 1934, pp.4–5. (It is astonishing that this one-track bigot continues to exert such an influence over Morris studies.)
38.) Thompson, op. cit., p.773.
39.) Ibid., pp.792–3.
40.) Ibid., p.807.
41.) *Steps to an Ecology of Mind*, Paladin edition, St Albans, 1973, pp.436–7.
42.) *John Ruskin's Labour*, op. cit. – probably the most important book to have been published in recent times on Ruskin's social theories.
43.) *Collected Works of William Morris*, op. cit., Vol XXII, p.11.
44.) Ibid.

CHAPTER FIFTEEN: THE SPIRITUAL IN ART
1.) LE XII, p.139.
2.) Ibid., p.142.
3.) Ibid., p.133.
4.) *De Profundis*, in *The Works of Oscar Wilde*, Galley Press edition, London, 1987, p.867 ff.
5.) *Religion in Recent Art*, London, 1905, p.x.
6.) Ibid., p.141.
7.) Ibid., p.3.
8.) Ibid., p.142.
9.) Ibid., p.151.
10.) Ibid., p.148.
11.) Ibid., p.155.

12.) Ibid., p.158.
13.) Ibid., p.181.
14.) Ibid., p.181–2.
15.) Ibid., p.188–9.
16.) Ibid., p.185.
17.) Ibid., p.182.
18.) Ibid., p.195.
19.) M. S. Watts, *George Frederic Watts: The Annals of an Artist's Life*, London, 1912, p.94.
20.) Ibid., p.96.
21.) LE XI, p.30.
22.) *George Frederic Watts*, London, 1906, p.135.
23.) LE XXXVI, pp.111–12.
24.) M. S. Watts, op. cit., Vol. I, p.91.
25.) Ibid., Vol. II, p.184.
26.) Ibid., Vol. I, p.144.
27.) See LE XXXIII, pp.287–305.
28.) M. S. Watts, op. cit., Vol. I, p.28.
29.) Watts modelled himself on Michelangelo; see Wilfrid Blunt, *England's Michelangelo*, London, 1975.
30.) *British Contemporary Artists*, London, 1899, p.6.
31.) M. S. Watts, op. cit., Vol. II, p.150.
32.) 'Our Academicians', in *Modern Painting*, new edition, London, p.108.
33.) 'G. F. Watts', *Burlington Magazine*, Vol. V, 1904, p.452.
34.) *G. F. Watts*, 1904, new edition, London, 1975, p.58.
35.) Peter Fuller, 'G. F. Watts: a Nineteenth Century Phenomenon', in *The Connoisseur*, Vol. 185, no.746, p.323.
36.) M. S. Watts, op. cit., Vol. II, p.302.
37.) Ibid.
38.) Ibid.
39.) Ibid.
40.) Jean Renoir, *My Father*, London, 1962, p.389.
41.) See 'Renoir', Arts Council catalogue, London, 1985.
42.) Jean Renoir, op. cit., p.222.
43.) Ibid., p.348.
44.) Ron Kitaj, foreword to 'Degas Monotypes', catalogue, The Arts Council, London, 1985.
45.) R. H. Wilenski, *Modern French Painters*, London, 1940.
46.) Ibid.
47.) Quoted in Peter Fuller, 'The Garden of Art', in *New Society*, 16 May 1985, Vol. 72, no.1168, p.232.
48.) For a discussion of this see Peter Fuller, *Art and Psychoanalysis*, new edition, London, 1988.
49.) See Peter Fuller, *Images of God*, London, 1985, p.46.
50.) Ibid., p.43.
51.) See Tom Gibbons, 'British Abstract Painting of the 1860s: The Spirit Drawings of Georgiana Houghton', in *Modern Painters*, Vol. 1, no.2, Summer 1988, pp.33–7.
52.) *Parochial Sermons*, London, 1839, Vol. IV, no.13, p.239.
53.) *Rückblicke: 1901–13*, Berlin, 1913, translated as *Reminiscences* in *Modern Artists on Art*, edited by Robert L. Herbert, New Jersey, 1964, pp.20–44.
54.) See Wassily Kandinsky, *Concerning the Spiritual in Art*, New York, 1977.

55.) Timothy Ware, *The Orthodox Church*, Harmondsworth, 1963, p.232.
56.) Hans K. Roethel, *Kandinsky*, New York, 1979, p.76.
57.) See also Peter Fuller, 'Beyond the Veil, Stars and Stripes?' in *Art and Design*, Vol. 3, no.5–6, 1987, pp.66–72.
58.) *The Evolution of Life and Form*, quoted ibid., p.70.
59.) Rudolf Otto, *The Idea of the Holy*, Harmondsworth, 1959, p.85.
60.) Ibid., p.85. For a further discussion of the psychological implications of Otto's ideas, see Peter Fuller, *Art and Psychoanalysis*, op. cit.
61.) Roger Fry, *Reflections on British Painting*, London, 1934, p.130.
62.) Ibid., p.134 ff.
63.) *Art*, 1914, O.U.P. edition, Oxford, 1987, p.93.
64.) 'Retrospect', in *Vision and Design*, London, 1920, p.199.
65.) Ibid.
66.) 'The Place of Art in Art Criticism', in *Since Cézanne*, London, 1929, p.94.
67.) Ibid., p.95.

CHAPTER SIXTEEN: LOVE'S MEINE

1.) LE XXVI, pp.335–6.
2.) Ibid., p.334.
3.) LE XXV, p.240.
4.) Ibid., p.241.
5.) Ibid.
6.) Ibid., p.242.
7.) Ibid., p.245.
8.) Ibid., p.246.
9.) Ibid.
10.) LE XXVI, pp.265–6.
11.) LE XXII, p.237.
12.) LE XXV, pp.249–50.
13.) Ibid., p.264.
14.) LE XVII, pp.civ–cv.
15.) *New Society*, no.1123, 31 May, 1984, pp.343–5.
16.) Edward O. Wilson, *Biophilia*, Harvard and London, 1984.

CHAPTER SEVENTEEN: KARL BARTH AND THE DEATH OF GOD

1.) *Church Dogmatics*, Vol. I, pt.2, New York, 1936, p.300.
2.) Ibid., p.302.
3.) See Eberhard Busch, *Karl Barth*, London, 1976, p.81.
4.) *The Epistle to the Romans*, New York, 1960, p.97.
5.) Ibid., p.98.
6.) Ibid., pp.98–9, 29.
7.) *Christliche Dogmatik*, Munich, 1927, p.ix.
8.) LE IV, p.210.
9.) Ibid.
10.) LE VII, p.462.
11.) Hans Küng, *Art and the Question of Meaning*, London, 1981, p.29.

CHAPTER EIGHTEEN: BLACK SKELETON AND BLINDING SQUARE

1.) Max Raphael, *Proudhon, Marx, Picasso*, London, 1980.
2.) 'Cubism and "The Fourth Dimension" in the context of the Late Nineteenth-Century and Early Twentieth-Century Revival of Occult Idealism', in *Journal of the Warburg and Courtauld Institutes*, 1980, pp.130–47.

3.) See Leo Steinberg, 'The Algerian Women and Picasso at Large', in *Other Criteria: Confrontations with Twentieth-Century Art*, New York, 1972, pp.154–60.

4.) Quoted in Herschel B. Chipp, *Theories of Modern Art*, Los Angeles and London, 1968, p.287.

5.) See Peter Fuller, 'Gaudier-Brzeska', in *Images of God*, London, 1985, p.142 ff.

6.) Chipp, op. cit., p.286.

7.) Quoted Robert Hughes, *The Shock of the New*, London, 1980, p.95.

8.) Quoted Chipp, op. cit., p.376.

9.) R. H. Wilenski, *John Ruskin: An Introduction to Further Study of His Life and Work*, London, 1933.

10.) *The Modern Movement in Art*, London, 1927; pp.22–3.

11.) Ibid., p.24.

12.) Ibid., p.23.

13.) Ibid.

14.) Pevsner, *Pioneers of Modern Design*, op. cit., p.210.

15.) Ibid., p.38.

16.) Ibid., p.39.

17.) Ibid., pp.216–17.

18.) LE XIX, p.217.

19.) Ibid.

20.) Pevsner, *Pioneers of Modern Design*, op. cit., p.217.

21.) *The Scientific Attitude*, Harmondsworth, 1940, p.68.

22.) Ibid., p.69.

23.) Ibid., caption to Plate 12.

24.) Ibid., p.66.

25.) J. M. Richards, *An Introduction to Modern Architecture*, Harmondsworth, 1940, p.32.

26.) *Art and Industry*, London, 1934, p.33.

27.) 'The Fate of Modern Painting', in *The Philosophy of Modern Art*, Meridian edition, 1955, p.64.

28.) Ibid.

29.) Ibid., p.65.

30.) Ibid.

CHAPTER NINETEEN: THE ART OF ENGLAND

1.) Roger Fry, *Reflections on British Painting*, London, 1934, pp.25–6.

2.) Perry Anderson, 'Components of a National Culture', in *New Left Review*, no.50, pp.3–57.

3.) Martin Weiner, *English Culture and the Decline of the Industrial Spirit*, London, 1983.

4.) *Baudelaire: Selected Writings on Art and Artists*, ed. P. E. Charvet, Cambridge, 1972, p.287.

5.) Ernest Chesneau, *The English School of Painting*, London, 1887, p.169.

6.) Robert de la Sizeranne, *La Peinture Anglaise Contemporaine*, Paris, 1895.

7.) Preface to Chesneau, op. cit., p.ix.

8.) See 'Retrospect', the final chapter of Holman Hunt, *Pre-Raphaelitism and the Pre-Raphaelite Brotherhood*, Vol. II, p.468 ff.

9.) Chesneau, op. cit., pp.172–3.

10.) *Since Cézanne*, London, 1922, p.190.

11.) Roger Cole, *Burning to Speak: The Life and Art of Henri Gaudier Brzeska*, Oxford, 1978, p.10.

12.) Ibid., p.132.

13.) Ibid., p.133.

14.) Quoted Peter Fuller, *Images of God*, op. cit., pp.144–5.

15.) LE VIII, p.75.

16.) For a succinct anthology of Gill's ideas, see Brian Keeble, *A Holy Tradition of Working: Passages from the Writings of Eric Gill*, Ipswich, 1983.

17.) Jacob Epstein, *Epstein: An Autobiography*, London, 1955, p.59.

18.) Ibid., p.56.

19.) Quoted Peter Fuller, *Images of God*, op cit., pp.140–1.

20.) *The Sculpture of Epstein*, London, 1986, p.58.

21.) Quoted *Henry Moore on Sculpture*, ed. Philip James, London, 1966, p.38.

22..) *The Meaning of Modern Sculpture*, London, 1932, p.158.

23.) Ibid., p.159.

24.) Quoted James King, *Interior Landscapes*, London, 1987, p.2.

25.) Quoted Meiron and Susie Harries, *The War Artists*, London, 1983, p.56.

26.) Quoted Mervyn Levy, *The Paintings of L. S. Lowry*, London, 1975, p.17.

27.) Ibid., p.23.

28.) William Lipke, *David Bomberg*, London, 1967, p.119.

29.) See Richard Cork, *David Bomberg*, London, 1987, p.155 ff.

30.) Lipke, op. cit., pp.124–5.

31.) Roy Oxlade, 'David Bomberg 1890–1957', Royal College of Art Papers no.3. See also Oxlade, 'Notres Dames of the Mind', *Modern Painters*, Vol I, no.I, Spring 1988, pp.12–19.

32.) Lipke, op. cit., p.119.

33.) LE IX, p.294.

34.) Ibid., pp.244–5.

35.) Douglas Cooper, *The Work of Graham Sutherland*, London, 1961.

36.) *The Art of Graham Sutherland*, Oxford, 1980.

37.) 'A letter to Colin Anderson', in 'Graham Sutherland', catalogue, Tate Gallery, London, 1982, pp.23–6.

38.) Quoted ibid., p.108.

39.) LE IV, p.332.

40.) Cecil Collins, *The Vision of the Fool*, Chipping Norton, 1981, p.10.

41.) Winifred Nicholson, *Unknown Colour*, London, 1987, p.37.

42.) See *The Tate Gallery*, London, 1963, p.42 and *British Art Since 1900*, London, 1962, pp.22–4.

43.) In *The Genius of British Painting*, London, 1975, p.325.

44.) 'Painting Since 1939', in *Since 1939*, London, 1948, p.169.

45.) 'A View of English Painting', in *Penguin New Writing*, no.31, ed. John Lehmann, West Drayton, 1947, p.136.

46.) Ibid., p.144.

47.) *Art and Social Responsibility*, London, 1946, p.74.

48.) Ibid.

49.) Jacquetta Hawkes, *A Land*, 1951, Penguin edition, Harmondsworth, 1959, pp.9, 208.

50.) *Landscape into Art*, London, 1949, p.142.

CHAPTER TWENTY: THE TRIUMPH OF LATE MODERNISM

1.) Quoted in John S. Harris, *Government Patronage of the Arts in Great Britain*, Chicago and London, 1970, p.38.

2.) See Peter Fuller, 'The Eastward March of Civilisation', in *Art and Design*, Vol. 3, nos.9–10, 1987, pp.19–25.

3.) Foreword to 'An Exhibition of Paintings and Drawings by Graham Sutherland', catalogue, Tate Gallery, 1953.

4.) Quoted in 'Richard Hamilton', catalogue, Tate Gallery, London, 1970, p.31.

5.) Introduction to 'Modern Art in the United States', catalogue, Tate Gallery, London, 1956, p.5.

6.) 'The Realist Predicament: Past and Present Traditions of the National Scene', *The Times Literary Supplement*, 6 Nov. 1959, p.xxiv.

7.) 'Wholly American', Ibid., p.643.

8.) Kenneth Clark, *The Other Half*, London, 1977, p.135.

9.) Clement Greenberg, *The Collected Essays and Criticism: Volume 2: Arrogant Purpose, 1945–1949*, Chicago and London, 1986, p.215.

10.) Clement Greenberg, *The Collected Essays and Criticism: Volume 1: Perceptions and Judgements, 1939–1944*, Chicago and London, 1986, p.8.

11.) Greenberg, op. cit., Vol. 1, p.22.

12.) Ibid., p.173.

13.) Greenberg, op. cit., Vol. 2, pp.126–7.

14.) Ibid., p.318.

15.) Ibid.

16.) Ibid., p.323.

17.) Greenberg, op. cit., Vol. 1, p.34.

18.) Greenberg, op.cit., Vol. 2, p.325.

19.) Greenberg, op. cit., Vol. 1, p.32.

20.) Ibid., p.8.

21.) Ibid.

22.) Ibid., p.202.

23.) Ibid., p.203.

24.) Ibid.

25.) Robert Rosenblum, 'British Painting vs. Paris', in *Partisan Review*, Vol. XXIV, no.1, 1957, pp.95–100.

26.) *The Moment of Cubism and Other Essays*, London, 1969, p.7.

27.) Ibid., p.37.

28.) Ibid.

29.) Ibid., p.39.

30.) Ibid.

31.) Rod Taylor, *Education for Art*, London, 1986, pp.208–9.

32.) Sandy Nairne, *State of the Art*, London, 1987, p.60.

33.) See Charles Jencks, *What is Post-Modernism?*, London, 1986, and *Post-Modernism*, London, 1987.

34.) Gray Watson, 'Sad and Blue: Gilbert and George Interviewed', *Artscribe International*, no.65, Sept–Oct, 1987, pp.34–7.

35.) Ibid., p.37.

36.) *Ways of Seeing*, London, 1972, p.46.

37.) Watson, op. cit., p.37.

38.) *Ways of Seeing*, op. cit., p.134 ff.

39.) Roger Scruton, 'Beastly Bad Taste', in *Modern Painters*, Vol. 1, no.1, Spring 1988, pp.40–2.

40.) Nairne, op. cit., p.68.

41.) Letter to the author, 9 February 1981.

CHAPTER TWENTY-ONE: THE GLARE OF THE ANTIPODES

1.) LE XIII, p.491.

2.) John Berger, 'David Bomberg', in *Permanent Red*, London, 1960, p.95.

3.) John Berger, *The White Bird*, London, 1985, pp.8–9.

4.) LE XXXIV, p.78.

5.) LE VII, p.258.

6.) Kenneth Clark, catalogue note in 'Recent Australian Painting', Whitechapel Gallery, London, 1961, p.4.

7.) See Jane Clark and Bridget Whitelaw, 'Golden Summers: Heidelberg and Beyond', catalogue, National Gallery of Victoria, 1985, pp.104–5.

8.) Lloyd Rees, *The Small Treasures of a Lifetime*, Sydney, 1969, p.34.

9.) See Noel Barber, 'Sidney Nolan', in *Conversations with Painters*, 1964, pp.83–100.

10.) Kenneth Clark, *The Other Half*, op. cit., p.195.

11.) 'Gate to a Landscape: Arthur Boyd's Suffolk Outback', *The Melbourne Age Monthly Review*, Vol. 6, no.6, October 1986, pp.9–11.

12.) Introduction to 'Arthur Boyd', catalogue, Whitechapel Gallery, London, 1962, pp.18–19.

13.) See T. S. R. Boase, *Nebuchadnezzar: 18 drawings and 34 paintings by Arthur Boyd*, London, 1972.

14.) Norman Scarfe, *Shell Guide: Suffolk*, new edition, 1976, p.144.

15.) Clark, 'Recent Australian Painting', p.4.

16.) 'Adrian Berg', catalogue, Arthur Tooth & Sons, 1967.

17.) Communication to the author; received 12 November 1973.

18.) 'Adrian Berg', op. cit. For a fuller analysis of Adrian Berg's pictures, see Peter Fuller, 'Adrian Berg', in 'Adrian Berg: Paintings 1977–1986', catalogue, Arts Council, London, 1986.

19.) Gregory Bateson, *Mind and Nature: A Necessary Unity*, Fontana edition, London, 1980, p.27.

CONCLUSION: THE BLIND WATCHMAKER AND THE HORTUS CONCLUSUS

1.) LE XXII, pp.169–70.

2.) Ibid., p.170.

3.) Note in 'Victor Pasmore', catalogue, Arts Council, London, 1980, p.37.

4.) Edward O. Wilson, *Biophilia*, op. cit., p.81.

5.) Ernst Gombrich, *The Sense of Order*, London, 1979, p.5.

6.) Bateson, *Steps to an Ecology of Mind*, op. cit., p.13.

7.) Ibid., p.14.

8.) 'Purposeless People', ms. of talk sent by P. W. Atkins to the author, pp.6–7.

9.) Ibid., p.10. See also *The Creation*, San Francisco and Oxford, 1981.

10.) *The Blind Watchmaker*, London, 1986.

11.) 'The Fractal Geometry of Nature', Mike Dibb interviews Prof. Benoit B. Mandelbrot, *Modern Painters*, Vol. 1, no.1, Spring 1988, pp.52–3.

12.) Benoit B. Mandelbrot, *The Fractal Geometry of Nature*, Cambridge, Mass., 1980.

13.) Ibid.

14.) Ibid.

15.) Ibid. See also Peter Fuller, 'Art and Science', *Art Monthly* no. 103, pp.108–11, and 'Tomorrow's Shapes: The Practical Fractal', *The Economist*, 26 December 1987, pp.99–105.

16.) LE IX, p.293.

17.) See Fuller, *Art and Pyschoanalysis*, new edition, London, 1988.

18.) E. O. Wilson, op. cit., p.12.

19.) LE XXV, p.265.

20.) E. O. Wilson, op. cit., p.109.
21.) Ibid.
22.) LE IX, p.411.
23.) E. O. Wilson, op. cit., p.51.

Index